Symbolism

Symbolism

Robert Goldwater

Icon Editions
HARPER & ROW, PUBLISHERS
NEW YORK

Cambridge
Hagerstown
Philadelphia
San Francisco

London
Mexico City
São Paulo
Sydney

1817

FIRST U.S. EDITION

LIBRARY OF CONGRESS CATALOG CARD NUMBER: 77-82780

ISBN: 0-06-433265-9 79 80 81 82 10 9 8 7 6 5 4 3 2 1

ISBN: 0-06-430095-1 pbk 84 85 86 10 9 8 7 6 5 4 3

Contents

Foreword

Robert Goldwater had all but finished this book when he so tragically died. The Introduction was drafted and it is printed here as he left it. The rest of the text, apart from the epilogue, was in its final form, though with a number of afterthoughts and minor revisions carefully inserted. For the epilogue or final chapter, alas, he left only notes and his book therefore appears without it. We have not attempted to provide the annotations which Robert Goldwater might have wished to add. But his former student, Kristin Murphy, has compiled a catalogue for the illustrations. To her, to Professor Albert Elsen for timely help and to our friend Louise Bourgeois, for her patience and understanding, we are deeply grateful.

John Fleming, Hugh Honour

Symbolism

I

Introduction

Symbolism, as a movement beginning in the eighties, can be described as a reaction against naturalism which took on its classic form in about 1870 but had its roots in the sixties and, when seen in a larger perspective, was itself the final stage of realism already carried far by the preceding generation. In broader terms, symbolism can be thought of as part of a philosophical idealism in revolt against a positivist, scientific attitude that affected (or infected) not only painting but literature as well. Gustave Kahn in 1886 (the date of the last impressionist 'group exhibition') used as a foil the definition Zola had formulated in his defence of Manet: 'Our art's essential aim is to objectify the subjective (the exteriorization of the idea), instead of subjectifying the objective (nature seen through a temperament).' The symbolists themselves often thought in these terms, as witness Redon's well-known criticism of the 'low-vaulted ceiling' of impressionism, and Gauguin's complaint that it 'neglected the mysterious centres of thought'. And some of the impressionists felt the same way, notably Pissarro, who feared that the 'truth' of impressionism would be replaced by a sentimental, escapist 'aestheticism'.

But the general change in attitude that did occur in the mid-eighties should not be seen as a simple swing of the pendulum or a conflict of generations: Redon was a contemporary of the impressionists, and Gauguin not much younger. Van Gogh and Seurat (as well as Cézanne, whose evolution raises other issues) develop out of impressionism, remain indeed partly impressionist, rather than merely reacting against it. And among the impressionists themselves there were changes of direction and a breaking up of old ties. The 'crisis' of the eighties was thus more than just a question of those who had once been the *avant-garde* continuing unaltered a now established style, while the younger artists, seeking their place in the sun, worked out a new one.

Monet's development exemplifies the emergence of a new

Monet

attitude, not fully born until the beginnings of his series-pictures (i.e. not until the fifteen *Haystacks* of 1891 and the succeeding sequences), but already embryonic in the Étretat and Belle-Isle paintings of 1886. One of the principal motivations of the series-pictures was a desire for a further elaboration of the impressionist programme in the direction of 'scientific objectivity' – a parallel to the neo-impressionist goal. Fragmenting the object (conceived as a duration) into a succession of observed moments increased the accuracy of the record, but because this accuracy, in fact, depends upon an acute sensibility in the artist which he wants the spectator to share, subjectivity is also increased.

Already in the Étretat paintings Monet had gone beyond naturalistic accuracy. He had accepted the logic of the painting itself and its growth as colour harmony, in order to create each work in accordance with what the symbolist vocabulary of the period called the musical (i.e. abstract) imperatives of his art, minimizing optical contrasts and allowing a single hue to become the dominant note of his painting. Concentration and reduction remove the scene from transcription in the direction of symbol and towards the fuller development of the nineties and later. Of course, the impressionism of the seventies, whatever its conscious intentions, was never an 'objective' transcription of nature; nevertheless, in the course of the decade a change takes place in both style and intention: simplification of design, purification of rhythm, elimination of contrasting detail, lessening of perspective, dominance of a single hue, have altered the object – or the subject. No longer a segment of nature referred back to the extensive setting from which it has been cut, the picture has been turned into something complete in itself, something which, paradoxically, through becoming in intention more momentarily accurate has become less temporal, suggesting a duration beyond the moment that gave it birth. The exacerbation of the impressionist method has led to a work that stands for rather than represents the object and has arrived at the Mallarméan principle of suggestion through infinite nuance.

The symbolist critics were aware of these affinities. In the eighties they wrote of the impressionists' 'subjectivity of perception' and their desire for 'expressive synthesis', while somewhat later Monet's *Poplars* were described as containing 'a sense of mystery' and so participating 'in that symbolic universe of which the poets have dreamed'. [1] They were also conscious that Whistler's subtle and attenuated painting was similarly congenial. [2] He was for a time very much part of the group. Mallarmé translated the 'Ten O'Clock' lecture in 1888, and told him that he 'sympathized with his artistic vision' and Jacques-Émile Blanche recalled that in the late eighties 'the Whistler cult became entangled in men's minds with symbol-

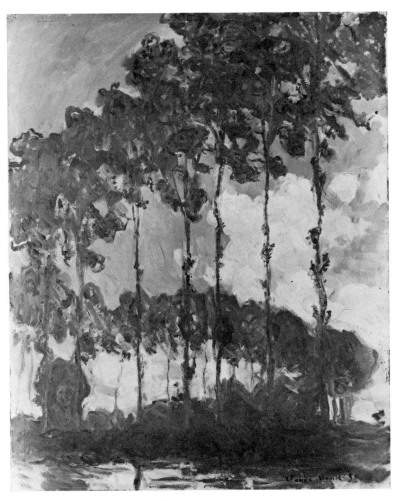

1. *Poplars on the Epte*, 1890. Monet

ism, the Mallarmé and . . . the Wagner cults.' Of course, neither
Monet, who seems to have been entirely untheoretical, nor Whistler
were symbolists, although Whistler's insistence upon the indepen-
dence of art from nature, and the consequent freedom of the artist
to control his design (whence his musical analogies) were steps
along the same road. Both painters (Whistler earlier than Monet)
move gradually away from naturalism towards a painting that 'has
the character of continuity with states of interior feeling.' This
change comes about much less through any alteration in the
repertory of objects depicted than through a changing interpreta-
tion of essentially the same kind of objects, which in effect results in

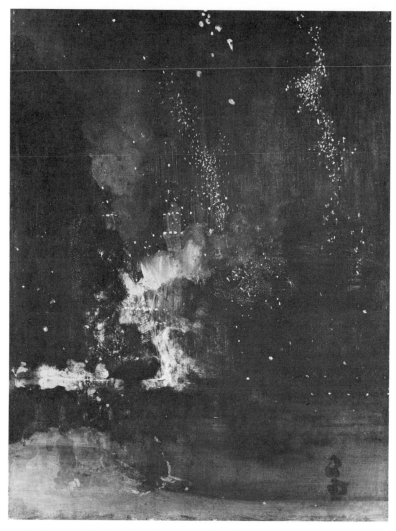

2. *Nocturne in Black and Gold, c.*1876. Whistler

a new kind of subject matter, since those objects take on new significance.

One of the principal characteristics that sets off the eighties from the previous decade is its concern with theory, related to a common concern for meaning. The theories were many, but their import was much the same. Some had a more objective bias, seeking, in Sérusier's later words, those relationships 'on which the exterior world is constructed'; others were more concerned with the artist's emotions. But whether psychological or idealist, semi-scientific or

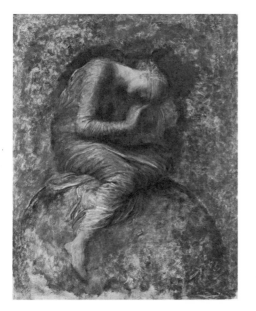

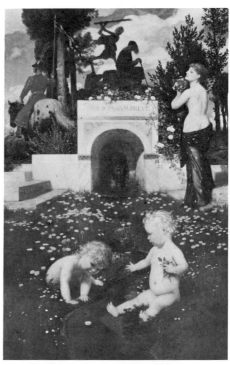

3 (*below*). *Hope*, c.1876. Watts

4 (*right*). *Vita Somnium Breve*, 1888. Böcklin

semi-philosophical, the purpose is to establish the importance of the representation the artist has undertaken, and to establish it precisely by making it, in some way, go beyond realism.

In these circumstances, how was the subject matter to be dealt with? The temptation was allegory in its traditional forms, in its use of conventional signs and symbols. [3] It was a temptation to which many so-called symbolists, in both painting and poetry, did indeed succumb. [4] But others intuitively understood the dangers and, in their theorizing as well as their painting, found personal solutions that yet had much in common. By various avenues they approached the development of a new kind of subject matter that lay somewhere between allegory and expressionism. Pictures like Gauguin's *The Yellow Christ* [5] Hodler's *Spring* [175] or Munch's *Spring* [6] have deliberately intended reflective (i.e. philosophic) overtones that go beyond the subjects represented. They are not allegories in the traditional sense: the picture begins in personal experience and emotion. But the artist wants to do more than simply express these emotions with infectious intensity, to be re-lived by the beholder. He wishes to induce a reflective mood, to indicate a wider frame of reference. So allegory with its conventional attributes will no longer do, because, having in the course of the century lost the common

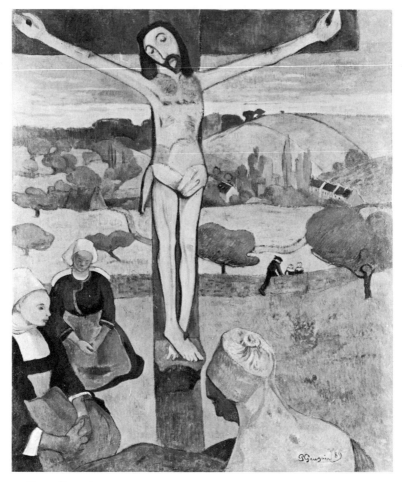

5. *The Yellow Christ*, 1889. Gauguin

tradition by which its power was sustained, it no longer captures feeling. Therefore relations within the painting — and in consequence its ideas — must be expressed through a series of interior states, generalized in figures and settings of a congruent mood that at once embody the old sense, and convey, in the new, that are (allegorically) and suggest (emotionally) the states of feeling they portray.

This desire to make emotion meaningful, by connecting it with humanity at large and by seeing nature as its reflection, is the common element in a diversity of styles in the eighties. It is the preoccupation of the symbolists themselves (as we shall see), whether

6. *Spring*, 1889. Munch

or not they support it with a philosophic rationale. But the tendency
is also at work in the immediate forerunners of the movement.
Monet and Whistler move towards it from an earlier naturalism;
Burne-Jones from a literary romanticism; Gustave Moreau and
Puvis de Chavannes from contrasting kinds of allegory. Expressive
unity was achieved in varying degrees and often the elements of
representation, design and subjective emotion remained parallel,
falling short of symbolism's desired fusion. But always there was a
subordination of specific subject to a wider purpose so that the
theme or object shown is invested with an emotional idea and
stands for something other than itself.

What counts in the development, as far as subject matter is con-
cerned, is not so much new motifs as new attitudes which, through
new formal methods, instil new meanings. The projection of
thought and feeling upon the work of art that this ideal goal entailed
can perhaps be illustrated by an example which has by now become
so banal that we are largely unaware of it. Van Gogh was not at all
times a symbolist, and he was among the least theoretical of the
artists whom it affected. Yet he infused the nature that he painted
with such intensity of emotion and execution, made of each object
such a microcosm of an animized universe vibrating with his own

8 feelings, that it is, in this new sense, a symbol — of himself and of a
pantheistic spirit. [7] The 'symbolist' result he achieved (partly in
spite of himself) can perhaps be pointed up by a contrast with a
picture by Roland Holst on the subject of Van Gogh himself. [8]
Holst's self-conscious application of theory to put together a sym-
bolic composition results in allegory, while Van Gogh's short-
circuiting creates a truly symbolist fusion of art and idea.

It has already been suggested that symbolism was not alone in its
reactions against naturalism and its desire to go beyond realism.
These ambitions were general during the last two decades of the

7. *Sunflowers*, 1889. Van Gogh

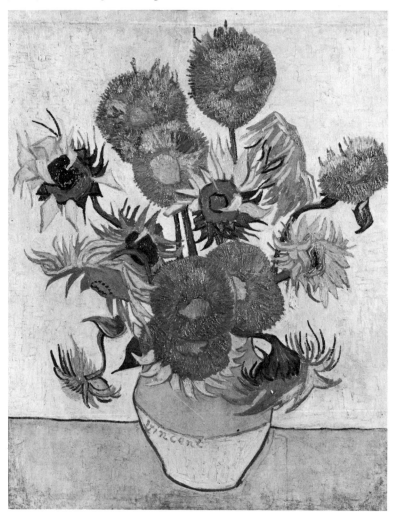

century and played their part in forming other idealizing tendencies 9
to which symbolism is at once parallel and opposed. This broader
movement is perhaps best characterized by its German name of
'thought painting' (*Gedankenmalerei*), an appellation which suggests
what its adherents had in mind: the necessity for an art of ideas and
of feeling. Symbolists and thought-painters alike wanted to give
pictorial form to the 'invisible world of the psyche'. They had a com-
mon admiration for the idealists of the preceding generation, among
them especially Gustave Moreau and Puvis de Chavannes, Burne-
Jones and the Pre-Raphaelites, and many of their subjects were the
same. Where they differ is in their attitude towards the form in
which they cast their anti-positivist impulses. Although it is not
possible to draw any hard and fast line between them, the distinction
is roughly that intended by Albert Aurier when he separated the
idéisme of the symbolists from the *idéalisme* of the academy; where
the former sought for an expressive unit of form and meaning, the
latter were content to have them remain parallel: the one was true
symbolism, the other merely personification or allegory. Thought-
painting might appear to move towards a subjectivity that bore a

8. Van Gogh Exhibition Catalogue, 1892. Roland Holst

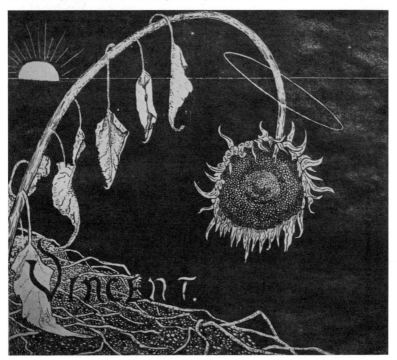

9. *Sin*, 1895. von Stuck

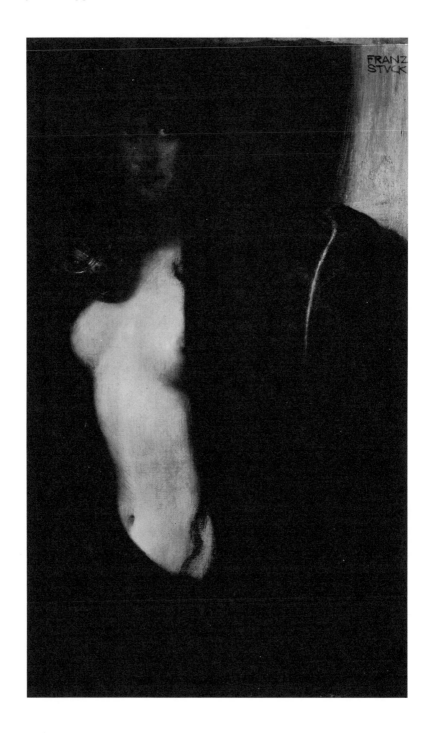

certain resemblance to that of symbolism, it might attempt to make
emotion meaningful by connecting it with humanity at large and by
seeing nature as its reflective extension, but its separated elements –
representation and design – lack symbolism's desired fusion. Of
course, many symbolist artists fall short of the ideal, and much of
their work has in consequence a semi-allegorical character. For the
thought-painter, on the other hand, this separation was an essen-
tial character of his art. Franz von Stuck's *Sin* engages a subject –
the *femme fatale* – that engaged both Gauguin and Munch. [9] The
picture, which might also be called *Eve and the Serpent*, shows an
academic nude accompanied by an immense snake, and only the
presence of the added attribute justifies the title. The darkness from
which her flesh emerges is intended to give mystery – and so mean-
ing – but her sensuousness is hardly more symbolist than a Cabanal
Venus. There is, however, an insistent seriousness or portentous-
ness which is characteristic of thought-painting's materialist render-
ing of allegorical themes. It is present in Klinger's *Brahms Phantasy*
[10], where the theme of music instead of leading to an intangible
suggestion of reverie and inspiration, as it does with such varied
symbolists as Khnopff [34] or Klimt, is given a remarkably tan-
gible solidity.

10. *Brahms Phantasy*, 1894. Klinger

In the same way, Böcklin's *The Plague* [11] becomes a scene of dramatic, indeed of heroic even though tragic, action, in marked contrast to the inward anxiousness and pervasive doubt that fills Ensor's etching of *Death pursuing the People* or Gauguin's *Spirit of the Dead Watching* [12] or Redon's several treatments of the same subject. (There is a similar contrast between Ensor's *My Portrait Skeletonized* [13] and Böcklin's assertive *Self-Portrait with Death Playing the Fiddle* [14].)

11. *The Plague*, 1898. Böcklin

12. *Spirit of the Dead Watching*, 1892. Gauguin

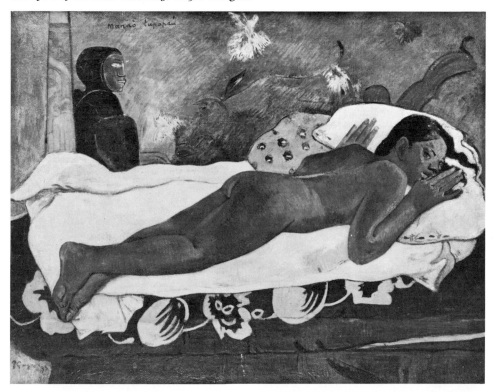

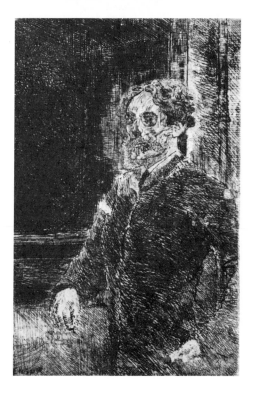

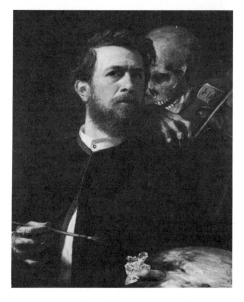

13 (*left*). *My Portrait Skeletonized*, 1889. Ensor

14 (*below*). *Self-Portrait with Death Playing the Fiddle*, 1872. Böcklin

15. *Princess and the Unicorn,* 1896. Point

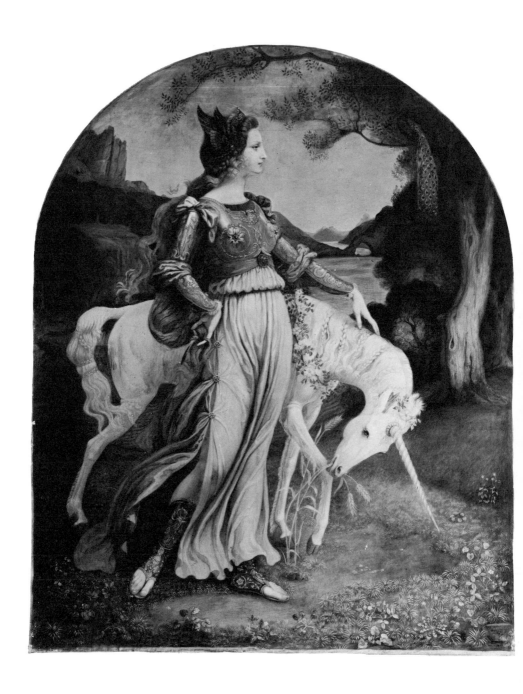

Such high-flown literalness is not confined to the German artists of the time: it can be found as well in France and Belgium, especially among those artists associated with the revived idealism centred on the association of the *Salon de la Rose + Croix*. Armand Point's

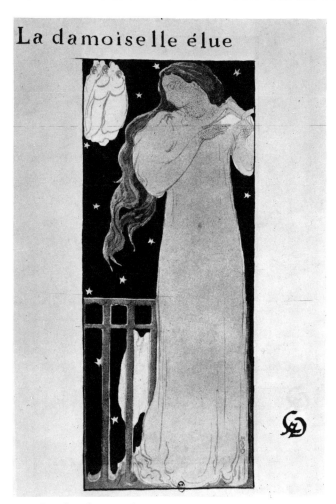

16. *The Blessed Damosel*, 1893. Denis

Princess and the Unicorn [15] spells out her symbolic purity in its every detail: the white flowers scattered on the ground, the well-moulded armour of her breastplate, and of course her virginal mastery of the unicorn. This ˙ , a far cry from the reticent suggestive-ness and stylized simplifications of, for example, Maurice Denis's *The Blessed Damosel*, where evocative mood has displaced illustra-tive allegory [16]. This is the distance, too, between the detailed

16 portrayal of the beautiful nudes of Jean Delville's *Love of Souls* [17],
which makes us only too conscious of their physical attractiveness,
and the nearly disembodied silhouettes of Munch's *Encounter in
Space*, whose almost empty setting needs no sun, no stars or swirling
emanations to suggest their mystic marriage with the universe [18].

17. *Love of Souls*, 1900. Delville

Seen in these terms, the historical position of the symbolist tendency would seem to be clear enough. It was a reaction against the 'sole concern with the world of phenomena' which had dominated the art of the middle years of the century and which was expressed not only in the purer realism and impressionism of what

18. *Encounter in Space*, 1899. Munch

was then the *avant-garde*, but also in the naturalistic vision of the most traditional artists ('academic' or not) who produced an 'idealist' art that illustrated a theme. This desire to give pictorial shape to 'the invisible world of the psyche' affected not only the symbolist generation (if there is such a group) but also the naturalists and academics of the older generation whose work, while never fully symbolist, was affected by a generally comprehensive tendency of which 'symbolism' in the narrower sense was the most thorough expression.

Such a description, however, ignores one greatly complicating factor. Side by side with symbolism, which is highly personal in style and mirrors both aspiration and unease, romantic faith and isolating doubt, arises a style unconcerned with either philosophic idealism or individual, emotional conflict. This style is public in the double sense: it is decorative, of a utilitarian character best suited to architecture and the applied arts; and it communicates a feeling

of well-being and reassuring harmony with a common external environment. It is, of course, *art nouveau*. Like symbolism, which is in these respects its opposite, *art nouveau* develops during the last fifteen years of the century, although it flowers somewhat later than symbolism and lasts somewhat longer, and it has many of the same ancestors, notably the Pre-Raphaelites, but also certain of the exotic and 'primitive' arts. And there is the further complication that *art nouveau*, in the working out of its attractive compositional arrangements, makes use of many stylistic forms and relationships similar to some of those the symbolists employ to give their art an ideational, non-naturalistic significance.

One of the chief characteristics of symbolist painting (and its graphic derivatives) is the stress it puts upon the pictorial surface and its organization. In the words of Maurice Denis' famous definition of 1890: 'Remember that a picture — before being a war horse, a nude woman or some anecdote — is essentially a plane surface covered with colours assembled in a certain order.' Looked at in this way the work of art was freed from its impossible task of attempting to imitate nature and assumed its proper role of an equivalent but independent representation. The emphasis then was upon the autonomous existence of the work of art, not for its own sake but because, thus freed of dependence on externals, it could alter and rearrange them in accordance with the artist's desire to evoke emotion and suggest ideas and so could become a symbol of the affective life of the mind. Accompanying this consciousness of surface was the expressive role given to the use of continuous line, which along with an attenuation of modelling in favour of flat colour, helped to hold composition within a single unifying plane. But these features — importance given to surface and flowing, uninterrupted line — are also characteristic of *art nouveau*, and do not themselves define the style of symbolism any more than the widespread tendency towards one or another kind of *Gedankenmalerei* ('thought-painting') defines its content. There are nevertheless significant differences, as a few typical examples can make clear.

Art nouveau was indeed dedicated to the surface and elaborated it for its own sake with charm and verve [19]; it delighted in calling attention to itself and its inherent sensuous qualities [20]. Symbolism, with quite different ends in view, established disjunction between surface and depth which called attention to the work's function in painting beyond itself. As Robert Schmutzler has said: 'Even though the different areas . . . represent planes and appear decorative, they are nothing but projections in the plane of perspectives and of volumes observed in the round which contradict the real silhouettes of *Art Nouveau* which, from the very start, exist and are composed only in two dimensions.' This distinction (and

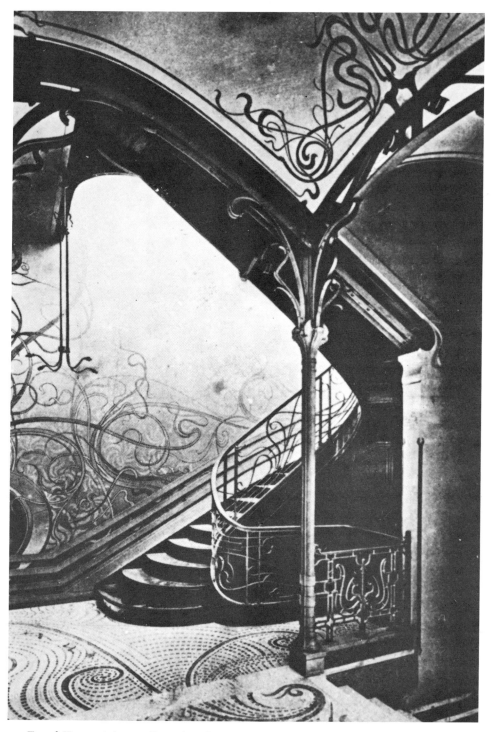

19. Tassel House staircase, Brussels, 1892–3. Horta

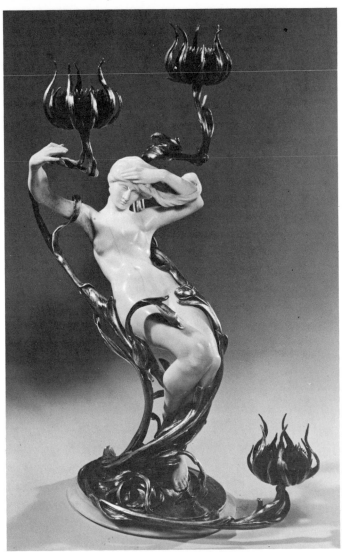

others besides) become evident in the juxtaposition of two com-
positions by Henry van de Velde who, during his few years as a
painter, came under the influence of Gauguin and his 'school' and
later was one of the most creative leaders of *art nouveau*. His title-
page for Max Elskamp's *Dominical* (1892), a woodcut without
either modelling or foreshortening, nevertheless suggests a deep
space, and more than that, a void, thus establishing a meaningful
mood [21]. In contrast, in his *Tropon* poster design of 1898, depth
plays no part and the elegant curves and the intervals between all
lie on the same surface [22]. This disjunction between depth and

21. *Dominical*, 1892. Van de Velde

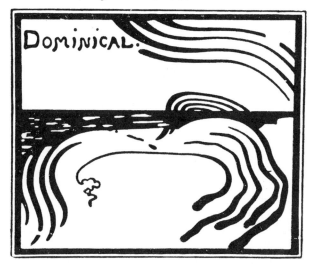

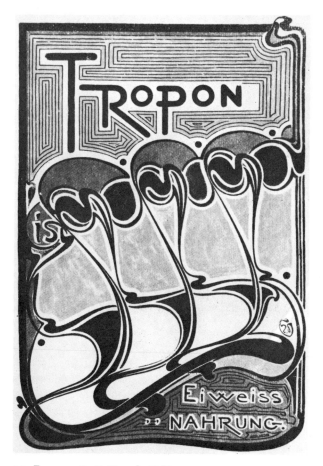

22. *Tropon*, 1898. Van de Velde

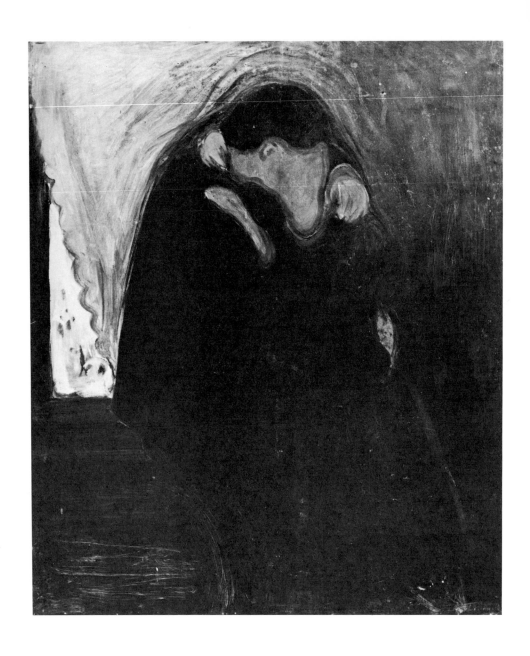

23. *The Kiss,* 1892. Munch

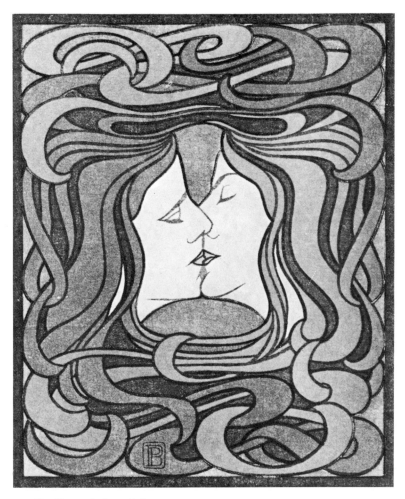

24. *The Kiss*, 1896-7. Behrens

surface is clearly present in artists as different as Redon, Seurat and Munch, each related to symbolism in his own way. When it is missing, even in the work of an avowed symbolist such as Paul Ranson, it inclines his work in the direction of *art nouveau*, as it does again in many of the designs of Georges de Feure. Even so ideally symbolist a subject as *The Kiss* [23] is assimilated to *art nouveau* when Peter Behrens interprets it in a purely decorative way [24].

This distinction between the real flatness of *art nouveau* (with its consequent acceptance of sensuous materiality) and the symbolist tension between work and image (with the resulting ambivalence of image and idea) is bound up with a difference in the kind of line

they use. Many symbolist painters unify their compositions with an unbroken line not unlike the swirling line (it is not always the 'whip-lash' line) characteristic of *art nouveau*. But this line, as it is found at its most expressive in Gauguin [25] or in Munch [26], has a taut-ness and intensity of a special kind: it too suggests an inevitable tension between the idea and its necessarily approximate material embodiment. 'Line is a force . . . It derives its strength from he who draws it.' This is Henry van de Velde's definition of the line that would, as decoration, express the functional character of the new art; but it is more applicable to symbolism than to *art nouveau*.

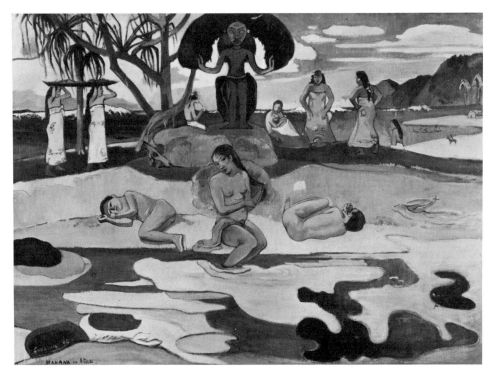

25. *The Day of the God*, 1894. Gauguin

Symbolist line reveals the impulse of its creator; its curves retain a weight and awkwardness which are evidence of a struggle to give shape to an impelling idea, of a conflict between control and expres-sion, between awareness of form and an awareness of emotion. In its most characteristic manifestations the lines of symbolism still bear traces of the creator's hand and are never altogether free of his presence. In this respect they have some of the quality of those 'primitive' arts the symbolists admired.

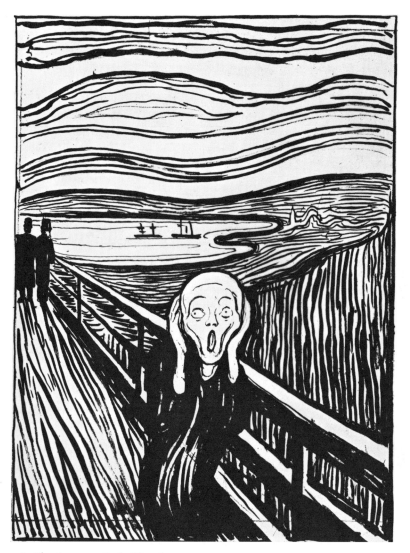

26. *The Scream*, 1896. Munch

In contrast, the characteristic line of *art nouveau* is light and graceful; seemingly self-generated, it is smooth and fluid, responsive only to its own character. At its best, its force appears to lie within itself and we take pleasure in its independent presence, free of any evidence of creation. It is thus a line of care and reassurance, expressive of nothing but itself, and so finally the very opposite of the personally expressive line of symbolism. These are, of course, ideal characterizations meant to indicate the contrasting goals to

which symbolism and *art nouveau* put the stylistic features that belong to the time and which, while sharing, they alter for their purpose. There are many artists whose work contains something of both tendencies and blends their qualities. Ricketts's illustrations for Wilde's *The Sphinx* (1894) have more of the symbolist spirit than those for *The House of Pomegranates* (1891); Maurice Denis' vernal scenes approach the peaceful harmonies of *art nouveau*: Jan Toorop's book illustrations belong to *art nouveau*, his paintings are defiantly symbolist.

The practitioners of *art nouveau* became conscious of the degree to which the abstract, rather than associational or representational, elements should constitute the character of a work of art – in van de Velde's words, 'in a life and soul which are proper to it, not in the life and soul of its model'. As August Endell, designer of the Elvira House in Munich, one of the paradigms of the style, wrote in 1896: 'Form and colour free in us, without any mediation, like anything else that comes to consciousness, a particular state of feeling . . . the impressions, altogether without associations . . . will find an inexhaustible source of extraordinary and unexpected pleasure.' Such emphasis parallels the importance symbolist theory gave to the 'musical' qualities of line and motion. But in the application of this theoretical awareness the ideal of *art nouveau* and the ideal of symbolism are at the opposite ends of an emotional scale.

SYMBOLS AND ALLEGORIES

Redon's painting of *Silence* is often cited as an epitome of symbolist style and intent [27]. This figure with closed eyes and fingers to the lips, removed from the framing oval into an indeterminate space, only partially emerging from the surrounding darkness, contains that suggestion of the mysterious reality beyond appearance that is proper to symbolism. Both in its subject, which stresses a concentration upon the usually unseen and unheard, and in its handling, which suggests more than it depicts, it is characteristic of the movement. This is perhaps because (like so much of Redon's *œuvre*), quite apart from its theme which is paradoxically central to symbolist literature – and perhaps even music – as well as painting, in its fusion of symbol and representation, of personification and suggestion, of the literary and the synthetist, it stands midway in the symbolist repertory of stylistic directions. Redon himself, in other pictures, notably *Closed Eyes* [28], has embodied the same theme of reserve, isolation and deeper reality, without the use of any specific iconography, thereby coming closer to that identification of subject and form which was central to theoretical *idéisme*.

27. *Silence*, 1911. Redon

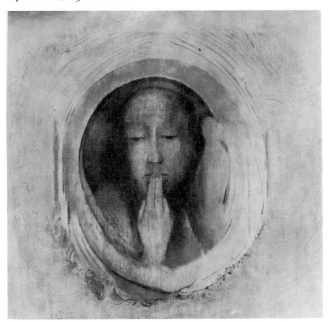

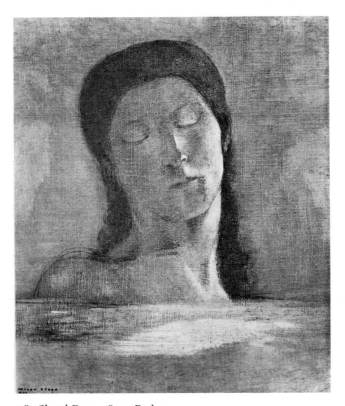

28. *Closed Eyes*, 1890. Redon

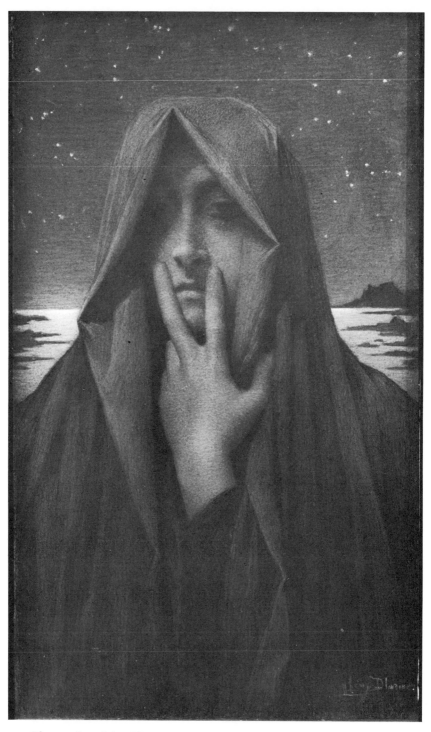

29. *Silence*, 1895. Lévy-Dhurmer

The contrast with a more specific treatment is instructive: Lévy-Dhurmer's *Silence* [29] spells out its meaning. The figure, isolated now only by a costume with religious associations, tells us to be silent, while the starlit sky and the unearthly light of the deep receding waters leave no doubt that we are in the presence of a spiritual message or, as a sympathetic critic phrased it, 'a work of profound symbolic thought'.

For the artists of the movement silence was of course not merely the simple absence of sound, nor was it an end in itself: one cultivated silence as a means of shutting out appearances in order to concentrate upon essence, and so isolation became the condition through which the artist could ignore the material and thus be able to penetrate the spiritual. The Belgians especially, both artists and writers, gave great importance to such withdrawal into silence. Maeterlinck, whose whole early work is oriented towards the eloquence of the inarticulate, believed that 'the life that is genuine, and the only one that leaves some trace, is made of silence alone', and he conceived of an active silence 'as a force that makes it possible to communicate with the unknown'. So Georges Rodenbach wrote *Du Silence* (1888) and *La Règne du Silence*, coupling it with a pessimism (learnt from Schopenhauer) that taught the necessity of 'solitude raised to the level of a moral principle'.

The significance of such silent communion with the universe could be expressed without recourse to traditional personification or allegory. Xavier Mellery, son of a gardener at the Royal Park at Laeken, had been penetrated – like Maeterlinck in Ghent and Gallé in Nancy – with a kind of osmotic participation in the silent life of plants and flowers. It was thus quite natural for him to put his feeling for the universal 'sense of things' – for their 'interior psychic life' – into a series of dark drawings he called *The Soul of Things*, inspired by Rodenbach, in which everyday objects are transformed into mute symbols: stone stands for strength, a rising staircase suggests an ideal to be attained, the slow growth of plants implies endurance and tenacity, and the filtering light, however dim, an all-pervasive ideal life that never completely dies away. Thus Mellery's feeling that only through silence could man hear what he called the 'occult voices of heaven' is expressed, not in conventional attributes, but more directly through the rendering of the empty crepuscular spaces of his own familiar interiors [30].

In this sort of symbolist (as opposed to symbolic) suggestive representation of meaningful silence Mellery was not alone. Not only did Vuillard execute a programme for Maurice Beaubourg's *The Wordless Life*, presented at Lugné-Poë's Théâtre de l'Oeuvre in 1893 [31], but the sense of unexpressed communication, more important than any words, pervades many of his early domestic

30. *The Soul of Things.* c.1890. Mellery

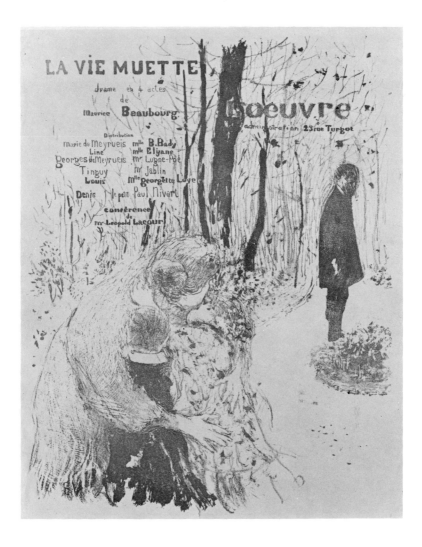

interiors, where both persons and objects seem informed and united by the same hidden *âme des choses*. And if Carrière's maternities belong in any way to symbolism, as at least some of his contemporaries believed they did, it is because by enveloping them in an attenuated darkness he suggests that they are shrouded in a mysterious continuum, in which a not too solid matter shades imperceptibly into a space not truly void, both informed by the same silent spirit, a spirit which can only be overheard in silence [32]. In the words of Charles Chassé: 'What is this fuliginous liquid in which

they are all bathed if it is not the Oversoul of which Emerson speaks, a mystical liquor which penetrates all individual souls.' And as with Maeterlinck's 'static theatre', it is only in stillness that such voices become clear.

Besides, this sort of silence, attentive to those forces hidden beneath the surface of the commonplace, can already be found in the

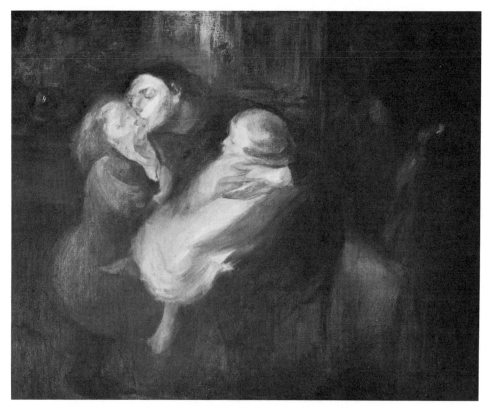

32. *Maternity*, *c*.1892. Carrière

early works of Ensor. In his interiors of this time — *La Dame sombre* [33], *La Dame en détresse* — the rooms seem filled with some pervading, subduing presence which compels the action, or rather the inaction, of the persons present — a waiting for something undefined. There is here already implicit, beyond the realist surface, that feeling for the 'static theatre' of everyday life which Maeterlinck made explicit in the following decade and which Ensor himself abandoned for the more overt symbolic play between appearance and reality conveyed by his many paintings of figures in masks and of masks whose wearers and their useless deceits have been discarded.

33. *La Dame sombre*, 1881. Ensor

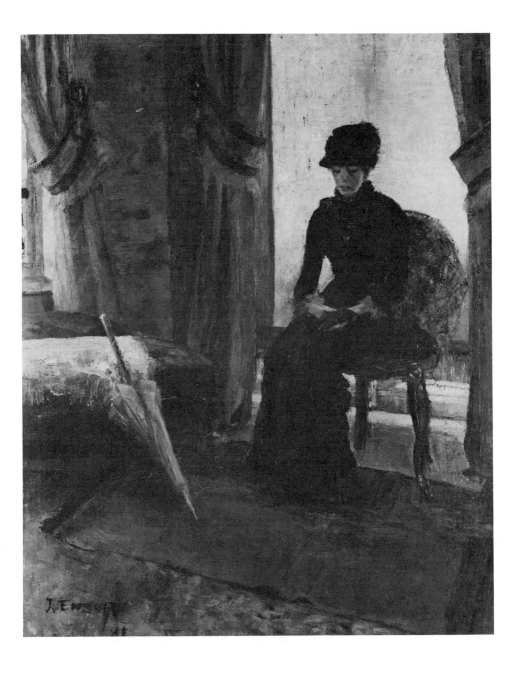

34 Paradoxically, such indications of resonant silence can include references to music, theoretically the most 'symbolist' of all the arts because it is supposedly the least material. Fernand Khnopff's *Listening to Schumann* [34], for which Ensor's *La Musique russe* [35] was the immediate inspiration, suggests that it is not so much the musical sounds which are being heard by the self-absorbed listener as the universal music that they symbolize. This is why Khnopff includes only the right hand of an otherwise invisible pianist. Other artists on the borders of symbolism were less subtle — and, so to speak, more noisy — in their portrayal of the correspondence between the arts and the spiritual meaning of music. Klinger's *Evocation* [36] from his Brahms Fantasy series, is clearly a *Gedankenmalerei* but its personifications are all too tangible and literary —

34. *Listening to Schumann*, 1883. Khnopff

35. *La Musique russe*, 1881. Ensor

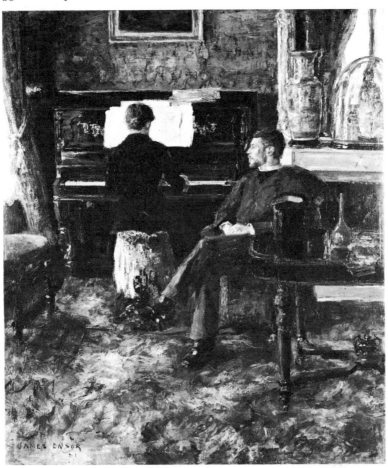

36. *Evocation: Brahms Phantasy*, 1894. Klinger

more puzzle than mystery. Fantin-Latour, who was an early devotee of Wagner and not uninfluenced by Victorian idealism, veils the figures of his 'musical compositions' in an atmospheric style that influenced Redon but thereby only mutes the impact of a traditional allegorical illustration [37]. As with many lesser artists of the period, the ethereal intention is evident and unequivocal, and is far from that belief in an underlying correspondence among the arts and between the arts and ideas which was implicit in the symbolist stress on the direct expressive power of the 'music' of painting.

37. *Prelude to Lohengrin*, 1882. Fantin-Latour

There is, of course, an intimate connection between silence and solitude. It is suggested not alone by such pictures as these, or by the figures of Osbert's landscapes who inhabit what he called 'the silence which contains all harmonies'. It is inherent as well in Gauguin's *Gethsemane* [81], in Munch's *Melancholy* [38], even in Hodler's introverted figures [47] and the kneeling youths of Minne's *Kneeling Youth* [39], so drawn in upon themselves and resigned to their isolated self-preoccupation. This sort of inwardness was very much a part of the symbolist's anti-material concerns, of his desire to express mood rather than interaction with the world, and it ex-

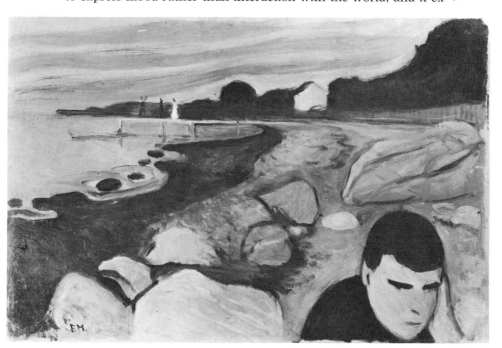

38. *Melancholy*, 1893. Munch

plains the restrained and static character of much symbolist art. But such (pessimistic) self-reliance was generally not spelled out in any explicit iconography; indeed to do so would have been in some measure to reject those promptings of the unconscious so important to symbolist expression.

For Fernand Khnopff, however, whose personal motto was 'one has only oneself', the unhappy necessity was transformed into a positive and altogether conscious rule to guide his art. The iconography of his paintings often seems to illustrate these lines of his good friend Rodenbach: 'Thus my soul alone, and which nothing influences: it is as if enclosed in glass and in silence, given over

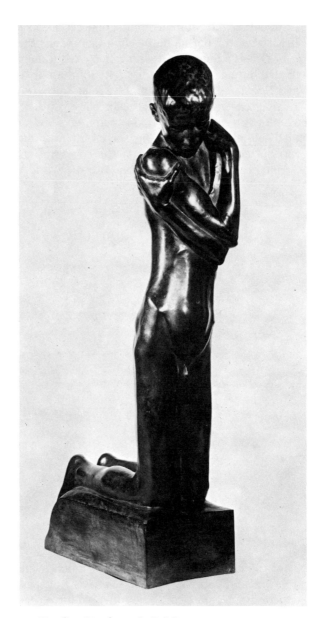

39. *Kneeling Youth*, c.1898. Minne

entire to its own interior spectacle.' This ideal is perhaps most clearly
realized in the picture whose title comes from a poem by Christina
Rossetti, *I lock my door upon myself* [40] and whose Pre-Raphaelite
influence is evident not only in the ecstatic gaze and the features
and spread hair of the lady who leans her strong-willed chin upon
elegantly tapering fingers, but also in the elongated rectangles of

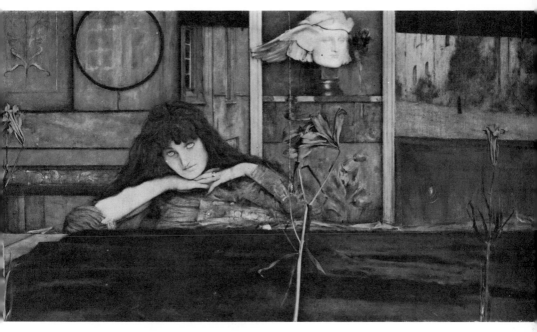

40. *I lock my door upon myself*, 1891. Khnopff

the composition. But it is hardly less clearly evident in the *Portrait of the Artist's Sister* and in other paintings of the same model such as *Une aile bleue* [41] and *L'isolement*, in which, as Francine-Claire Legrand observes, she is shown as indifferent and remote, her expressionless gaze to the side avoiding all 'contact between painter and model and between model and public, with the closed door behind her shutting off an unknown world, a secret shrine of which this woman is the priestess'. In all these pictures isolation is seen as the necessary condition of purity. Khnopff, like Mellery, considered art a median between the visible and the invisible. Yet in Aurier's terms, although he is an idealist, he is altogether not an *idéist*. Perhaps because he seems to have worked out the intellectual basis of his aesthetic before he developed his style, Khnopff's yearning for a world of higher things is contained almost entirely in his iconography and very little in the expressive form of his compositions. His use of a deliberately unobtrusive transparent *métier* — in accordance with the rules laid down by the Sâr Péladan — denies that the sensuous elements of painting can in any way suggest emotions or ideas, thus denying any theory of correspondences.

Khnopff takes great care that we shall not mistake the meaning of the untouchable woman thus portrayed. Though her rendering is realistic, she belongs to that galaxy of creatures who are really not of

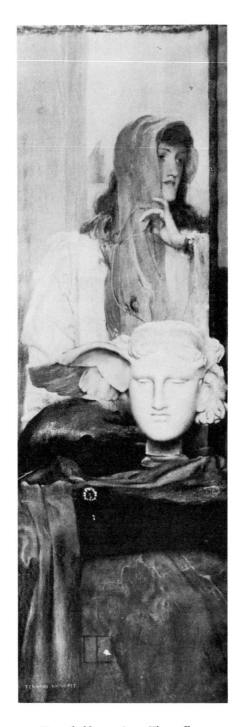

41. *Une aile bleue*, 1894. Khnopff

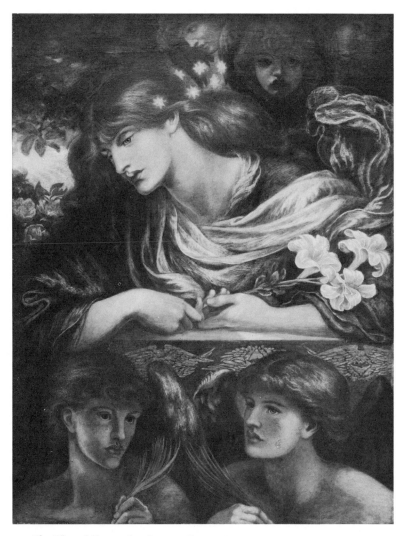

42. *The Blessed Damosel*, 1875–9. Rossetti

this world, but of another realm, and are symbols of an ideal of abstract beauty for which man longs though he cannot perceive it. There are as many such in the visual repertory of symbolism – as there are many of her sister, and opposite, the embodiment of evil – whose virginal character is more or less clearly spelled out. *Arum Lily* and *L'isolement* employ one of the most common devices. Khnopff's immediate source for this sign of purity is in the practice of the Pre-Raphaelites whose art he much admired, where it had a long history. Characteristically, it is to be found in Rossetti's *The Blessed Damosel* [42], typical of the generalized spirituality this figure

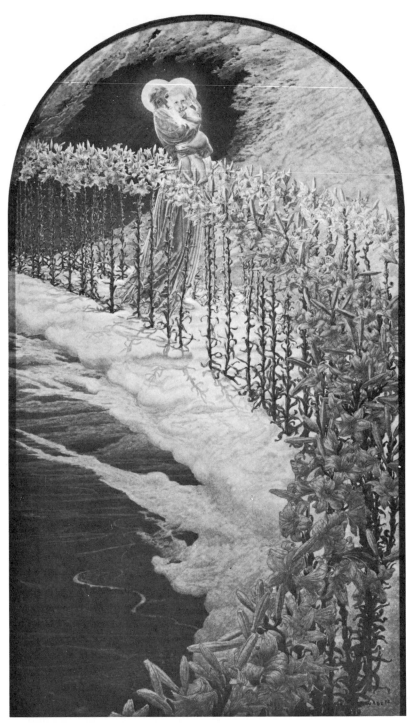

43. *Virgin of the Lilies*, 1899. Schwabe

came to stand for. But the lady herself, and her accompanying flower, had of course a more specifically Christian history as rendered in Rossetti's early pictures of *The Girlhood of the Virgin Mary* (1849) and *Ecce Ancilla Domini* (1850) and continued in Moreau's *Fleur mystique*. This tradition can still be found among the more conventionally religious of the symbolist painters such as Carlós Schwabe in whose *Virgin of the Lilies* its multiplication has been arranged in the plunging. perspective of an Oriental landscape [43]. Similarly Toorop employs it as a sign of the ascetic soul, who, dressed in a nun's habit, is one element in the allegorical counterpoint of *The Rôdeurs* and *The Three Brides* [52]. The virginal whiteness of the lily is also attributable to the swan, which Toorop employs to suggest the ideal quality of the angelic maiden drawn by swans (shades of Lohengrin) who preserves mankind from the sea of illusion and the oppression of the state in his mystical *Faiths in Decline* [184].

The use of such attributes is in partial contradiction to the avowed purposes of symbolism. Because their meanings are known and established they are at once recognized and are read as part of a vocabulary rather than being felt through the more immediate and less literary medium of an expressive form. For this reason symbolism's use of the details of nature to convey its meanings is usually much less specific and tries to depend more upon common human experience and association than upon a learned iconography. At the opposite pole from these uses of the lily and the swan is Gauguin's inclusion of the flowered wallpaper in the self-portrait he sent from Pont-Aven to Van Gogh at Arles — 'the delicate maidenly background with its child-like flowers is there to signify our artistic virginity'. Here, like the symbolist poets, his desire for newly meaningful equivalents with which to replace worn-out images leads him to hidden, personal metaphors.

But more usually the symbolist search for expressive correspondences in nature results in less esoteric, more generalized images. Maurice Denis distinguished between 'those tendencies which are mystical and *allegorical*, that is the search for expression by means of the subject, and symbolist tendencies, that is, the search for expression through the work of art'. But the distinction was rarely so clear-cut. Both Gauguin himself, as well as Redon and Munch, though they sought for 'abstract' or 'musical' correspondences which were the formal expression of their themes, also found analogies for their subjects in the natural objects they depicted. This was quite generally the case among the Nabis where, as in Sérusier's *Solitude* [44], the barren hills of Brittany express not only a union with the simple things of nature but carry out the sombre theme. (One of the reasons for the popularity of Puvis de Chavanne's

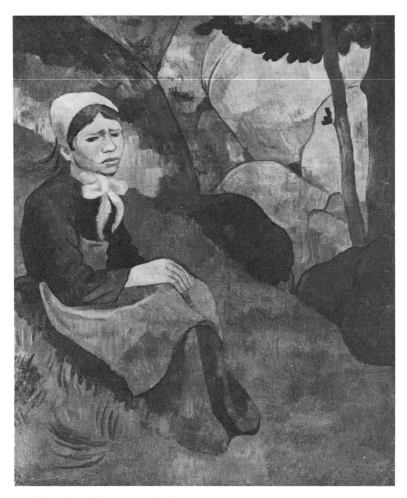

44. *Solitude*, c.1890–92. Sérusier

Poor Fisherman [45] was that the symbolists found that it employed this kind of expressive equivalent.) Maurice Denis himself, whose tone is persistently joyful, employs the happy setting of perpetual springtime to tell us, through the associations of green grass and flowers and luxuriant trees as much as through the restful harmonies of a flowing composition, of the spiritual peace he himself has found [46]. For Hodler, too, flowers and fields have this double attraction, that through continuity of line and repetition they can serve to establish the visual unity of the design, while, without the details of a religious iconography, they can suggest the spiritual meaning of the subject (e.g. the flowers that are the setting for the

45. *The Poor Fisherman*, 1881. Puvis de Chavannes

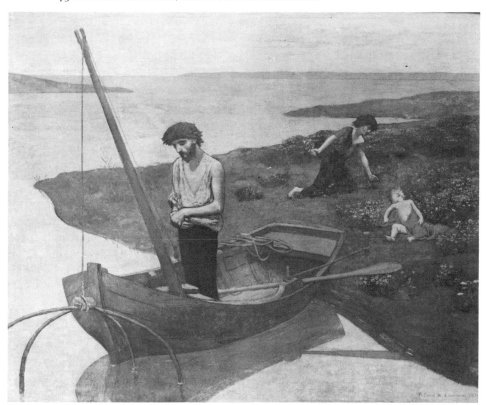

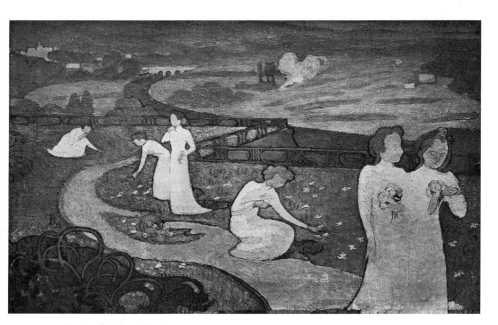

46. *April*, 1892. Denis

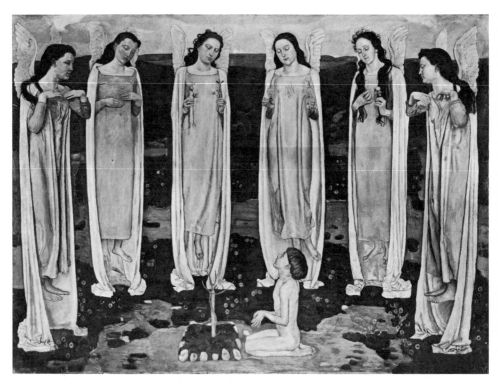

47. *The Consecrated One*, 1893–4. Hodler

young boy in *The Consecrated One* [47]). And for both Hodler and Segantini the mountains of the Alps were inseparable from a suggestion of the sublime. Segantini, who found his inspiration among the high farms of the Engadine where the light and infinity of horizon seemed close to God, was a kind of pantheist who 'lived in the exalted regions of a poetic naturalism' so that the settings of his *Triptych of the Alps* or *Love at the Source of Life* were also symbolic of their subjects.

It might be said that throughout these works there runs a kind of moralizing of nature that is perhaps basic to symbolism, that for all the artists of this tendency natural objects become both the iconographic explication of the subjects they treat and the formally expressive equivalents of those same ideas; and that however the proportions may vary – from the illustrative idealism of Moreau or Khnopff to the abstract synthetist *idéisme* of a Gauguin or Seurat – some element, however small, of each of these factors is always found.

Such dual employment of natural objects is nowhere clearer than in the work of the Glasgow Four (Charles Rennie Mackintosh,

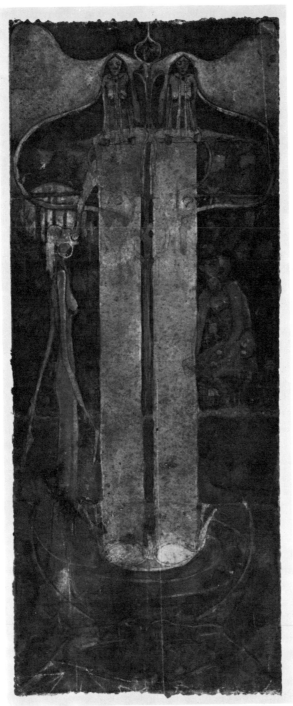

48. *The Fountain*, *c*.1894. Margaret (or Frances?)
MacDonald

Herbert McNair and their wives Margaret and Frances Macdonald),
a close-knit group who, in the mid-nineties, created their own idio-
syncratic style of 'ethereal melancholy' out of a mixture of sources
including the Celtic revival in Scotland, heralded by Yeats' *The
Wanderings of Oisin* (1889), Beardsley and Toorop – the latter's *The
Three Brides* was illustrated in the March 1893 number of the newly
founded *Studio*. Margaret or Frances Macdonald's *Fountain* [48] and
Frances Macdonald's *A Pond* both combine in a characteristically
elongated symmetrical format, reed-like, bulbous-topped plants with
stretched-out emaciated nudes whose hair flows into natural forms.
In Mackintosh's Diploma Award Design stylized vines bearing
flowers or fruit form a grill work that frames the three figures. In an
1896 book-plate by Herbert McNair the tree of knowledge enfolds
two sad female figures representing the spirits of art and poetry,
holding rosebuds and lilies, the emblems of painting and sculpture,
and is itself nourished by the dew of inspiration. The significance of
this kind of symbolic formalism is sometimes obscure, for example
in Mackintosh's *The Tree of Influence* (1895) – and often more vague
than mysterious, for instance Margaret Macdonald's *5 November*
(c.1894) – but whatever the details and whether the mood is more
or less melancholy, the Four evidently intended these works to be
informed by a general sense of growth and renewal flowing through
the interconnected plants and figures. As Thomas Howarth has
said, there was 'a close Scottish literary parallel in the short-lived
review of Patrick Geddes and William Sharp–Fiona Macleod, *The
Evergreen* (1895), with its emphasis on nature and the seasons, on
birth, flowering, harvest and death . . .' The symbolic implications
of its title are similar to those of its continental parallels, *Pan, Jugend,
Ver Sacrum* – but unlike them and also unlike the later work of the
Glasgow group, its existence was too brief to allow it to move into
the easier, more decorative forms of *art nouveau*.

Despite the melancholy of the Four – a state of mind in which, in
contrast to other symbolists, they seem to have taken some satis-
faction – their spiritual symbiosis with nature was of a harmonious
kind. But there were also other, less pleasant and fruitful objects in
nature and these could be used to render struggle, or at least the
passive resistance to the all-encompassing rhythms of existence.
This is eminently the case for George Minne's drawings for the early
poems of Maeterlinck. Done in Ghent just after Maeterlinck (and
Grégoire Le Roy) had returned from Paris, where he had been in-
spired by Villiers de l'Isle Adam and at a time when the poet was
engaged in the translation of Jan van Ruusbroec's *The Adornment
of the Spiritual Marriage*, the same mystical attitudes were at work in
Minne. The spirit is evident in the frontispiece of *Serres chaudes* [49]
in which women in nun-like garments so closely wrapped that they

49. Frontispiece to Maeterlinck's *Serres chaudes*, 1889. Minne

resemble shrouds, rise and droop in agony (or ecstasy), their linear rhythms almost indistinguishable from the foliage of the equally enveloping landscape; one kneels, another leans over the river bank with reaching hands; two in the foreground, only their eyes barely showing in their hooded costumes, yearn downward towards the earth. In the midst of this clinging, claustrophobic deliquescence, a lily grows upright out of a pool of water. The representational symbolism is clear enough and also indeterminate enough to permit that suggestive equivocation upon which Redon insisted. It is matched by a design whose darkness and downward-moving

curves render a mood of mournful intensity. This same sense of souls enmeshed in nature, a kind of centripetal, despairing pantheism, is found in *Les Adolescents dans les épines* [50], where their hair and the branches of the thicket through which they struggle become a single inextricable maze. The meaning of the thorns is evident: as in Burne-Jones's series of the *Briar-Rose* [51], which may have been their source, they represent the hostility of matter to spirit, but now for Minne their jagged, staccato line in itself suggests that opposition — by the very form alone.

50. *Les Adolescents dans les épines*, 1892. Minne

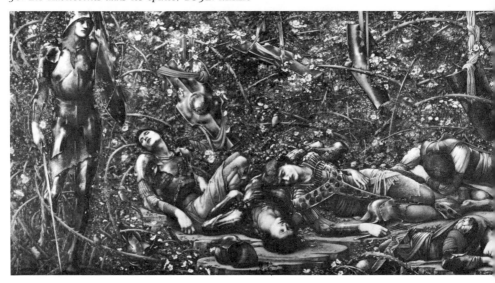

51. *The Briar Wood*, 1884–90. Burne-Jones

The Dutchman Jan Toorop expresses the menace of evil in a very similar fashion, but with more explicit allegorical detail. Although he had been in Belgium during the eighties it was not until after 1890, when he was back in Holland, that under the influence of Maeterlinck's plays (and perhaps his translations of Ruusbroec's mystical writings) his paintings become animized environments displaying the conflict of good and evil. As Spaanstra-Polak notes: 'he draws gloomy scenes of ghostly gardens with dark ponds, overshadowed by weeping willows like living beings whose arms writhe like tentacles. From branches women's hair streams down. In the *Garden of Woes* (1891) death's hands grow on thorns, symbol of the destruction caused by lust.' Here, as well as in *The Rôdeurs* and *O grave where is thy victory* [182], where the good angels disentangle the soul from the gnarled and twisted branches in which the demons of evil have enmeshed it, line is paramount: it holds the surface as a decorative design which permits only the suggestion of space; it is also the theme's visually expressive equivalent. Toorop denotes the dangers of evil, or temptation, by a nervous, broken, angular line which often takes the representational form of thorns but which can also be abstractly staccato, irregular and pointed, in opposition to lines which, flowing smoothly through hair or drapery, connote the harmonious recognition of the good.

Toorop's best-known picture *The Three Brides* [52] is composed around these same symbolically expressive contrasts. Its theme — which might be called 'on the nature of woman' — is the mystical equivalent of Munch's more sensuous and personally expressive treatments of the same subject (and was perhaps influenced by them). As Toorop explained, the earthly bride stands in the middle, 'a perfumed, hardly blossomed flower which hides under its veil both things: the pure aroma of tenderness and the burning gift of sensual pleasure'. Flanking her are the nun ('ardour filled with gruesome asceticism') and the whore ('a hungry unsatisfiable sphinx') and behind them the matching lines of the background, those on the good side relaxed and correct, those on the side of evil taut and sharp — Toorop called them 'yell and bang lines' — which also contrast with the billowing lines that carry Christ's message as it flows from the bells in the upper corners. Toorop makes the same progression from represented symbol to its formal or 'musical' equivalent even more explicit in *The Song of the Times* [61] where both the evil, tangled agitation of the left side and the rhythmic order of salvation of the right retain their character as they overflow into the abstract decoration of the frame.

Even at its most visually intense, Toorop's inconographic programme is so precise that his art is never truly synthetist in its import. His intention is none the less related to that of the Nabis and

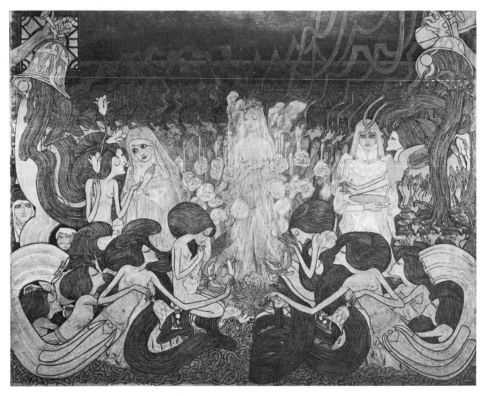

52. *The Three Brides*, 1893. Toorop

the relation of subject to design is not unlike that in the equally
religious (but entirely calm and unconvulsed) pictures of Maurice
Denis. This is a parallel. An historical connection can be found in
the very similar work of Toorop's countryman Johan Thorn-
Prikker, who followed the lead of his good friend Henry van de
Velde, whose ideas were strongly influenced by the synthetist prac-
tice of the Nabis and the more theoretical symbolism of Seurat and
his circle. Like van de Velde, who believed that line is not some-
thing that describes an object but 'a force that works on human
beings', Thorn-Prikker, by varying the 'speed' of his line – its thick-
ness, tangibility and colour – sought, as he said, to express 'abstract
concepts such as life, purity and mysticism, but also the emotions
of love, hate and depression'. Thus *The Bride* [185], herself only an
insubstantial transparent veil, is drawn with an appropriate thin
white line; but she is bound to suffering (Christ) by heavy black
lines and 'by the myrtle branch that gradually turns into Christ's
crown of thorns and by the treacherous sensuality in the shape of
the phallic tulips and the skull-like snap-dragons'.

Segantini too employed the twisted forms that could be found in nature as the formal symbols of sin and consequent suffering. In both *The Evil Mothers* [53] and *The Lascivious Ones* (1897), whom he 'sentenced to a Nirvana of snow and ice and who, thrown out into the ether without wings, float, hopeless and grief-stricken against

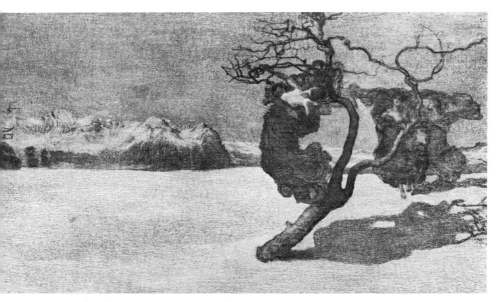

53. *The Evil Mothers*, 1897. Segantini

the setting sun', it is not only the winter season that suggests their punishment. For this he has made, as he said, 'a symphony in white and silver, gold and blue', which, contrary to its meaning, is 'pleasant to the eye'. In both pictures it is rather the animated, tortured branches of the gnarled and barren trees that convey their suffering. Just as the flowers and grass of spring express love and hope, so the spirit of evil too can be discovered in the corresponding forms of nature.

In contrast to such natural manifestations — visual correspondences which suggest the idea of evil — was its specific symbol: the sphinx. Its use among the artists of the movement has, of course, its origins in the paintings of Moreau, especially his early *Oedipus and the Sphinx* [54]. For Moreau she has lost some of her original meaning: she stands less for life's mystery, more simply for the material, sinful existence that is the enemy of the spirit. The sphinx was the obvious symbol of all the fleshly, tempting baseness that Moreau put into the rhythmic ornamental poses of his *Salomé* and *Delilah*. In so far as she is an unequivocal personification, Moreau's

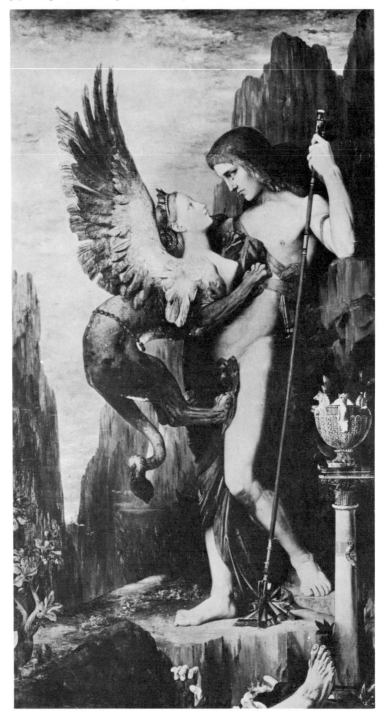

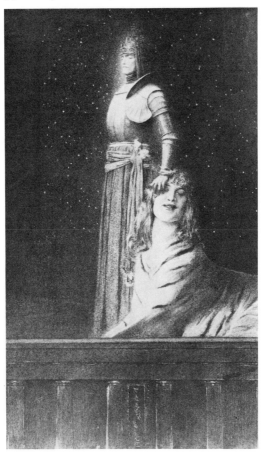

sphinx, although she is part of an idealist vocabulary, hardly be-
longs to symbolism at all, any more than do some of her opposites as
painted by Moreau's disciples — Armand Point's *Princess with Uni-
corn*, for example. Even Alexandre Séon in his *Chimera* (1890),
strange though her pastel shades now seem to us, attempted to
match the mood of his modish sphinx with 'melancholy blues and
violets'.

Khnopff's sphinxes also stem from Moreau, and from the Sâr
Péladan [55]. But already the first, painted as a frontispiece for *Le
vice suprême* (1884), has about her an aura of equivocation and con-
flict. Of this sphinx, the enigmatic temptress with the seductive,
ironic smile (Khnopff's vision of *La Belle Dame Sans Merci*), Emile
Verhaeren wrote in *L'Art moderne*: 'A delicate sphinx, exquisite,
refined, subtle; a sphinx for those who doubt everything, and who
make everything doubtful, for those who are weary of everything; a
sphinx for the sphinx herself.' This image of man's baser side, seen

as a woman both appealing and domineering, whose animal nature associates her with snakes and leopards, Khnopff repeats in a variety of guises: *De l'animalité, Pour l'art, The Blood of the Medusa*. Characteristically she remains inaccessible and well-bred, the very opposite of Félicien Rops's rendering of the same symbol – for example, his title-page for Barbey d'Aurevilly's *Les Diaboliques* or his frontispiece for Verlaine's poems. In this she influences Toorop whose *Sphinx*, as she presides over those souls who have attained, or more ascetically strive for, a spiritual life retains a certain reserve and a disdain. In the background are the world's religions – a cathedral, an Egyptian statue and a seated Buddha (recalling Edouard Schuré's *Les Grands Initiés*, 1889, which had also influenced certain of the Nabis) and in the foreground swans and lilies and angelic musicians. Yet, as in all Toorop's work, there is an intended congruence between design and theme: the density and flow of the linear movement express the subject's mystical intensity.

For all their readable iconographic detail, both Khnopff and Toorop have symbolism's characteristic inward vision. 'Literary' as they are, their sphinxes convey the same mood and message that, without attributes, Munch embodied in so many of his women (and Gauguin in some of his Eves), the fascinated repulsion whose ambivalence has its prototype in Moreau's *Salomé* (who is both flesh and idea) and which, refined and abstracted, is also present in Beardsley's 'decadent' illustrations for Oscar Wilde's play. The same can hardly be said for the solidly pornographic nudes of Félicien Rops, such as *Pornocrates* [56]. They are indeed intended to portray the dangers of the flesh, but given the care with which their nakedness is set off against hats or boots or gloves, they accomplish this – if they accomplish it at all – through their accompanying cautionary detail (skull or pig or insect) rather than in themselves. Rops illustrated the work of the symbolist poets and he was a favourite of the Sâr Péladan, but in style he is an allegorical realist, equally at home in *œuvres badines* and moralizing subjects. His sexual obsession is of the period, as is his diabolism (e.g. *The Sacrifice* from the series *Sataniques* of 1883) but his artistic relation to symbolism is at best tangential.

This also applies to the temptresses of Franz von Stuck and of Klinger (e.g. *Salomé*, 1893). Here the pleasures of realism are again paramount, and there is an academic discrepancy between title and style. The German artists do indeed proclaim that they are dealing with ideas, but there is nothing in the manner of their art which suggests that the visible world is a sign for any further reality. The same holds true for the supreme German *Gedankenmaler*, Böcklin, whom both Stuck and Klinger revered. Indeed Böcklin, admired as a thinker, proposed an art whose assumptions are the very opposite of

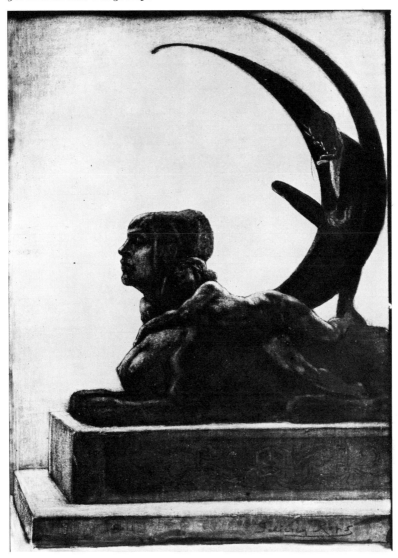

those of symbolism. He sets out to make us believe in the physical
existence of his very solid pagan creatures – to make them live, not
in the fluid world of the imagination, like Redon's avatars of equi-
vocal intentions, but very much now and here on earth. For Hein-
rich Wölfflin, writing in 1897, Böcklin's pictures grew from 'an
inner image with the figures always seen together with landscape
. . . The fabulous beings are not simply nude figures with mytho-
logical attributes put into a given landscape, but rather they have
been born out of a contemplation of the elements, impregnated
with the particular character of the momentary atmospheric mood,

57. *The Island of the Dead*, 1886. Böcklin

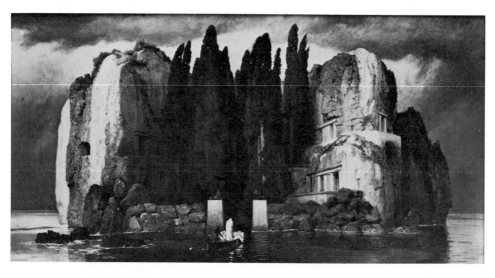

58. *Madeleine au bois d'amour*, 1888. Bernard

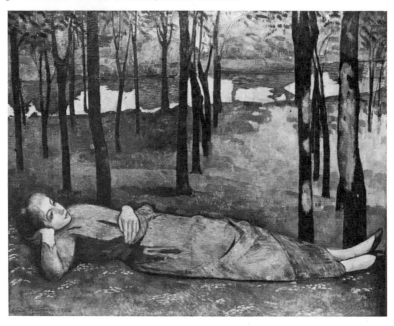

and so are altogether inimitable and untranslatable.' This has been called a classical ambition. But Böcklin's pleasure in physical energy and naturalistic detail (despite the fact that he created 'out of his head' and, at the insistence of his wife, did not use models for his nudes!) is such as not to permit those typifying generalizations of

situation and of rendering which remind us that we are, after all, in the realm of the ideal. Besides, and this is perhaps essential, in the characteristic symbolist landscape with figures, it is not the figures who give substance to the landscape (as in Böcklin they so materially do) but rather the landscape which projects the inner world by which the figures are possessed. Because his *Island of the Dead* [57],

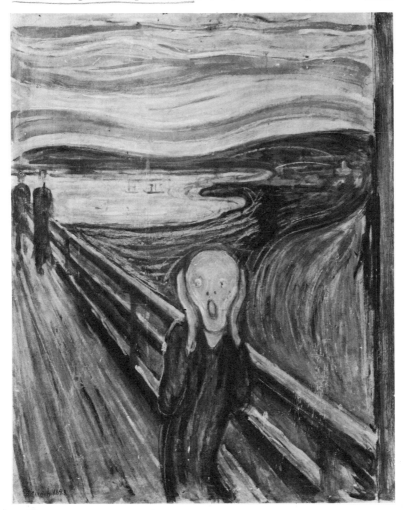

59. *The Scream*, 1893. Munch

exceptional in his *œuvre* and despite its many conventional features, does seem an emanation from the muted figures, it is often cited to show Böcklin as a symbolist.

This sense of the diffusion of mood is common to Munch's *Moonlight* and *Anxiety*, to Gauguin's Tahitian pictures, even to Hodler's

Day and *Spring* despite his only half-hearted relinquishing of realism. It is why the times of day, the round of the seasons, which mirror in nature the moods of man and his life's progression and link him with the spiritual universe, are recurrent symbolist themes, in a gamut that can run from Bernard's *Madeleine au bois d'amour* [58] to Munch's *Scream* [59], from Segantini's *Triptych of the Alps* to Gauguin's *Whence do we come?* and which at its extremity takes the form of the nearly animized pantheism of Van Gogh's fields and trees and heavens. And it is this subjective projection upon the universe which distinguishes the symbolists from the early romantics they admired. For Runge and Friedrich, for all their mysticism, create within a less individual emotional context, which still sees nature as God's handiwork rather than finding the spiritual immanent within it. So in Runge's *Tageseiten* (1808) the arabesque of plant forms and the children who clamber over them operate on the same symbolic level, while in Friedrich's *Morning* (c. 1818) and his other paintings of the sublime in nature, man is not set as a creature within it but rather stands apart, in awe of this spectacle of God's creation.

HAIR

There is no more striking or more common feature in the art of the end of the nineteenth century than the representation of women's hair. It is a marked element in the iconographic repertory of symbolism, and it is one of the most widely used items in the design dictionary of *art nouveau*, and the manner of its employment is a touchstone of their relations and their differences.

Its use was of course already prominent in the pictures of the Pre-Raphaelites. For Rossetti especially [42] but also for Millais [60] a flowing and abundant *chevelure* was part of woman's mystery. Like her eyes, wide open and profound, or closed in ecstasy, it contains something of her ideal essence, a symbol of that spirit at once pure and dangerous, of which she is both substance and symbol. It also fits into the scheme of Pre-Raphaelite composition since it goes well with that graceful, somewhat languid harmony of design and suffused atmosphere proper to the idyllic character of their art. In Burne-Jones the hair that surrounds and isolates has become part of a generalized and removed ambiance into which it is comforting to read ideal meanings [51]. Since Khnopff admired the painting of Burne-Jones, the long locks of his enigmatic women play much the same role – as in *Who shall deliver me* and *I lock my door upon myself* [40]. They help to establish the sensuous attraction and the cruel self-absorption that both accompany and contradict the purity of the ideal image, its rich texture contrasting with the ethereal smoothness of the features, but in the cool exactitude of

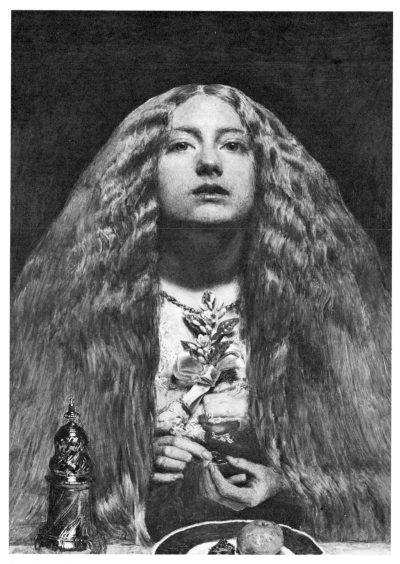

60. *The Bridesmaid,* 1851. Millais

Khnopff's airless style they play a minor role. Toorop also found direct inspiration in the Pre-Raphaelites and long, stylized, billowing strands of hair play an extraordinary role in his pictures. From the point of view of design, it allows him to retain in his finished works that concern for the 'plane surface covered with colours in a certain order' to which the flowing, nearly abstract patterns of his studies for his paintings bear witness [61]. But more than this: as it

connects the bells from which Christ's message come to the heads of the floating angelic spirits in *The Three Brides* [52] or is blown out into the landscape in *O grave where is thy victory* [182], it becomes the symbol of the spirit of salvation that pervades the universe, triumphing over the malevolent thorns and barren trees. Toorop has in this way given to these long and ordered strands of hair a much more definite iconic character than they had among the Pre-Raphaelites. And under the influence of synthetist theory — to which

61. *The Song of the Times*, 1893. Toorop

he had been exposed in Brussels — he also makes a more conscious use of their expressive qualities. Minne in his illustrations for Maeterlinck and Grégoire Le Roy uses hair with a similar but more subjective, melancholy intention. Its heavy strands, from which faces barely emerge, fill up the design, and in their weight reduce the figures to that state of helpless velleities and resigned inaction congenial to the poet's spirit.

For both Minne and Toorop hair embodies mystical attitudes. It is thus disconcerting to find Toorop on occasion employing it in an altogether mundane way. (His *Girl with Swan*, 1895–6, is, despite its symbols, a neutral design with the hair given a purely decorative

elaboration.) But Toorop was also willing to use this same figure in medievalizing robes, with hair now elaborated simply to fill up the interstices of the composition, in *Delftsche Slaolie* [62]. It is revealing that with the loss of the iconic function of the hair, and of the emotionally expressive function of the line with which the hair is drawn, symbolism disappears: without them, and the personal feeling that is at their source, we are in the presence of a public work — a typical exemplar of *art nouveau*.

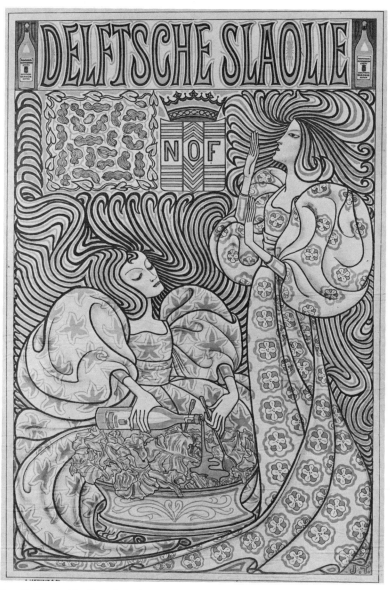

62. *Delftsche Slaolie*, 1895. Toorop

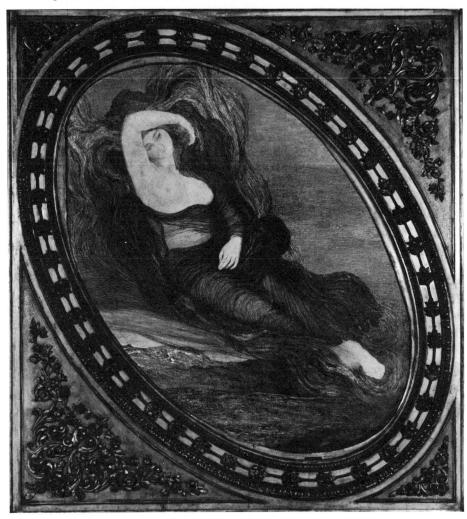

The two functions — the ideational and the decorative — are not always so easily distinguishable. Segantini's *Goddess of Love* [63] floating in the heavens, enveloped in a cocoon of billowing hair and drapery, is conceived as an ideal creature in the Pre-Raphaelite mode; but her easy grace lacks the inner tension of the artist's more moralizing themes and we forget his expressive intention. Jean Delville, on the other hand, does not let us forget his. The hair of his mystic creatures only too closely joins them to that 'divine fluid' in which he believed the universe is bathed, and whose vapours surround and support their suffused souls. The hair of *Madame Stuart Merrill* becomes part of 'the great reservoir of indefinable magnetic forces' from whose rays her mystic glance emerges [146].

But symbolist woman has of course a double nature and as her
hair can be the sign of her benign aspect (symbol of man's aspira-
tions) so it can also be used to express her malevolent aspect (sym-
bol of all that prevents their realization). Of this the snake-hair of
von Stuck's or Khnopff's *Medusa* is the obvious depiction – close to
the edge of traditional allegory [9 and 151]. But the suggestion of
evil can be conveyed without representation, as Beardsley does in
his illustrations to Wilde's *Salomé* [64], where the evil is contained in
the animized strands that menace – and then drip with their own
black blood. Beardsley's lines have their own expressive, symbolist
force, though he often uses much of the standard representational

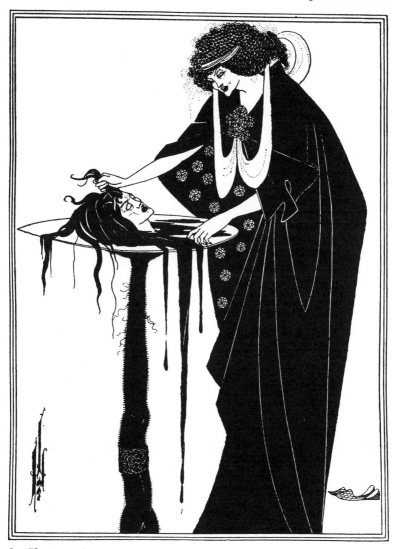

64. *The Dancer's Reward*, 1894. Beardsley

repertoire of *art nouveau*, and if his art has as well the odour of decadence, it is because he appears to reverse the symbolist moral struggle and take unalloyed pleasure in the temptation. Beardsley belongs in all three worlds.

Edvard Munch is Aubrey Beardsley's ethical opposite. Throughout his work woman's hair connotes her ever-present power and enticement. The attraction is not always evil. He uses it in *The Brooch* (1903) to create a Pre-Raphaelite image; in the love ecstasy of the *Madonna* [65] it unites her with the energies of a larger world; in *Separation* (1894) the streaming hair of the pure woman shows how she still lives in the imagination of saddened man. In

65. *Madonna*, 1895. Munch

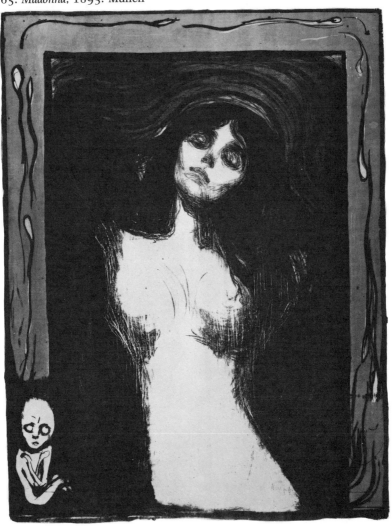

Lovers in the Waves it joins them in harmony and also 'rocks them in the cradle of the deep' in a way akin to Gauguin's *Woman in the Waves* [75] who also casts herself upon the ocean of love. (The expressiveness of symbolism, which these works exemplify, becomes more evident in comparison with an illustration of the same theme in *Fishblood* [66] in which Klimt separates the components of design and meaning: the decoration of the hair and water and the iconography of the phallic fish.) But more often Munch employs woman's hair to suggest her domination over man and the power of her inescapable erotic fascination. In *Ashes* her disordered locks which, as in *Woman in Three Stages* [168] show evil passion, still fall upon

66. *Fishblood*, 1898. Klimt

his bowed back, as they do in *Vampire* and *Jealousy* [67] and the symbolism is even more evident in the two woodcuts, *Man's Head in Woman's Hair* and *Paraphrase on Salomé*, where the hair is made to enclose the head in an enveloping net. Thus in all these works woman's hair, through representation and design, becomes the symbolic expression of the moral force which, for good or ill, woman exercises over the will and psyche of man.

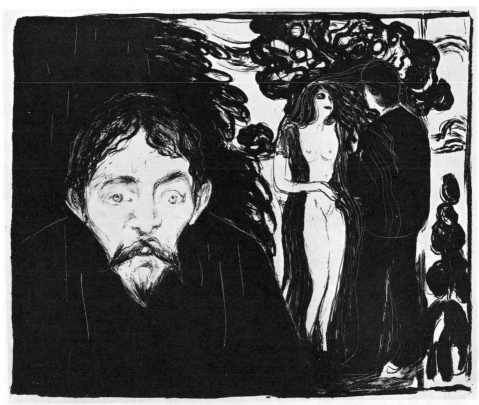

Given the obsessive concern with woman, characteristic of much of symbolism, its constant use of such an obvious feature is not surprising. But flowing hair occurs with at least equal frequency in the images of *art nouveau*. The distinction in their use would appear to be easy enough to make: iconographic meaning, the suggestive intensity, the tension between representation and idea that marks the usages of symbolism is lacking in *art nouveau*, or is at least reduced to the pleasant and harmonious. In the illustrations of George Lemmen, in the posters of Mucha, the curves are ample and relaxed and blend easily into the decorative rhythms of the whole composition; in Peter Behrens' *Kiss* [24] hair has been turned into an intricate, weightless abstract frame for the two profiles. Indeed this sort of line, employed in many ways and in many materials, applied to architecture and the decorative arts, is the hallmark of *art nouveau*: it is the whip-lash from whose elaboration *art nouveau* develops its characteristic look. But this sort of line, as we have seen, is also an element of style in many symbolist artists. It can be found in Gauguin and the Nabis, in Seurat and Van Gogh, as well as in the work of the Glasgow Four, Toorop and Munch.

The question of precedence is complicated and cannot be resolved here. (The two draw upon many of the same sources, notably in England from the middle of the century and before, since Blake was influential for the Pre-Raphaelites and, of course, for Yeats.) But if we allow what Nikolaus Pevsner has called 'the incunabala of *art nouveau*' in the eighties — which include Mackmurdo's title-page for *Wren's City Churches* and Louis Sullivan's work of about 1886 — then *art nouveau* and symbolism are generally contemporaneous, both belonging to the last two decades of the nineteenth century. Nevertheless, though they have certain elements of style in common they do not employ them in the same way. The symbolist style has an energy and simplicity which, though difficult to define, is recognizable and recognizably lacking in the more decorative productions of *art nouveau*. This force and intensity, which dictates the tensions between (in Schmutzler's words) 'the qualities of material reality, such as perspective, foreshortening, volumes in light and shadow' and the internal order of art, stems ultimately from the symbolist's expressive purpose. For whether or not the artists of the movement worked out a philosophy of idealism, so that they believed they were creating symbols of unseen ideas, or, more simply, believed that the properties of line and colour can express emotion, they intended their pictures to have meaning, and this conviction that art conveys personal feeling and/or universal ideas was, of course, of no concern to *art nouveau*.

But if the symbolism of 1880–1900 was never altogether abstract, can symbolism be found in architecture and the applied arts, where the necessary tension between nature and its transformation in the work of art (whose existence as symbol is thereby confirmed) is ruled out from the start? Historically the connection is made by Henry van de Velde who himself turned from painting to architecture and the decorative arts. A comparison between his title-page for Max Elskamp's *Dominical* [21] and his *Tropon* poster [22] illustrates one transition, as we have already seen — the woodcut, a seascape in Nabi mode, reduced to a few expressive lines and flattened areas, is still symbolist; the poster is a fine example of *art nouveau*. But van de Velde's ideas — if not his actual practice — were strongly in debt to his early symbolist connections (as another side of them was to William Morris and the English Arts and Crafts Movement). In elaborating his theory of ornament, line becomes more than description or decoration. It is a 'trace of movement . . . the obvious expression of a force . . . a clear psychic demonstration in that it issues from us spontaneously . . . and transforms the condition of our soul in a way that only dance and song can awaken'. 'The beauty of a work of art,' he declared, 'lies in a life and spirit that are proper to it, not in the life and soul of its model',

because colours and lines have 'the same logical and consistent relationships . . . as numbers and as musical notes.' As Karl Hüter has observed, this 'absolutizing of the effects of colour and line in van de Velde's work had been prepared by Van Gogh and Seurat . . . but none of his immediate contemporaries went as far as he towards such an abstract formulation', even though August Endell held similar theories.

Yet it must be said that it is questionable whether these ideas were actually realized in the architecture of the time. Sullivan's ornament, to be sure, had a symbolic function, but one that was, so to speak, more allegorical than symbolist, being illustrative of his formal expression rather than fused with it. Neither van de Velde nor Victor Horta lent themselves to personal expression. Horta composed in terms of space and structure and although he 'interpreted his metal structures . . . as something plant-like' this biological analogy contained no broader suggestions [19]. And van de Velde himself was mostly concerned with developing an abstract ornament which would express the character of the object by growing out of the form itself. But it is only the vague organic pantheism behind such concerns that relates them at all to the idealist philosophies of symbolism. Nor can Mackintosh's designs for the life-cycle images of his wall panels, once separated from the occult, be called symbolist.

SYMBOLISM AND 'L'ART SOCIAL'

Symbolist poetry and painting is generally – and correctly – thought of as the creation of more or less self-concerned individuals, artists cut off from the mass of mankind by its incomprehension of their ideals, and in turn by their own choice in anticipation of a rejection: the esoteric language which their goal of other-worldly expression imposes (they feel) upon their art, is the measure of their distance from society. Mallarmé, the prototype of the poet withdrawn from the world, had already argued in L'Art pour Tous (1862) that 'art was a sublime accessible only to the few'. 'The isolated ones', 'men of exception', 'the inner life', these were terms of praise in the critical vocabulary of the time. 'An artist is, by definition, a being strong enough to react against the influence of his milieu'; this was Albert Aurier's definition in 1892. Gide's image of Narcissus is perhaps an exaggeration, but in general the symbolists lived and created through reflection, through introspection, and the projection of personal emotion rather than by conscious interaction with the surrounding social world. As has often been noted, Gauguin was only carrying out Mallarmé's imagined flight (or unrealized dream) – fuir, fuir là-bas – when he

escaped to the South Seas: the symbolist poet more often escaped
into himself, there to discover, as much in his unconscious prompt-
ings as in his reasoned thoughts, a connection with an ideal world.

But there was also a balancing strain, especially in the nineties.
Unhappiness with the world as it was, its vulgarity and its injustice
(some among them had known poverty), caused many of the sym-
bolist writers to join forces, more often in print but occasionally in
action, with political reformers and revolutionaries. In the words of
Eugenia Herbert:

. . . symbolism had been in part a rebellion against authoritarianism in art
and an insistence on the right to individual aesthetic canons; it was con-
sistent for symbolists to respond to the same war cry of individualism in
anarchism. [And so the] poetic vanguard . . . wrote articles of a frankly
political character . . . their opinions and commentary circulated in the
petites revues and were eagerly printed by the radical, especially anarchist
press.

Félix Fénéon, aesthete and dandy, one of the chief 'midwives of
symbolism', was also an anarchist indicted for complicity in the
crime of his friend Émile Henry, who in 1894 exploded a bomb in
the Café Terminus. (And we have Fénéon's word that Seurat shared
these anarchist ideas.)

It was therefore natural that certain of the symbolists had a desire
to bring art to the people. They were a decided 'gang', and their
ideas were unwelcome to the purists. For example, the group of
L'Art Social, which had launched a monthly review in 1891, was
attacked in the *Mercure de France* (1893) for lacking talent, and,
more important, for having 'sinned against Beauty. They have re-
nounced integral Art for some vague and poverty-stricken philan-
thropic utopias . . . they do not practise Art at all, but sociology.'
Yet some persisted in the belief that the people, in a new, egalitarian
society, free of the vulgarity and repression of the existing middle
class, would be able to exercise their natural gift of artistic apprecia-
tion. Most believed that this would become possible only after the
coming of a new society. As Fénéon wrote in *Le Symboliste* (1886):
'A day will come . . . when art will be part of the life of ordinary
men . . . when it does the artist won't look down at the worker
from his celluloid collar: the two of them will be a single one. But to
achieve this the Revolution must get up steam and we must build a
completely anarchist civilization.'

Gustave Kahn believed that more immediate contact was pos-
sible. By 1885 he was convinced that

art had to be social. By this I meant that as much as possible it should
ignore the habits and the pretensions of the bourgeoisie, and, while waiting
for the people to interest themselves in it, had to address itself to the

proletarian intellectuals, to those of tomorrow, not to those of yesterday. I did not think for a moment that one had to be banal to be understood . . . It was necessary to grant a pre-eminence to social art, without in any way abandoning the right of synthesis and style; the people would understand.

Apparently Rodin shared some of these ideas, since in 1889 he joined the short-lived *Club de l'Art Social*. Somewhat later, his friend Carrière attempted to carry them out. He and the symbolist writer Charles Morice (who discusses the symbolist qualities of Carrière's art in *La Littérature de toute à l'heure* (1889)) envisaged the establishment of '*fêtes humaines*' to remind men of their common human destiny, and he was one of the rare artists who joined in the education of the workers through *universités populaires* (see below, p. 161).

Although much of the work of the Belgian symbolists was deliberately esoteric they too were affected by ideas of social action. Émile Verhaeren, writer and supporter of the movement in the arts, helped to found, in 1891, the *Lection d'Art* of the Brussels *Maison du Peuple*, and even Maurice Maeterlinck was briefly an ally. The socialist ideas of William Morris, which were known by the early nineties, had a profound influence on Henry van de Velde, who linked symbolist theory with his own hopes for the beneficent social effects of a 'new art' of domestic architecture and applied art. So secluded and consciously 'élitist' an artist as Fernand Khnopff could serve as an advisor to the *Lection d'Art*, while George Minne probably through the good offices of van de Velde was commissioned to create a monument to Jean Volders who had been an editor of its newspaper *Le Peuple*. It is some indication of the problems raised by these outgoing socially communicative impulses, which were contrary to symbolism's other, more introspective tendencies, that Minne's much criticized model was never carried out.

*Synthetism — or Cloisonnisme — a movement founded by Émile Bernard and Gauguin c.1888, aimed at reducing visible phenomena to unmodelled colour areas, almost like Japanese prints, in an attempt to achieve a synthesis of form and colour. Robert Goldwater observed, in *Primitivism in Modern Art* (1938, revised edition 1967), that Maurice Denis 'pointed out that synthetism, which only becomes symbolism in contact with poetry, was not at first a mystic movement although it implied a correspondence "between exterior forms and subjective states". If, however, to synthetize meant "to simplify in the sense of rendering intelligible", it is strange that the painters should have had any contact at all with poets who were following the opposite course. Neither the ideal of Verlaine "*pas la couleur, rien que la nuance*", nor Mallarmé's preference for white and his wish finally to get rid of limiting words entirely had anything formally in common with the broad, flat, undifferentiated colors separated by a sharp dividing line and the bright hues that were the goal of the painters.' [Editorial note.]

2

From Synthetism to Symbolism

As the winter season of 1890 opened in Paris pictorial symbolism appeared to be gaining in strength, coherence and critical recognition. The stylistic reaction to impressionism, evident even in the work of some of the impressionists since 1886, had more recently gained increased momentum. Gauguin, 'synthetism's' chief mag- (p72) netic centre,* had since 1888 clarified his own style and ideas and attracted several younger disciples. During the same time the movement had been finding literary spokesmen to interpret its achievements to a wider (but still very limited) public interested in the new painting and poetry. The moment seemed right for a certain cohesion and ascendance.

In retrospect it is clear that the moment was brief. When, having been honoured at a banquet of poets and painters at which Mallarmé presided, Gauguin left for the South Seas in early April 1891, the first period of symbolism, instead of expanding, came to a sudden end. It was a short period. Its beginnings in Gauguin's own art can be traced back no further than 1885; its mid-, and perhaps high, point for Gauguin and the group around him came in 1888 and included the catalytic encounter with Émile Bernard in Pont-Aven during the summer and the recruiting of Paul Sérusier in the autumn, leading directly to the conversion of the Nabi group in Paris. In 1889 came the exhibition of 'Impressionists and Synthetists' at the Café Volpini hard by the Exposition grounds with Gauguin again in the chief role. During these same few years Van Gogh was influenced by synthetist ideas and Georges Seurat's paintings were increasingly shaped by symbolist conceptions, and were so defended by his friends among the critics and poets. Redon's kinship, already understood by Huysmans and Mallarmé, was now acknowledged by his younger colleagues. In the summer of 1890 came a somewhat technical manifesto by Maurice Denis, published however in one of the many symbolist periodicals, *Art et*

*see footnote on page 72.

4

Critique. Now, in the *Mercure de France* (March 1891), a literary review begun the year before, Albert Aurier, one of its founders, who had already written on Van Gogh, under the title *Le Symbolisme en peinture: Paul Gauguin* expounded the aesthetic philosophy of the style and eulogized the work of the man he considered its chief exponent if not, indeed, its creator. Thus 'synthetism' in painting was fused with the wider, but until then chiefly poetic, movement of 'symbolism', grounded in the same thinking – a theoretical working out of the close personal connections and understanding formed during the preceding years. There was every reason to foresee a further consolidation of the style and the expansion of the influence of its central figures: the future turned out somewhat differently.

Seen only as part of his biography, Gauguin's departure, on which he had been ruminating for some time (he had spent several months in Martinique and Panama in 1887), had about it that combination of the willed and the inevitable leading to achievement and to tragedy which characterized his whole life. Seen as an event in the history of symbolist painting, it appears as the last of a series of accidents that prevented a group development, ended a period, and led to a new phase of dispersal and fragmentation. These changes were foreshadowed by Van Gogh's death in Auvers at the end of July 1890. But during the autumn group ties grew closer, and both painters and poets met in the Café Voltaire and came to Mallarmé's apartment on the Rue de Rome on Tuesday evenings. The banquet in honour of Gauguin was itself a symbol of this spirit.

But then, also in March, Émile Bernard, because his name had been omitted from the article he had persuaded Aurier to write for the *Mercure*, broke with Gauguin. On 29 March Seurat died of a sudden illness. A week later Gauguin left Paris. Symbolist painting in Paris was to continue until the end of the century (and sometimes beyond), but in different, diversified, and often eccentric ways. It is a sign of these changes that already by 1892 the Sâr Péladan, who had been present at the Café Voltaire, organized the first of his international, Latinizing, mystical and occultist exhibitions, the *Salon de la Rose + Croix*.

The historical and theoretical relation between the synthetist–symbolist tendency in painting and symbolism in poetry is, as we shall see, complicated and often imprecise. In the background are Baudelaire's poetry and criticism, before and after 1850, and Baudelaire himself calls upon an ancient tradition. Rimbaud, Verlaine and Mallarmé (to name only the masters) enter the scene before 1880. But symbolism as a movement belongs to the next decade, and there are striking parallels between the events just out-

lined – from 1886 to 1891 – and those that mark the evolution of literary symbolism during the same brief period. In 1886 Mallarmé began his Tuesdays in the Rue de Rome, and published his definition of poetry ('the expression of the sense of mystery in the aspects of existence') in *La Vogue*, the same 'little magazine' for which Félix Fénéon wrote his review of the last 'impressionist' exhibition; and in the same year Jean Moréas, in *Le Figaro*, defined the aims of the new poetry by a *Manifeste littéraire*, suggesting that its proper name was not decadence but symbolism. Schopenhauer's *The World as Will and Idea*, already influential but relatively inaccessible, was translated into French in 1888. The following year came George Vanor's *L'Art symboliste* with a preface by Paul Adam (a friend of Seurat) and *La Littérature de toute à l'heure* by Charles Morice (Gauguin's friend and collaborator and later Rodin's), both of which also discussed the place of painting and sculpture within the movement. These few years were fertile not only for poetry but for symbolist theatre and criticism; it is enough to add the names of Villiers de l'Isle Adam, Maeterlinck, Huysmans and André Gide; but a change was soon to take place. In September of 1891 Jean Moréas, who earlier in the year, like Gauguin, had been honoured by a dinner at the Café Voltaire, broke with the symbolist group and proposed the founding of an *École romane*. Thus by 1892 poetic symbolism too had lived through its most active and cohesive phase, and though, like painting, it was to continue until the end of the century and beyond, it was in a different spirit, no longer revolutionary, and without that faith in the redemptive powers of art which had characterized the previous few years.

GAUGUIN

'Peindre, non la chose, l'effet qu'elle produit.' – (Mallarmé, 1864)

'Let us, then, invent a new vocable in *iste* for the newcomers who are led by Gauguin: synthetists, ideists, symbolists, as you like.' – (Aurier, 1891)

We would do well to follow Aurier in beginning to define the new style. Writing early in 1891 he goes back several years for a work which contains all those features that set the new tendency off from impressionism. He begins his article on *Symbolism in Painting* with a descriptive interpretation of Gauguin's *Vision after the Sermon* [68], painted in Brittany late in the summer of 1888. Gauguin's title gives Aurier his clue. He emphasizes that, rather than being a scene executed from nature observed, this is the interpretation of an idea. The peasants in the foreground are experiencing a vision of the Biblical scene described to them in a Sunday sermon; the walls of the village church fade and they see, set upon a ground of brilliant

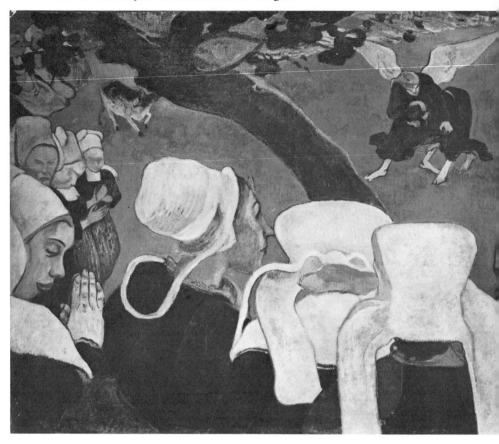

colour, the struggling figures of Jacob and the Angel. 'All the
material surroundings have dissolved in mist, have disappeared,
and the Voice [of the village Bossuet] has become visible . . . the
fabulous hill whose soil is vermilion-coloured, this land of childish
dream where two Biblical giants, transformed by distance into
pygmies, fight their hard and dreadful fight.'

There is thus here a double vision, the religious vision of the
Breton women and the monk on the right, and the artist's own
imagined view of them and the power of the faith by which they
are inspired. So there is no record here of ordinary reality, because
Gauguin too has been inspired, not by any actual 'corner of nature'
in the fashion of the impressionists but by his idea, or ideal, of the
sincerity and purity of a simple people, an ideal whose pursuit will
drive him far beyond Pont-Aven and Le Pouldu. The style of the
painting, its 'synthetism', suggests its 'ideism'. The women are
separated from their vision by a deep, angled perspective and the
omission of a middle ground, barred from approaching it by the

curbed tree-trunk, just as we, standing somewhere above them, are prevented from entering the space that they inhabit. But in fact no depth is portrayed. The unreal red of the ground, rising to the top of the canvas, comes forward to flatten the space; against it the figures stand out in strong, unmodulated areas separated by clearly drawn contours; there is no broken colour to suggest light or intervening atmosphere. Here then is a subject that has not been seen and recorded, but imagined and interpreted in visual metaphors, the simple faith rendered through simplified forms; strength of emotion given by boldness of colour, and the whole deliberately reduced and unified by the curving, rhythmic line that is to recur in so many future paintings.

The line, the flattening, the arbitrary colour, the simplification which is their common denominator are the hallmarks of a style that Gauguin (and his younger friends in Brittany) were creating. Their use may be seen simply in terms of composition, elements tying together a design upon a picture-plane of forms derived from nature, their degree of stylization linked to the necessities of that design — a structure at once coherent and expressive. In so far as we respect this limitation we speak of 'synthetism'. This was the term that Gauguin and his group were using at this time, the one they put into the title of their exhibition of the following year at the Café Volpini: 'Impressionists and Synthetists'. It is a style of synthesis, opposed not so much to analysis as to imitation, that yet ultimately refers to our experience of the real world. It is the style that the young Maurice Denis, two years later, struggled to describe as Neo-Traditionism: 'I am seeking a *painting* definition of that simple word "nature" . . . The emotion . . . springs from the canvas itself, a plane surface coated with colours. There is no need to interpose the memory of any former sensation . . .' Denis was (as we shall see) not too clear about the relation between art and nature, but Émile Bernard was quite right when he later complained that Denis' popular description of the new style with which his article in *Art et Critique* (1890) opened was a limited formula that stopped far short of the philosophic symbolism as defined either by Aurier, with his background of literary theory, or by Bernard himself with a more religious intention. (Nor did it have anything to do with the abstract or non-figurative art of the twentieth century.)

'Remember that a picture — before being a battle horse, a nude woman or some anecdote — is essentially a plane surface coated with colours assembled in a certain order.' Denis remains within the bounds of synthetism. 'Everything,' he concludes, 'is contained within the beauty of the work itself.' There is here apparently no reference to the transcendental, nothing, in Aurier's terms, that is '*idéiste*', nothing that will lead us from the perceptual simplifications

on the canvas, through emotion, finally to an unseen world of ideas.

It is perhaps unwise to pursue these distinctions here — although we shall have to return to them. There is the danger of refining definitions that at the time were not so clear, theories whose general drift was understood but whose structure was still vague, concepts whose logic was less important than their resonance. Gauguin himself had for some time been familiar with the theories of expressive form that were in the Paris air, more psychological than philosophical in their import, and continuing a tradition that found support in Delacroix and Baudelaire. Already in January 1885, using words that seem to echo certain passages of the *Curiosités Esthetiques* (issued the year before), Gauguin writes to the painter Schuffenecker from Copenhagen: 'There are lines that are noble, deceitful, etc., the straight line renders infinity, the curve limits creation . . . There are noble tones, others that are common, harmonies that are quiet, consoling, others that excite by their boldness.' And he goes on to explain that in and of themselves these elements of art are directly expressive of the profound unconscious nature of the artist who employs them, 'because one cannot make up for oneself a character, an intelligence and a heart . . . because this is the most secret part of man, hidden and veiled'. So Raphael's quality cannot be taught in the academy. The conclusion is that genial work is the expression of inherent genius — and the implication that Gauguin is of the same quality as Raphael. Such a view is, after all, not too different from that of Zola for whom the artist is a 'temperament', but for Zola, as a realist, the artistic temperament filters and interpretatively renders the real world; for Gauguin it is the expressive medium of universal harmonies, like those, as he says, which may also be found in numerical relationships. (These hidden harmonies underlie painting and music alike. This is why, as Gauguin says in his *Notes synthétiques* (c.1888), 'harmonious colours correspond to the harmonies of sound.')

Therefore the artist must free himself from too close an adherence to the particularities, to the 'corner of nature' which, for Zola, is both his stimulus and his subject. In another letter to Schuffenecker, written in the same summer of 1888 in which he painted the *Vision after the Sermon*, Gauguin advised his friend, '. . . don't copy nature too much. Art is an abstraction, derive this abstraction from nature while dreaming before it, and think more of the creation which will result [than of the model]. This is the only way of mounting towards God — doing as our Divine Master does, create.' The formulation is very general, and still largely within the limits of synthetism. (He is urging the same view upon Van Gogh at this time.) 'Abstraction' implies both simplification to arrive at visual coherence (synthesis), and the freedom to alter nature for the purposes of expression — a

handling of the artistic means congruent with the subject; what Maurice Denis will later define as 'objective' and 'subjective deformation'. But there is also something more; Gauguin's advice is to 'dream' in front of nature, and with that word, the '*rêve*' of the poets (more waking reverie than sleeping dream), we are within the ambiance of symbolism. We cannot say whether, in using it, Gauguin was aware of its precise implication for the aesthetic theory of the time, and it seems unlikely that he understood its philosophic background. But it was so current that he must have been prepared for Bernard's more detailed explanations. In the *Vision* Gauguin has imagined (dreamed up) his theme and its appropriate treatment — as he wrote to Van Gogh, 'I believe I have attained in these figures a great rustic and superstitious simplicity' — and Aurier, giving it a fully symbolist interpretation, developed these suggestions when he wrote about it three years later.

The synthetist style as Gauguin employs it in this painting has several direct sources (quite apart from whatever Bernard's immediate stimulus may have been). The struggling figures are taken from a print by Hokusai. The bent diagonal of the tree-trunk that holds the picture-plane (a device Van Gogh also employed), the view from above that lifts the horizon and flattens the space derive from Japanese prints generally. The flat, bold, clearly outlined colours were given further sanction by the *images d'Épinal* and especially by the areas of medieval stained glass, of which Gauguin must have been conscious through the *cloisonnisme* practised by Louis Augustin and Émile Bernard only the year before. Such direct adaptations are characteristic of Gauguin's methods of creation throughout his life. Most of his favourite motifs (as distinct from his compositions) come from a wide range of specific sources (Egyptian tomb painting, the Parthenon frieze, reliefs from the Temple of Barabudur, as well as Delacroix, Monet, Pissarro, and other modern painters) whose photographs he kept with him. Their common denominator is that they offer the possibility of decorative integration, and their use is entirely consonant with the synthetist distinction between art and nature. Gauguin and Van Gogh admired Japanese prints and the so-called primitives for their 'honesty', i.e. their refusal to attempt to reproduce the sensations of the real world, and their acceptance of the means proper to the medium of art, through whose evident statement and even exaggeration were created, not banal imitations of perceptions, but rather metaphors of a more profound experience. So in transposing motifs from elsewhere, and in recombining elements from his own earlier paintings in later compositions, Gauguin still remained within the realm of symbolic discourse, employing the language of art rather than imitating nature.

The *Vision after the Sermon* is the first (and in some ways stylistically the most radical) of a series of works of similar orientation executed by Gauguin during the two and a half years until his departure for Tahiti. There are also paintings considerably less symbolist in attitude, some reflecting his respect for Cézanne (in 1888 he said a Cézanne he still owned was 'the apple of his eye'), others the continuing influence of impressionism, and many of his ceramic vases have a decorative character that anticipates *art nouveau*. But in both style and theme, Gauguin's direction is increasingly symbolist. His friend, Jean de Rotonchamp, said that the painter was unduly influenced by the literary speculations of his Parisian acquaintances ('golden-tongued theoreticians'), especially during the winter of 1890–91, but it is quite evident that he was increasingly sympathetic to the movement and was giving his own interpretations to its theories [69]. During his brief stay in Arles in the autumn of 1888 he convinced Van Gogh to try to paint less closely from nature, an attempt Van Gogh quickly abandoned, while in 1889 he executes works that are synthetist in style and symbolist in theme. For two of these compositions he has again condensed the space, stylized the drawing and heightened the

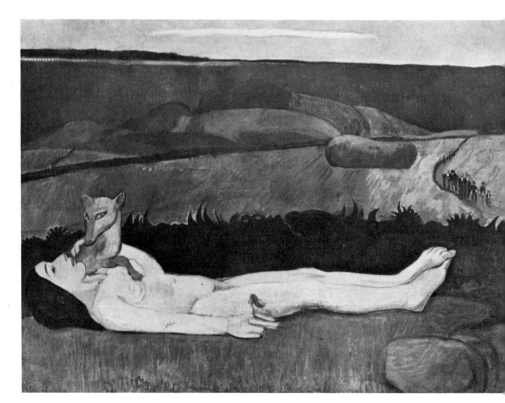

69. *The Loss of Virginity*, 1890–91. Gauguin

colour so as to impart, through these means alone, the 'rustic and superstitious simplicity' of the subject, which is to say that he has employed a synthetic style. Both the *Yellow Christ* [5] and the *Cavalry* [70] are based upon examples of the folk art that Gauguin and his group admired: the one on a wooden Crucifixion in the church of Tremalo not far from Pont-Aven, the other on a Romanesque stone Calvary grown green with age at near-by Nizon. He

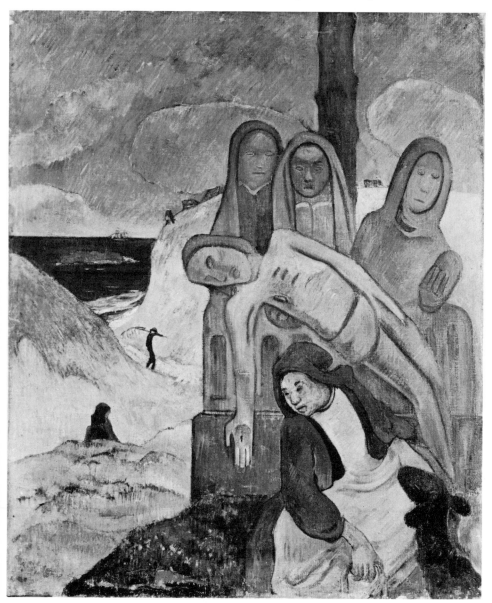

70. *Breton Cavalry*, 1889. Gauguin

82 thus starts, not with nature, but with a distillation of emotion, an object of faith — therefore a symbol — summary and simplified in style, which in itself already concentrates the mood (idea) he is seeking to depict, or to express, through the means of form. Twice removed from nature, he is free to create an ideal scene, imagined, but for that reason more essentially true than if he had been 'shackled by the need for probability' for which he later criticized the impressionists.

The attraction such subjects held for Gauguin was immediate and personal. 'I love Brittany,' he wrote to Schuffenecker, with a musical analogy. 'I find wildness and primitiveness there. When my wooden shoes ring on the granite, I hear the muffled, dull, powerful tone I seek in my painting.' But it was also grounded in attitudes more general to the period. Throughout Europe at this time painters were drawn towards peasant life; they sought inspiration in existences that were physically simple and spiritually undoubting, and were envious of a wholeness of character and an acceptance of fate they themselves had lost. Not that they shared these existences (although both Gauguin and Van Gogh, in very different ways, hoped they could do so); rather they observed and transmuted them through their own artistic faith. The nostalgia for this lost wholeness, and a desire to recapture it, is one of the reasons for the proliferation of provincial artists' colonies during this period,

71. *Vineyard in Arles*, 1888. Gauguin

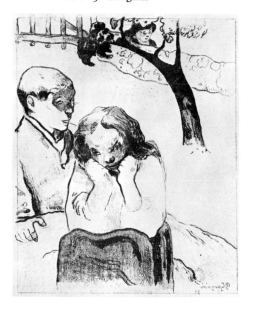

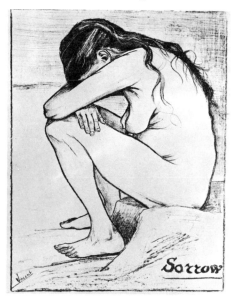

and is not unrelated to the more urban ideal of '*l'art social*' which seems so at variance with the strong sense and cultivation of individuality and isolation characteristic of the symbolist artist. As Rilke wrote of the group at Worpswede in Northern Germany, 'What do the painters want from these people [the peasants]? . . . They do not live among them, but as it were stand opposed to them . . . They push these people, who are not like themselves, into the surrounding landscape, and in this there is no violence . . . The artists see everything in one breath, people and things.' In other words they imagined the peasants as effortlessly living out the pantheistic union they hoped to recapture through their art.

In many of Gauguin's pictures of the first Brittany period that imagined union is idyllic: in the Breton *Haymakers* (1889) the curved synthetist shapes that flow through figures and landscape convey a sense of relaxed harmony. But this is not always the case. There is a series of oils and pastels that shows a crouching girl, with knees drawn up, elbows on knees, and hands to the side of the face. It seems to start as a genre figure suggesting isolation and unhappiness, set off from the surrounding group activity, and apparently drawn with some kind of special feeling. She appears in this way in the *Vineyard in Arles* [71] and *Human Miseries* [72], and may have been suggested by an early drawing of Van Gogh called *Sorrow* [73] which he himself used for the picture *At Eternity's Gate*. In 1889, in a lithograph shown in the Volpini exhibition (*Aux Roches Noires* [74]) Gauguin coupled her with a figure seen from

74. *Aux roches noires*, 1889. Gauguin

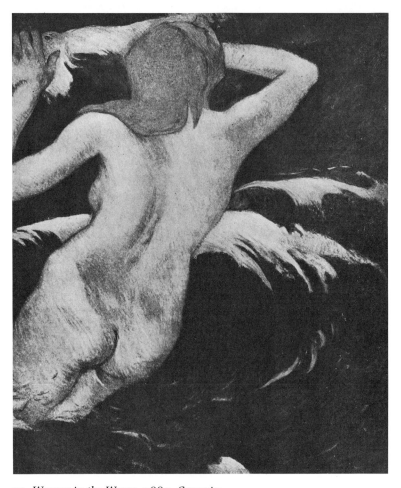

75. *Woman in the Waves*, 1889. Gauguin

76. *Les Ondines*, 1889–90. Gauguin

the back, floating or swimming with spread arms against the waves (who appears again in the oil of *Woman in the Waves* [75], and in a wood relief, *Les Ondines* [76], of the same year). These figures are generally interpreted as suggesting the reactions of women to love – the one fear, the other abandonment, and though they are far from precise it is evident that Gauguin has sought to convey a mood through the contrasting character of the pose and the quality of the line, rather than through any specific iconography. But in a pastel of the *Breton Eve* [77], where the snake of Temptation appears

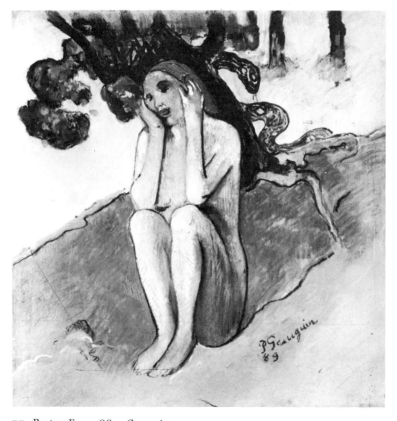

77. *Breton Eve*, 1889. Gauguin

78a, b, c *Leda and the Swan*, c.1889.
Gauguin

behind the tree against which she sits, as well as in two representa-
tions of *Leda and the Swan* (a ceramic vase [78a, b and c], and a
drawing that also includes a watchful snake), the elements of the
story become more explicit. Although the style is still decorative and
synthetic, the separate parts of the subject are spelled out in such a
fashion that a long step has been taken towards allegory, which
has replaced the condensed suggestion that was the ideal of
symbolism.

This same tendency can also be observed in other paintings of
the time. In 1888 Gauguin, in Brittany, exchanged self-portraits
with Van Gogh in Arles. He described his own image to Van Gogh
as that of a 'powerful ruffian like Jean Valjean who has a certain
nobility and inner kindness . . . The design of the eyes and nose,
resembling that of flowers in a Persian rug, sums up an abstract
and symbolic art.' In the background there is a flowered wallpaper,
in the tradition of Cézanne [79]. These designs and colours also
have their meaning: 'The delicate maidenly background with its
child-like flowers is there to signify our artistic virginity,' which is to
say that Gauguin was seeking a 'painting equivalent' to carry the

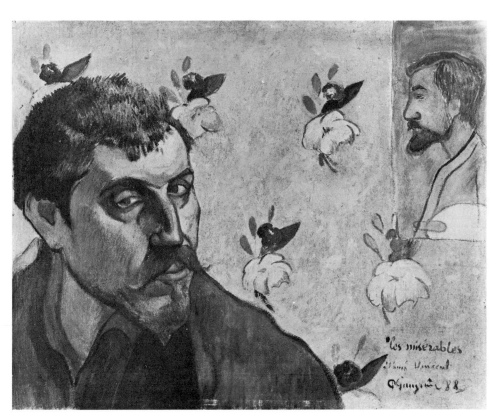

79. *Self-Portrait ('Les Misérables')*, 1888. Gauguin

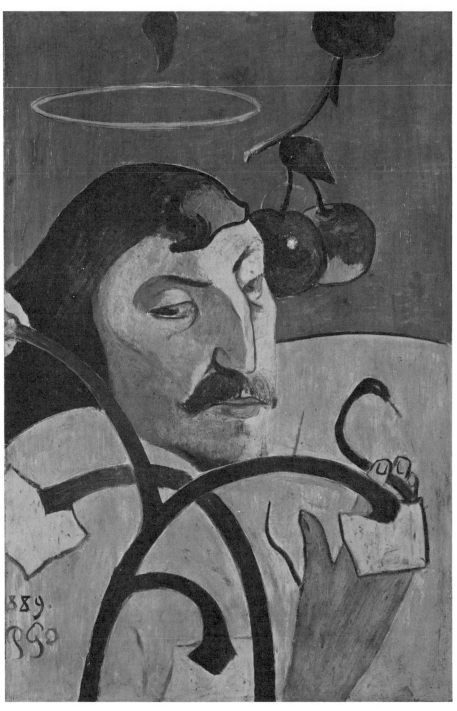

80. *Self-Portrait with Halo*, 1889. Gauguin

ideas expressed. In a letter to Schuffenecker concerning the same painting he is even more precise: 'The whole is on a chrome yellow background scattered with childlike flowers. Bedroom of a pure young girl. The impressionist is a pure being, unsullied by the putrid kiss of the École des Beaux-Arts.' Gauguin stresses the abstract character of this work ('so abstract that it is absolutely incomprehensible') because, in large part at least, the meanings are embodied in qualities of colour and design that are their formal counterparts. He here renews the ideas of his letter of 1885 from Copenhagen, and now comes very close to the Baudelairean theory of correspondences that was crucial to poetic symbolism. The *Self-Portrait with Halo* [80] of the following year is much more representational: the iconography sets forth in detail an essentially literary subject — the apples of Temptation, the halo of purity, the snake, emblem of evil, and in the centre, behind a screen of curved and stylized lily stalks, his own seductive three-quarter profile, the whole painted in flat planes and bright colours. There is pride and mockery here, and the further irony of self-mockery; Gauguin displays himself as Milton's satanic angel. There is no doubt that this is, and is meant to be, a painting with a symbolic message. Like his similarly devilish portrait of Meyer de Haan, it includes many identifiable attributes. But is it a symbolist work? By putting together a related group of objects of traditional meaning a symbolic programme has been clearly set out and can be read off in a way that is

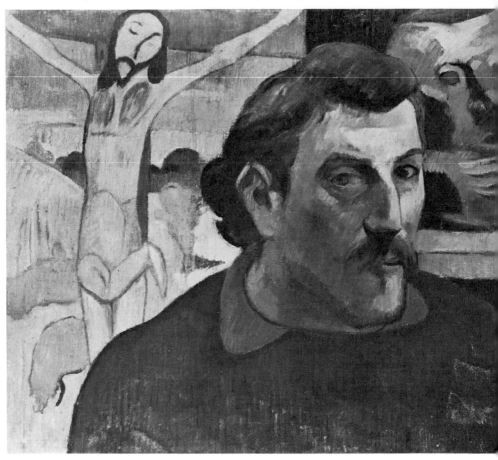

almost literary in effect and that remains apart from the visually unifying stylizations of the overall design. Synthetist form and symbolic meaning are both present, but remain side by side.

The effect may be contrasted with two other self-portraits of approximately the same time. In both the artist again plays a heroic role, in both, too, he has depicted himself as a god-like figure. In the *Christ in Gethsemane* [81], Gauguin shows the artist suffering as Christ did, a lonely figure whose passion is symbolized by the flaming colour of his hair. In the *Self-Portrait with Yellow Christ* [82] the meaning remains suggested; he is both sufferer and creator. Gauguin is here calling on, indeed calling attention to, his own personal experience; but this was possible because he was sure to be understood in a more general way. Loneliness, poverty, ridicule were of course his daily experience, counterbalanced by a sense of mission. The tradition of the artist who is god-like because he too has the power to create (and to whom God has given that power)

is a long one, much present among the romantics, of which Gauguin, as his words indicate, was very conscious. And among the symbolist poets whom Gauguin knew the concept of art as a new religion, a way of life to which the artist was called and to which he gave himself utterly, was an article of poetic faith. Mallarmé's dedication, not alone to *his* art, but to art as such, the retired life he led, monastic in its own way, was an inspiration and an ideal among the symbolists. Gauguin's own life, in its very different fashion, and even more that of Van Gogh for whom art was a direct symbolic substitute for the unbearable poignancy of a truly religious life, were sustained by a very similar faith. Gauguin's two self-portraits thus condense attitudes having more than an individual reference. The same holds true for the self-portrait that Van Gogh painted in September 1888 [83] as part of the exchange between himself, Bernard and Gauguin (in contrast to the one he painted for

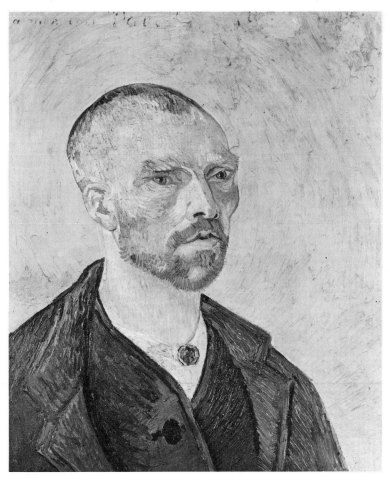

83. *Self-Portrait*, 1888. Van Gogh

Laval). Of it he wrote to his brother: '. . . if I too may be allowed to exaggerate my personality in a portrait'; he thus indicates that he understood Gauguin's intention. 'I have done so in trying to convey in my portrait not only myself but an impressionist in general. I have conceived of it as a *Bonze*, a simple worshipper of the eternal Buddha. And when I put Gauguin's conception and my own side by side, mine is as grave, but less despairing.' Despite Gauguin's obvious egotism, the faith implied is very similar, and it is this

84. *Soyez amoureuses et vous serez heureuses*, 1889. Gauguin

palimpsest of meaning, more suggested by the whole than by details, conveyed more by attitude and gesture than by legible sign, that (in distinction to the *Self-Portrait with Halo*) gives these pictures their essentially symbolist character.

Two other important works done during these same years when Gauguin worked alternately in Brittany and Paris are more difficult to characterize [84, 85]. One of the pair of wood reliefs, *Soyez amoureuses et vous serez heureuses* was carved in 1889, the second,

85. *Soyez mystérieuses*, 1890. Gauguin

Soyez mystérieuses, in 1890. When they were shown together at the exhibition of *Les XX* in Brussels early in 1891 they were very badly received, being considered inexcusably lewd and maladroit. Their simplifications are, of course, intended, and as the raised bands and even the style of the inscriptions show are derived from provincial cabinet-making — later the source of so much vulgarized *style rustique* — which naturally appealed to Gauguin's generalized feeling for the primitive. (The contrast with refined adaptations from the same folk sources in his carved cupboard doors is most instructive.) Each, and especially the first, has an elaborate iconographic

programme laid out in terms of symbolic figures. The first relief is more personal: Gauguin in a letter to Émile Bernard explains that he is the 'monster' in the upper right-hand corner 'taking the hand of a woman who holds back, saying to her: Be loving and you will be happy,' and that the fox is 'the Indian symbol of perversity'. The unhappy (sinful?) crouching woman of *Aux roches noires* [74] also is included. The rest is less clear, except that, as Aurier already noted in 1891, the inscription is ironic, since here 'all sensuality, all the struggle between flesh and thought, all the pain of sexual pleasure, twist themselves and, so to speak, grind their teeth.' *Soyez mystérieuses* has as its central figure the Woman floating in the Waves (from the right side of *Aux roches noires*), surrounded by a rich floral design and flanked by two women's heads. These reliefs, with which Gauguin was pleased, have been variously interpreted, and there is no need here to adjudicate the intricate explications, which must in any case remain speculative. *Soyez heureuses* is more personal in its iconography than *Soyez mystérieuses* which is perhaps based on Gauguin's study of Polynesian mythology, already begun in 1890 in preparation for his voyage. The former sets forth both his ambivalent psychology, at once cynical and idealistic, and his personal situation, driven by sexual desires entirely divorced from his need for love; the latter has perhaps something to do with the polarities of matter and spirit. Aurier said that *Soyez mystérieuses* 'celebrates the pure joys of esotericism, the troubling caresses of the enigma, the fantastic shadows of the forest of problems.' This is of course pure symbolist doctrine (it even contains a reference to Baudelaire's 'forest of symbols' in his famous sonnet *Correspondances*), and it is entirely fitting since the attainment of that sense of 'mystery' that Gauguin has taken as its title is one of the central goals of symbolist art. Modern critics have been willing to allow this work the vagueness of suggestion that accords with its theme. There is perhaps no more reason to suppose that the whole iconographic programme of *Soyez amoureuses* can be 'solved'. And this for two reasons: Gauguin was an especially passionate man in a very difficult situation. But many other artists of this time had an ambivalent attitude towards woman and her dual role of sinful temptress and virtuous idol. For the Pre-Raphaelites, for Klinger, for Munch (and for many poets) she is both sexual object and symbol of pure love. So Gauguin's bitter intentions cannot be understood as too narrowly autobiographical. And, equally important, we must remember Mallarmé's injunction, as Gauguin surely did, since he constantly employs the same terms: 'To *name* an object is to suppress three-fourths of the enjoyment . . .; to *suggest* it, that is the dream.' One suspects that a demand for wholly unambiguous answers would have called forth all of Gauguin's ironic mockery.

'Everything was nourishment for symbolism: nature, the Breton Calvaries, the *images d'Épinal*, popular poetry . . . In sum, symbolism did not paint things, but "the idea of things".' (Émile Bernard)

'Remember that a picture – before being a war horse, a nude woman, or some anecdote – is essentially a plane surface covered with colours arranged in a certain order.' (Maurice Denis)

'Art is a means of communication between souls.' (Paul Sérusier)

In the years before he left for Tahiti early in 1891, when he divided his time between Brittany and Paris, Gauguin became a kind of *chef d'école*. His experience, the force of his personality, and the depth of a conviction for which he had sacrificed his own comfort were such that he made converts to his faith. Most of these younger men, brought up in the academies in more conventional modes (thus by-passing impressionism), recognizing their need for a way out of naturalism, acknowledged his leadership at the time and in later life paid tribute to him. The one exception was Émile Bernard, who, as has been mentioned, considered that it was he, in Pont-Aven in the summer of 1888, who had introduced Gauguin to the ideas that resulted in *The Vision after the Sermon*, and that he, Bernard, just twenty years old, was as Roger Marx called him in 1892, 'The father of symbolism'. There is no need here to examine the details of that ancient quarrel of precedence, which has been so point-lessly over-analysed. Certainly Bernard was a stimulus. He was clearer in his verbal formulations and could quote from the neo-Platonic philosophers. The *cloisonnisme* that he and Louis Augustin had developed the previous year, influenced by medieval stained glass as well as by Japanese prints, gave a new emphasis to the outlining of component forms and to the flattened areas within, simplifications to which Gauguin, already familiar with Japanese prints, was receptive. But whether or not Bernard's *Breton Women in the Meadow* [86] preceded the *Vision after the Sermon*, as he claimed, it is not in the same sense a symbolist work. Bernard, in his later writing, called Maurice Denis' 1890 definition of the new style 'ridiculous and anti-symbolist' because, though it dealt with stylization, it neglected its purpose and its meaning. For Bernard it was important to 'see the style and not the object' not merely to compose a picture but in order to 'strip off immediate appearances so as to more profoundly convey the underlying ideas . . . It was no longer a question only of painting, it was necessary to achieve stylization and significant harmony. There was where the symbol began.' The goal was to create a 'spiritual meaning' to match the styles of the past – Byzantine, Egyptian or Gothic, and which, like

them 'collective and religious', would express the whole epoch. Gauguin was incapable of this, Bernard maintained, since he lacked true Christian belief, and his work was only a simulacrum, 'a symbolism without symbol', and his religious themes, painted only at Bernard's instigation, were a mere pretence.

86. *Market in Brittany – Breton Women in the Meadow*, 1888. Bernard

Bernard, writing later, and out of a strong sense of personal neglect and historical injustice, is defending his youthful role as innovator: his creation had been stolen and misappropriated. (He has forgotten how much he admired Gauguin at the time, and how often and how generously he praised him in his letters to Van Gogh.) But precedence in the events of the summer of 1888 is perhaps the least of the questions that he raises; the others are more fundamental to the nature and aims of symbolism. Without doubt Bernard was a catalyser, for Van Gogh as well as Gauguin. He was in touch with the literary world in Paris, he was a link between the critic Aurier and the painters. His *Breton Women in the Meadow*, carried to Arles by Gauguin in October 1888, was copied by Van Gogh and briefly influenced him towards a more *cloisonniste* technique. And

87. *Bretonnes au Goémen*, 1892. Bernard

Bernard was an adept at idealist theory. Yet despite all this, the synthetist pictures he executed, whether in 1888–90, or again in 1892–3, seem to carry with them no sense of symbolism. They remain Breton genre subjects whose simplifications of modelling and design, although audacious for the time, are still chiefly concerned with purely visual harmonies. Only in repetitions and continuities of carved silhouettes (as in *Bretonnes au Goémen* [87]) is there some expression of a 'soul of the people' and the natural goodness of a simple group existence. They are instances of a rhythmic 'parallelism' not unrelated to ideas of 'correspondence' to which Hodler tried to give a theoretical base and whose intuitive use, as here, is common throughout the period. Otherwise the design remains external to the subject, and the artist an observer.

Thus Bernard's work, in comparison with Gauguin's, does not bear out his philosophical contention that only a formal religious belief can infuse symbolist art with true meaning. Indeed it is possible that just the opposite is the case: the primary belief must be in art itself rather than in some other faith which art mediates; else that quality of identity, of congruence between form and idea, between the seen and the unseen, is vitiated. In Mallarmé's terms, art is the expression of the mystery of our existence: 'elle doue ainsi d'authenticité notre séjour et constitue la seule tache spirituelle.' In other words, faith must reside in art itself, and as has often been pointed out this was indeed the case for Mallarmé himself throughout his life, and, more briefly, for the younger symbolist poets in the years before 1890. So it is perhaps not surprising that Bernard's most directly religious painting of this time, executed during a

88. *The Pietà*, 1890. Bernard

mystical crisis that followed an unhappy love affair, should be more expressionist than symbolist. *The Pietà* [88] is heavily dependent on references outside itself: medieval and popular art on the one hand, and naturalistic representation, especially in facial expressions, on the other. (Van Gogh understood this, and objected to the artificial manner which Bernard had briefly adopted.) In consequence it does not achieve the self-contained 'style ... which would be the expression of our epoch' that was Bernard's goal. His preoccupation

with a clear religious message, conceived more in traditional than in personal terms, has led him close to that 'literary' art which symbolism was determined to overcome.

The Pont-Aven group employed the term 'style' in several senses. It could mean a period style – like the Egyptian or the Gothic – or the modern one the symbolists aimed at creating that would embody the 'spiritual sense' of its own time. It could also however be used in a more restricted way, as when Bernard says that he was seeking 'an art which would employ form to express style, and colour to determine mood', and here something like the traditional distinction between intellectual line and emotional colour is being continued, but with a more immediate spiritual intention. This·is what Gauguin has in mind (probably using Bernard's vocabulary) when in October 1888 he writes to Schuffenecker, 'This year I have sacrificed everything – execution, colour – in favour of style, wanting to impose upon myself something else than what I know how to do.' In a letter (613) of 1889, Van Gogh is even more explicit: '. . . I feel strongly inclined to seek style, if you like, but by that I mean a more virile, deliberate drawing. I can't help it if that makes me more like Bernard or Gauguin.' Style could also, however, have its more usual meaning: a way of painting both integrated within itself and expressive of the individual artist. And when a group of artists were similarly attuned, as were the young painters who at this period came under Gauguin's influence, this would also result in something like a group style within which the individual styles would be sympathetic variations.

This last point of view is largely encompassed in Maurice Denis' definition of the new attitude, which he summarized in the propositions of his 1890 article in *Art et Critique*. He called it *Neo-Traditionisme*, since, in opposition to both academicism and impressionism (including the 'scientific impressionism' of Seurat), he conceived of it as renewing the true tradition which they had lost. Although Denis does use the word symbol ('A Byzantine Christ is a symbol') there is no indication that any idealist theories lie behind his formulations, which are limited by the psychological determinants of structure and emotion:

> The artist's imagination must stylize nature into a distillation of his feeling, and by emphasis, by omission, by exaggeration if necessary, produce a form that conveys his sentiment. And an artist's sensibility must impose upon the haphazard shapes of nature an arrangement, a composition, a harmony and a structure which make his picture a delight to the eye. From the fusion of these two, the one determined by the *subjective* necessity of emotion, the other by the *objective* necessity of the laws of colour and line, results that expressive synthesis which is a work of art.

Denis' analysis is admirably clear-headed, but it seems somehow to

by-pass all those questions of struggle and mystery that are at the core of the more intense forms of symbolist art. And unlike Aurier, who a year later uses much the same language in a passage of his article on *Le Symbolisme* in the *Mercure,* Denis nowhere refers to those 'correspondences' (between the ideal world and the world of sensation) which underlie the necessity of synthesis and give the work its meaning.

With Maurice Denis, perhaps even more than with Émile Bernard, this resolution can be attributed to religious faith. Denis' diaries during these years when he was an extraordinarily precocious young painter, record what can only be called a kind of wilful innocence, a religious refuge from any acknowledgement of temptation in himself or evil in the world around him. Although he celebrated his marriage with a Nabi ceremony (as well, of course, as a Catholic one) and was much involved in the symbolist theatre,

89. *The Sacred Wood,* 1893. Denis

his paintings fully mirror this state of mind. Evidently for Denis the message that Sérusier brought back from Pont-Aven in September 1888, exemplified in the famous *Talisman* [92] painted under Gauguin's tutelage and partly expressive of Bernard's favourable view of 'abstracting from nature', remained within the realm of design and raised no problems of deeper meaning. Denis' decorative compositions show an admiration for Puvis and the Quattrocento at least equal to his understanding of Gauguin. He shares with the other Nabis a fluid arabesque that is at least incipient *art nouveau* (and through van de Velde has a direct influence in its formation), a reduction of space through the use of a high horizon line or a filling of the sky at the top of the canvas, and frieze-like arrangements of vertical tree lines and figures turned in flattened profile. Everything is peaceful and harmonious. His scenes, whether classical (as in *The Sacred Wood* [89], which owes much to Puvis in its

[handwritten margin note: description of style]

90. *The Annunciation*, 1890. Denis

profiled heads and receding planes) or Christian (as in *The Annunciation* [90]) evoke a golden age more innocent than Puvis, and much more intimate. His *Jacob and The Angel* [91] in sharp contrast to Gauguin's [68], simply clasp hands at arms' length, while *Spring* (1891), which the young Henry van de Velde transmuted in an embroidery, becomes a quiet garden party, with, as in *The Sacred Wood*, figures in a classicized contemporary dress. Denis' symbolist intention is clear: to transcribe his own unquestioning sense of the continuing and constant presence of God. In the result the mood is sometimes lyrical, but perhaps more often merely domestic. (Vallotton, whose own paintings were ironic in spirit and deliberately

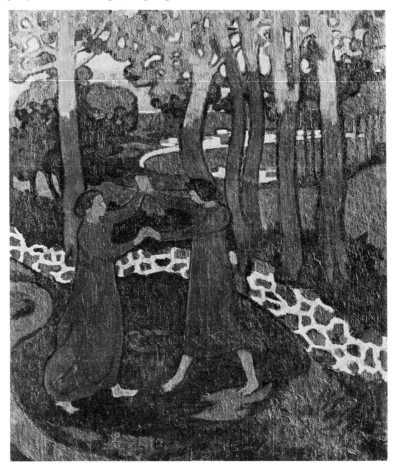

blunt in their simplifying stylizations, somewhat cruelly referred to Denis' 'Holy Virgins on Bicycles'.) In either case all doubt has gone; faith is accepted and need not struggle to clarify itself through being expressed; there is none of that sense of tension as the artist searches to make the idea visible in the form which marks the more heroic kinds of symbolist expression. Denis seems to have fled from the recognition of sin (sexual or otherwise), and in this light it seems ironic that he should have illustrated Verlaine's *Sagesse* (1891) and Gide's *Voyage d'Urien* (1893), which are among the first symbolist collaborations in which the illustrations are conceived as parallel evocations (rather than documentation) of the mood established by the written word. It is perhaps the very confidence and peace given him by his faith that helps Denis to paint many handsome pictures and decorations throughout the decade of the nineties. As he himself pointed out, after 1891, with Gauguin's departure, the severe

synthetist style of the Volpini exhibition of 1889 had softened, and
in the exhibitions of the group at Le Barc de Boutteville (1891–6)
'the areas of flat colour no longer appeared with such insistence,
the forms were no longer set within black outlines, the exclusive
use of pure colour was no more.' Denis' own works continue within
this softened style, made attractive by a command of arabesque and
subdued colour, but their iconic character is so gentle and their
specific imagery so subjected to formal order that the symbolist
intention hardly matters: they have become part of the decorative
world of *art nouveau*.

The landscape that Sérusier brought back with him to Paris in
September 1888 (*The Talisman* [92]) was essentially a synthetist
picture with expressive colours. It had been painted in the Bois
d'Amour at Pont-Aven (where earlier that summer Bernard had

92. *The Talisman*, 1888. Sérusier

painted his sister Madeleine lying in reverie on the grass, a chaste and fully-clothed wood-nymph [58]) under Gauguin's tutelage. 'How do you see those trees?' Gauguin asked him. 'They are yellow: well then, use yellow; that rather blue shadow, paint it with pure ultramarine; these red leaves? Use vermilion.' But Sérusier was also receptive to Gauguin's insistence upon the primacy of the artist's imagination and the interaction of his mind with reality; he was familiar with the neo-Platonic tradition, and was interested in the occult, and he at once made the connection. It was he who named the group of converted friends (it included Bonnard, Denis, Ranson, Vallotton and Vuillard, and later others), Nabis (or prophets), and who, with Denis and Ranson, provided most of the ritual

93. *Christ and Buddha*, c.1890. Ranson

as well as the theory of the group. He knew of Swedenborg, and the theory of correspondences, and he read Edouard Schuré's *Les Grands Initiés* (1889) with enthusiasm. Both Ranson and Sérusier were interested in theosophy, and like many poets and artists of the period (including Gauguin) searched for common ground in Eastern and Western religions. Ranson's *Christ and Buddha* [93], which recalls Gauguin's *Yellow Christ* [5], also includes the sacred lotus of the Hindus and an Arabic inscription, symbolic of Mohammedanism, which reads 'knighthood of the prophets' in reference to the Nabis' mystical brotherhood. In the same year Sérusier painted Ranson [94] in an imaginary Nabi costume studying a sacred book and holding a medieval-looking crozier perhaps carved by the

94. *Ranson in Nabi Costume*, 1890. Sérusier

sculptor Georges Lacombe, the only sculptor of the group [95]. At first the Nabis' monthly meetings (from which women were excluded) were monkish gatherings, with a formalized ritual and serious discussion of philosophical and doctrinal questions, but most of the members (and especially Bonnard, Vuillard and Roussel) were more secularly disposed and after a short time their reunions were more relaxed.

95. *The Dream*, 1892. Lacombe

Almost from the start painting tended to contrast with doctrine, even for the mystically- minded. Ranson's paintings and tapestry designs (the early ones executed by his wife), filled with flowers, fruit, animals and figures either nude or in medievalizing flowing dresses much like those of Denis, are light-hearted decorations, altogether *art nouveau* in style and mood [96].

Ranson lived in Paris, Sérusier (who had returned to paint with Gauguin in Le Pouldu in 1889 and 1890) divided his time between Paris and Brittany. For him, as for others of the Nabi group – Séguin and Filiger especially – Brittany continued to hold something of the mystery it had for Gauguin. Its monuments, menhirs and roadside crucifixes, and its language, Gaelic, were survivals of a primitive past; its people and their costumes were untouched by modern life, and an ancient faith was an integral part of their daily lives. In Brittany one could believe in the constant presence of the mysterious and the occult, in the spiritual power of original simplicities and in the renewal of ancient forms of art. These are the background references of Sérusier's farmyard scenes and Filiger's landscapes; they seek to render 'the mystery that . . . lies at the heart of the world's oldest humanity, the Celtic race'. Yet, apart from the use of

certain synthetist compositional devices, their works seem to have little to do with the original symbolist message or an idealist aesthetic. Filiger's gouaches on religious themes, executed during the early 1890s, with their fixed, hieratic compositions and precise drawing based on his admiration of trecento and quattrocento style and medieval stained glass, while they are the expression of a sincere mysticism are essentially primitive revivals, as are the wood-

96. *Women in white*, 1895. Ranson

cuts he made for the review *L'Ymagier* (1894–6) of Rémy de Gourmont. Once again religious acceptance has taken precedence over the original symbolist artistic intention; to use the symbolists' own terms, the 'literary' subject, which was to have been banned, has returned in the guise of reference, not to the associations of an anecdote, but to those of an earlier art. Later, in a series of works done around the turn of the century, Filiger once again reinstates a kind of synthetism, now basing its generalizations upon geometrical order and colour analyses. These *Geometric Heads*, some of which come close to abstraction, are symbolist in so far as they are seen as microcosms of a pervasive universal structure, conveyed through the analytic forms which inhabit both the figure and its surrounding space and give evidence of their unity. (There is an obvious analogy here with certain features of cubism, which Filiger anticipates by only a few years.)

Other members of the Nabi group were prompted by the same reliance on geometry. Jan Verkade, who had painted in Brittany in the summer of 1891, the year he arrived in Paris, was converted to Catholicism in 1892. In 1897, after several previous visits, he entered the Benedictine monastery at Beuron in the Black Forest where the monks devoted themselves to painting, following the archaizing aesthetic of Father Desiderius Lenz 'based upon a mystical interpretation of Egyptian, early Greek and medieval art [which] must have seemed the complete affirmation of the less ordered, but analogous spirit' of the early Nabis. Verkade introduced Sérusier to Lenz' theories of 'holy measurements', and Sérusier's 'published translations of Lenz, beginning in 1904, entered prominently into the Nabis' concern with geometric proportions as divine truth.' Sérusier's own little book, *L'ABC de la peinture* (not published until 1921, with a preface by Maurice Denis, but conceived much earlier) invokes the mystic qualities of numbers and emphasizes the golden section as a compositional method: 'Apart from the style peculiar to an individual, a period or a nation, there are forms of a superior quality, a language common to all human intelligence. Without some trace of this universal language, there is no such thing as a work of art . . . This universal language is based on the science of numbers, above all on simple numbers – Mathematics – whose application to the visual arts, necessarily spatial, is geometry.' 'Synthesis consists of containing all forms within that small number of forms we are capable of conceiving: straight lines, a few angles, the arcs of a circle at the ellipse; beyond that we become lost in the ocean of the particular.' So Sérusier, like others of his generation, has reversed the direction with which symbolism began: rather than begin the anxious search for symbolic form from within, he rests his synthesis upon conformity to laws outside himself. His belief in the

saintes mésures is the aesthetic parallel to the religious conversions among both writers (Charles Morice is a typical instance) and artists during the last decade of the century.

Throughout the years of the nineties the Nabi group had a direct and continuing association with another aspect of symbolism. Even within the movement it was frequently remarked that poetry played the leading role and that no, or few, equivalent novels or plays were being created. Villiers de l'Isle Adam, author of *L'Ève future*, had indeed written for the theatre in the eighties (e.g. *Le Nouveau Monde*), but his work was unperformed, and he left no French successor of anything like his stature, although there were a few lesser figures such as Maurice Beaubourg who occasionally wrote plays. Nevertheless, there was a symbolist theatre, and the Nabis were closely connected with it.

Realism in the theatre had been led by the energetic Antoine, who at the *Théâtre Libre* demonstrated his belief in the power of the actual. For Antoine the set of a butcher shop had to be hung with real hams. The reaction was led by the actor-manager Lugné-Poë, who for a time was Antoine's assistant, and by Paul Fort, himself a symbolist poet. In the autumn of 1890 Fort founded the *Théâtre d'Art*, which during the less than three years of its existence presented poetic recitations and plays – among others, works by Laforgue and Rimbaud, prophets of symbolism, Mallarmé, Maeterlinck, Rachilde, and Paul Fort himself. It was for *Madame La Mort*, by Rachilde, that Gauguin did a drawing in early 1891, and it was the *Théâtre d'Art* that arranged the benefit for Verlaine and Gauguin at which in May 1891 were presented *L'Intruse* of Maeterlinck and a *Don Juan* by Gauguin's collaborator Charles Morice.

Lugné-Poë was closely associated with these activities. He had been a classmate of Vuillard and Maurice Denis at the Lycée Condorcet, and in August 1890 he had assured the publication of the twenty-year-old Denis' article on *Neo-Traditionisme* by personally taking it to *Art et critique*. In 1891 Lugné-Poë shared a studio with Denis, Vuillard and Bonnard where together, as he wrote, they 'read Rimbaud, Gide who was just beginning, Verlaine, Maeterlinck. Lugné-Poë called upon his friends to do sets and programmes for the *Théâtre d'Art*, but Denis, Ranson and Sérusier (as well as Ibels and Augustin) were more active than either Bonnard or Vuillard. The sets (which have been lost) were true to the principles of suggestion and indirection of literary symbolism. As a contemporary described them, they employed 'simplification of the décor, use of only those elements indispensable to the creation of each scene, stylization, complete harmony of décor and costume', and, primary article in their reaction from realism, 'avoidance of all *trompe l'œil*'. They were deliberately fragmentary statements which called upon

the imagination of the audience and so were made to suggest more than they portrayed.

For lack of money, but perhaps just as much because the symbolist ideal, as Fort presented it, was essentially non-theatrical, having more to do with mood than with action, the *Théâtre d'Art* did not last. But Lugné-Poë went on, first at the ephemeral *Escholiers* (1892), and then at the solidly founded (1893) *Théâtre de l'Œuvre*, to his true mission – the introduction and championing in Paris (and even in London) of the modern, symbolist theatre. It turned out that this theatre was largely foreign, and northern. Except for the Belgian Maeterlinck, it was also a theatre in translation; its mainstay was Ibsen, though Hauptmann, Björnsen and Strindberg were also important. Ibsen had first been played at the *Théâtre Libre*, where in 1890 Antoine presented *Ghosts* at the urging of Zola, who evidently saw him as a realist. But Lugné-Poë and his friends perceived other, more mystical values under the realist surface, and it was at the *Théâtre de l'Œuvre* that Paris became familiar with Ibsen's plays.

Of the Nabis, Denis, Sérusier, Ranson and Vuillard were most closely associated with the *Théâtre de l'Œuvre*, but little that Sérusier or Ranson did has been preserved, since they worked mainly on sets and curtains. Denis, who had already done the costumes for the puppet presentation of Maeterlinck's *Seven Princesses* and the programme for Ibsen's *Lady from The Sea* given at the *Escholiers* in 1892, drew programme designs and also the sets for the performance of Alfred Jarry's *Ubu Roi*, given at the *Théâtre de l'Œuvre* in 1896, eight years after the Nabis collaborated on its puppet performance at their *Théâtre des Pantins*.

Vuillard's sets (for *Rosmersholm* and *The Master Builder*, for example) have also been lost. The style of his lithographic programmes is much like that of the more familiar posters of the period: scattered colour, elliptical drawing and witty representation, all put down in apparent casual improvisation. Its purpose was to tie picture and text together into one visual whole which neither would dominate. In this it succeeded brilliantly, but one may well ask what relation, if any, such a light-hearted style more generally associated with *art nouveau*, bears to symbolism? The tone of Vuillard's programmes is rather gay, and they convey little of that sense of tension, and of the hidden forces of destiny and desire that control the fate of Ibsen's characters, and of which they are the symbols. But the fusion of letter and line into a single image may well have something to do with the theory of correspondence among the arts (rather than between essence and appearance) which had inspired Rimbaud's famous sonnet of the vowels. It was an essential part of the common symbolist inheritance from Baudelaire; Gauguin had discussed it in

his *Notes Synthétiques*, and Van Gogh refers to it. It was, after all, the wish to apply and extend this theory that inspired the 'perfume accompaniment' to the performance of Maeterlinck's *Les Aveugles* (and perhaps also to Roinard's *Song of Songs*) in 1891 at the *Théâtre d'Art*. All in the group were familiar with Wagner and the *Gesamtkunstwerk* (Sérusier, in 1889, had written Wagner's 'Credo' on the wall of the inn at Le Pouldu) and in their collaboration on costumes, sets and programmes they were, in their own delicate, *intimiste* — and in the puppet theatres often ironic — way, far removed from the grandiose and the sententious.

Vuillard and Bonnard were among the first to receive the message Sérusier brought back from Brittany in September 1888; Albert Aurier included them in his long article on *Les Symbolistes* in the *Revue encyclopédique* in April 1892; they were familiars of the symbolist milieu. Vuillard was a friend of Mallarmé and Bonnard throughout his life, read Mallarmé's poetry with affectionate attention. But to what degree did they share in the aims of symbolism? Maurice Denis noted that 'For Vuillard the crisis caused by the ideas of Gauguin lasted only a short time, and he and Bonnard (*Le Nabi très japonard*) were perhaps the least theoretically inclined of the

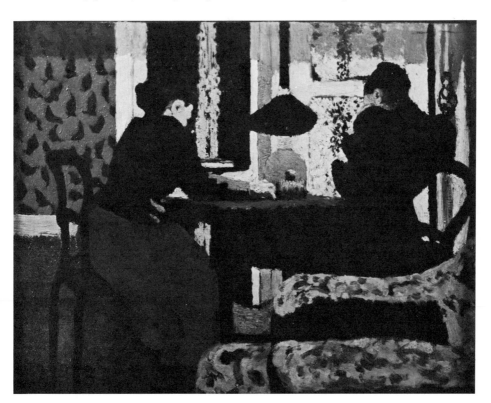

97. *Two Women by Lamplight*, 1892. Vuillard

group.' Compositionally, their early work is, of course, 'synthetic' in its tendency: it employs the flattened space, silhouetted bodies, continuous outlines of the style, and to reinforce its decorative aspect often does away with the horizon line. But these elements, although they occur in some symbolist painting, are not specifically symbolist in character. Rather, like the tall and narrow proportions both painters often use to contain the lively vibrations of an impressionist surface, they are stylistic features which begin to evolve in the late eighties under Japanese inspiration, and which contribute, in the nineties, to the formation of *art nouveau*.

Because of their subjects — friends and family in everyday settings and occupations, interior scenes painted at close range and on a small scale — they have been called *intimistes*. In this there is nothing inherently symbolist. But many of Vuillard's early canvases (e.g. *Two Women by Lamplight* [97]) and a few of Bonnard's

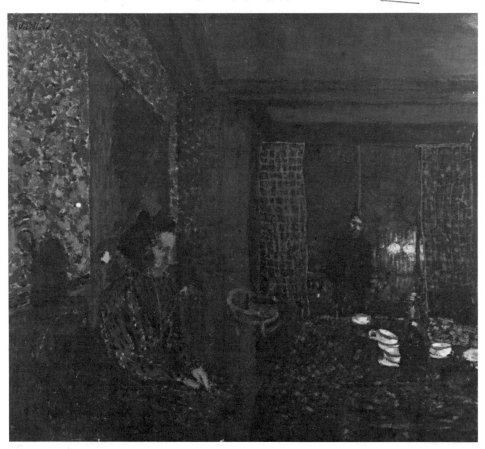

98. *Married Life*, c.1894. Vuillard

suggest that the lovingly rendered surface of this familiar environ-
ment, with its pleasures of shape and colour and texture, is just that
— a surface. The objects and the figures, treated so much alike,
though they seem to dissolve, are held together in a tight and
claustrophobic space, at once separated and bound into a rigid
structure. (Sometimes his actors do not even have room to stand
upright — a device he may have learned from Burne-Jones, whose
work was well known in Paris at this time.) There is something here
of Mallarmé's minute observation of aesthetic surface, and his de-
votion to the effective sum of infinite suggestion, the indirect glance
which catches reality unaware. Bonnard, especially, interrupts his
descriptions as different forms impinge upon his consciousness, pro-
ducing the visual equivalent of Mallarmé's interrupted, parstheti-
cal phrases designed for simultaneous, rather than sequential,
reference. His style thus parallels what Huysmans in *À rebours* called

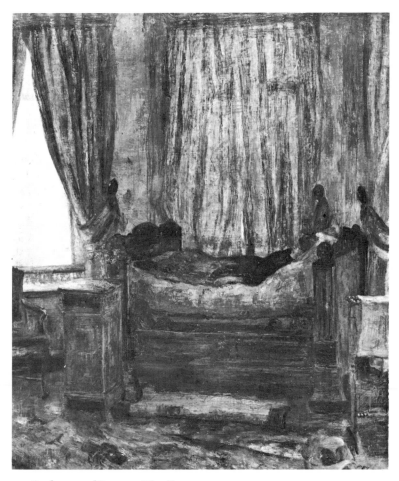

99. *La dame en détresse*, 1882. Ensor.

the poet's 'adhesive language, solitary and secret, full of retracted phrases, elliptical figures, audacious tropes'. Vuillard's strong contrasts of artificial light, whose source is often within the picture, not only flattens out forms in the synthetist manner, but also heightens the sense of spatial confinement. In the end a heavily laden psychological atmosphere pushes through the surface of domestic ordinariness, unifying the whole with a sense of charged personal relations more real than any analytic phenomenal observation [98]. For all the differences of scale and milieu, the interpretative effects are much like those of Ensor, who a decade earlier, in *La Musique russe* [35] and *La Dame en détresse* [99], transformed the traditional realistic rendering of middle-class genre with undertones of silent awareness and tension, of isolation and unspoken communication. The ambience of these works is similar to that which Maeterlinck, though he employed a more stylized and artificial language, strove for in what he called 'static' theatre of everyday life, whose drama lay not in decisive actions, but in continuing unspoken tensions. Vuillard's paintings, less sombre and more intimate, also hint at an undeclared, and sometimes oppressive, communion, the true reality of the familiar scene. This is the (symbolist) quality that Vuillard loses in his more objective interiors and portraits after the turn of the century.

3

Suggestion, Mystery, Dream

REDON

'. . . Suggestive art is embodied in the provocative art of music, but I have also made it mine by a combination of disparate elements juxtaposed and of forms transposed or altered which, free of any contingencies, nevertheless have a logic of their own.' (Redon, 1898)

'The sense of mystery lies in always being in the equivocal, in double and triple aspects, in the surmisal of aspects (images within images), forms which will come into being, or which will exist in accordance with the state of mind of the spectator.' (Redon, 1902)

Perhaps more than any other artist of his time Odilon Redon linked the related worlds of graphic and literary symbolism. Older than the other symbolist painters, he was a contemporary of Mallarmé and from the time they were introduced by Huysmans (at a Wagner concert in 1885) his very good friend – his 'ally in art', as Redon wrote at the poet's death in 1898. Some months before they met, Mallarmé wrote to Redon that the titles of his lithographs went 'to the heart of the matter': and towards the end of his life he chose him to illustrate *Le Coup de dès*, his culminating poem. They led similar, outwardly uneventful lives, combining domesticity with intense devotion to their art; it was a *casanier* existence in which, said Redon, 'the will alone maintains the equilibrium, along opposing roads travelled by neither bourgeois nor bohemian.' Huysmans, who had praised his first exhibition in 1881, was also an intimate at this time.

The famous passage in *À rebours* (1884) (which also celebrates Mallarmé) describing the gallery of 'decadent' art gathered by the hero des Esseintes gave Redon a symbolist notoriety. For Huysmans, who linked him with Moreau, Redon was above all a 'perverse' artist whose drawings, beyond the bounds of painting, innovated 'a very special fantasy, a fantasy of sickness and delirium' and were of interest for this very reason. Though Redon regretted

this overly literary (and naturalist) interpretation he remained in touch with the writers. 'What have I put into my work to suggest so many subtleties to them?' he asked in his journal in 1888. 'I placed a little door opening on mystery. I invented some fictions. It is for them to go further.'

During this period, although naturally retiring, Redon also increased his contacts among the painters. He was a founder of the Indépendants in 1884; he was included in the 1886 'impressionist' exhibition, where he met Gauguin, who admired his work.

In that same year, Théodore de Wyzewa, voicing the attitude of the *Revue wagnérienne* founded in 1885 by Edouard Dujardin, and to which Redon contributed, cited him (and Moreau) as one of the newly oriented 'symphonic painters' who through 'emotional signs . . . suggest to us the precise sensation of visions'. The younger members of the synthetist group honoured him as a sage and prophet. Aurier, in 1892, hailed Redon as a precursor and noted how his 'disdain for materialistic imitation, through his love of dreams and of the spiritual' had had a strong, if indirect, effect upon the 'new artistic souls of today'.

Denis called him 'our Mallarmé' and later wrote that Redon's manner of thinking had helped to orient the art of 1890 towards idealism. It seems significant that at the banquet in honour of Jean Moréas (February 1891) he was seated between Seurat and Gauguin, who at that time were no longer friends. He was much admired among the Belgian symbolists (he first showed with *Les XX* in 1886), while Arthur Symons called him a French Blake. And like so many members of his milieu, both writers and painters, Redon, about 1895, underwent a religious crisis; in his case, fortunately, it affected the subjects more than the manner of his art.

'Suggestion', 'mystery', 'dream'. These key concepts of symbolist aesthetics are crucial also for Redon's art. His first lithographic series is called *Dans le rêve* (1879); *La Nuit* appears in 1886, and *Songes* in 1891, while three others, the *Poe* (1882), the *Goya* (1885), and the *Fleurs du mal* (1890) are dedicated to artists of similar imaginative bent [100]. In the spirit of symbolism, Redon, although he admired Pissarro, objected to the literalism of the impressionists: his strictures on 'the low-vaulted edifice' of their art matched Gauguin's charge that they 'neglected the mysterious centres of thoughts'. Redon described his own work as 'suggestive art [which] is like an illumination of things for dreams, towards which thought is also directed . . . [It] can fulfil nothing without going back uniquely to the mysterious play of shadows and the rhythm of imaginatively conceived lines.' 'My sole aim,' he wrote to his Dutch patron André Borger, 'is to instil in the spectator, by means of unexpected allurements, all the evocations and fascinations of the

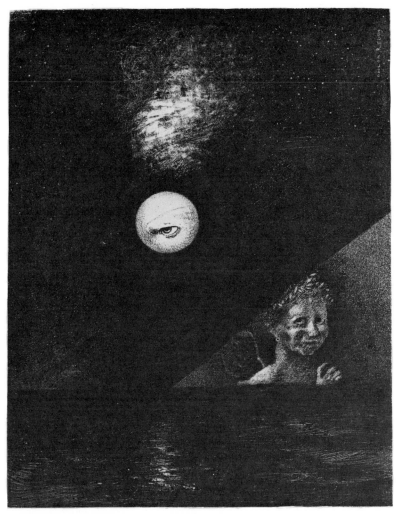

100. *À l'horizon, l'ange des certitudes et, dans le ciel sombre, un regard interrogateur*, 1882. Redon

unknown on the boundaries of thought.' In the purity of their symbolist doctrine, these phrases seem to echo Mallarmé.

Huysmans, generally more concerned with subject than with style, viewed Redon's art in very literary terms, and partly because of this Redon had to fight against the label of illustrator, although – as the dedications of his lithographic series show – both literature and some aspects of evolutionary science were essential to his imagination. He insisted that his titles were only vague and indeterminate attractions for the imagination; he was conscious of the 'effect of abstract line acting directly on the spirit', and from

Delacroix, the hero of his youth, he, like Seurat and Gauguin, had learned the expressiveness of tone and colour. Yet Redon is never a synthetist in the manner of Gauguin and his younger Nabi friends. As imaginative and suggestive as his creations are, and as directly visual in their impact, their details still continue something of the naturalism of his own earlier generation. He said of himself, 'my whole originality . . . consists in having made improbable beings live humanly according to the laws of the probable, by as far as possible putting the logic of the visible at the service of the invisible . . . Any time that a human figure cannot create the illusion that it is, so to speak, going to step out of the frame to walk, sit, or think, truly modern art is missing.' No synthetist, conceiving his 'plastic equivalents' of the ideal world in terms of simplification and generalization, invoking parallels with the stylized decorative unity of the primitives, would make such an analysis. Thus Redon, despite the formal analogies he draws between the suggestive powers of music and painting, is a different sort of symbolist. The surrealists were not wrong when they named him one of their ancestors.

They could have subscribed to Redon's own 'small banal aphorism [of 1898]: nothing in art is done through the will alone, everything is done by docile submission to the arrival of the unconscious.' And they too could have added, as Redon did in 1903, 'When I saw this mysterious agency of art, I treated it with great respect, but also with an imperturbable clairvoyance.' It is true that Redon's space is never really a dream space with its violent distortions of perspective, but rather a natural space in which some misplaced objects make their appearance; nor does his sense of the equivocal include the formal ambiguity and suggestion of the surrealists. But there is the surprise of altered scale and unexpected association. Gauguin, taking issue with Huysmans' literary interpretations (in *Certains*, 1859), said that with Redon 'dreams become a reality' – a very surrealist attitude. In contrast, Gauguin's formally expressive symbolism, because it maintains its distance from reality, lays the groundwork for even greater stylization and, eventually, abstraction.

If Redon's insistence upon what he called an intellectual art – as opposed to an art of sensation – is essentially symbolist, so are the particular forms shaped by his imagination. Long before Huysmans associated them in *À rebours* Redon had been inspired by Gustave Moreau, whom he considered a painter of ideas, but whose accuracy in the separate parts of his imaginary combinations is close to his own. (Later Redon changed his mind, because he judged him cold and 'celibate', out of touch with life.) He was first impressed with *Œdipus and the Sphinx*, shown in the Salon of 1864. In two of Moreau's best-known pictures, the *Thracian Maiden with the Head*

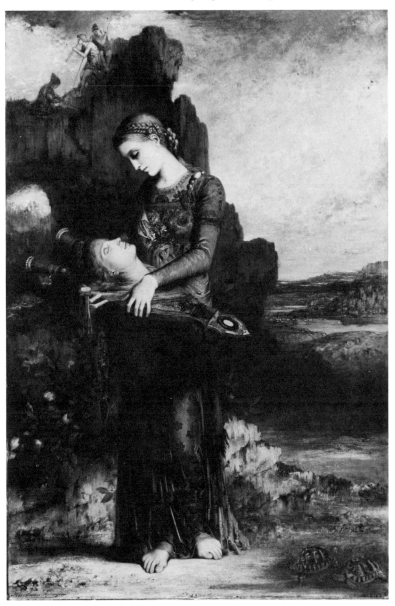

of Orpheus [101] and *The Apparition* (c. 1875), Redon found the initial artistic source of one of his most pervasive motifs: the isolated head, a fragment conveying a symbolic meaning [102]. It appears as early as 1869 in a crayon drawing, and (usually several times) in every lithographic suite beginning with *Dans le rêve* (1879). Characteristically the head carries no specific allegoric or religious reference (a few times it is the head of Christ). Much more generally, it

suggests, without being named, the soul or the intelligence, struggling to free itself of its corporeal inheritance and to rise towards union with a pantheistic spirit. Thus a series of heads of increasing parts and classicism float upwards in *Germination* (*Dans le rêve, II*), 1879 [103], whose title, like that of the first plate – *Eclosion* – may come from a passage in Baudelaire's study of Victor Hugo; and small heads again ascend in *N'y a-t-il pas un monde invisible* (*Le Juré, V*, 1887). Often this meaning is amplified by an evolutionary reference, as when a head bursts forth from a plant in *La Fleur du marécage* (*Hommage à Goya, II*, 1885) [104], or from an insect in

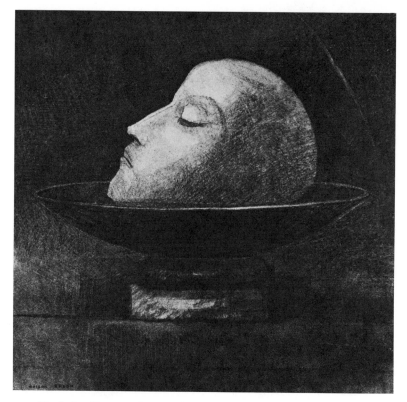

102. *Head of a Martyr*, 1877. Redon

Une longue chrysalide couleur de sang (*À Gustave Flaubert, II*, 1859). In most of these instances it retains something of that *équivoque* so important to Redon, and so remains symbolist – i.e., within the realm of suggestion. The attitude that lies behind the suggestion is made most specific in the frontispiece to André Mellerio's short essay on *L'Art idéaliste* [105], where the head, looking upwards, is closely encircled by a worm-like creature with human eyes; here the double reference of art and soul – an idealist musical art, since

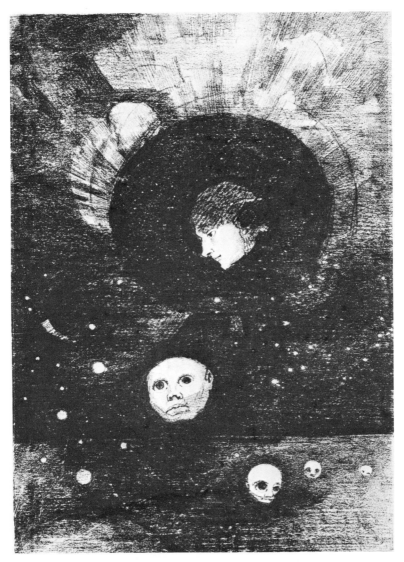

103. *Germination*, 1879. Redon

there is a reminiscence of Orpheus — attacked by earthly forces of destruction is quite clear, so explicit, indeed, that (like Gauguin's *Self-Portrait with Halo* [80]) symbolic fusion has been spelled out and become an allegory of symbolism.

Often, throughout the many lithographs of these two decades, Redon refers to the presence of the ideal, invisible world in an even more concentrated image: all that remains of the head is the eye, pure, penetrating intelligence. Like the head, the eye struggles to free

104. *La fleur du marécage, une tête humaine et triste*, 1885. Redon

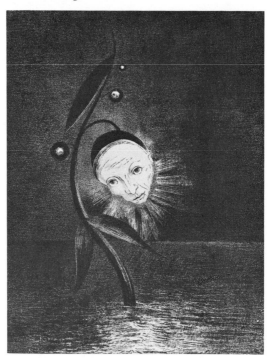

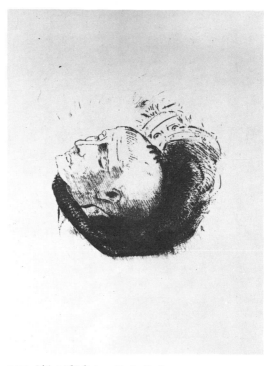

105. *L'Art idéaliste*, 1896. Redon

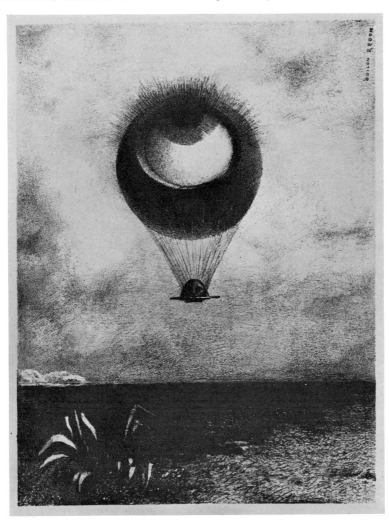

itself from matter (*Il y eut peut-être une vision première essayée dans la fleur, Les Origines, II,* 1883) and to rise in the evolutionary scale, or to float heavenwards (*Vision, Dans le rêve, VIII,* 1879), and with its power of intelligence carry the mind towards a union with the infinite [106].

Personal in their invention and fantasy and in their apparently obsessive recurrence, these uses of the eye and the head to suggest a penetration of outward appearances nevertheless belong to the period, just as Redon's fascination with black in his lithographs can be found in the crayon drawings of so different an artist as Seurat. The traditional concept of the eye as the window of the soul is also

given a new intensity (in very different ways) by Ensor, Khnopff and Munch, and the head as symbolic fragment is notably employed by Rodin, and later in works that continue aspects of symbolism by Brancusi, the first of whose memorable series bears a remarkable resemblance to an early Redon drawing, naturalistic in its detail, of a child's head lying on its side.

Redon's interest in evolutionary development was first stimulated by his friend Armand Claraud, a botanist concerned with organic forms on the borderline between plant and animal life. This interest continues throughout his life, but at least until 1900 his interpretations, although they are consonant with his sense of a striving for an ideal, are often more ironic than positivist in their tone. The false evolutionary starts (*Il y a peut-être une première humanité essayée dans la fleur fusain, c.*1890) appear again in the 'vain victories' of his centaurs and sirens, and are continued in the failure of Pegasus and the chariots of Phaeton (which stem from both Delacroix and Moreau) whose immense desire to rise only causes them to fall backwards. This duality is best seen in his renderings of Satan as the heroic fallen angel, symbol of man's divided personality [107]. In all this Redon is very much of his time, as he is in a mysticism which invokes the Buddha as well as Christ.

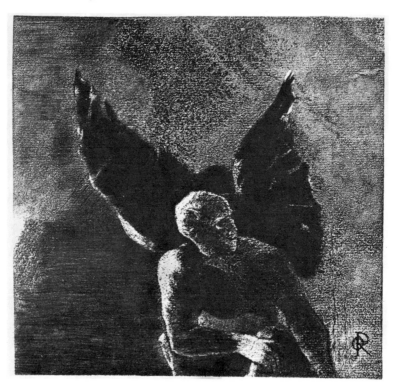

107. *Gloire et louange à toi, Satan,* 1890. Redon

108. Detail of *The Gates of Hell*, 1880–1917. Rodin

126 In common with many other poets and artists of the period Redon
 was strongly influenced by Baudelaire whom he had read as a
 young man and for whose *Fleurs du mal* he did a suite of lithographs
 in 1890. Perhaps this is one of the reasons why his moral atmo-
 sphere is neither that of the believing optimist (Maurice Denis) nor
 his opposite the satanist (Felicien Rops) of the black mass. Despite
 all the obvious disparities of medium, scale, physical energy in the
 form, and of allegoric reference in the subject (as well as of self-
 image in the artist), the closest psychological parallel is with Rodin's
 Gates of Hell, whose working out is contemporaneous with the two
 decades of Redon's lithographs [108]. For Rodin too Baudelaire's
 poetry was an important stimulus, and although his emphasis is

109. *La mort: mon ironie dépasse*, 1889. Redon

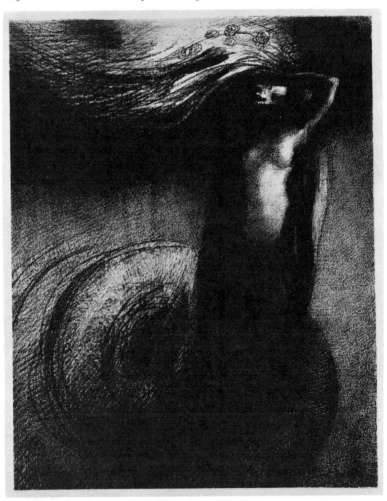

upon heroic, Sisyphean effort rather than resigned romantic irony,
there is a similar Baudelairean atmosphere of division within the
soul and finally despairing struggle. This is especially true in
Redon's two series *À Gustave Flaubert* (1889) and the *Tentation de St
Antoine* (1896), where there is also a formal parallel: small figures
emerge from an immense darkness, and are briefly lit, only to dis-
appear again, their symbolic materiality once more drawn into a
void that is of another world than this one [109].

Redon transposed many of his lithographic themes into his later
pastels and oils. The insect and the flower world reappear, there are
heads that float in space, and Apollo's horses that rear against the
sky. But though many of these themes are also common with other
symbolist artists (one thinks especially of Maeterlinck's studies of
flowers and insects, of Gallé's *Décor symboliste*, itself influenced by
Baudelaire, and of Georges Rodenbach's central theme of *Silence*
that Redon also painted), the colourful paintings of post-1900 are
more decorative than intense. Perhaps here, as elsewhere, sym-
bolism has been attenuated by the looser, more flowing forms of *art
nouveau* and its less 'intellectual' intentions.

VAN GOGH

'He is, nearly always, a symbolist . . . feeling the constant necessity of cloth-
ing his ideas in precise, ponderable, tangible forms . . . In nearly all his
pictures, beneath this morphic envelope, this very fleshly flesh, this very
material matter, lies, for the mind which knows how to see it, an Idea, and
this Idea, the work's essential basis, is at the same time its efficient and its
final cause.' (Albert Aurier, 1890)

'It is rather like this that I *ought to be*, rather than the sad reality of how I
do feel.' (Vincent Van Gogh)

Vincent Van Gogh arrived in Paris early in 1886. There he experi-
enced his first direct contact with impressionism, of which he had
heard from his brother Theo, but had not until then actually seen.
He was quickly captured by the impressionists' love of light and
colour and by their technique of the broken brush stroke: '. . . though
not being one of the club, yet, I have much admired certain im-
pressionists' pictures,' he wrote in mid-1886. From then on until
his death four years later he thought of himself as an impressionist,
but an impressionist with a difference. That difference is evident
enough in the enormous intensity and expressive energy of so many
of his paintings, where both line and colour take on a life of their
own, are impelled besides by some further energizing force which,
using them as medium, makes its existence known and felt. The
struggle between these two compulsions, the one grounded in the
necessities of realistic observation, the other desirous of imaginative

freedom, determines Van Gogh's uneasy relation to the symbolist tendencies of his period. The intensity of the landscapes is such that their temperament seems to be less that of the observing artist, selecting those moods and corners of nature congenial to his feelings, than of the insistent pantheist temper of Nature herself, not to be denied. Vincent's letters made it clear that however the unconscious balance of these impulses changed and shifted, he was well aware of them and, like any other artist, used them for his conscious purposes.

Van Gogh's brief two years in Paris (March 1886 through February 1888) coincided with the emergence of literary symbolism; but though pictorial symbolism was nascent (as we now know) it was not yet altogether evident. In these months, under the impact of the 'plein-air' paintings to which his brother Theo introduced him, his previously dark palette lightened, his attitude towards his subjects became more objective, he was influenced by Japanese prints, and he briefly became, in effect, an impressionist. Through Pissarro and Signac he learned much about neo-impressionist colour theory. Seurat he met only briefly on a visit to his studio just before leaving Paris, although his 'personality . . . and his beautiful great canvases' remained vividly in his memory. The really lasting contacts he established were with Gauguin and the enthusiastic young Émile Bernard. Once having moved to Arles, Van Gogh invited them both to join him in establishing his dream of an 'atelier of the south'. Bernard never came, though there was a continuing exchange of letters and paintings; Gauguin, of course, financed by Theo, spent the two fateful months of November and December 1888 with Vincent in Arles.

These two friends brought Van Gogh his closest contacts with symbolist practice – and theory: the former he adopted only sporadically (and never completely); passages in his letters seem to imply ideas akin to the latter, although there is no evidence of his ever having concerned himself with its philosophic bases. But the implications of their art and argument were certainly congenial to his previous intentions. Even before coming to Paris Van Gogh had been familiar with the ideas of Delacroix and Charles Blanc ('I am completely absorbed in the laws of colour' [November 1885]), and interested both in the technical questions of harmony and luminosity and in the expressiveness of colour. Thus he writes to his brother from Nuenen: 'Colours . . . indeed have something to say for themselves . . . Suppose I have to paint an autumn landscape, trees with yellow leaves. All right – when I conceive it as a symphony in yellow, what does it matter if the fundamental colour of yellow is the same as that of the leaves or not? It matters very *little* . . . *Colour expresses something in itself*, one cannot do without this,

one must use it; what is beautiful, really beautiful, is also correct.' So it is not surprising that already then, in 1885, he had a strong feeling for 'the relation between our colour and Wagner's music', and had remarked to his friend Rappard that Delacroix had said 'that one must get one's *studies* from nature, but that the *ultimate picture* ought to be made *from memory*'. In Arles, in the summer of 1888, he explains that 'fertilized' by the ideas of Delacroix (whose *Christ in the Boat* 'speaks a symbolic language through colour alone') he is returning to ideas he held before he knew the impressionists, and is using 'colour more arbitrarily, in order to express [himself] forcibly'. He then describes how he would like to paint the portrait of an artist friend, 'a man who dreams great dreams', beginning 'faithfully', but then going on 'to be the arbitrary colourist', exaggerating to get oranges and yellows in the hair to set off against the 'infinity' of a plain blue background, and so 'by this simple combination of the bright head against the rich blue background [to] get a mysterious effect, like a star in the depths of an azure sky'. Here Van Gogh, expressing a preoccupation that will have its definitive formulation in *The Starry Night* [115], employs certain key words ('infinite', 'azure', 'mysterious') of the symbolist vocabulary.

Even at this date, however, his meaning is perhaps less specifically symbolist than generally pantheistic, in the sense (as Lövgren has suggested) of his early admiration for Whitman who, it should be remembered, was also invoked by the symbolist poets, among them Mallarmé and Maeterlinck. Such pantheism, or vitalism, is indicated in Van Gogh's letters long before he could have come into contact with any theoretical symbolism – though he had read Carlyle. From The Hague (in 1882) he writes to his brother: '. . . in all nature, for instance in trees, I see expression and soul, so to speak. A row of pollard willows sometimes resembles a procession of almshouse men. Young corn has something inexpressibly tender about it, which awakens the same emotions as a sleeping baby.' Since he reads *into* nature such human emotions, he wishes to transmit them to his own works, so that the viewer may read them *out of* the painting and so share that sense of participation in universal feeling (which more detached observers call the 'pathetic fallacy'). Thus, again from The Hague, he notes: '. . . I tried to put the same sentiment into the landscape as I put into the figure . . . I wanted to express something of the struggle for life in that pale slender woman's figure as well as in the black, gnarled, knotty roots.'

Van Gogh was thus not unsympathetic to the expressive stylizations that his friends were urging upon him. He wanted more than 'academic correctness': '[Millet, Lhermitte and Michelangelo] are the real artists,' he wrote in 1885, because they 'paint things as

110. *Portrait of Eugene Boch,* 1888. Van Gogh

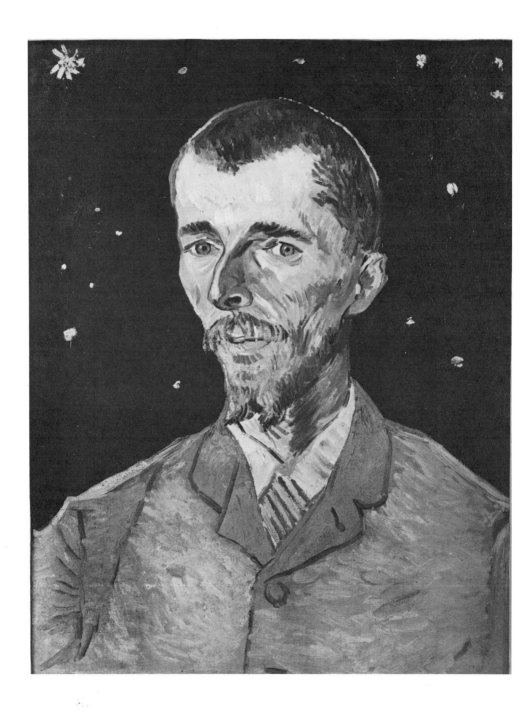

they feel them . . . [My] great longing is to learn to make those very incorrectnesses . . . lies, if you like, but truer than literal truth.' Yet Van Gogh's feeling for nature, his intimacy with it, was such that despite these leanings, which seem to accord with the messages from Brittany, Vincent could not bring himself, in practice, to follow the theoretical arguments being urged upon him in his friends' letters. Writing to Bernard in early October 1888, he promises him a study he has just made which, however, he will not sign, since it has been done from memory. And then he explains: '. . . I cannot work without a model. I won't say that I don't turn my back on nature ruthlessly, in order to turn a study into a picture, arranging the colours, enlarging and simplifying; but in the matter of form I am too afraid of departing from the possible and the true.'

This suggests that, like Gauguin, Vincent detached colour from line in the construction of his painting, which, given the character of his style, is a surprising separation. He was willing to be more arbitrary, and so more 'expressive' in the use of colour, while he was reluctant to employ the linear 'abstraction' being developed in Pont-Aven.

We know that in the months before Gauguin's arrival in Arles Van Gogh executed three famous paintings, very different in the mood they were intended to convey. He told his brother that these pictures 'carried on the style of the *Sower*', which was a 'first attempt' to use 'colour not locally true from the point of view of the delusive realist, but colour suggesting some emotion of an ardent temperament'. In each of them he employed colour towards a more specific expressive purpose. (We will examine later how far his purpose may also be called symbolist.) The first of these is the portrait of the Belgian painter Boch, whose blond and yellow tones he posed 'against a starry sky of deep ultramarine' [110]. The same letter to his brother explains the attitude embodied in this work: 'In a picture I want to say something comforting, as music is comforting. I want to paint men and women with that something of the eternal which the halo used to symbolize, and which we seek to convey by the actual radiance and vibration of our colouring.' And he later on describes his hopes in broader terms:

. . . to express the love of two lovers by a wedding of two complementary colours, their mingling and their opposition, the mysterious opposition of kindred tones. To express the thoughts of a brow by the radiance of a light tone against a sombre background.

To express hope by some star, the eagerness of a soul by a sunset radiance. Certainly there is no delusive realism in that, but isn't it something that actually exists?

The method of the *Night Café* [111] is the same, but its colours convey a contrasting message:

"Night Café"

I have tried to express the terrible passions of humanity by means of red and green . . . the idea that the café is a place where one can ruin oneself, go mad or commit a crime. So I have tried to express, as it were, the powers of darkness in a low public house by soft Louis XV green and malachite, contrasting with yellow-green and harsh blue-greens, and all this in an atmosphere like a devil's furnace, of pale sulphur. And all with an appearance of Japanese gaiety, and the good nature of Tartarin.

Thus, before the arrival of Gauguin in Arles, Van Gogh is using expressive colour in his own meaningful way. He was conscious of an innovative undertaking that yet had its roots in the past: 'I do not know if anyone before me has talked about suggestive colour, but Delacroix and Monticelli, without talking about it, did it.' (And

111. *Night Café*, 1888. Van Gogh

on this evidence, one may question that he was learning much explicit theory from the letters of Gauguin and Bernard.) He was also, perhaps, somewhat doubtful about what he was doing, while clear that he was being true to his own deeper impulses. The *Night Café*, he says, 'is one of the ugliest [pictures] I have done. It is the equivalent, though different, of the *Potato Eaters*.' And two letters later there is a revealing sentence: 'Exaggerated studies like the

Sower and like this *Night Café* usually seem to me atrociously ugly
and bad, but when I am moved by something, as now by this little
article on Dostoevsky, then these are the only ones which appear to
have any deep meaning.'

Van Gogh carries out a third picture in which as he says 'colour
is to do everything'. This is the view of his own *Bedroom* [112],
painted in reaction and as a contrast to the 'terrible passions' of the
Night Café. In it, shadows and cast shadows are suppressed, 'colour
is to do everything, and giving by its simplification a grander style to
things, is to be suggestive here of *rest* or of sleep in general'. Cer-
tainly the restfulness of this composition is relative; Van Gogh plays
the drama of receding space against the flattening close-up impact

112. *The Artist's Bedroom at Arles*, 1888. Van Gogh

of bright shadowless colour and strongly delineated forms, and
through his response these familiar objects nearly become animate
personages. Only he could find such intensity restful.

What does Van Gogh mean when he designates as 'ugly' pic-
tures as different as these three? He says he knows that what he is
doing is contrary to impressionism. He is conscious that by omis-
sions and reductions, and by exaggerations, he has transformed

individual objects into types; they are something other than remi-
niscences of the seen and remembered, and are made to 'express
something in themselves'. Thus they go beyond the observation of
nature, and even beyond 'all the music of the colour' that he strives
for in other, more relaxed paintings towards a symbolist fusion of
form and meaning. (Though in the somewhat later *Berceuse* [early
1889], which in Dutch he called 'a lullaby', his purpose was to 'sing
a lullaby in colours' to match the subject.)

It is then clear that Van Gogh, in both intention and achievement,
was no longer an impressionist – not even an impassioned impres-
sionist – before Gauguin joined him in Arles late in October 1888.
Gauguin seems to have influenced him in two ways: in a few pic-
tures (e.g., *Novel Reader in a Library* or *L'Arlésienne*) he tried out the
heavy contours which Gauguin and Bernard (whose *Breton Women
in a Meadow* [86] Gauguin had brought with him) had been em-
ploying in Pont-Aven. And, more important, at Gauguin's urging
he began to work from memory because, or so he felt at least briefly,
'canvases from memory are always less awkward, and have a more
artistic look'. As he wrote to his sister, Gauguin 'strongly encour-
ages me to work often from pure imagination'. Thus, in a com-
position very like Gauguin's steeply rising perspective and angular
view, he paints *A Memory of the Garden at Etten* [113], in which, as
he wrote, 'bizarre lines, purposely selected and multiplied, may fail
to give the garden a vulgar resemblance, but may present it to our
minds as seen in a dream, depicting its character, and at the same
time stranger than it is in reality'. These words must closely re-
semble those with which Gauguin expounded to Vincent the ideas
which he and Bernard had been developing, and which, at the
moment, could not fail to have a strong impact. Van Gogh felt (as
he later explained) that his friend was 'something like a genius'
when he was explaining these things, and he was receptive to the
further development of his own previous inclinations. But here too
the influence was short-lived; this was not his way of working, his
relation to nature was too deep.

Just before Gauguin's arrival, as we have seen, Van Gogh had
already responded to similar suggestions from Bernard, saying that
he could not work without a model, and lacked their 'lucidity . . .
in . . . abstract studies'. In St Rémy, when he resumed painting
after his first attack of illness he recalled that during Gauguin's stay
he had once or twice given himself 'free rein with abstractions'. But
now he knows better: 'it is enchanted ground . . . and one soon
finds oneself up against a stone wall'. In his struggle with his illness
he had to retain his grip upon nature and he 'found danger in these
abstractions'. His objections, however, are more than personal. At
this time Bernard had turned towards a style of medievalizing

113. *Memory of the Garden at Etten*, 1888. Van Gogh

visionary expressionism (in the manner of his *Pietà*) and to Van Gogh this was anathema. His own direct religious feeling for humanity had been rejected by the church, he had transferred that feeling to his painting and he had no use for a religious art which was out of touch with the realism of modern life. Although, as he said, 'sometimes religious thoughts bring me great consolation', the images in which he cast them came not from traditional icons but from his feeling for nature and for those simple people who were part of it, and whom he knew much better than Gauguin knew their Breton counterparts. For him, Millet, because he rendered the peasant with sympathy and understanding, was 'the voice of the wheat' and a 'believer'. In Van Gogh's own works peasant figures, heightened and made monumental, could become symbols of life

and death, as for example his *Reaper* [114] — 'all yellow, terribly thickly painted'. '. . . I see in this reaper [he wrote in September 1889] a vague figure fighting like a devil in the midst of the heat to get to the end of his task — I see in him the image of death, in the sense that humanity might be the wheat he is reaping. So it is, if you like, the opposite of the sower I tried to do before. But there is nothing sad in this death, it goes its way in broad daylight with a sun flooding everything with a light of pure gold.'

114. *Reaper in a Cornfield*, 1889. Van Gogh

So it is not surprising that he deplored work which was 'gone on the primitives' and wrote to Gauguin and Bernard that he 'was astonished at their letting themselves go like that'. He told Bernard that his painting was 'appalling', a veritable 'nightmare', and asked him to become himself again. (He had the same opinion of Gauguin's *Christ in the Garden of Olives*.) Only a 'virile life-time of research of hand to hand struggle with nature' might justify such attempts; he had had enough of such 'reaching for stars'. As he wrote to his brother Theo (November 1889): 'Our friend Bernard has probably never even seen an olive tree. Now he is avoiding getting the least

idea of the possible, or of the reality of things, and that is not the way to synthetize.' Against such 'abstractions', the unfortunate result of dreaming instead of 'thinking', Van Gogh placed the 'hard and coarse reality' of his own work which, grounded in the uncompromising observation of nature, 'will have a rustic quality and will smell of the earth.'

But even now, a year after Gauguin's visit, he still believed in the emotional power of colour, in the same way as when he had painted the pictures of his *Bedroom* and the *Night Café*. He writes to Bernard in December 1889 about the *Garden of St Rémy*: 'You will realize that this combination of red-ochre, of green gloomed over by grey, the black streaks surrounding the contours, produces something of the sensation of anguish, called *"noir-rouge"*, from which certain of my companions in misfortune suffer.'

And he also describes a painting of a field of wheat, violet and yellow-green, with a 'white sun surrounded by a great yellow halo' in which he has 'tried to express calmness, a great peace'. Only, unlike Bernard, who was taking refuge in the subjects and stylistic mannerisms of a distant past, Vincent insisted upon the necessity of directness and immediacy: 'I am telling you about these two canvases, especially the first one, to remind you that one can try to give an impression of anguish without aiming straight at the historic Garden of Gethsemane; that it is not necessary to portray the characters of the Sermon on the Mount in order to produce a consoling and gentle motif.'

These insistences upon 'the possible, the logical, the true' have their roots in Van Gogh's whole previous history. They are mirrored in his love of the naturalist novel (Goncourt, de Maupassant, George Eliot) and realist painting (Millet, Daumier, Israëls); in his religious evangelism, his social attitudes, and his own direct feeling for the simple people he painted in the Borinage and Arles. His illness, with its painful excess of emotion, gave this realistic aspect of his art a more particular poignancy; he was compelled to rely upon it for healthy sustenance, the danger of madness forbade refuge in an inner world of fantasy. Yet despite all this Van Gogh has clear affinities with the symbolist currents of the eighties, though in ways very different both from Bernard's mystic neo-Platonism, and the more allegorical suggestions of Gauguin's thematic subjects. (There is, however, a poignant parallel between the 'blue sky with branches of full blossoms standing out against it' in the picture he so touchingly began upon the birth of his nephew, and the background of the self-portrait Gauguin had sent him in Arles, with 'its child-like flowers', that stood for the impressionists' 'artistic virginity'.)

Van Gogh's connection does not depend upon a philosophic aesthetic, for despite his occasional musical analogies, there is no

indication that he absorbed any of Bernard's neo-Platonist idealist theories. Nor does his symbolist relation depend upon the reference of specific images – the star in his portrait of Boch, the foxglove held by Dr Gachet, or even the moon and sun of *The Starry Night* [115];

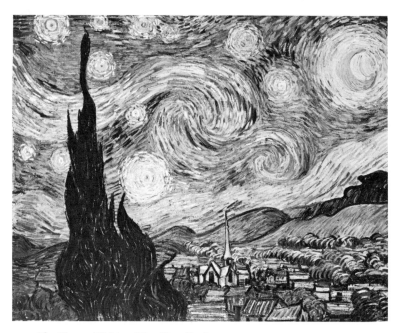

115. *The Starry Night*, 1889. Van Gogh

these appear only occasionally and as allegorical additions to something more pervasive. Van Gogh's symbolism lies first of all in his consciousness of expressive colour (and line). Based initially on his understanding of Delacroix, and developed without his having known the writings of Charles Henry, it nevertheless constitutes a violent and intuitive parallel to what Seurat, through analytical method, strove to systematize. This infusion of meaning into form, quiescent in most of his paintings from 1888 on, takes increasing precedence over the 'harmonies' and the 'music of colour' of the less intense works, such as *The Berceuse*; while in some it actively dominates. These paintings – the *Sower, The Starry Night, Landscape with Olive Trees* [116], *Crows over the Wheat Fields*, for example – are both shaken and bound together by a projection of feeling on to the line and colour of the landscapes. Into these works, as Meyer Schapiro has said, Van Gogh put a 'pantheistic rapture . . . the exultation of his desire for mystical union and release, but no theology, no allegories of the divine'.

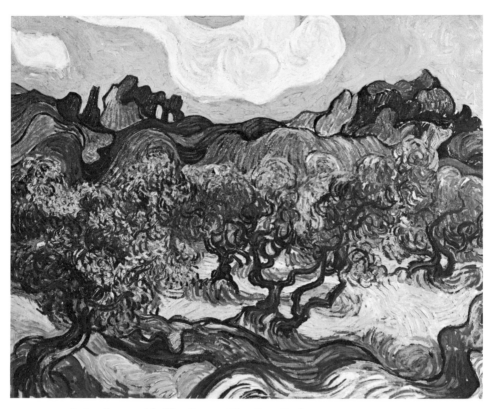

116. *Landscape with Olive Trees*, 1889. Van Gogh

There result flowing rhythms, which if seen purely as a design, strongly resemble the arabesques of *art nouveau*. They have, however, an entirely different depth and force of emotion; they are an anxiety projected upon, and apparently embodied in, nature itself. Van Gogh's symbolism thus lies in the way these paintings heighten and generalize their expressive form and colour, and so (as in the analogous works of Edvard Munch) become something other than simply expressionist. Aurier recognizes these qualities when, in his article in the *Mercure de France* (January 1890), he points to 'the naive truth of [Van Gogh's] art . . . his great love of nature . . . the almost orgiastic excesses of all that he paints', and, paraphrasing Moréas, describes him as 'a symbolist feeling the constant necessity of clothing his ideas in precise, ponderable, tangible forms . . . [Be]neath this very material matter there lies, for the mind who knows how to find it there, a thought, an Idea . . .' Originating in intense personal emotion that affects a no less careful observation, individual feeling has externalized and fused in a work which now

'expresses something in itself'. Even though Van Gogh may not have been consciously aware of 'The Idea' behind appearance, his painting does conform to Gustave Kahn's symbolist definition: it 'objectifies the subjective'.

SEURAT

The ascendant years of symbolist poetry coincide not only with the working out of 'synthetism' by Gauguin, the school of Pont-Aven and the related Nabis, but also with Georges Seurat's all too brief career. The *Baignade*, his first monumental picture, was shown at the opening exhibition of the Indépendants in 1884; his last, the *Cirque*, remained unfinished at his sudden death at the end of March 1891, the moment of Gauguin's departure from Paris. Seurat was thus, almost completely, of the symbolist period. He was also (we now begin to understand) very much of the symbolist milieu, much closer, indeed, to the poets and critics than the unsociable Gauguin ever managed to be. Gustave Kahn, 'inventor' of free verse who was later to publish Seurat's drawings, and the critic Paul Adam were his friends and wrote about his work. He must, at least briefly, have known Kahn's good friend the poet Jules Laforgue who in Berlin had been impressed by Böcklin and who envisioned a 'poetry which would be a psychology in the shape of a dream'. Although not on intimate terms, he was acquainted with Mallarmé, who in 1884 became associated with *Revue indépendante*, at that time edited by Félix Fénéon, who later contributed to several symbolist periodicals including *La Vogue* and *La Cravache*. Fénéon was Seurat's chief critical interpreter, and it was through him that Seurat (in 1886, during the last of the impressionist group exhibitions) met the mathematician (and psychological philosopher) Charles Henry, whose theories played a major role in the formation of his later work, and Henry, who had met Kahn as early as 1879, was a familiar figure among the poets.

But to what extent and in what manner can Seurat, trained in the drawing of the academy – the grandson, so to speak, of Ingres – and the immediate heir to impressionist colour, be associated with symbolism? To a friend he wrote: 'They see poetry in what I have done. No, I apply my method and that is all there is to it.' At first glance that method of simultaneous contrasts has little to do with the 'imagination' or the 'dream' of a Gauguin or a Redon, and equally little with an idealist philosophy. It seems entirely rational and realist, a systematization of the impressionists' analytic observation of the phenomena of nature: this is what is implied in the name, neo-impressionism. Certainly Seurat's 'method', as he evolved it in his early work, was based on two complementary

analytic procedures – the study of the laws of light and colour as they appeared in nature, and the study of how pigments should be applied to canvas in order to obtain comparable optical mixtures and thus achieve both harmony and luminosity. This is what Seurat investigated in his early examination of Delacroix's paintings, his reading of Chevreul's *De la loi du contraste simultané* (1839) and of Charles Blanc's *Grammaire des arts du dessin* (1867), itself largely influenced by the author's knowledge of Delacroix's art as well as older traditional painters' rules. These interests were given a more modern scientific basis through Seurat's study of O. N. Rood's book on chromo-luminarism, published in France in 1881 as *Théorie scientifique de la couleur*, and he applied Rood's principles of colour harmony and the additive mixture of coloured light in *Une Baignade*, *La Grande Jatte* and *Les Poseuses*. From 1887 on, under the influence of Henry, this reasonable 'reform' of impressionism continues, but in an altered, or expanded, form which now includes the exploitation of the expressive possibilities of line and colour. Again, Seurat was already familiar with these ideas: Charles Blanc, referring to the earlier work of Humbert de Superville, had suggested that horizontal lines induced calm, and vertical lines gaiety; Henry gave a more detailed and systematic exposition to the analogies of objective form and subjective mood. As Henry explained his theories, first in his 1885 *Introduction à une esthétique scientifique*, then in the *Rapporteur esthétique* (1888) and the *Carelle chromatique* (1889), and as Seurat applied them (particularly the ideas of the two later books), they resulted in art that embodied what might be called a kind of scientific synthetism – parallel to but also very different from the intuitive synthetism of Gauguin and the Pont-Aven school. Seurat's theoretical beliefs are summarized in his famous letter of August 1890 to Maurice Beaubourg in which he explains how states of feeling (gay, calm and sad) can be conveyed through tone, colour and line. These beliefs were put into practice in his last large-figure paintings. The *Parade* [117] is calm because it has been composed with an equivalence of light and dark tones, of warm and cold colours, and a predominance of horizontal lines; the *Chahut* [118] is gay because in it there is a dominance of light tones, warm colours, and lines above the horizontal. (It need hardly be said this elementary summary omits many theoretical questions – the use of the golden section for purposes of harmony in the *Parade*, for example – and barely touches on the full expressive content of these rich works.)

Seurat's programme, then, is based on a belief in 'the inherent evocative power of visual forms', and so bears a close relation to synthetism; but it is also in opposition to it. Because Seurat, following the increasingly 'scientific' analyses of his mentor's perceptual

psychology, sets out, not from an expression of personal, subjective feeling, but from a materialist analysis – physical, physiological and psychological – of a world external to him. Making use of the laws thus discovered he can compose works in a methodical fashion towards a foreseeable result. Seurat had such knowledge and control of colour that he could paint, away from the motif, by artificial light; it is not too much to say that his goal in the realm of expressive form was a comparable objective method.

The above few paragraphs are only a skeleton outline of Seurat's point of view. We may nevertheless ask what such a rationalist approach, which seems designed not to invoke, but rather to do away with, mystery and central inspiration has to do with an

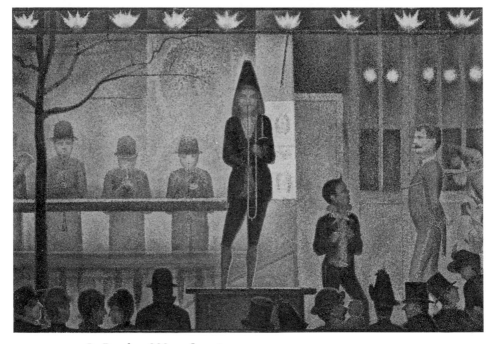

117. *La Parade*, 1888–9. Seurat

idealist philosophy, and why his friends among the symbolists saw in his painting an expression of their own poetic belief, in the reality of an unseen world.

As William Homer and Robert Herbert have pointed out, Seurat's reaction against impressionism was not merely 'scientific', although he did wish to codify the recording of colour sensation. Central to it was also the desire to 'strip away the casual and accidental features of reality to reveal the "essence" of form, which for [the symbolists] was a superior truth'. This wish, although intensified after 1886 by his close association with Henry and the poets, had its roots much

118. *Le Chahut*, 1890. Seurat

earlier in the opening chapter of Blanc's *Grammaire*. Blanc describes
the artist as being charged with the mission of recalling the ideal,
'that is, to reveal to us the primitive beauty of things, to discover
their imperishable character, their pure essence.' From the shifting
forms of life, 'the variations of the day and the hour', the artist must
extract beauty — 'that beauty which contains the immortal idea,
which reveals the divine'. The language here is within the classical
tradition, but as Herbert has explained, it already imparted to
Seurat's 'reform' of impressionism a direction that was entirely
congenial to symbolist thought. Blanc also anticipates the admira-

tion for the 'primitive' shared by both 'scientific' and 'intuitional' symbolists. These artists of an earlier time, and some more recent folk artists, unspoiled by false notions of imitation, came naturally to that avoidance of the phenomenal surface and so to the synthetic expression of permanence and essence which the moderns sought to re-discover. When Eduard Dujardin, in 1888, writes that 'primitive art and folklore are symbolic [because they] retain, with the smallest possible number of characteristic lines and colours, the intimate reality, the essence of the object' he is continuing a conviction already expressed by Blanc. Since styles as different to our eyes as the Egyptian, the Greek and the Gothic (or early Renaissance) shared these qualities they were all worthy of emulation, and 'hieratic' became a term of praise.

Charles Henry's aesthetic, although scientific in its analyses, was also seen within a symbolist context. His friend, Gustave Kahn, explaining the intentions of the symbolist movement in *L'Événement*, points out the connection, which he was later to emphasize in his preface to his own *Premières Poèmes* (1897). The symbolists, he says (September 1886), tired of the everyday as the material of art, wish to replace sensations by ideas:

The essential aim of our art is to objectify the subjective (the exteriorization of the Idea) instead of subjectifying the objective (nature seen through a temperament). Similar considerations have created the multi-tone scale of Wagner and the latest technique of the impressionists [i.e. the neo-impressionists]. It is an adherence by literature to the scientific theories of M. Charles Henry, constructed by induction and controlled by experiment, formulated in an introduction to the principles of a mathematical and experimental aesthetic. These theories are based on the same purely idealist philosophical principle which makes us reject the reality of matter, and only admit the existence of the world as representation.

In this concluding phrase Henry's science is directly associated with the idealist philosophy of Schopenhauer (to be translated only two years later), which so largely, and often so imprecisely, influenced French thinking about the arts throughout the last two decades of the century. Basing himself upon Henry's theories, Seurat was putting into practice the principles of symbolism.

The same apparently paradoxical association of a presumably positivist science with an idealist intention can be most clearly followed in Fénéon's interpretations of Seurat's art. In his articles on the last 'impressionist exhibition' of 1886, which appeared in the symbolist magazine *La Vogue* in May and June (and later that same year were published as *Les Impressionistes en 1886*) Fénéon analyses the *Grande Jatte* in great detail. His major attention is given to an explanation of pointillist technique and the optical blending of colour, i.e. to making clear the method and purpose of the neo-

impressionist colour theory which Seurat had begun five years earlier in his notes on Delacroix's painting and his reading of Rood's *Modern Chromatics*. Fénéon justifies the method as a technique for systematizing the colour observations of impressionism. Writing later that year as Parisian correspondent of the Belgian periodical *L'Art moderne* (recently oriented towards symbolism), he is still concerned with the 'neo-impressionist method' (the first time this phrase is used) and is at some pains to point out that it is only a method, one which Charles Henry's 'general theory of contrasts, rhythm and measure' will make more perfect, which in no way detracts from the individual artistic personalities of the painters who employ it.

Less than one year later, writing again in *L'Art moderne*, Fénéon's interest has turned towards symbolism. In the same way as Gustave Kahn he emphasizes the neo-impressionist's 'distance from the accidental and the transitory [of the impressionists]', their desire 'to synthetize landscape' and figures in a definitive aspect which perpetuates sensation, and the personal use of the 'emotional meaning of colour' by each artist according to his individual sensibility. He then comes to the core of his argument: 'Among the crowds of mechanical copyists of externals, these five or six artists impose the sensation of life itself: for them objective reality is simply the theme for the creation of a superior and sublimated reality into which their personality is transfused.' 'Superior and sublimated reality': in this image from the chemical laboratory, in which matter is turned into its gaseous state, at once purified and invisible, is contained a central metaphor of the symbolist doctrine. Although it reverses the direction it expresses the same relation between visible reality and a higher, invisible 'reality' that Jean Moréas had formulated in his *Literary Manifesto* of the previous September (and may even refer to it).

Enemy of instruction, declamation, false sensibility, and objective description, symbolist poetry seeks to clothe the Idea in a sensible form [i.e. which can be sensed] which, nevertheless, would not be an end in itself, but would remain subordinated to the Idea while serving to express it. The Idea, in its turn, must not let itself be deprived of the sumptuous trappings of external analogies; for the essential character of symbolist art consists in never going all the way to the concentration of the Idea itself.

As Fénéon interprets him, Seurat thus moves beyond what we have called 'scientific synthetism' into the realm of symbolist art. The forms of his art — line, tone and colour — are employed for something more than representation, and even for something more than their power to induce states of mind or feeling; they concentrate a higher reality, 'synthetize' it by giving it a sensible form; their psychological effectiveness must (in this view) have an underlying philosophic base. It is thus understandable that Henry should

have defined line in Hegelian terms as a 'synthesis of the two parallel and opposite meanings in which it can be described: reality and direction' (terms which we know Seurat found significant enough to note down); and that Fénéon, in 1889, should have written: 'Monsieur Seurat will understand that a line, independent of a descriptive role, possesses a measurable abstract value.' But, as

119. *Le Cirque*, 1890–91. Seurat

Herbert has pointed out, 'abstract' did not mean 'devoid of reference to the real world' (Henry's definition makes this quite clear), but rather 'the distillation of essential shapes and movements . . . superior to nature because they partake of *ideas*'.

The ambience these few quotations exemplify helps to explain the particular quality of the *Chahut* and the *Cirque* [119]: the paradoxical fusion of movement and stasis, and of description turned into abstraction. The 'gaiety' of these compositions stems from its induction by the expressively analogous upward moving lines (and to a lesser degree from the related tone and colour), which in turn are appropriate to the character of the scene depicted. But this sense of movement in the figures and fluid direction in the lines is simultaneously denied by a stiffness in the poses and rigidity in the design which cancels any possibility of change. Thus a record of ephemeral accident has, by means of 'abstraction', been made to suggest an eternal essence. And was not Seurat, in his subjects, also following a traditional metaphor and using these scenes of make-believe (carnival, theatre and circus) as symbols, microcosmic reductions of a larger world, itself the reduced reflection of an even greater reality. Henry van de Velde, writing in *La Wallonie* on the occasion of Seurat's death in 1891, stresses both the 'moving and undulating lines' of these works, and their 'hieratic postures . . . and a method which immobilizes life'. And van de Velde, who dates his own conviction of the abstract, dynamic nature of line from this year, describes the ideal of neo-impressionism as a desire 'to fix the Dream of realities, the Formless hovering over them, to dissect them pitilessly so as to see their Soul, to relentlessly pursue the intangible, and to meditate – in silence – in order to take note of its mysterious Significance'. For van de Velde, who had painted in the neo-impressionist mode, and who through *Les XX* was familiar with Gauguin, Van Gogh, Redon and a wide variety of anti-naturalist styles, there was no question that Seurat was a symbolist.

4

Supernaturalism and Naturalism

Today there seems no reason to associate the names of Gustave Moreau and Puvis de Chavannes. To our eyes their work is poles apart, the one crowded, sparkling, intense, filled with figures and subjects of an obvious or repressed eroticism, the other sparse, pale, calm, inhabited by forms and themes of unquestionable allegorical purity. Yet their historical relations to the symbolist movement have many similarities, and (as Huysmans complained in *Certains*) the 'refined taste' of the time often associated them in its admiration. As members of a previous generation (they had begun to exhibit in the sixties), they were never part of the symbolist group; they had nothing to do with impressionism, nor did they really belong to the academy, although Moreau taught at the *École des Beaux-Arts*, and Puvis received official commissions. Each in his own way was a link with traditions of idealism that had preceded those currents of naturalism (and positivism) which symbolism opposed. Both were in some ways forerunners who worked on through the ascendancy of the new tendency in the last two decades of the century (they died in the same year, 1898), and were an inspiration to certain of its artists.

As a young man Redon greatly admired Moreau. 'I defy you', he wrote in 1878 *à propos* of Moreau's *Phaeton*, 'to find under the chilly vaults of the academic temple a mind who rejuvenates antiquity with such entire freedom and in a form so controlled and so vehement.' He remembered the *Phaeton* in his own later *Chariot of the Sun* (1900), but long before that Moreau's *Thracian Maiden with the Head of Orpheus* (1865), and *The Apparition* [120], each with a severed head, were a lasting influence in the creation of his own pervasive motifs of the isolated head and eye as symbols of the spiritual life. But Redon was an exception, and in the eighties Moreau's complicated and cerebral art appealed chiefly to the poets, who saw in its allegorical message idealist ambitions similar to their

120. *The Apparition*, 1876. Moreau

own. In his *Souvenirs du symbolisme* André Fontainas explains how Moreau's *Salomé* haunted the young writers: 'As the painter intended, our emotion sprang from his studied evocations, from allusions to legends and myths, from the concerted consequences of emblematic or archaeological or enigmatically hazardous parallels, much more than from his purely pictorial or graphic means.' Fontainas notes that he and his friends viewed Moreau in the same way they did the Pre-Raphaelites, and did not distinguish between 'these moderns' and the Italian primitives – Gentile de Fabriano,

121. *Dead Poet Carried by a Centaur*, c.1870. Moreau

Fra Angelico, Ghirlandaio, and especially Botticelli whose figures
inspired dress and hair styles (in the manner of Maurice Denis).
Thus, in the minds of the writers, Moreau's intricate elusive refer-
ences to ancient legend were equated with the simplicities of early
style since by different paths both led away from the real and to-
wards suggestion. Nor can the poets have been displeased by
Moreau's natural association of painting and poetry, and his fre-
quent representations of the dreaming artist, solitary, sad, or dead
(*Dead Poet Carried by a Centaur* [121], *Orpheus at the Tomb of
Eurydice*, 1891–7, or *Poète voyageur*), as a symbol of the life of ideas.

Thus the precisely multiplied detail of Moreau's crowded alle-
gories, so opposed in style to the symbolist suggestive simplicity,
could be admired for its idealist message. Moreau's recurrent theme,
often implied, sometimes made explicit, is a dualistic opposition of
matter and spirit. It is present in the early *Œdipus and the Sphinx*
(1864) and the later *Sphinx Victorious* (1886 Salon), as well as in
the *Galataea* (1880 and c.1895) and the versions of the Orpheus
legend. It is most elaborated in the *Jupiter and Sémélé* [122], the only
one of the large allegories Moreau completed, where the contrasting
symbols are the female and the god. Sémélé's prayer to Jupiter has
been granted, and he reveals himself in all his splendour, then, as
Moreau explained, 'Sémélé, suffused with the divine emanation, re-
generated and purified by the Sacred, dies thunder-struck, and with
her the god of earthly love, the god of the cleft foot . . . the great
mystery is accomplished, all nature is transformed. It is a hymn to
Divinity.'

So, despite his intricate iconographic coruscations (or perhaps
because of them, since they could be read in verbal detail), the
writers could view Moreau as he saw himself, as an idealist, the
creator, as he said, of an art of 'soul, spirit, heart and imagination'
whose goal was 'the evocation of thought through line, arabesque
and plastic means'. Moreau admired Michelangelo because his
figures 'seem to be frozen in gestures of an ideal somnambulism . . .
absorbed in reverie to the point of appearing carried away towards
other worlds'; he found in them that 'Beauty of Inertia' he strove for
in his own art. All this is symbolist enough – at least in intention;
did not Mallarmé says of himself that he was 'a man accustomed to
dream'?

There was as well another side to Moreau's popularity in literary
circles. In Huysmans' notorious description of Moreau's *Salomé* in
À Rebours (where Moreau and Redon are des Esseintes' favourite
artists), after he has dwelt with considerable pleasure on the beauty
and lubricity of the girl dancing before Herod, Huysmans goes on
to give a further, more basic reason for the attraction of this
apparently purely fleshly art:

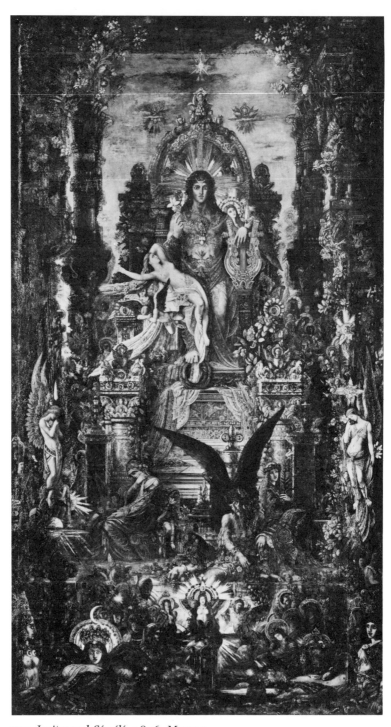

122. *Jupiter and Sémélé*, 1896. Moreau

In the work of Gustave Moreau . . . des Esseintes realized at last the Salomé, weird and superhuman, he had dreamed of. No longer was she merely the dancing-girl who extorts a cry of lust and concupiscence from an old man by the lascivious contortions of her body . . .; she was now revealed in a sense as the symbolic incarnation of world-old Vice, the goddess of immortal Hysteria, the Curse of Beauty, supreme above all other beauties . . . a monstrous Beast of the Apocalypse, indifferent, irresponsible, insensible, poisoning, like Helen of Troy of the old Classic fables, all who come near her, all who see her, all who touch her.

In his various renderings of woman as the embodiment of earthly temptation (*The Sphinx, Salomé, Delilah*) Moreau expressed one of the preoccupations of the period [123]. It was a tradition that went back to Baudelaire and Verlaine, was carried on by the symbolist poets and is to be found in such different painters as Gauguin, Beardsley, Khnopff and Munch, all part of the symbolist tendency.

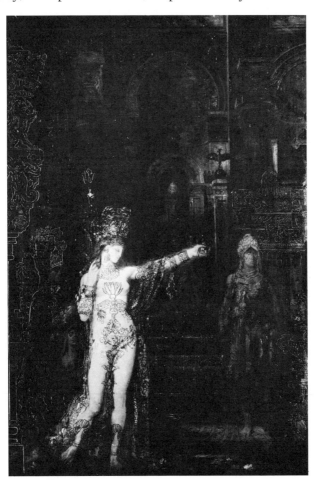

123. *Salomé*, 1876. Moreau

As Mario Praz has pointed out, the continuing presence, or the reading into, of *La Belle Dame sans merci*, in English art, was one of the reasons for the popularity of the Pre-Raphaelites in France. The writers were sympathetic to Moreau's projection of the occult and the satanic, to his obsession with woman as the agent of the Devil (but also as the symbol of beauty and purity – the *Princess with the Unicorn*). Huysmans himself gave a long description of the black mass in *Là-bas*, and wrote a preface for Jules Bois' study of *Satanism and Magic*. But though Moreau denied that his art was overly literary, except for Redon's early attraction, and a certain cult among the Rose + Croix, of whom his pupil Armand Point was one, it played little role in the stylistic development of pictorial symbolism.

(This same fascination with the occult–erotic and the satanic explains the popularity of the frankly vulgar Félicien Rops, whom even Mallarmé asked for a frontispiece. Rops also illustrated the *Diaboliques* of Barbey d'Aurévilly [56] and Péladan's *Vice Suprème* (1884). Huysmans said that he 'celebrated that spiritualism of sensuality which is Satanism, the supernatural of perversity, beyond Evil.')

The homage paid to Puvis de Chavannes had a broader base: he was admired by a wide spectrum of artists and writers. In 1885, as Strindberg (who disliked Puvis' pallor and 'insipidity') later wrote to Gauguin: 'One name was pronounced by all with admiration, that of Puvis de Chavannes. He stood quite alone, like a contradiction, painting with a believing soul, even while he took passing notice of the taste of his contemporaries for allusion.' Ten years later, early in 1895, Puvis was honoured by a dinner at the Hotel Continental. Among the over 500 painters, sculptors, poets, writers and critics of many tendencies, the symbolist contingent included Mallarmé, Gustave Kahn and Georges Rodenbach, as well as Rodin (who presided), Carrière, Aman-Jean and Gauguin. In further homage several symbolist periodicals joined to publish an *Album des Poètes* dedicated to the master, made up almost exclusively of contributions by the spokesmen of *l'art idéaliste*.

Gauguin himself, who had always admired the work of Puvis, not only hung a reproduction of *Hope* (c.1871) in his hut in Tahiti, but included it in his *Still Life with Hope* (1901), while the still much criticized *Poor Fisherman* [45] was included in a sketch by Seurat and was copied by Maillol. Georges Rodenbach wrote that in creating 'an unreal ambience, a light from the beyond', Puvis established his affinity with symbolism.

Quite naturally Puvis' more conservative followers such as Any Renan took issue with those who wished to make of him 'the leader of a spiritualist school, mystic, symbolist and ethereal'. They quoted

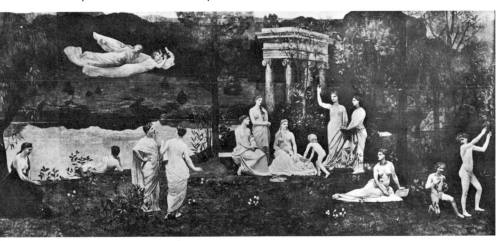

him as protesting that his artistic doctrine, 'healthy, pure and without mystery', was both clear and simple: 'A work is born out of a sort of confused emotion [he explained]. I roll the thought which lies in this emotion until it is clear before my eyes and appears with greatest possible distinctness. Then I look for a scene which translates it exactly . . . This is symbolism, if you like . . .' But it was, obviously, a very different kind of symbolism, even if Puvis also, on another occasion, spoke of his 'need for synthesis'.

Is Puvis' clear-eyed, and clear-headed, view simply to be translated as intending allegory of the traditional kind, related to a Poussinesque idealism with a consistent style only minimally inflected to accord with an iconographic programme as in the slight variation of 'mode' that separates *War* from *Peace*? The symbolists at least refused to think so. The mystically minded (and classically inclined) Sâr Péladan, after studying Puvis' *Sacred Wood* [124] decided that he was 'forced unreservedly to proclaim Puvis de Chavannes the greatest master of our time'; Georges Rodenbach described the 'unreal atmosphere, a light from the beyond' that Puvis created; Paul Adam felt that Puvis had mastered 'the art and craft of translating a thought into a symbol' and discovered in his drawings 'the perhaps unconscious voice of pensive humanity'. Aurier, saluting the 'right to dream' in Puvis, grouped him with artists who, while not quite true symbolists, were none the less able to 'write the beautiful poem of their dreams and their ideas'.

Puvis' reticent art had almost always been able to elicit recognition for its intention, even when there were reservations as to the result. To be sure, Castagnary, as a defender of realism, had complained about just those qualities which the symbolists later came to value. The three figures in his *St John the Baptist* (1896), he said,

'are arranged on the same plane in attitudes of a naiveté which borders on the childish.' But Charles Blanc, propounder of an idealism largely influential among the symbolists, was already aware that Puvis' figures were 'more dreamed than painted'. In general it was recognized that despite his shortcomings Puvis wished always to convey an 'idea' and this could hardly displease the traditionalists; thus Georges Lacombe inferred that *Summer* (1873) is 'summer in that eternal country where the artist's soul lives'.

So it is not surprising that these non-naturalistic intentions, academic though they were in large degree, should also have appealed to the symbolists. An article of 1894 by the Wagnerite Téodor de Wyzewa tells us that the symbolists were bound to interpret those intentions as their own:

In the pictures of M. Puvis de Chavannes, we admire something other than what is there . . .

In painting as in literature a moment came . . . when we had enough and too much of realism . . . We were struck by a thirst for dreams, for emotions, for poetry . . . And it was then that we attached ourselves to the poetic art of Puvis de Chavannes. We liked even its worst mistakes, even its faulty drawing and its lack of colour . . .; [it] became for us something like a cure.

There were, of course, characteristic aspects of Puvis' art that made this attachment possible. Not the least of these was his tendency (within limits) to minimize perspective, turn his figures in profile and arrange them in shallow relief. As early as 1865 Théophile Gautier approved Puvis' compositions because they conformed to the first rule of decorative painting which 'should hang on the walls like a veil of colour, and not penetrate them'. This meant that Puvis too understood that a picture was first of all 'a plane surface covered with colours'. From the start of his career Puvis had been considered something of a naive artist, largely because of his simplifications in figure drawing. For the academics, this had been a (sometimes forgivable) defect; for the symbolists, with their love of the primitives, these simplistics were a positive virtue; they suggested the deeper truths conveyed by a more spontaneous creation. There was also Puvis' penchant for eliminating from his depictions both bodily action and facial expression, thereby also reducing any narrative in their subjects. Contrary to those of Moreau, they did not really need to be read in iconographic detail: instead they established 'dream regions [peopled with] figures born for contemplation and dreams' easily associated with symbolist intentions. In such pictures as *The Sacred Wood* [124] Puvis created a form of allegory so severely static and so evenly and harmoniously spread that the meaning of the scene rendered mattered much less than its general reference, through form and colour, to a world of classicism and

to all of its ideal, if unspecified, associations. Even when Puvis' subject contains a contemporary 'social' lesson, as in *Rest* (1867), his means are so refined and indirect, so classic and eternal, that its immediate moral message is largely lost.

Besides, it was Puvis' easel paintings which most interested the symbolists, and in them allegory is reduced to its simplest form and given a generalized and suggestive character inducing reverie and association. The pictures of the eighties – *The Poor Fisherman* [45], *Orpheus* (1883) and *Dream* (1883) – all have this quality of reflection and inwardness, an isolation and an immobility of the figures, a generalization or reduction of the specific attributes of allegory that removes them to an indeterminate plane. It is thus not surprising that Gustave Kahn should have read his own preoccupations into the *Girls by the Sea-shore* [125]: '. . . it might be possible

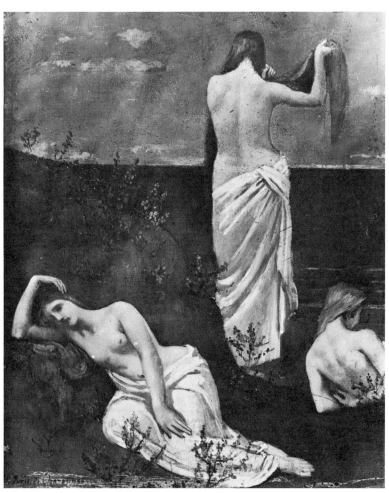

125. *Girls by the Sea-shore*, 1879. Puvis de Chavannes

to see in these free women . . . the same woman at three different moments in time, at three different stages in her life: young at the moment of her awakening, then at the moment of waiting, and at the moment of the return into herself, when she returns weeping over the eternal strife between the sexes.' In giving the typically symbolist interpretation of an altogether neutral depiction of a quiet ideal land, Kahn made Puvis the innocent forerunner of such tormented spirits as Munch and Toorop, for whom the 'strife between the sexes' had a poignant personal reality. So from Puvis' joining of allegory with mood, the symbolists understandably chose what was most congenial to their own aims: the stillness and preoccupation of the individual figure. They concluded that Puvis' beautifully composed subtractive style was the counterpart of their own syntheses, and that behind his reductive classicizing idylls lay a more truly symbolist meaning.

CARRIÈRE

'He was convinced that there are mysterious analogies among all [visible] forms. They appeared to him as the ideas of a single mind which manifests itself in them without ever losing itself, and whose laws, always obeyed, are once again found in the laws of our thought.' (Gabriel Seailles)

One of those present at the banquet for Gauguin in March 1891 was Eugène Carrière. His presence there correctly suggests that he was part of the symbolist circle. He attended Mallarmé's Tuesdays; he painted the well-known portrait of Verlaine [126]; and Carrière and Gauguin at about this time also painted each other's portraits. The symbolist writer Charles Morice, who collaborated with Gauguin on *Noa-Noa* (making considerable changes in the text), and was also Carrière's intimate friend, discusses his symbolist qualities in *La Littérature de toute à l'heure* (1889). Rodin admired his art.

Carrière exhibited his first *Maternité* at the Salon of 1879, and for the next two decades his subjects and his style hardly change. His main themes are those of family life, mother and child or children, clearly domestic, yet also abstracted, since the setting has disappeared into shadow. The figures, picked out in sparse light from within a dark-filled space, are modelled in golden-brown tonalities entirely lacking in contrasting hues. All this is very different from the flat planes and bright colours of Pont-Aven, yet a tendency towards the dark and sombre, and indeterminate space with overtones of inexplicit meaning, is also part of symbolism's method. Seurat's conté-crayon studies, Redon's lithographs in black and white, the shaded drawings of Khnopff and Mellery, all similarly make use of an attenuated darkness to suggest something

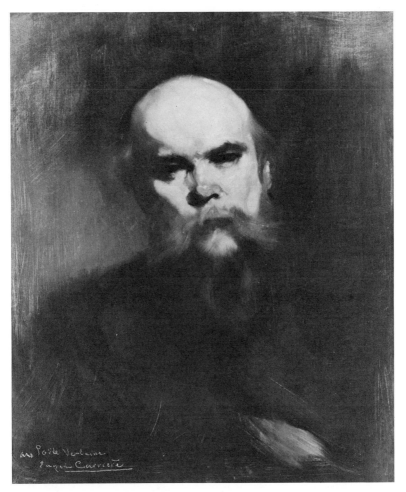

126. *Portrait of Paul Verlaine*, 1890. Carrière

beyond the scene depicted, a whole visible only in this symbolic fragment. Carrière's heavy figures, enveloped in a misty atmosphere almost as dense as they, remain shrouded in this mystery. They are part of a continuum, not too solid matter shading imperceptibly into a space not truly void, both informed by spirit [127].

Thus Carrière transforms the familial scenes that are his almost unique subject. His wife and children were always the models, because only in their presence could these everyday themes take on a wider meaning, and so grow from individual anecdote to spiritual metaphor; only with them could he realize the binding emotion which is his real theme and which the figures only adumbrate, and so be able to generalize these states of feeling, to 'unveil

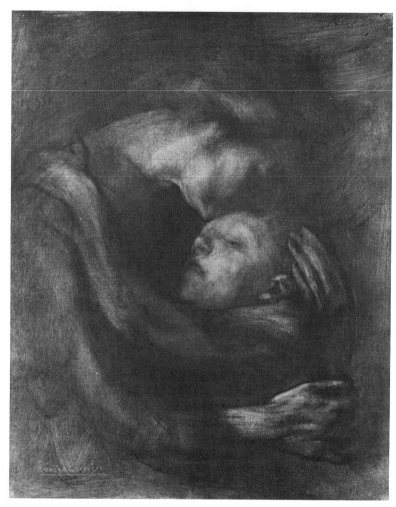

127. *The Sick Child*, c.1890. Carrière

by veiling'. It was a method to which Fénéon objected. His eye,
attuned to Seurat's precise line and colour, found Carrière's forms
more vague than synthetized, and he contrasted them with the
clarity with which Mallarmé's created a sense of mystery. Never-
theless, like the *intimiste* interiors of Bonnard and Vuillard, Carrière's
intention parallels that of Maeterlinck's 'static theatre': to suggest
the forces hidden beneath the surface of the commonplace, less
tangible but more real, the 'melancholy' and 'unease' which
Raffaëlli found in it. For Carrière (as for Munch and Hodler), *The
Sick Child* (a subject he painted in 1886 and again in 1892), is
more than the reminiscence of an event or a sad or sentimental
personal emotion. Like the *Source de vie* [128] and his other mater-

nities, these are symbolic episodes, implicit of the whole of human existence and its universal matrix. Despite Redon's objections to Carrière's 'rather dirty and neutral umbers' which he felt had none of the life and colour of his own blacks, their darknesses have a similarly intended meaning. The title of the fifth plate of Redon's Poe series (1882) might well have been a motto for Carrière: 'Le souffle qui conduit les Êtres est aussi dans les sphères.'

It is also in this sense that the *art nouveau* line of some of Carrière's paintings and many of his drawings and woodcuts must be under-

128. *Source de vie*, 1901. Carrière

stood. (His brief early apprenticeship in the atelier of Jules Cheret is hardly its source.) The fluid rhythms are not simply decorative; they are the visual expression of the artist's own emotion and of a unifying pantheistic spirit.

Not only Carrière's art, but his views on the position of art in society, tie him to symbolism — and this in an unexpected way. For Carrière shared the ideas and beliefs of the *L'Art Social* group (see above, p. 72). Believing, as he put it, in the visionary quality of reality, he thought that the ordinary man had to be taught to see nature before he could be led towards artistic understanding; so he helped to establish 'the School of the Street', taking groups to factories and the city's more populous districts to examine their

surroundings, but not neglecting art in the museums: Carrière's lectures at the Louvre on Sunday mornings attracted large crowds. In these ways he sought to put into practice the symbolist belief in the possibility of an *art social*.

RODIN

L'homme visionnaire de la réalité – so Carrière described his concept of the artist's dual nature. It was a definition he might have found well illustrated in his good friend Auguste Rodin. The sculptor himself would surely have insisted upon the almost absolute realism of his art. In a way not too dissimilar to that of Van Gogh (surprising as this may seem) he distrusted his own visionary powers; he had to work from nature, from the 'motif' like any impressionist painter, and for him this meant the direct observation and experience of the living model. Sculpture he said was the 'art of the hollow and the lump', the analysis of the structure of the body as it is revealed in the surface, and its laws could only be learned from observation constantly renewed. Rodin's early work was so faithful to this conviction that his academic critics, accustomed to their own conventional renderings, insinuated that *The Age of Bronze* had been made from casts of the living model, while later Rodin often drew and modelled from the figure in motion to give vitality to his material.

'It is only in life that one searches for life,' he said. 'Life alone is worthy of the name of beauty, and it is not to be seen in the dream, the imagination or illusion.' Rodin was thus always a profoundly naturalistic sculptor. Like the impressionist painters he was compelled to reject the formulae of the academy, since only through direct contact with nature, constantly renewed, could he render truthfully (according to his temperament) the emotions it aroused and so transmit this truth to others. The goal was the (logically) contradictory fusion of an utter fidelity to his subjective feelings and to the objective recording of his sensations. Like the impressionists, too, his sense of reality went beyond observation to a sensuous awareness of his materials. He emphasized, even identified with, the physical substance of his clay and bronze, so that as a part of nature and not mere counterfeit it takes on its own existence aside from any theme or subject the work illustrates. Such insistence on renewed inspiration from nature meant that Rodin resisted the application to his work of any external style, as much a modern one as a traditional. In so far as possible (at least in his best work) material and illusion are not to be separated; the idea and its embodiment are not to be distinguished. It is thus not surprising that Rodin objected to being called a symbolist; in his own eyes he was a realist using the stuff of nature to extend and sharpen the experience of nature, not to deal with it in unreal metaphors.

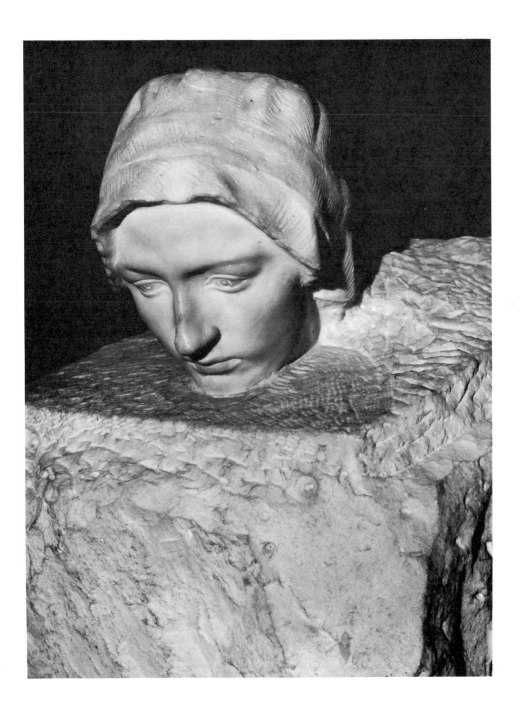

129. *Thought*, 1886. Rodin

When I say that the law of space is paramount: when I now add that the sight of the plains, the hills, the perspective of a landscape awakes in me the principle of planes that I employ in my statues, that I feel the law of the cube everywhere, that for me volumes are the fundamental law of all life and all beauty, will one then still insist that I am a symbolist, a generalizer, a metaphysician. It seems to me that I have remained a realist, a sculptor.

Despite the demurrers many aspects and qualities of Rodin's art are closely allied with symbolist intentions; the methods and the concerns of the symbolist painters find their parallels in his sculpture. At the simplest level is Rodin's practice of giving an abstract meaning to a realistic study. Much as the generalizing overtones of Carrière's *Baiser du soir* transform it into *La Source de la vie*, or Van Gogh's rendering of an exhausted old man becomes *At the Threshold of Eternity*, so Rodin's portrait of Camille Claudel, her head emerging from the unfinished block of marble, can also stand for *Thought* [129]. Munch paints *Jealousy* and Hodler *The Disenchanted*, Rodin portrays *Sorrow* [130] and *Fatigue*. In *She Who Was Once the Helmet Maker's Wife*, a figure both pathetic and didactic, he matches the

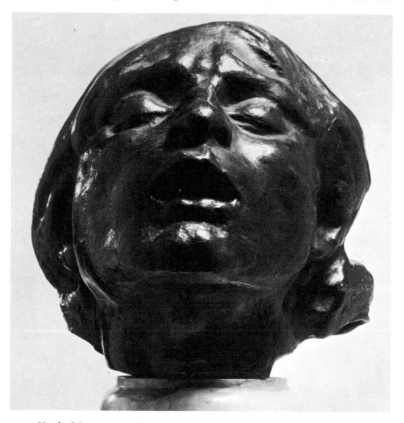

130. *Head of Sorrow*, c.1882. Rodin

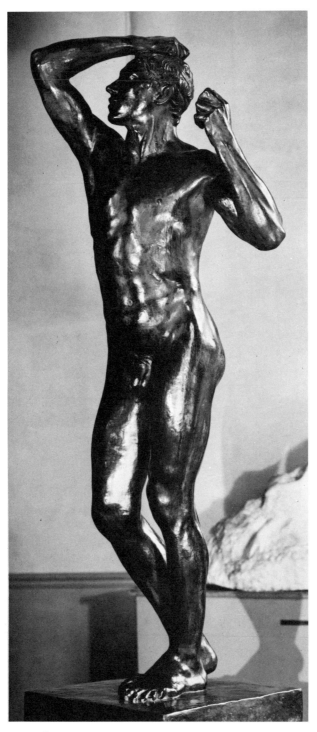

131. *The Age of Bronze*, 1875-6. Rodin

moralizing symbolism of Gauguin, Redon, Munch and other some-
times merely academic artists of the period when they depict the
round of life, old age and death. Similarly Rodin assigns generalized
meanings to the deliberately incomplete, or fragmented, figures of
Meditation and *Earth*. Such subjects were of course part of the com-
mon stock of allegory, and they fit well with Rodin's traditional
belief in the instructive and ennobling purposes of sculpture; but
in Rodin's handling they are not conventional allegorical figures,
identified by attribute and costume, and so leading to literary refer-
ence and association. Their <u>significance lies entirely within the
forms themselves; through expression, through gesture, through
the entirety of bodily pose, they embody states of feeling.</u> This is
what Rodin indicates when he says, 'The sculpture of antiquity
sought the logic of the human body, I seek its psychology.'

So if Rodin's art is grounded in naturalism, much of it is more
than naturalistic. Even *The Age of Bronze* [131] is based on an arti-
ficial pose painful to the model, and from the beginning its meaning
was far from clear, although it is evident that it *did* have a meaning
other than the faithful capture of the details of the model from whom
the sculptor worked for so long. As Rilke said, 'It indicates in the
work of Rodin the birth of gesture, that gesture which grew and
developed to such greatness and power . . .' The gestures of the
Burghers of Calais 'have been wrung from true states of feeling',
observed in others and within himself, as Albert Elsen notes, but
they are both heroic and dramatic; for all Rodin's dislike of the pub-
lic monument, which he here wished to take off its pedestal and
place among the modern citizens of Calais, the gestures of the
Burghers (as in the French classic theatre) are considerably larger
than life so that they may carry and convey their moral message
[132]. Besides, even in the *Burghers*, where arms and hands and
fingers play so large a role [133], it is incorrect to speak of gestures
as if they were movements contrasting with a static torso. In
Rodin's work it is in fact the body as a whole that gestures; in the
Burghers, as in the more passionate figures in, or associated with,
the *Gates of Hell*, the whole figure strains and bends in response to an
inner feeling so strong that it attempts to free itself from its bodily
confines. Although they take human shapes, the informing forces
are akin to those that run through Van Gogh's landscapes, twisting
trees and earth in a continuous rhythm. This is why facial expres-
sion, which communicates only individual feeling, is rarely ren-
dered in detail and never counts as separate from the rest, and why
the fragmented figures lacking heads, or reduced to torsos, con-
centrate the same kind of energy and feeling. It is not persons that
Rodin portrays, but states of mind, despair, or joy, or anguish that
have for the moment taken material form so as to become visible:

132. *The Burghers of Calais*, 1886–9. Rodin

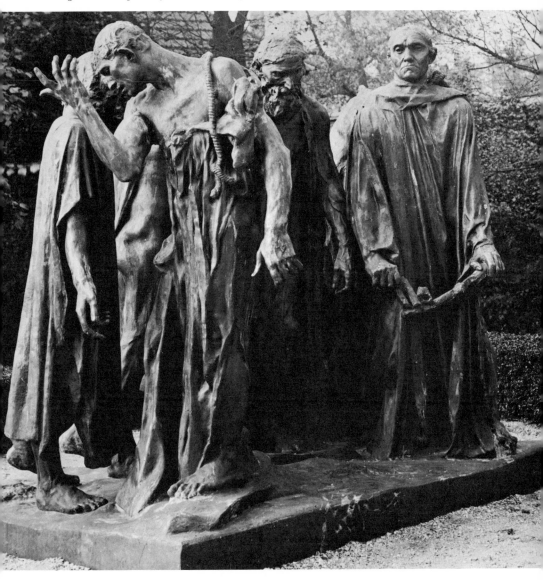

in the words of Mallarmé, 'to clothe the Idea in sensible form'.

This is not to suggest that Rodin had worked out anything like a coherent philosophy of art, still less one based on unseen Ideas. If he was not the uncultivated craftsman sometimes depicted by his enemies, neither was he an abstract theoretician. In his statements he returns again and again to the power of an expressive naturalism. What Elsen says of *The Age of Bronze* can be applied to most of Rodin's figures, even when they have referential titles, 'The indeterminate meaning of the sculpture is the natural result of the

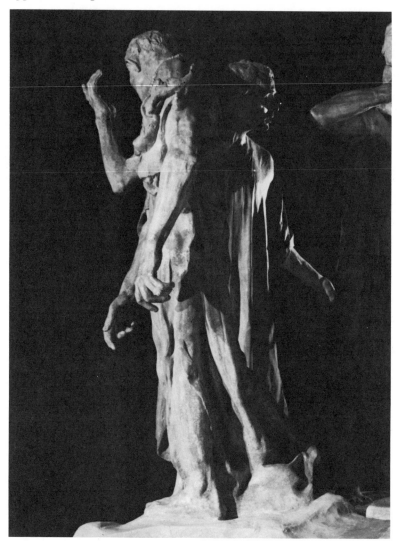

artist's search for an expressive pose, above all; and "expressive of
what" is irrelevant, or at best a secondary consideration.' Rodin's
figures are expressive 'in themselves', much as through colour and
the composition synthetist painting is expressive in its own right,
apart from whatever 'subject' was its point of departure. Thus
Rodin's work moves from exact observation to generalized sug-
gestion. Like many other artists of his time and tendency Rodin was
fascinated by the dance. Late in his career he sketched Loïe Fuller
and Isadora Duncan, the French can-can and then Royal Cam-
bodian dancers; recording their movements was an extension of
his own studio practice. But, in another sense, all of his sculpture

134. *The Gates of Hell*, 1880–1917. Rodin

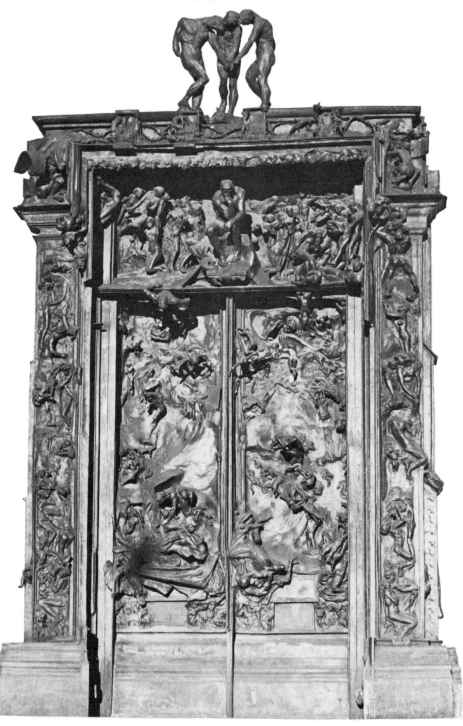

(with the exception of the portraits and some marbles) and its 'psychology of the body' has an intimate affinity with the dance. Rodin's desire 'to express inner feelings by the mobility of the muscles' would be understood by any dancer. And since for Rodin the gesturing body, accurately rendered, is more than physical and more than individual, his work accorded with the symbolist view that the dance was the Idea made visible. In Mallarmé's words:

> . . . The dancer is not a woman who dances, for the juxtaposed reasons that she is not a woman, but a metaphor, summing up one of the elementary aspects of our form, blade, cup, flower, etc., and that she does not dance, but suggests, by prodigies of bending and of leaping, by a corporeal writing, what would require paragraphs of prose, both dialogue and description, to express in words: a poem freed from all the machinery of the writer.

It is true that in *The Gates of Hell* [134] – the work which, with its offshoots, was for decades central to his aspirations – Rodin drew upon literary as well as mythological sources. Elsen has described how he was inspired by both Dante and Baudelaire, fusing their drama and despair to create a modern Inferno in which each man is ruled by 'an internal Hell of passions' to which all are subject without true hope of salvation. Every one is part of a crowd – no longer are there special men or heroes – and utterly solitary, alone with the 'duality of desire and the incapacity to fulfil it' which is the common fate of all. Among the many figures and groups of *The Gates* some – Ugolino or Paolo and Francesca [135], Adam and Eve – can be recognized and their origins traced. Many of these, taken from the total programme, were cast as separate sculptures whose titles preserve their poetic source [136]. But in the end *The Gates of Hell* is no true allegory. 'The identifiable figures are so few in number, so scattered, so ambiguous and so intermingled with a greater number of anonymous men and women as to confound attempts to translate [it] according to a literary programme.' Instead its theme is stated visually, symbolically [137]. The truly unifying element has nothing to do with narrative; it is the restless energy which flows through every portion and detail, a suffusing force that charges the figures with an agony of hopeless struggle, and moves from them into the separating spaces, binding solid and void, light and darkness into a fated, inescapable universe [138]. And so, finally, it is the material of the sculpture, its modelling in 'the hollow and the lump' to create its all-pervading visual rhythm which envelops and supersedes the subject, that gives *The Gates of Hell* its symbolic meaning. Immensely physical, it is the direct visual expression of Rodin's descent into his own being. In *The Gates* Rodin transmits a state of anxiety, the same intense instability engulfing both the self and its ambience, to be found in many of the poets and

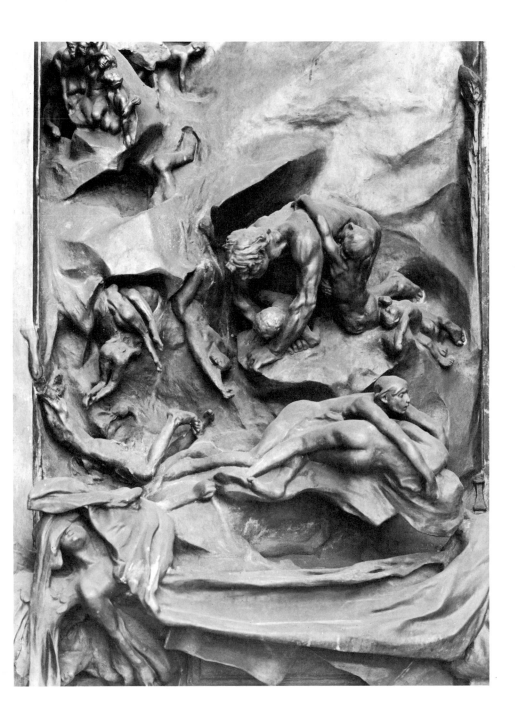

135. Detail of 134.

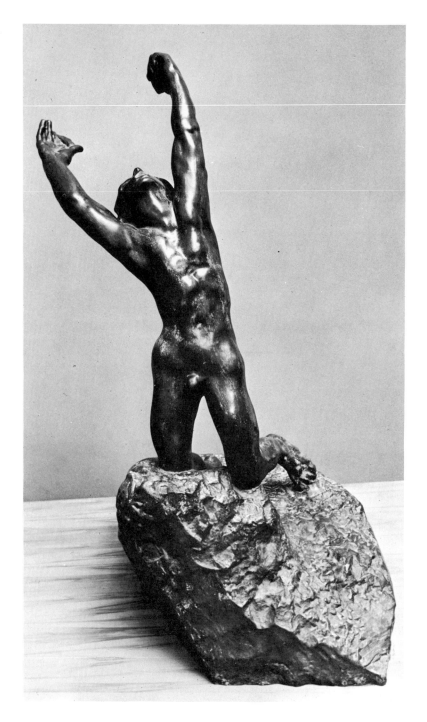

136. *The Prodigal Son*, 1889. Rodin

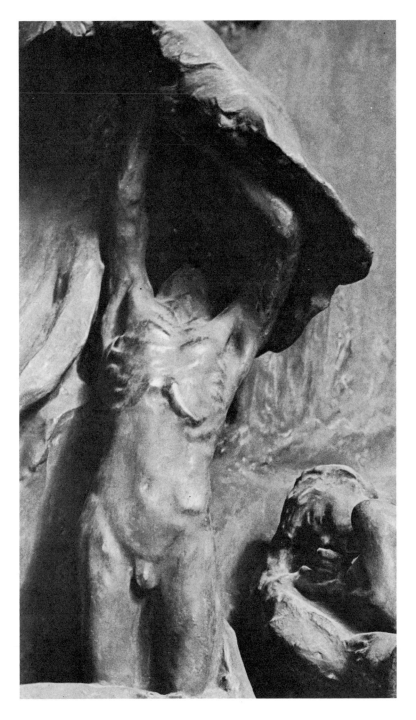

137. Detail of 134.

138. Detail of 134.

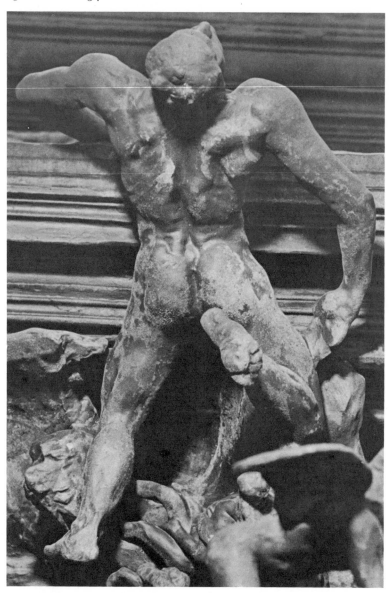

painters of symbolism. In Van Gogh and Munch it is projected upon a landscape or in an environment at once threatened and threatening; here the illusionistic space has been transformed into a visionary setting, the universal prison within which each tragic, isolated figure is driven, but without hope, to seek escape from himself.

The passage from naturalism to symbolism is given a kind of exemplary exposition in the long development (from 1891 to 1898) of the monument to *Balzac* [139]. Jacques de Caso has noted how,

139. *Balzac*, 1891–8. Rodin

at the start, Rodin 'accumulated his evidence just as the naturalists – Zola and Maupassant, following on Flaubert – had amassed documentation for their novels.' He owned the reproduction of a daguerreotype of Balzac; he travelled to the writer's native Touraine, where he made clay sketches of citizens who he thought resembled Balzac; he made successive studies of the head, from a living model, and of the nude body in various poses; to work out the robe he dipped drapery in plaster and then enlarged the casts. But all these were only preliminaries to the final form which was so far from naturalism that it was rejected by the Société des Gens de Lettres and mocked by the critics. The initial naturalism still persisted, the massive folds are based on Balzac's voluminous dressing gown: 'I wanted to show the great worker haunted at night by an idea and getting up to go and write it down at his working table,' Rodin said. But all the details, the size, the stance, the folds of cloth, the modelling of the head, although accurate in their origin, are both enlarged and simplified; they have been 'exaggerated [in my] search for a synthesis of the whole'. In the course of Rodin's meditation on this theme the athlete of the nude study, actively confronting the world, has become 'the suffering, misunderstood creator, wounded by society' and torn by his own inner conflicts. As with so many of Rodin's figures – the *Adam*, *The Prodigal Son*, *The Centauress*, for example – the struggle here too is finally located within the nature of the man: he is one of the *isolés*, the superior man cut off from the world. The impressive unbroken silhouette, the figure gathered into itself carrying its energy into the lifted head, is at once defiant and receptive to the light of inspiration. And, like Gauguin's projection of himself as the suffering Christ in his *Gethsemane*, it is also – though less directly, with more pride and less pathos – a partial self-portrait. Inevitably Rodin identified himself with his subject. So this is no longer a monument to Balzac alone, but the symbolic celebration, through Balzac, of the vigour and heroism of prolific genius.

Rodin's use of the partial figure must be seen in the same light. The many headless bodies, the half-length figures, the torsos, the heads alone, these are neither incomplete, unrealized sketches, nor broken fragments of abandoned composition. Neither are they purely formal studies or academic exercises. Rather they are symbolic objects, incomplete as representation, but complete in themselves through their power of suggestion. Rodin was inspired by the classic fragment, which the double accident of broken form and temporal distance has removed from its context, and which, in isolation, has become the image of a civilization and a philosophy no longer present. His intentional fragments have the same kind of concentrated meaning. 'The object kills,' said Mallarmé. But these

are only partial objects, not imitations of the real world, therefore not finite and sterile. By a process similar to the verbal dissociations Mallarmé describes, which create words 'new and strange to the language, and incantatory', Rodin's fragmentary inventions become signs and symbols of an idea. Seemingly casual, organically impossible, they do not represent. Instead they invoke the world's material continuum from which their own clay and bronze (which is their reality) has been extracted, and an invisible universe which, by suggesting, they symbolize.

Many other artists of the period, both poets and painters, shared Rodin's obsession with physical love and its passionate moral implications and employed it as a symbol of spiritual aspiration. Others too created separate works whose subjects were nevertheless related. Gauguin, Munch, Hodler, even Klimt and Toorop, were to a greater or lesser degree concerned with the symbolic rendering of the stages of man's inner life, implying change and evolution in a series of works, which, taken together, made up a 'frieze of life'. Each is part of a larger ambience (if not of a concerted programme) of thought and feeling, and its full reverberation can be felt only in the memory of all the others. Nowhere is this sense of a totality in the *œuvre* more strongly felt than in Rodin. He created a related world of figures (not a pantheon, because these are men, not gods); each is the expression of a state of feeling – joy, agony, despair – at once ephemeral and eternal, all belonging to the same timeless flux. So in another sense each one is not a new and different figure, but the same one renewed, seen at another moment, possessed by another sentiment. Thus each figure, and perhaps especially each partial figure, is not simply a small fragment that needs the rest; it has within it all the others because it can (indeed will) become each one of them in time. In this way, too, Rodin's sculpture is symbolic: each single work evokes the total world of his creation, and achieves its meaning by the evocation of the absent and unseen.

5

Criticism
and Theory

'In the new era we have had two art critics: Aurier and Fénéon. One has died, the other is silent. What a pity.' (Rémy de Gourmont, 1892)

Félix Fénéon and Georges-Albert Aurier were not quite the only critics of the new tendency. Other symbolist writers also were interested in painting and sculpture and reported on it in many reviews of the period, and even, infrequently, in the *grande presse*. Most of what appeared in such periodicals as *La Revue indépendante*, *La Vie moderne*, *Le Mercure de France*, *La Plume*, was current journalism, devoted more to calling attention to exhibitions of which they generally approved than to any truly considered appraisals, and much of it was done by writers of no particular distinction. With such a plethora of short-lived little magazines, and so many enthusiastic young men, it could hardly have been otherwise.

But a certain number of still-remembered names do stand out. That of Rémy de Gourmont himself is among them, and others include Paul Adam, Gustave Kahn, Camille Mauclair, Charles Morice, and in Belgium Émile Verhaeren and Georges Rodenbach. And three writers of genius did pay attention to the visual arts — Huysmans, Laforgue and Strindberg. The poet Laforgue, while a language tutor in Berlin in 1883, reported briefly to the *Gazette des Beaux Arts*; surprisingly for someone who admired Hartmann's book on the unconscious he praised Böcklin, and suggested that Max Klinger was in the tradition of John Martin, Fuseli and Blake. The neighbour of Gustave Kahn in Paris, and a friend of Félix Fénéon, his early death prevented him from carrying out his plan of writing 'a series of studies in which, through the accumulation of well-selected words (*meaning* and *sonority*), of facts, of sentiments appropriate to the colour scale of a painter, I should convey the sensation of the world created by this painter'. Strindberg, who was later (1895) to refuse Gauguin's request for a preface to his exhibition, was willing to comment (1892) on Edvard Munch's painting, more congenial to his misogynist temperament; but these were

only occasional sorties. Huysmans' contributions more than span the decade of the eighties, but at first he was much concerned with the impressionists (at the same time that he was praising Redon), and later, his always somewhat literary appreciation focused on Moreau and Rops, in whose images he found a reflection of his own satanism. As he moved towards religious conversion he gradually moved out of the symbolist milieu. So none of these three contributed to establishing a systematic critical philosophy by which to judge the painting they approved.

Critics sympathetic to the symbolists were also faced with the problem of evaluating artists who had conflicting aims but whose work they continued to admire. The impressionists especially posed this problem. They were, after all, oppressed by the academy and had been in the *avant-garde*; but they were also imitators of nature, materialists opposed in principle to an idealism which, in part, had developed in conscious reaction to their acceptance of the world's appearance as its reality. But they were discovered to have certain symbolist qualities. Paul Adam, reviewing the impressionists' exhibition of 1886, differentiates them from other schools also based on 'the perceived sensation' in that they "pursue the subjectivity of perception to its most abstract formulation, thereby objectifying it as pure phenomenon.' Aurier mentions their 'attempts at expressive synthesis'. Pissarro generally remains in favour for his directness and honesty, both during and after his neo-impressionist phase. It is especially in Monet that new affinities with symbolism are discovered. Camille Mauclair finds the vision of Monet's *Poplars* (1892) so disconcertingly exact that its sensitive realities 'through the fantasmagoric vision of the master, also contain a sense of mystery, and so they suddenly participate in that symbolic universe of which the poets have dreamed . . .; from the very truth of the painter's vision springs the consoling certitude that *the world is as we create it.*' Thus Monet is made to exemplify Schopenhauer. In the same year Aurier in the *Mercure de France* praises Monet's 'naive, ecstatic artist's soul', and sees in him, not merely the realist, but a man 'in love with divine light . . . with ineffable sensations . . . which exempt him from dreaming, from thinking, almost from living'; he is a 'mystic heliotheist' who sacrifices everything to his god.

After 1890 even the long-time supporters of impressionism began to stress its poetic and suggestive aspects. For Gustave Geffroy, Monet, in his *Haystacks* (1891), does much more than 'give the sensation of an ephemeral instant . . . He evokes . . . the course of the globe in space [and] unveils the changing portraits of joy and despair, of mystery and fatality with which we endow in our own image all that surrounds us' — this is a Monet seen in the unexpected mirror of idealism. And another champion of naturalism discovers

that it is replacing its splendid evocations of nature by a 'mysterious, imaginative painting . . . A dawn scene by M. Pissarro, a marine by M. Claude Monet seems to us as suggestive as it is representational. From their warm harmonies thought frees itself, and the Dream takes flight.' By thus changing the angle of vision, and with whatever justice these new qualities may inhere in the works themselves (and this is surely more for Monet than for Pissarro), these artists of an older generation are made to conform to the new symbolist perspective.

In these evaluations there is only the implication, never the statement, of a theoretical background, and even this is of the most general kind. The vocabulary is borrowed from the theories of symbolist poetry, but the application of those theories to the peculiar conditions of painting is rarely spelled out. Although much was written about the relation of poetry to music, the position of painting and sculpture in the hierarchy of the arts is rarely defined. If, in the words of Édouard Dujardin, the symbolists, following Schopenhauer, conceived of music as communicating the idea of the universe directly, without mediation, and 'expressing the world as Will, i.e., in its profound reality, whereas the other arts express it as Representation, i.e., in its appearance', painting was obviously in a difficult position. The poets 'nourished on music', as Valéry said, could hope 'to take back from Music their rightful inheritance'. Mallarmé may indeed have understood painting better than he did music, and may well have admired Wagner less as a musical revolutionary than as 'one who in the history of literature, thought text and sound simultaneously'; but given the symbolist desire to bypass appearance, the visual arts were at some disadvantage precisely because they were visual.

These theoretical problems were rarely discussed in any comprehensive manner. Charles Vignier does briefly take up the position of painting in his *Notes d'esthétique: la suggestion en art* (December 1885), only to place it below both music and poetry. Since for him the core of the new art lies in a series of analogies from which, then, finally 'one suppresses all the preparatory scaffolding, and the metaphor appears distant and suggestive' it is hardly surprising that he finds the methods of painting necessarily too tangible.

The most detailed treatment is perhaps that of Charles Morice, whose important *La littérature de toute à l'heure* (1889) is a definitive statement of symbolist views. For him too 'suggestion' plays a central role in the new art. He himself (close friend of Gauguin and Carrière) was much concerned with painting but he points out that as a group the writers were more passionately affected by music because 'it is at the same time more distant and more intimate,

nearer both to the origin and the resolution of feeling and sensa-
tion . . . Line and colour arrest and defy time: sound yields at the
very moment it is born; it lives to die, it is a profound symbol . . .
Painting is a witness, Music is a yearning. Through music the soul
soars of its own accord, then recaptures its self-awareness in the
solid silence of painting.' So while music and poetry naturally fuse,
or at least can supplement each other, 'Painting taxes its ingenuity
to find, within its proper limits, new ways – musical and poetic – of
creating dream-like harmonies.' It is clear that even for Morice
painting is inherently less propitious to symbolism than the other
two arts.

Félix Fénéon did of course consistently apply his critical intelli-
gence to painting. He was at the centre of the literary movement,
and an editor and contributor to its reviews, but his tastes in paint-
ing were exclusive. Interested first in impressionism, and then in
neo-impressionism, whose method and aims he interpreted in a
series of articles of exemplary subtlety and precision, his critical
energies were directed almost entirely in this one direction. Besides,
though widely read and well-acquainted with the theoretical
thought of symbolism, Fénéon chose to suggest and imply rather
than to spell out the analytical background of his interpretations.
In a manner not unlike that of Mallarmé himself, his formulations
are concise, allusive and complicated, often as much prose poem as
elementary exegesis. By temperament aloof and ironic, it was not
in his nature to develop comprehensive theories. Soon after Seurat's
death he stopped writing altogether. Fénéon played a key role: he
was the defender and interpreter of neo-impressionism; he made
clear Seurat's fundamental relation to symbolism (above all in his
article of 1887 in *L'Art Moderne*); he was a writer of distinction and
of sympathetic insight. Fénéon was the indispensable critic of one
aspect of symbolist painting, but through the deliberate restrictions
of his taste and interest, he refused the larger role he might have
played.

That role was actively sought by Albert Aurier, who in less than
five years before his untimely death in October 1892, established
himself as the spokesman of the movement. Aurier was a prolific, if
not very distinguished, poet, who from the mid-eighties had been
associated with The Decadents. He also wrote a novel. After briefly
editing his own review (*Le Moderniste*) in 1889, he was co-founder
of the *Mercure de France* in 1890, and in the following years its chief
critic of painting. Just after his death Julien Le Clercq described him
as the 'intellectual brother of Rémy de Gourmont', author of the
Book of Masks, whose very title refers to the shifting, changing world
we each of us project in our own image.

Aurier wrote many notices and reviews which do little or nothing

to advance his ideas. His elaboration of symbolist theory is concentrated in three articles published during his lifetime, and the *Preface* to a never completed book on art criticism which was published in the *Mercure* two months after he died. Understandably, the *Preface* remains very general, and deals, not with works of art, but with the nature and position of the artist. Most of it is given over to an attack on the 'scientific' criticism of Taine, and his co-practitioners of the method, Sainte-Beuve and Émile Hennequin. For Aurier the notion that a work of art is 'an essentially relative and contingent phenomenon', whose character is determined by 'race, milieu, moment', is anathema. He turns upside-down what he calls this 'pretence of an aesthetic, [which] does not state laws, but coincidents which are besides exceptional and difficult to prove'. It is exactly wrong to propose that 'the interest of a work is proportional to the sum of the influences from his milieu upon the artist, when the evident truth lies in this proposition reversed. Taine is right: artists are not isolated men; but this can only be deplored. Unfortunately, yes, they are more or less subject to the influence of their environment despite their desire, which is a duty, to remove and abstract themselves from it. Taine's great mistake is that his conception of the world is too materialist and that he prefers Comte and Condillac to Plotinus and Plato.' Aurier considers him at best a mediocre sociological historian, who, in the end, is not concerned with either aesthetics or art criticism, and whose influence has been disastrous. Since even the *Preface* to his projected book remained unfinished, Aurier did not elaborate his own proposed methods.

Aurier's article on Van Gogh was published in volume I, number 1 (January 1890) of the *Mercure*. It was to be the first of a projected series on *Les Isolés*, a title which within the symbolist context referred less to the public's wrongful neglect than to the lonely glory which defines the true artist, who is always 'out of this world'. It is an enthusiastic endorsement of Van Gogh which begins with a prose-poem that translates the brilliant colours and emotional intensity of Vincent's art into the complicated, designedly arresting vocabulary of the symbolists. He emerges according to the 'ineluctable laws of atavism [as] duly Dutch, in the sublime tradition of Frans Hals'. Aurier emphasizes 'the naive truth of [Vincent's] art, the ingenuousness of his vision — his profound and almost childish sincerity, his great love of nature', and the force, the violence of expression, 'the almost orgiastic excesses of all that he paints', and his love of the materials with which he paints. Finally Aurier characterizes Van Gogh as 'a symbolist feeling the constant necessity of clothing his ideas in precise, ponderable, tangible forms, in intensely sensuous and material envelopes. In nearly all his paintings, beneath this morphic envelope, beneath this very fleshly flesh, beneath

this very material matter, there lies, for the mind who knows how to
find it there, a thought, an Idea, and that Idea, which is the essential substratum of the work, is at once its efficient and its final cause.' And Aurier insists that unless the existence of these idealist tendencies is recognized Vincent's art would be incomprehensible: he is 'a dreamer, an exalted believer . . . who lives on ideas and illusions.'

The article on Van Gogh tells us nothing of Aurier's conception of the structure of symbolist painting or how that structure mediates the Ideal. He grapples with these problems in his March 1891 essay (prompted by Émile Bernard, to his eventual regret) which, beginning as a study of the painters of Pont-Aven, was broadened into a more theoretical description of *Symbolism in Painting*, and narrowed to using only Gauguin as its exemplifier. At the head of his essay Aurier significantly places a quotation from Plato's allegory of the cave and its shadows mistaken for reality. After an eloquent description of *The Vision After the Sermon*, he goes on to insist that 'the newcomers, whom Gauguin leads, must not be mistaken for impressionists who only translate sensations and impressions'; Gauguin is the opposite: one of the 'sublime seers . . . with the clairvoyance of that inner eye of man of which Swedenborg speaks', part of an 'ideist' tendency opposed to realism, and the only one capable of supreme art. The artist is 'The *Expresser of Absolute Beings* . . . objects . . . appear to him only as signs . . .', used by the artist 'whose eye is able to distinguish essences from tangible objects. The first consequence of this principle, too evident to justify pause, is a necessary simplification in the vocabulary of the sign.' (Aurier then quotes from Baudelaire's sonnet, *Correspondances*, and refers to the 'symbolic correspondences' the artist alone understands; but he does not associate this concept, obviously basic to his whole point of view, with Swedenborg.) The artist must not reinforce the practical inclination to 'consider the object as nothing but an object' and so he must never in his painting give 'that deceitful impression of nature that acts on the onlooker as nature itself, that is without possible suggestion, that is, . . . not ideistically'. Therefore in using forms, lines and colours the artist must 'exaggerate them, attenuate them, deform them according to the needs of the Idea to be expressed.'

'Thus [writes Aurier], to summarize and to come to conclusions, the work of art, as I have logically evoked it, will be:

'1. *Ideist*, for its unique ideal will be the expression of the Idea.

'2. *Symbolist*, for it will express this Idea by means of forms.

'3. *Synthetist*, for it will present these forms, these signs, according to a method which is generally understandable.

'4. *Subjective*, for the object will never be considered as an object, but as the sign of an idea perceived by the subject.

'5. [It is consequently] *Decorative* – for decorative painting, in its proper sense, as the Egyptians and, very probably, the Greeks and the Primitives understood it, is nothing other than a manifestation of art at once subjective, synthetic, symbolist and ideist.'

'. . . decorative painting, is strictly speaking, the true art of painting. Painting can only have been created to *decorate* with thoughts, dreams and ideals the banal walls of human edifices.'

And so Aurier concludes that Ideist art is 'the true and absolute art', for not only is its definition logically demonstrable (as he has just shown) it is also 'fundamentally identical with primitive art, to art as it was defined by the instinctive geniuses of the first ages of humanity'.

There is still, however, Aurier adds, a missing element. The man who through his intelligence knows 'how to read in every object its abstract significance . . . how to use objects as a sublime alphabet to express Ideas', such a man is only an ingenious scholar. To be worthy of the name, the artist must also have 'the gift of emotivity . . . the transcendental emotivity, so grand and so precious, that makes the soul tremble before the pulsing drama of abstractions . . . Thanks to this gift, symbols – that is Ideas – arise from the darkness, become animated, begin to live with a life that is no longer our life of contingencies and relativities, but a splendid life which is the essential life, the life of Art, the being of being. Thanks to this gift, art which is complete, perfect, absolute, exists at last.' The article ends with praise for Gauguin as an artist who conforms to this tradition: he has the soul of a primitive, his work suggests an inexpressible ocean of ideas, he is above all a decorator (with Puvis de Chavannes perhaps), the only great decorator of the times, and Aurier closes with the cry – 'walls, walls, give him walls,' which Gauguin, later, was to echo in letters from Tahiti.

Aurier's long article *Les Symbolistes* in *La Revue Encyclopédique* (1892) adds little in the way of theory. He once more insists that just as our own body is the tangible form of our being, i.e. our thought, so 'In nature, every object is finally only an Idea signified,' and that 'art is, by definition, first and always the necessary materialized expression of some conjunction,' whose own language is those combinations of lines, planes, shadows and colours which constitute style. There are the abstract elements studied by Leonardo, Humbert de Superville, and also Charles Henry, whom no one could suspect of symbolist leanings. Aurier then adds an idea he repeats in his notes for the *Preface*: the work of art is a new living being, whose soul is the synthesis of two souls – of the artist and of nature; it is an immortal being which can be understood through love, 'through the delicious fusion of one's own soul with the soul of the work of art'. (These concepts deriving from Swedenborg, and

very similar to those of the German romantics, will soon be repeated by Henry van de Velde as he elaborates his theory of ornament.)

The last pages of *Les Symbolistes*, profusely illustrated, are devoted to a review of all the artists of the new tendency, beginning with Gauguin (its undoubted initiator), whose art is characterized as 'Plato interpreted visually by a genial savage', with Van Gogh and Redon, calling the roll of the Nabis, and ending with the surprising mention of the architect Trachsel. These numerous descriptions are all so brief that this article too leaves incomplete Aurier's analysis of symbolist painting. Only in his discussions of Van Gogh and Gauguin did Aurier have a chance to apply the principles of his philosophic idealism to the practice of art criticism; they spell out the attitudes and the assumptions with which the symbolists approached the art of their contemporaries.

6

Idéistes

Six months after Aurier gave his definition of symbolist painting in the *Mercure*, there appeared in *Le Figaro* the manifesto of an artistic programme similarly disdainful of both realism and the Academy. Its author, Joséphin Péladan, critic and novelist (*Le Vice suprême*, 1884), proclaimed that a work of art 'is more an operation of the soul than of the hand; man puts into his creations the best that is in him, i.e., the immaterial; in the creation of a masterpiece – more than any study and effort – there enters mystery.' To further this Art (dedicated to beauty, dream, the past and tradition) Péladan announced the creation of a new salon, the *Salon de la Rose + Croix*. Its opening exhibition (March 1892) included more than seventy-five artists and attracted over 1,000 people to a *vernissage* that was preceded by a mass at Saint Germain l'Auxérrois, and at which passages from *Parsifal* were played, and Erik Satie performed a trumpet fanfare he specially composed for the occasion.

The Sâr Péladan had grown up in Lyons, the son and brother of occultist, firmly Christian believers. A trip to Rome and Florence in 1881 had given him the revelation of the Latin tradition in painting, especially the Florentine primitives, and in his reviews of the Paris Salons during the eighties he called for the revival of an Italianate art, linear in style, imaginative in subject, to replace the vulgarities of the painterly and the realistic which had come to dominate French art. Opposed as he was to any northern influences in painting (they had largely contributed to the decline) he had nevertheless been given – on a pilgrimage to Bayreuth in 1888 – the further revelation of the music and the message of Wagner.

The purpose of the *Rose + Croix esthétique* (an extension of the more directly religious *Rose + Croix du Temple*) was 'to restore the cult of the IDEAL in all its splendour, with TRADITION as its base and BEAUTY as its means ... To ruin realism, reform latin

taste and create a school of idealist art.' Entry was by invitation only, and there was 'impose[d] no other programme than that of *beauty, nobility, lyricism*'. Realistic subjects of whatever kind, historical, patriotic, genre, still-life, or landscape (except in the manner of Poussin) were vigorously excluded; encouraged were 'the Catholic Ideal and Mysticism . . . Legend, Myth, Allegory, the Paraphrase of great poetry and finally all Lyricism . . . the nude made sublime' in the style of Primaticcio and Correggio.

During the six years of its existence the *Salon de la Rose + Croix* exhibited the work of some two hundred artists, many of them from outside France, for Péladan's effort was international. In his reviews of the official Salons, which were largely devoted to violent criticism, the Sâr had gone out of his way to praise his three modern idols – Moreau, Puvis and Rops; despite this (and though Rops had drawn frontispieces for his novels), he was never able to persuade the trinity to show with the *Rose + Croix*, Puvis even protesting against the use of his name. Nor was Péladan any more successful with the Pre-Raphaelites, whose work and fraternal spirit he admired, and whom he proposed to go to London to invite: Burne-Jones, whose work was by this date well-known in the official Salons, declined to show in 1892, and no further invitations were issued. Among the lesser Frenchmen Péladan would have liked to include, Redon, Anquétin, Schuffenecker and Maurice Denis all refused.

Denis explained that his participation was prohibited both by his religious beliefs (his Catholicism could hardly countenance occult tendencies) and his aesthetic convictions. This is understandable, for though the artists gathered by the Sâr were opposed to realism, and though their work was various in style, they joined together under the banner of Idealism, and this was something very different from the synthetism of the Nabis and from symbolism as defined by Aurier, since unlike them, it stressed meticulous representation, even if it was of imaginary, mystical subjects. Indeed, Aurier may well have had Péladan in mind (as well as the Academy) when he stressed the distinction between his own *idéisme* and those artists who 'pride themselves upon presenting us *beautiful* objects'. The *Rose + Croix* ideal was mystical allegory rather than a modern symbolist style. Some sense of this is conveyed by Carlos Schwabe's poster for the first Salon [140]. It depicts a nude in the foreground sunk in the mire of daily existence looking up at a young woman who has broken her chains and is being led by another, more ethereal figure (a guardian angel, or perhaps her own better nature) up a flight of flower-strewn stairs towards a celestial, light-filled realm in the distance. It is a spelled-out allegory of salvation and escape; and though *art nouveau* in its lettering and proportion,

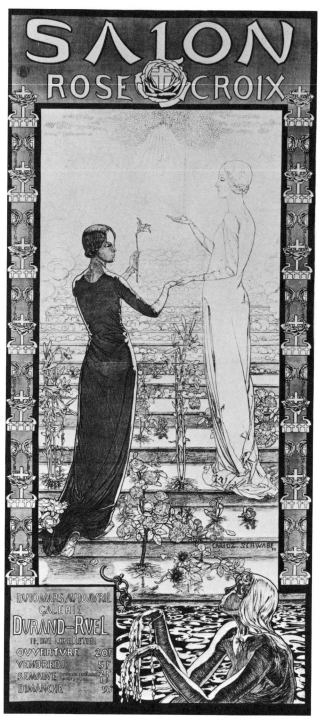

140. Poster for the first *Salon de la Rose + Croix*, 1892.
Schwabe

and in the incorporation of the decorative border of crosses into the design (features which influenced Mucha's posters for Sarah Bernhardt), it is strongly Pre-Raphaelite in feeling and well sums up the Rosicrucian tone of a somewhat pallid mysticism. Aman-Jean's poster for the second Salon, on the theme of Inspiration, with Beatrice led away by a winged angel as she gives a lyre to an unseen Dante, is very much in the same vein.

The Salon of 1892 was largely financed by Count Antoine de La Rochefoucauld, who while a mystic himself, painted in a divisionist style anathema to Péladan, and he withdrew his support even before it closed. (He was later to send a regular stipend to Filiger in

141. *Portrait of Péladan*, 1891. Séon

142. *The Siren*, 1897. Point

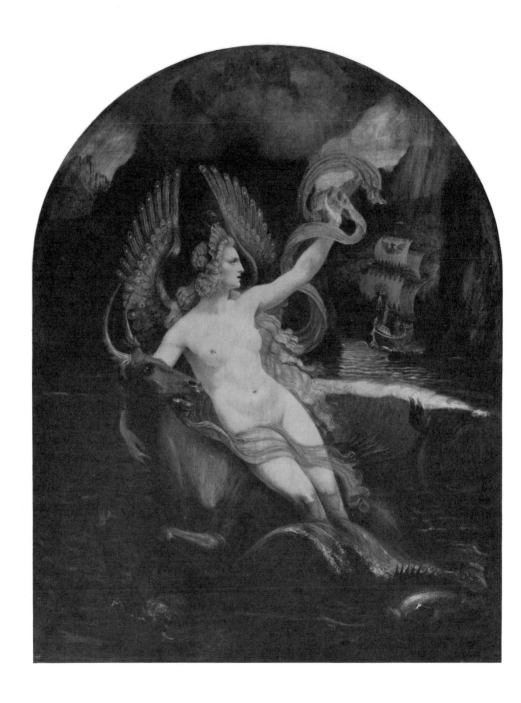

Brittany.) Among the artists in this first salon were many still re-
membered for other achievements: Bernard, Bourdelle, Filiger,
Grasset, Hodler, Khnopff, Toorop and Vallotton. Of these, Bour-
delle showed again in 1893 (when the Rosicrucians were lent an
important section of the official salon at the Champ de Mars), but
only Khnopff continued as a regular exhibitor; his work with its
strong English affinities and somewhat ambiguous sexual tone was
obviously very pleasing to the Sâr. However, the atmosphere of
Mediterranean Idealism endorsed by Péladan is perhaps best con-
veyed by other regular contributors to the Salon. Alexandre Séon,
for example, who missed only the exhibition of 1894, executed
frontispieces for Péladan's novels, and did his portrait [141]; most
of his work clearly is based on the style of Puvis de Chavannes. In
such works as *Princess and the Unicorn* [15] with its Botticellian
costume and detailed rendering of a flowered ground, Armand
Point demonstrates his debt to the medievalizing realism of the Pre-
Raphaelites, a style to which he gives a more ethereal interpreta-
tion in the pastel colours of *L'Eternelle Chimère* — an altogether
chaste lady in a flowing robe who contemplates the open book she
holds. Point was a student of Renaissance techniques and in *The
Siren* [142] he approximates something of a Leonardesque *sfumáto*
as a background for this example of 'the nude made sublime'.

Alphonse Osbert, who showed extensively in all six *Salons de la
Rose + Croix*, has been called by Pincus-Witten its most repre-
sentative painter, although his work ignores the Renaissance-
revival side of the movement. Osbert's chief debt is to Puvis de

143. *The Forest Pool*, 1892. Osbert

144. *The Vision,* 1892. Osbert

Chavannes, whose planar compositions and silhouetted frieze-like figure arrangements he employs to a much more introspective end. He groups his classically garbed, idealized women in meditative poses, their faces shrouded in his typically crepuscular half-light, communing as much with themselves as with each other. As with Puvis, these figures are symbolic, but in an even more general way; their evident nostalgia refers less to a previous Golden Age than to some lost state of the soul, which once knew peace and communion with an ideal Nature. Osbert's other source was in the scientific colour harmonies of his friend Seurat, and this interest has been idealized into a kind of luminary pantheism, evident in some of his titles, and above all in the diffused light that washes over his landscapes (as in *The Forest Pool* [143]) and transforms his figures into insubstantial shadows. In the large *Vision* [144] these formal qualities are given a more specific iconographic locus in the glowing halo and radiant eyes of Saint Geneviève, and in her accompanying (sacrificial) lamb; the too sentimental result defines the evocative limits of the style. In answer to a critic who had called his work literary, Osbert replied 'art lives only by harmonies . . . it must be the evocator of the mystery, a solitary repose in life, akin to prayers

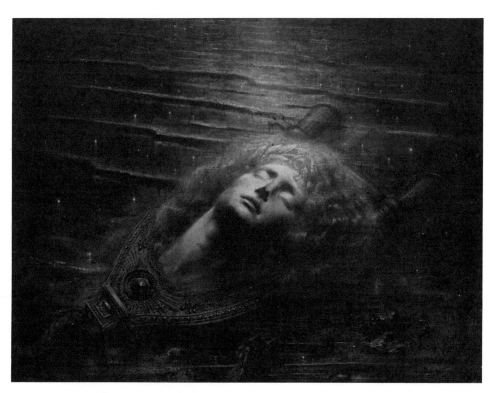

145. *Orpheus*, 1893. Delville

. . . in silence. The silence which contains all harmonies . . . art is, therefore, necessarily literary, according to the nature of the emotions experienced.' Isolation, withdrawal into meaningful silence, the more expressive because it permits suggestion, this is a symbolist means found in varying forms among both poets and painters. Osbert's 'literary harmonies', joining figures and landscape in silent prayer, are more often to be found outside of France, for example, in the very different work of Böcklin and Hodler.

In contrast, another Rosicrucian faithful, the Belgian Jean Delville, while echoing Péladan's taste for Wagner and the Pre-Raphaelites, continues the tradition of Gustave Moreau. His *The End of a Reign* (1893), which shows a decapitated head under an elaborately bejewelled Morellian crown suspended against the dim perspective of a ruined palace, is very much in the pleasurably macabre spirit of the Salomé pictures; and his *Orpheus* [145], the head alone, eyes closed, and hair abundant, cradled in a lyre floating on a rippling sea, comes directly out of Moreau's *Thracian Maiden with the Head of Orpheus* [101] which also had served to inspire Redon. Here Orpheus has been painted in the likeness of Delville's wife, thus transforming him into androgynous muse and assimilating him to those mystical symbols of feminine inspiration, pure and unattainable, which in the symbolist vocabulary alternate with the image of woman as the degrading temptress. Delville's apparitional portrait of Mrs Stuart Merrill [146], wife of the poet, shown grasping a book inscribed with a mystic triangle, her face emerging white from a surrounding infinite and her unseeing eyes cast upwards in ecstatic vision, is the nearly caricatural extreme of this ideal image. It is thus not at all surprising that Delville, in an action that paralleled Péladan's dispute with La Rochefoucauld, should that same year have broken away from the Brussels *avant-garde* association of *Les Vingt*, who were interested in another kind of symbolism (as well as naturalism), to establish a group called *Pour l'Art*, in which he was joined, among others, by Xavier Mellery, and even, in 1894, founded his own short-lived *Salons d'Art Idéaliste*.

After 1893, the *Salons de la Rose + Croix* continued in constantly diminishing circumstances; funds were lacking, and many of the artists preferred to show at the *Salons des Indépendants*, where their works would be seen by a larger public. Besides, the Rosicrucian ideal involved a fundamental contradiction: theoretically traditional in both subject-matter and style, since its purpose was to revive an art at once Catholic and Renaissance, it had in fact no appeal to its natural conservative audience, which was appalled by the excesses of its occult mysticism, and put off by a manner that went contrary to the academic naturalism it had come to expect in the treatment of even the most 'ideal' subjects.

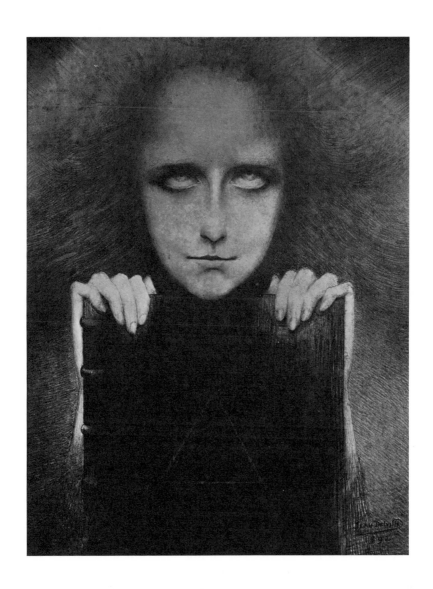

146. *Portrait of Mrs Stuart Merrill*, 1892. Delville

In 1899 Maurice Denis wrote to Gauguin, asking him to take part in an exhibition he was preparing for the coming Universal Exposition of 1900. It would once more bring together, among others, those painters who had formed the 1889 Café Volpini group of *Impressionists and Synthetists*. Gauguin, then of course in Tahiti, replied that, interesting as such a reunion would be, he was compelled to refuse; it would become too evident, he said, that he was 'the pupil of many' younger artists in the exhibition and had 'stolen much from my Master Émile Bernard'. After this bitterly ironic indulgence, he gave his serious reason: 'My personality of ten years ago is without interest today . . . my art of a Papuan would have no reason to be shown alongside [that of] the (Symb) symbolists, ideists; I am sure your exhibition will be a great success.'

Gauguin's painting had indeed changed during the intervening decade, but he was wrong (probably deliberately) in implying that his work was no longer either synthetist or symbolist; it was both, and in ways that had evolved out of his earlier attitudes and connections. The flat, decorative style of *The Vision After the Sermon* [68] and *The Yellow Christ* [5] makes only an intermittent appearance in work of the first Tahitian sojourn (1891–3) and the subsequent two years in France; but then, it had not been employed consistently even during the earlier Brittany period. When it does appear, the resulting design is as 'synthetist' as ever, with figures reduced to simplified contours, brilliant colours applied within clear outlines, shadows acting as independent, balancing shapes, and depth rendered only as a sequence rising of parallel planes. Besides, in these few paintings – *To Matete* (1892), *Fatata Te Miti* (1892), *The Day of The God* [25], *What, Are You Jealous?* [147] – Gauguin has stylized the forms of water, flowers and grass to a point closer to abstraction than he had ever come before (or would again), enclosing them in rhythmic curves that once again remind us that the symbolist painters are also the precursors of some of the elements of *art nouveau*. And in these paintings, as well as in several landscapes of the first Tahitian years, the colours are arbitrarily intensified for the twin purposes of decorative design and expressive mood, again carrying out the doctrines developed earlier in Pont-Aven.

While this synthetism of the 'plane surface' (to employ Denis' definition) diminishes after 1895, as Gauguin's palette grows darker, and his forms more rounded, what may be called his constructive synthetism – his method of incorporating pictorial motifs into compositions of his own construction – continues unabated and, after the first visual shock of his new surroundings has worn

147. *What, Are You Jealous?*, 1892. Gauguin

off, even increases. Thanks to the research of Bernard Dorival, Richard Field and others, we have some concept of how extensive the collection of photographs was that Gauguin took with him to the South Seas (many of them obtained earlier from his patron Gustave Arosa), and the degree to which he drew upon them. Just as in Brittany he had made use of local sculpture and Japanese prints, he now had recourse to this stock of reproductions, substitutes, perhaps, for distant, inaccessible museums. Thus the bas-reliefs of Borobudur make their contribution to the poses of the angel and the two Tahitian women of *Ia Orana Maria* (1891), as well as to *Einha Ohipa* (1896); Egyptian intaglio relief inspires the profile poses of the figures aligned on the bench of *To Matete*; a Rembrandt drawing is the source for the central figure of *Where Do We Come From?* [149], a motif Gauguin had already used in an earlier painting; a stable interior by Tassaert is the basis of a detail in the *Nativity* [148]; a figure from the Parthenon frieze (which Gauguin had pinned on his studio wall) provides the gesture of the title figure of *The Call* (1902). Gauguin went far to find the proper ambience for his creation, irresistibly drawn by the expectation of the unknown, as he himself said. That under such circumstances he continued to draw

upon a stock of familiar motifs indicates much less a lack of imagination than the degree to which his art was still profoundly *idéiste*: the concept came first, it was given material form through a synthesis of appropriate visual elements. The source of these symbols was unimportant and personal invention based on nature of no particular virtue; what mattered was the matching of symbol to idea.

Within the synthetic method, the circumstances and purposes of adaptation were various. Sometimes motifs were incorporated for reasons of design (as with the Tassaert), more often because overtones of ambience and meaning reinforced the more obvious compositional possibilities, as when Borobudur reliefs, Marquesan tikis or Easter Island hieroglyphs furnish the initial source. But when Gauguin has recourse to 'primitive' cultures, or when he calls upon the Indian, the Egyptian or the Greek, all in order to give substance to apparently Tahitian scenes, when he lights up the background of *The Idol* (c.1899) with *The Last Supper* or gives *The Nativity* a Maori setting he is carrying out that desire for the fusion of distant religions, that longing for a quasi-pantheistic mysticism and occult doctrine that had motivated the school of Pont-Aven, and in its more aberrant forms also marked the idealists of Rosicrucian persuasion. In his recurrent longing for mystery, and in his search for an innocence not of this world, Gauguin continued a character-

istically symbolist quest. Both Redon and Rodin dealt with primitive
man and his awakening consciousness. And Gauguin's awareness
of sin, and of woman's dual role as both its agent and its victim
(*Words of the Devil*, 1892; *Oviri*, 1894), however they were lodged
in the circumstances of his personal history, also belong to the
poetic language of his time. But if his paintings are mysterious, or if
like Puvis (whom he admired) he can evoke a golden age by a frieze
of figures in suspended animation, it is not because, having left a
civilization he detested, his quest for a primitive Arcadia was suc-
cessful; only in his work could he find what he sought, and there
he had to create it — symbolically:

To explain my Tahitian art, since it is held to be incomprehensible:
Wanting to suggest a wild and luxuriant nature, and a tropical sun which
makes everything around it blaze, I had to give my figures an appropriate
setting . . . Hence these fabulous colours, this fiery, yet soft and muted air.
But all this does not exist.
Yes, it exists as the equivalent of this grandeur and profundity, of this
mystery of Tahiti, when it has to be expressed on a canvas three foot square.
The Tahitian Eve is very subtle, very knowing in her naiveté . . . She is
Eve after the Fall, still able to walk naked without shame, possessing all of
her animal beauty of the first day . . . Enigmatically she looks at you.
All this is intangible, they say.
So be it. I am willing to agree.

Here Gauguin outlines a play between an initial idea — suggested
by observation and what is read into it — and pictorial form — in its
turn suggested by the idea and its elaboration. It is a process he
describes in detail when in his *Scattered Notes* he explains the
'genesis' of the *Spirit of the Dead Watching* [12]. He began, he says,
'captured by a form, a movement . . . with no other preoccupation
than to execute a nude'. But he wanted to make it chaste, 'and
imbue it with the native feeling, character and tradition'. And so
he used the bright *pareo*, and the yellow bark-cloth because 'it
arouses something unexpected for the spectator . . . I need a back-
ground of terror, purple is clearly indicated. And now the musical
part of the picture is all set out.'
But the idea, incipient in 'Terror', must be clarified, and made
visual:

I see only fear. What kind of fear? Certainly not the fear of Suzanna
surprised by the elders. That does not exist in Oceania. The *Tupapau* (*Spirit
of the Dead*) is clearly indicated. For the natives it is a constant dread . . .
Once I have found my *Tupapau* I attach myself completely to it, and make it
the motif of my picture. The nude takes second place.
What can a spirit be for a Maori? . . . she thinks necessarily of someone
she has seen. My spirit can only be an ordinary little woman . . .
The title has two meanings, either she thinks of the spirit; or, the spirit
thinks of her.

Thus Gauguin has allowed a naturalistic study (he began with a carefully rendered drawing of the nude) to suggest a meaningful idea, and then sought for its visual equivalents, in order that it might be 'objectified' and communicable to others. So finally, the two had to come together: 'To sum up: the musical part: undulating lines, blue and orange harmonies tied together by yellows and purples (which are their derivatives), lit by greenish sparks. The literary part: the soul of a living person linked to the spirit of the dead. Night and Day.' How closely the two aspects — the one synthetism, the other symbolism — were joined together is made evident from a sentence in Gauguin's letter to Daniel de Monfried, explaining the apparently purely decorative 'sparks': 'These flowers are at the same time like phosphorescences in the night (in her thought). The Maori believe that the phosphorescent sparks they see in the night are the spirits of the dead.' So, through suggestion, and 'without the use of attributes', design and meaning are to become one.

Gauguin's best-known painting, *Where Do We Come From? What Are We? Where Are We Going?* [149] played a crucial role in his own life. During the autumn of 1897, ill and almost unable to paint, in debt and abandoned by those who owed him money, sick at

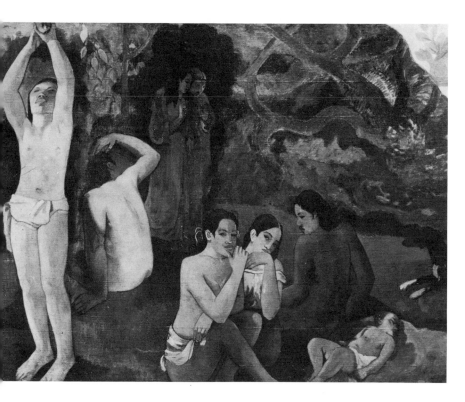

heart over the death of his daughter Aline (in whom he saw the image of his mother), Gauguin decided to kill himself. He wished, before dying, to create one great, last testamentary picture, and he summoned all his strength to paint this canvas, which is his largest. The attempt at suicide failed, and in later letters we have his explanation of the picture and its genesis.

For Gauguin, then, this composition intended as a kind of summing up, was filled with intense personal meaning. In his comment, he stresses that it was painted at fever pitch: 'Lord knows it is not done like a Puvis de Chavannes: sketch after nature, preparatory cartoon, etc. It is all done from imagination, straight from the brush . . . Before dying I put into it all my energy, a passion so painful, in terrible circumstances, and a vision so clear, needing no correction, that the hastiness disappears and life surges up.'

The suggestion of rapid improvisation was only partially true; the important figures and groups had already been employed elsewhere: the idol in *The Day of the God* [25], as well as an earlier painting; the large central figure in a picture done some months before; the woman leaning on her arm, and the bird to the left of the idol, in *Vairumati*, also of 1897, while the pose of the crouching old woman has a history that dates back to *Human Miseries* [72].

Gauguin was thus following his usual practice of additive composition, and this no doubt greatly helped the speed of his invention and his feeling that this work gathered together and completed much of his past art; and the theme is itself a symbolic summation.

Personal to Gauguin in the mode of its creation, its style and its position in his life, *Where Do We Come From?* is also characteristic and expressive of the symbolist period. Its subject (which Gauguin may well have derived from one of the best known of the *images d'Épinal, Les Degrés des Ages*), an allegory of human life from infancy to old age, is an old one. Because of what Gauguin called its 'philosophical . . . theme, comparable to the Gospels' it was popular with many idealizing painters. Artists as different in style as Böcklin, Walter Crane and Gustav Klimt treat it in a variety of ways. It is the connecting theme of a sequence of paintings done over a number of years by Hodler and, as *The Frieze of Life*, it is the preoccupation that unifies the great mass of Edvard Munch's œuvre. (Like Gauguin, but even more explicitly, Hodler and Munch relate the mystery of man's destiny to the puzzle of his relation to nature.) Linked to speculations on the evolution of species it is a major subject of Redon's lithographs.

If Gauguin has found a typical symbolist subject, he is also interpreting it in characteristic fashion. Because although the subject is allegorical, it lacks both the spelled-out iconography and the active inter-relationships of the traditional allegory. Movement is minimal, figures are isolated and self-contained, meaning, rather than adhering to conventional signs, is inherent in poses and attitudes; mood more than story is the binding fabric. Gauguin contrasts his method with that of Puvis; but if Puvis comes to mind it is because Gauguin and the symbolists admired the evocative, dream-like quality of his work; its sense of unspecified 'static allegory' was something they too desired. As Gauguin says, 'Explanatory attributes – known symbols – would freeze the canvas in a sad reality, and the question given would no longer be a poem.' This atmosphere of silent reverie, of a passivity that invites and has an intuition of its tragic destiny, was also known to the poets. Maeterlinck in *The Treasure of the Humble* wrote of the virtues of a silence through which 'there might be heard, above the ordinary dialogue of reason and sentiment, the more solemn and uninterrupted dialogue of the human being and his destiny.'

Symbolist in the subject he has chosen, and in the way in which he renders that subject, Gauguin is also a symbolist in his concept of how the work comes into being. Like Redon, he puts his faith in the unconscious impulses which even Moreau acknowledged and in the allusive inspiration of creation:

There is also this question which perplexes me: where does the inspiration of a painting begin and where does it end? At the very moment when the most intense emotions fuse in the depths of one's being, at the moment when they burst forth and issue like lava from a volcano, is there not something like the blossoming of the suddenly created work, a brutal work if you wish, yet great, and superhuman in appearance? The cold calculations of reason have not presided at this birth; who knows when in the depths of the artist's soul the work was begun — unconsciously perhaps.

Until the end of his life Gauguin continued to state his dislike for 'all the false ideas of symbolist (or any other) literature in painting'; his ideas on *painting*, however, remain symbolist in both formulation and intention; suggestion, music, dream, and finally a non-material idea, all these play crucial roles in his thinking and in his work. 'I have always said, or at least thought, that the literary poetry of the painter was special, and not the illustration or the translation, by forms, of writing: painting should seek suggestion more than description, just as, moreover, music does.'

It is through colour that the desired aim can be reached, 'colour, which, like music, is vibration, is capable of attaining what is most general and by the same token most vague in nature: its interior force'. In this fashion the work will be imbued with an evocative meaning that the painter summons up as his 'eyes close to see without understanding the dream in the infinite space' that recedes before him. And Gauguin makes it quite clear that he has not forgotten the non-material philosophy of his Parisian days: 'My dream is intangible, it implies no allegory; as Mallarmé said "It is a musical poem and needs no libretto." Consequently the essence of a work, insubstantial and of a higher order, lies precisely in what is not expressed; it is the implicit result of the lines, without colour or words; it has no material being.' All this is somewhat unclear, because Gauguin is no systematic philosopher, and the intangible is difficult to grasp. Nevertheless, it is evident enough that he is insisting that the work must go beyond even mood and reverie, beyond the emotional tone induced by colour, to convey by an even greater abstraction (the lines), an idea, an essence, of which the work is only a symbol. This is, once again, the purpose of that 'style' which Gauguin, ten years before in Brittany, had sacrificed everything else to attain. Here in Tahiti, he remains the *idéiste* whom Aurier had described.

7

Correspondences

THE BELGIANS

'It means withdrawing to the innermost recesses of existence, to the dark fantastic place where dreams and visions have their dwelling.' (Verhaeren)

'The life that is genuine, and the only one that leaves some trace, is made of silence alone.' (Maeterlinck)

Withdrawal and silence, or withdrawal into silence, are not the only distinctive marks of Belgian symbolism, but they are its most often proclaimed goals. They are characteristic ideals, not only of the writers – Rodenbach, Maeterlinck, Grégoire Le Roy – but also of the painters of the movement. The motto of Fernand Khnopff was: 'One has only oneself.' Typical as it is, this insistence upon isolation as the condition and the guarantee of quality (one recalls Aurier's *Les Isolés*) was in a certain measure paradoxical. Perhaps because they were few in number in a small country, and lacked any continuing indigenous tradition upon which to call, so that they had to seek affinities beyond their borders, the Belgian symbolists, even more than the French, felt themselves cut off from the practical immediacies and material concerns of their own middle class, with which they nevertheless had close social ties. Yet among themselves they formed a closely knit, cooperative group. As in France, writers were the spearhead of the movement, and the magazines *L'Art moderne* and *La Wallonie*, especially after 1886, furnished them means of its defence. But, unlike Paris, there was not only friendship, but close collaboration, between poets and painters, and the writers furnished the artists with immediate inspiration, comparable to the effect that the more removed work of Baudelaire, Flaubert and Poe had upon Redon. Thus Khnopff drew subjects from Verhaeren, Grégoire Le Roy and Maeterlinck (as well as from Flaubert, Péladan and Christina Rossetti), and used the word 'with' (as 'Avec Grégoire Le Roy, Mon cœur pleure d'autrefois') to indicate

that he was not an illustrator, but their companion in creation.
Mellery based a whole series of mysterious interiors upon a chapter
from Rodenbach; and Minne, who also illustrated Le Roy and Ver-
haeren, could say of Maeterlinck, whose first works he decorated,
'sometimes I have such intellectual communion with him that it
really seems to me that I have made the *Princesse Maleine*, with a
modelling tool or a pen, I no longer know which myself.' Thus the
artist's isolation, real in a fundamental sense, was on a daily level
very relative. On the wider social scene the Belgian symbolist artists
(as well as many of the writers) had a strong interest in *L'Art social*
and in political reform. For them, as for the Belgian innovators in
art nouveau (Henry van de Velde was for a brief while in both camps),
Morris and the later Pre-Raphaelites were an important source of
inspiration, and this carried with it an interest in socialism, or at
least the gospel of a popular art. In this way so secluded an artist as
Khnopff could serve as an advisor to the *Section d'Art* (organized in
1891) of the *Maison du Peuple* of the Belgian Workers' Party, while
Minne, probably through the good offices of van de Velde, was com-
missioned to create a monument to Jean Volders who had been the
editor of its newspaper, *Le Peuple*, though it is some indication of
the problems raised by these outgoing socially communicative im-
pulses that Minne's much criticized model was never carried out.

Although before 1880 Khnopff had already been profoundly im-
pressed by the work of Gustave Moreau, and of Burne-Jones, both
of whom were to be lasting influences, his first major painting,
Listening to Schumann [34], which already has solitude as its theme,
stems directly from James Ensor. There is no essential contradiction,
for all the differences between the soft, illusionistic handling em-
ployed here and the deliberately linear, smooth and brittle style of
Khnopff's later work. Ensor's interiors of this time – *La Dame sombre*
[33], *La Dame en détresse* [99], or *La Musique russe* [35] which is
Khnopff's immediate model – go beyond the recorded surface of
their subjects, accurate as this is. In these rooms a claustrophobic
heaviness is hardly alleviated by some light from the outside;
figures are immobile, alone or without direct communication with
each other; the rooms seem filled with some pervading, subduing
presence to which the people are compelled to listen. Action is sus-
pended, there is a sense of attentive waiting for something undefined.
In these early works of Ensor there is already implicit, beyond the
realist surface, that feeling for the 'static theatre' of everyday life
which Maeterlinck will make theoretically explicit in the following
decade, and which Ensor himself will abandon for the more overt
symbolic play between appearance and reality conveyed by his
many paintings of figures in masks, and of masks whose wearers
and their useless deceits have been discarded.

150. *L'Art* or *Les Caresses*, 1896. Khnopff

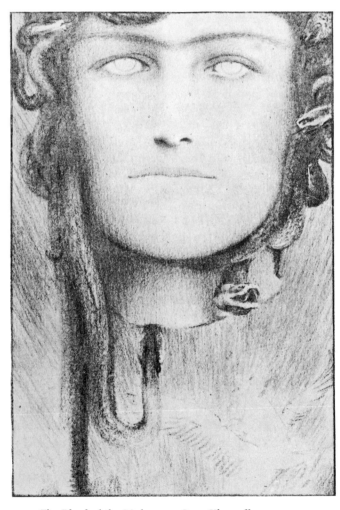

151. *The Blood of the Medusa*, c.1895. Khnopff

To indicate that his purpose is something more than the rendering of a naturalistic interior, Khnopff includes only the right hand of an otherwise invisible pianist, and turns the listening woman away from him; she hides her face behind her hand further to emphasize her solitude.

Khnopff's characteristic style appears in a painting shown at the Brussels Salon in 1884. *Une Sphynge* (significantly also called *Un Ange*) is the first of a number of subjects inspired by Péladan, also the first of a series which depict the ideally evil woman, the enigmatic temptress with the seductive, ironic smile, Khnopff's vision of *La Belle Dame sans merci*. This image of man's baser side, seen as a woman both appealing and domineering, whose animal nature associates her with snakes or leopards, Khnopff repeats in a variety of guises, largely inspired by Moreau and Péladan: *De l'animalité* (1885), *L'Art* [150], *The Blood of the Medusa* [151]; characteristically, she remains inaccessible and well-bred, the very opposite of Félicien Rops' rendering of the same symbol. Since technically Khnopff's style was everything the Sâr prescribed (linear, finished, and altogether controlled, with no remaining evidence of its materials or its making), it is revealing that he considered Rops by far the greater artist; perhaps he sensed that Khnopff's reserve made him inept for adherence to any whole-hearted faith, even that of the Rosicrucians, with whom, however, he exhibited four times. Even in *L'Art* [150] the youth, presumably the artist, is only half seduced by the self-conscious sphinx with the spotted body and the mystic smile, and passionate belief seems lacking.

True to the obsessive symbols of his time, Khnopff also portrays another woman, equally remote and inaccessible; she is the strong-willed, self-assured, idealized embodiment of all that is pure and good. This series begins with *The Portrait of the Artist's Sister* [152] who, as Francine-Claire Legrand observes, is shown as indifferent and remote, her expressionless gaze to the side avoiding all 'contact between painter and model, and between model and public'. The closed door behind her 'shutting off an unknown world, a secret shrine of which this woman is the priestess'. Khnopff's sister is again the model for *L'Isolement* (1892) and *Arum Lily* (1895), dressed in the same chaste fashion, and given in the one hand a sword, and in the other a favourite flower as attributes of the pure ideal she represents. She appears also as one of the figures in that strange assemblage called *Memories* [153], in which a group of figures (or perhaps the same one, repeated), frozen in attitudes of isolation, remain strangers to each other. Their unity lies not in the actual incident (ostensibly a croquet game), but only in the 'memory [which] can mark the enigmatic nature of the links between them . . . can break the spell, and fuse reality and dream by showing their

essential unity'. Thus Khnopff, who painted this picture from separate photographs (in a practice not so far removed from that of Gauguin), has like Hodler, and not unlike Puvis, created a static, repetitive procession to convey the greater reality of a state of mind.

But good and evil are not always clearly distinguished. As Verhaeren remarked, Khnopff's women, 'with their glacial attraction

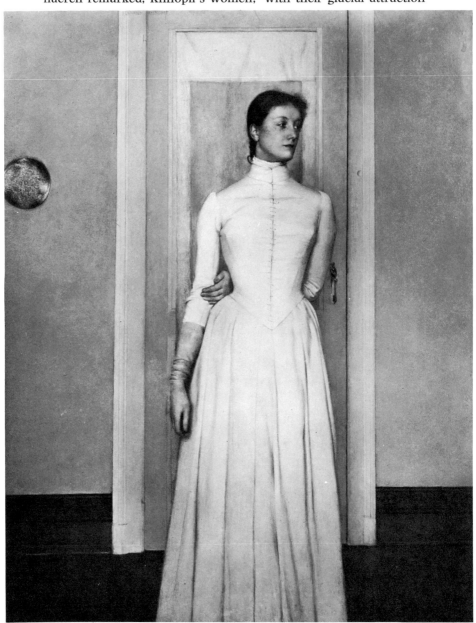

152. *Portrait of the Artist's Sister*, 1887. Khnopff

and medusa-like perversity . . . mouths slit as if by a fine horizontal
sword-cut, and smooth brows . . . are above all the aesthetic ex-
pression of his ideas. His art is refined, complicated by mysterious
and puzzling meanings elusively filtered through a multiplicity of
allusions.'

His ideal is perhaps most clearly rendered in the picture *I Lock*

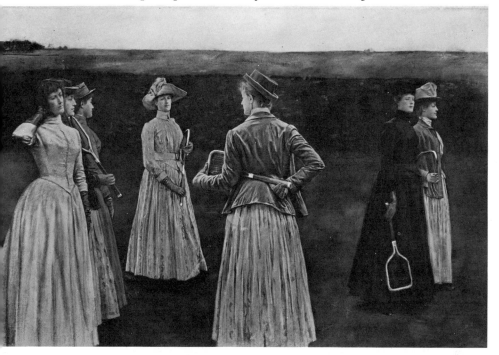

153. *Memories*, 1889. Khnopff

My Door Upon Myself [40], whose title comes from a poem by
Christina Rossetti. The Pre-Raphaelite influence is very strong here,
as it is in many other paintings, not only in the ecstatic gaze of the
lady who leans her strong-willed chin and spreads her abundant
hair upon her tapered fingers, but also in the elongated rectangles
of the composition. Khnopff generally composes in a style of 'straight
line *art nouveau*' to which oriental proportions were not unfamiliar.
The secretive lady is flanked by lilies, and behind her is the winged
bust of *Hypnos* owned by Khnopff, and to which he had built an
altar in his studio, since for him it had a transcendental meaning.
Khnopff's studio and house, created in his own image (as van de
Velde and Guimard created theirs), were an austere refuge from the
world, a spare and spiritual temple of art, over whose front door
was the disenchanted legend: *Passé-Futur*.

Rodenbach had been a dominant influence in Khnopff's doctrine of artistic isolation. They were together in Paris in 1878, when Rodenbach attended Caro's lectures on 'Pessimism in Schopenhauer and Leopardi', a subject on which he later lectured in Belgium, and (as Legrand suggests) Khnopff may well have gone to one or the other. In 1888 Rodenbach published *Du Silence*, and in 1891 *La Règne du Silence*. From his pessimism stemmed the idea of 'solitude raised to the level of a moral principle', and he, like Maeterlinck, conceived of an active silence 'as a force that makes it possible to communicate with the unknown'. Khnopff's paintings often seem to illustrate these lines of Rodenbach: 'Thus my soul, alone, and which nothing influences: it is as if enclosed in glass and in silence, given over entire to its own interior spectacle.'

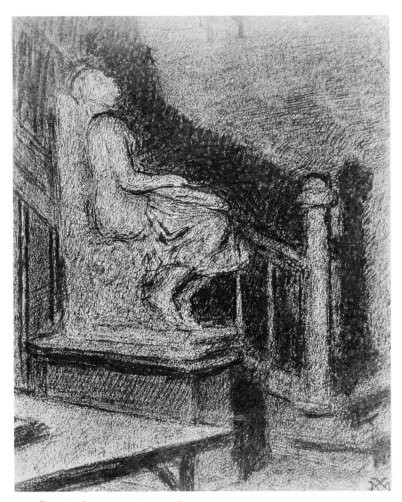

154. *Evening Dream*, *c*.1890. Mellery

A similar attitude of solitary communion also inspired the symbolist work of Xavier Mellery, who had been Khnopff's teacher at the Academy, but he came to it only in the nineties, well after his pupil, and following a decade of highly traditional painting and a period of naturalistic and romantic genre subjects. *Isolé* though he was, Mellery's mysticism was of a more pantheistic kind, oriented towards an intuition of the world of nature and of things. 'The problem of the work of art,' he said, 'is to embrace a subject with a unity as great as that which the plant and the tree have with their innumerable branches and leaves, making a sublimely homogeneous whole.' He was perhaps predisposed to this evolution by the environment of his childhood, his father being a gardener for the Royal Park in Laeken, so that as with Maeterlinck in Ghent and Gallé in Nancy, he experienced very early a kind of osmotic participation in the silent life of plants and flowers. Rodenbach's writings also played a role. A series of drawings he called *L'Âme des Choses* derives from *La Vie des Choses* in *La Règne du Silence* and from *Le Crépuscule au Parloir* in *Le Musée des Béguines*. In these dark drawings, in which the vibrations of shadowed light play a pantheistic role similar to that intended by Carrière, Mellery transforms everyday objects into symbols: stone stands for strength; a rising staircase suggests an ideal to be attained [154]; the slow growth of plants implies endurance and tenacity, and the filtering light, however dim, a universal life that never completely dies away. In the same dark manner Mellery also did a series of more obviously idealizing decorations — *Dance, Friendship, Art Reaches to Heaven and to Earth*, in which silhouetted figures in slow trance-like movement are the indicators of lofty states of mind; these are closer to conventional reverie. Mellery said that he had 'experienced certain contacts which seemed to . . . be occult voices of heaven.' But his feeling of the universal 'sense of things', of man's union with the forces of an unseen world, is expressed much more directly through the empty, silent crepuscular interiors of *L'Âme des Choses*.

Both Khnopff and Mellery considered art a median term between the visible and the invisible; in this they are altogether symbolists, yet in Albert Aurier's terms, although they are idealistic, Khnopff at least is altogether not an *idéiste*. This is to say that his yearning for a world of higher things is contained almost entirely in the associations of his representations, and very little in the expressive form of his compositions. Thus Khnopff's art contains no synthetist element, unless it can be said to be in its unobtrusive, transparent métier, which allows meaning to shine through pure and undistorted; but this is to deny that the sensuous elements of painting can in any way suggest emotions or ideas, and so to deny any theory of correspondences. Perhaps this is because (as seems to be

the case) he worked out the intellectual basis of a personal aesthetic
before developing his style.

Georges Minne's art was also strongly marked by his literary
friendships. At the age of twenty he found a spiritual communion
with Maurice Maeterlinck, just returned to Ghent from a winter in
Paris with Grégoire Le Roy. There they had met and been inspired
by Villiers de l'Isle Adam, author of *Axël* and *L'Eve futur*, had also
met Verlaine, and had founded their own little revue, *La Pleiade*,
which had eighteen subscribers during its six-month existence. The
poets' mood of *ennui* and silence, of helpless velleities and resigned
inaction was entirely congenial to Minne. In close collaboration
with Maeterlinck during the following year he did drawings for
Serres chaudes [49] and *La Princesse Maleine* (hand printed in mini-
scule editions), and for Le Roy's *Mon Cœur pleure d'autrefois*. The
simplified drawing he employed, influenced by late medieval Ger-
man woodcuts (it preceded a parallel interest of the Pont-Aven
group), was in accord with a common desire to find renewal in the
simple, but more profound, traditions of the past; it was a return to
sources, like that of Gauguin, although never elaborated in the
same theoretical way. Besides this was the time when Maeterlinck
was engaged in the translation of Ruysbroeck's *Adornment of Spiri-
tual Marriage* (as he was later to translate Novalis), and the same
mystical attitudes were at work in Minne.

Maeterlinck called Minne's sculpture '*statuaire statique*'. He was
of course implying a parallel to his own 'static theatre' and a com-
mon desire to give symbolic expression to the modern, externally
undramatic human condition in which, as he said, 'men's tears
have become silent, invisible and almost spiritual', their lives flat
tragedies without any redeeming romantic action. Since Minne too
conceived of art as a method of communication with the ideal he
attaches no importance to the usual sensuous qualities of sculpture.
As André Fontainas remarked, 'It is not the expression of the eyes,
or of the face, or the modelling of the muscles that is to be admired;
plasticity is only an intermediary able to reveal something more
profound and more intangible, the drive of instincts, or the obscure
impulse of the soul.' But since Minne must employ the human form
to symbolize pathetic states of mind, he wishes to minimize its in-
evitable material presence. To this end skeletal structure and muscu-
lar tension are hidden beneath a soft unity of surface modelling (as
in *Mother Mourning Her Dead Child* [155] and *Mother Mourning over
Her Two Children*, 1888), and a fluid line joins head, torso and limbs
in a continuous rhythm. (When action is rendered in such a style it
is awkward and incongruous [*The Mason*, 1897], or reduced to a
kind of ritual dance [*The Little Wrestlers*, 1886]; realistic portrayal
is never truly intended.) Characteristically, Minne's figures are

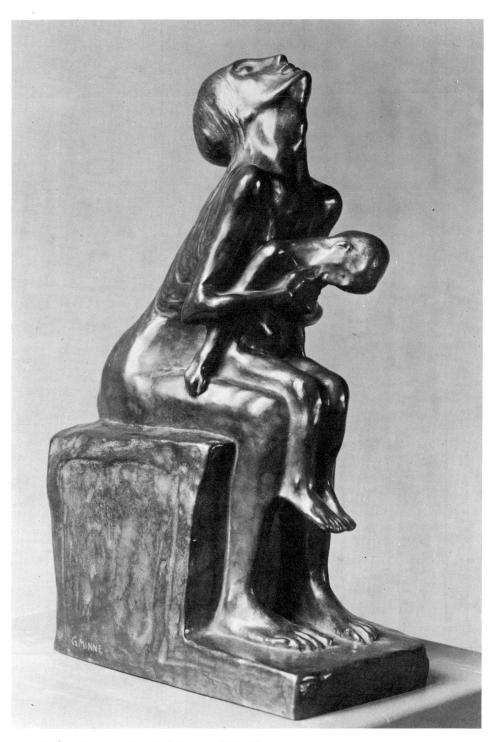

155. *Mother Mourning Her Dead Child, c.*1886. Minne

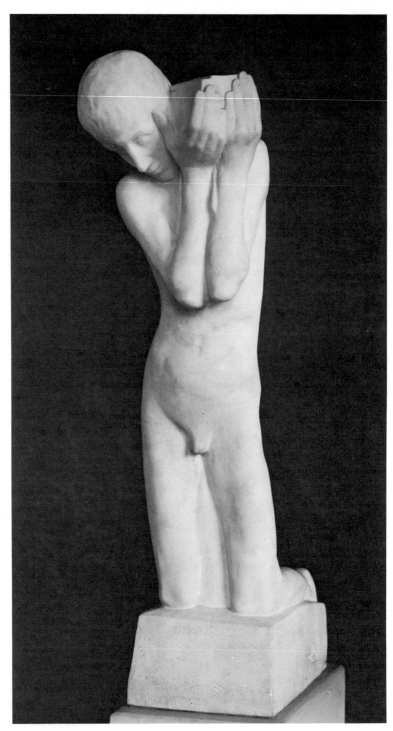

156. *Relic Bearer*, 1897. Minne

157. *The Fountain of the Kneeling Youths*, 1898–1906. Minne

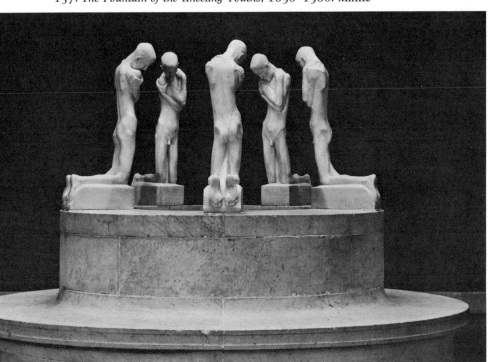

oblivious of anything but their own emotion; clasping to themselves their regretful emaciated bodies, they contemplate a world within. If Minne so often uses a kneeling posture, it is because he thus inhibits movement and implies humility in a pose at once natural and symbolic. A mood of acceptance (of 'white inactions' as Maeterlinck wrote in *Serres chaudes*) is suggested, but except in *St John the Baptist*, 1895 (and even he does not really pray but, holding his head in his hands, considers his suffering) there is no explicit religious iconography, though one infers the presence of obscure, surrounding forces. In the end the figure remains in dolorous isolation, its body an encumbrance to thought. Minne's obsession with the enervated world of the adolescent, with its overtones of mysticism and anxious sexuality is very much of his time (Munch especially comes to mind, and, somewhat later, Schiele). The elegiac, semi-classicizing drawings of Charles Ricketts (e.g. *Eros* and *Anteros*) or the more sinister ones of Aubrey Beardsley may indeed have been the immediate precedents for his emaciated boys, but they now express an occult temperament.

Two such contemplative single figures — *Small Kneeling Youth*, 1896 and the *Relic Bearer* [156] — precede Minne's culminating conception, *The Fountain of The Kneeling Youths* [157] (commissioned in marble, 1905, at the urging of Henry van de Velde, by

K. E. Osthaus for the Hagen Museum). Minne has repeated the identical attenuated, narcissistic figure five times around the pool, so that, although the same in himself, he is various and changing to the observer who must see him from the outside. He has no connection with momentary externals, but directs his thought within, absorbed in a vision more profound than that of the physical world. By this means he directs us away from appearance, towards that world of ideas in which he is absorbed, and of which he is the image. Minne was not alone in making use of this sort of symbolic repetition. Rodin transformed his Adam into *The Three Shades* above *The Gates of Hell* (a perhaps influential example for the Belgian, who visited Rodin in 1891), and it became an aesthetic principle for Hodler, who used it constantly, e.g. in his *Disappointed Souls*, by which he was represented at the first (1892) *Salon de la Rose + Croix*. These figures too are captured by thought, generalized in their iconography, therefore suggestive and equivocal. Minne's fountain was called 'Narcissus in five-fold reflection' and Gide's *Treatise* and Valéry's poem *Narcisse parle* come to mind, and the silent fountain in Maeterlinck's *Pelléas and Mélisande*. They are all captured by an inner universe of mood and feeling, part of that true world which is unseen.

MUNCH

'Beneath consciousness lies that great area of the soul (subconscious) which is still a total mystery, but which demonstrates its workings in dreams, in the somnambulistic state under hypnosis and which existed before one's earthly life and which will exist after death. From there arise . . . [anxiety], the passions, love, hate, and all that which occurs without reflection.' (Gerhard Gran, 1893)

'Munch sees . . . the branches of trees in waves, women's hair and women's bodies in waves . . . He feels colours and he feels in colours . . . he sees sorrow and cries and worry and decay. He does not see yellow and red and blue and violet.' (Sigbjorn Obstfelder, 1892)

In the autumn of 1889 Edvard Munch arrived in Paris on a Norwegian state scholarship. His intention was to study under the conservative direction of the academician Léon Bonnat; the outcome was very different. He left Bonnat's studio after a few months, and during the three years spent (with summer interruptions) in France before the Oslo exhibition of 1892 which prompted Obstfelder's description of his vision, Munch found that his artistic affinities lay elsewhere. As Christian Krohg said at the time, 'Munch is the only one, the first one to turn to idealism, who dares to subordinate Nature, his model, to the mood . . . It is related to symbolism, the latest movement in French art.'

Today it appears evident enough that Munch had set out upon

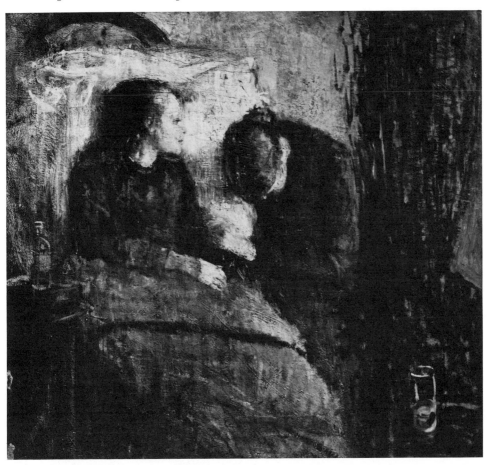

this path years before he came into contact with French symbolism. *The Sick Child* [158], although it is in one sense a bourgeois genre scene in the manner of the Norwegian painters Krohg and Hans Heyerdahl, has wider overtones. It belongs with those interiors of Ensor and Carrière painted during this same time, in which states of feeling, rather than observed details of environment or anecdote, are the true subjects. Munch has followed Hans Jaeger's advice to seek the subject of his art within his own experience (as did Carrière and the early Ensor), but as Reinhold Heller has pointed out:

Munch refuses to give the sick girl positive portrait-like features and places the scene within an almost vaporous atmosphere where solely she and her mother possess true plastic values . . . By his de-emphasis of detail throughout the painting, Munch replaced the specific with the universal . . . to permit the mood to emanate from form and colour, from general gesture and posture . . .

This is the very opposite of impressionism's camera eye.

Here, and in the related *Spring* [6], Munch, haunted by the tragic experience of the deaths from tuberculosis of his mother when he was five and his sister when he was thirteen (cf. the later *Death Chamber* scenes), is already beyond realism, using observation to show, not a single accident but the constant menace of death. Motionless as these pictures are, they already contain that pre-

159. *Night in St Cloud*, 1890. Munch

occupation with time – with the eternal round of life – that runs
through Munch's whole *œuvre*: in *Spring* the contrast is between foreshadowed death within the room and the sunshine of rebirth on the outside.

These paintings and the first versions, now destroyed, of *Puberty* and *The Morning After*, have been called expressionist. This is true only in so far as they have an immediate foundation in Munch's own personal experience. In style they have none of expressionism's gestural intensity and representational exaggeration, while in subject they are naturalist, in accord with the artistic ideals of Munch's friends among the Christiana Bohème, whose models were Ibsen, Bjornson and Zola. But Munch has generalized his theme (Jaeger's dictum that work should be done from memory is not unlike the advice that Bernard gave to Gauguin), has suggested something more inherent and more fateful than the accident of a single life, and by using colour and bodily attitudes (without attributes) has come to the edge of symbolism. These works show us why Munch would be receptive to the new non-naturalist directions which he was soon to come into contact with in Paris. Twenty years later he wrote that in *The Sick Girl* 'I broke new trails for myself – it was a breakthrough in my art. Most of what I later did was born in this painting.'

Night in St Cloud [159] is another such emotionally constrained and unified interior, whose mood is prompted by personal tragedy. Painted at St Cloud upon learning of the death of his father, with whom he was in conflict, it has an angular perspective structure based upon impressionism (perhaps specifically Degas, as Svenaeus has suggested), and it is also a study in the effect of light and colour to evoke mood, perhaps influenced by Whistler. But the naturalism, rather than being an end in itself, is employed as a pictorial equivalent. The featureless figure pushed to the farthest corner of the room, the dark browns and purples of the dim moonlight on the walls and curtains, the glimmer of space in the distance, all these contain and become the picture's subject, more symbolic than the cross cast by the shadow of window frame upon the floor. It is the self-portrait of a man who, as Munch said, 'is communing with the dead'. Thus during these first years in France while Munch was absorbing elements of composition and palette from Pissarro and Monet (e.g., *Rue Lafayette*, 1891), and from the neo-impressionists (e.g., *Spring Day on Karl Johan Street*, 1891), he was also aware of the new tendencies in French painting and was moving towards a much more introspective art, in which the spectacle of nature would symbolize an interior landscape. He would 'depict external reality as it was reflected on the subjective mirror of his soul'. And so he noted in his diary in a statement written at about the time he painted *Night*:

No longer will interiors and people reading be painted.
There shall be living people who breathe and feel and suffer and love.
I will paint a number of such paintings.
People will understand that which is sacred in them and will take off their hats as if they were in church.

Or, as he wrote a year later, while he was working in Nice:

In these paintings [in which 'a tree can be red or blue . . . a face can be blue or green'], then, the painter depicts his deepest emotions. They depict his soul, his sorrows and joys. They display his heart's blood.
He depicts the human being, not the object.

So Munch moves towards the expressive use of both form and colour, employing them to convey his own dark moods. The 1888 *Evening Hour* [160] is a thoroughly naturalistic scene of house and landscape in perspective, given a somewhat melancholy tone by the brooding look and contemplative pose of the girl (Munch's sister) seated in the foreground. It is a sensitive genre scene, or at most a *Naturstimmung* [mood landscape], in which the isolation of the

160. *Evening Hour*, 1888. Munch

figure is really only hinted at. What is essentially the same theme develops, however, into the study of *Despair* [161, 162], in which a dramatic deep perspective like that with which Van Gogh intensified his pictures, has been fused with the sweeping curves of shore line and clouds that (in the manner of Gauguin) flatten and unify the design on the surface through the use of simplified, expressive colour areas. Thus the tension in the pictorial space, whose depth is both stressed and denied, is the visual equivalent of the

psychological conflict in the man seen in profile in the foreground, who, isolated in his own thoughts, nevertheless remains painfully conscious of a world from which he is cut off. In *Melancholy* (or *Evening*), scene, design and mood are even closer to Gauguin and Pont-Aven, of whose work and theory (through Aurier's March 1891 article) Munch may have been aware before he returned to Norway. Although this is not a self-portrait, being inspired by the love agonies of a friend, its emotion has intimate roots in his own experience but, as with Gauguin, the intended overtones, the symbolist suggestions, reach far beyond the personal. *Spring Evening on Karl Johan Street* [163] employs the same meaningful contrast of great depth and strong frontality. In the earlier *Military Band on Karl Johan Street*, 1889, the figures are set at intervals within the receding space and warm atmosphere. But now they flee as from a hostile, lowering sky, confronting in crowded anxious isolation, not us, at whom they seem to stare, but some awful interior vision. As with Ensor's masks, and Redon's heads suspended in the sea of creation, which these skull-like heads resemble, they perceive the reality of another, invisible world.

Munch engages these unseen mystical powers in other pictures as well. Only a few (e.g., *Mystic Shore*, c.1892 or *Starry Night*, c.1893) are unpeopled, expressing their sense of hidden pantheistic presences through vague mysterious light and continuous rhythms that move through shore and sea sky, suggesting an occult power that binds them all together. More often a frontal figure, static, self-contained, in no active relation to its surroundings yet immersed in

162. *Despair*, 1892. Munch

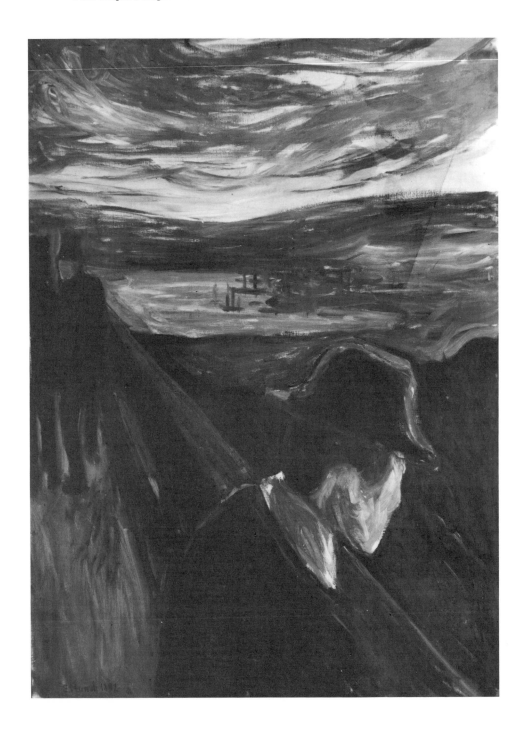

them by repetitive harmonies of line and colour and a pervading light, indicates the existence of a spiritual universe that controls both nature and man. So in *Moonlight*, 1893, the movement in the purple sky echoes the curves of the dark foreboding shadow the figure casts upon the house behind it, a vague indication of pervasive menace.

As Reinhold Heller has shown, the beginnings of Munch's interest in painting pictures which together would make up a *Life Frieze* go back to 1892, when he gave directions as to how certain of his works should be hung together, to make up a series. He was particularly concerned with the subjects of 'love and death'. Then in his Berlin exhibition of December 1893, six paintings were listed under the heading 'Study for a Series Entitled "Love"', and these were at the origin of the continuing *Life Frieze* to which, directly or indirectly, so much of Munch's subsequent work was related. They included the following: *A Summer Night's Dream (The Voice)* [164]; *The Kiss* [23]; *Love and Pain (The Vampire)* [165]; *The Madonna* [166]; *Jealousy* [167]; *Melancholy* [38]; *Despair (The Scream)* [59].

164. *The Voice*, 1893. Munch

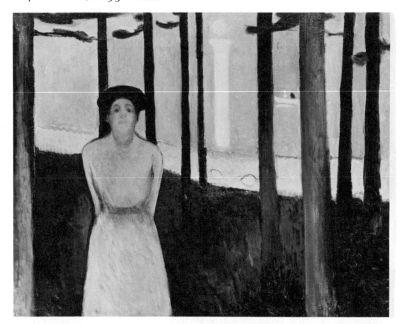

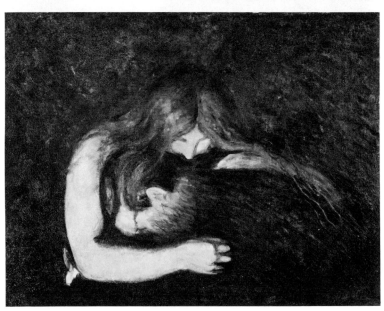

165. *Love and Pain (The Vampire)*, c.1893–4. Munch

The title of the series suggests a comparison with Max Klinger's series *A Love*, ten etchings done in 1887, but despite the similarity of theme the two are utterly different. As Heller says, 'Klinger's

naturalistic and paraphrasing images, with their roots in contem-
porary fashion and cliché, contrast to Munch's new images with
their neurotic sensitivity as they re-enact the dreams of individual,
emotional states of attraction, union, separation and despair.' Be-
sides Klinger's tale is a cautionary one, which clearly states that
'the wages of sin is death', whereas for Munch these states of con-
sciousness, going from puberty through ecstasy to despair, are
inevitable and universal. Munch's concern, one might say his

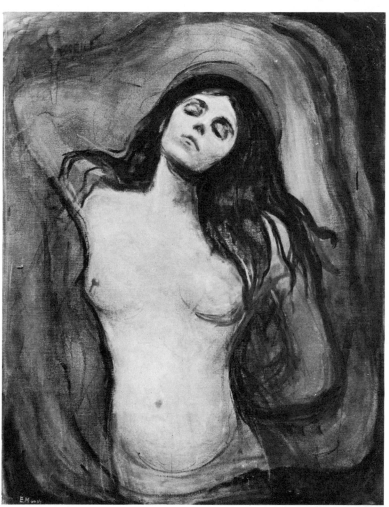

166. *The Madonna*, 1893. Munch

obsession, with sex and sexual psychology, his ambivalence to-
wards women, was grounded both on personal experience and the
specific artistic milieu of Norway: his linking of woman and death

was due to the painful history of his own family, his conception of adolescence (as in *The Voice*) was derived from Hans Jaeger and Kristiania's *Bohème*. But these were concerns he shared with the writers and artists of symbolism in general. It is not Munch alone who both fears and longs for the loss of man's individuality through love of women (*The Kiss* [23]), who associates love and death (*The Madonna* [166]), or who recoils from the power over man that sexual attraction gives the woman (*Love and Pain* [165]); these were the repeated subjects of the poets and painters of the time.

In subject then (and these subjects are to be the continuing themes of his art) Munch belongs to his period, but it is above all the manner of their interpretation – in style – that confirms his affinity with symbolism. Not that Munch specifically subscribed to any idealist, or an *idéiste* philosophy as it was outlined by Aurier. But like his contemporaries in Paris (and unlike Klinger, Böcklin and the other German painters of *Gedankenmalerei*) he put the meaning of his pictures into design and colour, and into the stance and gesture of the whole human body, whose pose and contour flowed and fused with a larger composition that gave direct expression to the mood and substance of the theme. As Herman Esswein said of *The Vampire* (*Love and Pain*) 'Munch's symbols still remain totally free of symbolism here, do not have need of paltry attributes.'

Whether or not Munch was directly influenced by Pont-Aven and the Nabis, his stylistic purposes are clearly similar; thus in *The Voice* [164] the design of repeated verticals is akin to the serene compositions of Maurice Denis and the early decorative screens of Vuillard, though the dusk-darkened hues and laden atmosphere express an altogether different kind of melancholy exaltation, while in *Melancholy* [38] the rocks become semi-abstract colour shapes, the undulating shore line continues in the bands of the sky, and the suffering figure squeezed into the foreground corner turns away from an indifferent world, like the Gauguin Christ of his *Gethsemane* [81] aware only of his own suffering.

The last painting in the series of six, now known as *The Scream* [59], is stylistically and emotionally the most 'expressionist'. It was originally called *Despair*, and its composition not only combines dramatic perspective and swirling planar colour (like the earlier picture of the same name) but it also moves both inwards and outwards. The desperate figure is overwhelmed and diminished by the expressive energies which converge upon it, yet the cry that issues from its hollow oval mouth expands in waves to encompass, in fact to become, the visionary landscape which is the reason for its fright. The acute nervous tension of a single figure has revealed hidden pantheistic forces, and the two have become one. Neither figure nor landscape is real, but rather the synthetist pictorial equivalent of an

idea. Like Redon, Munch is putting the visible at the service of the
invisible, employing line to portray hidden forces, and putting the
universal *Scream* of the title into what Christian Krohg called
'resonant colour' in order to make it heard. The reference here is of
course based on the 'correspondence' between colours and sounds
which is an essential part of the symbolist attitude. When *The
Scream* was shown in Berlin Munch's friend the writer Przybyszewski
commented: 'In a magic way a sound can evoke an entire life in
endless perspective, a colour can become a concerto, and a visual
impression can arouse terrifying orgies in the depths of the soul.'
And in his novel *Overboard* he has Munch say: 'Have you seen a
shrieking sky? I have seen it. It was as though the sky opened up
into a thousand oral cavities, shrieking colour into the world.' In
this conception, not only do man and the universe meet and com-
municate through symbolic correspondence, but also reflecting
Swedenborgian thinking even further, the universe itself is con-
ceived as having an analogous human form. It is the same sort of
pantheistic awareness that Knut Hamsun was expressing in *Hunger*
and his other novels.

Munch's circle of friends in Berlin (where he spent most of the
years 1892–5) was very much aware of the symbolist trends in
Paris, and they, unlike the German critics, understood Munch's in-
tentions. Przybyszewski defined them in terms that would apply
equally well to Redon, with whose lithographs Munch was familiar:

> The old kind of art and psychology was an art and psychology of the
> conscious personality, whereas the new art is the art of the individual. Men
> dream, and their dreams open up vistas of a new world to them; it is as
> though they perceived things with their minds and ears, without having
> heard or seen them physically. What the personality is unable to perceive
> is revealed to them by the individuality – something that lives a life of its
> own, apart from the life of which they are conscious.

This is language which Gauguin also would have understood, both
in its vocabulary, and in its stress upon those unconscious means
that establish the connections among men and between men and
an invisible reality; it implies symbolism's idealist metaphysics,
though it does not spell it out.

August Strindberg was an intimate of the Berlin group that in-
cluded Przybyszewski. The three shared an extreme pessimism
towards life in general, which in turn gave rise to a violent
mysogyny even though Munch's attitude to women was a good
deal less violent. The mistrust of woman is an almost necessary con-
comitant of symbolism: she is the constant reminder of that world
generally called real, but which is only a false appearance, she is the
temptress who reveals man's animal nature and prevents his union
with the ideal. This attitude, common to the period (as we have

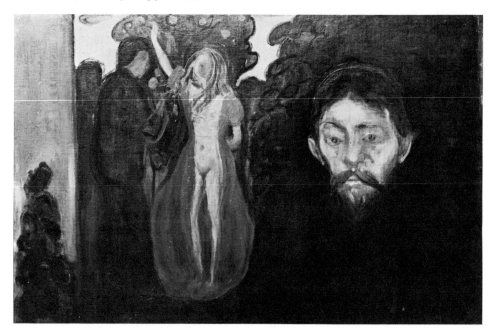

seen), was carried to its limits by Strindberg and Przybyszewski whose obsession with sex was matched only by their fear of its attractions. In June 1896, when Munch was given an exhibition at the *Revue Blanche*, Strindberg gave this interpretation of one version of *The Kiss*: 'The man who gives, giving the illusion that the woman also gives, the man asking the favour of giving his soul, his blood, his liberty, his peace, his salvation, in exchange for what? In exchange for the happiness of giving his soul, his blood, his liberty, his peace, his salvation.' To a lesser degree, Munch shared these fears; some of his titles are a clear enough indication: *Vampire*, *Jealousy*, *Separation*, *Woman in Three Stages*, *Ashes*, *The Madonna*. These are all allegorical subjects, telling a story through the depiction of figures which refer to a wider meaning. They are also expressionist in their projection of an intense personal emotion (however much the character of the times helped determine the nature of that emotion). But Munch's purpose as an artist who shares the aesthetic aims of his period (as well as an individual who shares its feelings) is to fuse message and pictorial means. Both allegory and emotion must be conveyed directly by the methods proper to painting, so that line and colour are perceived as their symbolic equivalents, and, without description, carry in themselves the 'intangible idea'. So in *Jealousy* [167] there is a reference to Eve who picks the sinful apple, but it is the flame-red of her open cloak, and the spatial dichotomy between the couple and the figure who sees them though he does not look

that convey the idea of an obsessive nightmare – a reality of feeling
only. In *Ashes* (1894), with the spermatozoa-like forms of its frame,
there is again the same isolation of the figure, the same suggestion
that the woman exists only as man conceives her, and that the
dark pinewood is equally the projection of his state of mind.

It might be supposed that in these pictures the isolation of the
figures, their self-absorption and lack of communication is a func-
tion of their specific subjects. But they stem from a much more
general principle of Munch's art and are a means whereby he
suggests the ideational intention of his portrayals. In this he is very
much of his period: Puvis, Gauguin, Khnopff, Hodler, all in dif-
ferent ways restrain their figures, minimize or eliminate all action,
in order to indicate that they have something other than a physical
existence. As in the quiet, frieze-like quality of Puvis' paintings, of
Gauguin's *Whence Do We Come?* and *Faa Ikeihe*, in which the
'Turkish' manuscript's instructions to avoid all motion are still
kept in mind, so in *Woman in Three Stages* [168] and *The Dance of
Life* [169], the figures are spread evenly across the canvas, hold-
ing the 'plane surface' by their size and their position in the fore-
ground. But with Munch (unlike Puvis and Gauguin), isolation
never means relaxation, and there is always a strong sense of ten-
sion felt across the separating spaces. This connectedness is some-
times described by iconographic means, as when, in *Separation* and
Ashes, flowing, reaching strands of the woman's hair show us the
obsessive web in which man remains entangled, or as in *Madonna*
the hair billows out to become the expansive energies of creation
itself. (In the 1895 lithograph, embryo and spermatozoa complete
the narrative of birth [65], as the frame did in the earlier painting.)
Here Munch, like Toorop and other symbolists, has learned from
the Pre-Raphaelites, whose practice also influenced the more purely
decorative uses of hair and drapery so widespread in the designs of
art nouveau. But more basically (and more generally) the unifying
consciousness is conveyed directly by the interlocking rhythm of
the composition, whether of the shore-line or the figures; contours
echo each other across intervals, and intervening spaces take on a
positive existence; thus the separate figures are caught up in an
ambience of mystery, which they help to create, but from which
they cannot escape.

The fusion of permanence and time, the recognition of the im-
mutable repetition of change, is perhaps best seen in *Woman in
Three Stages* [168] and *The Dance of Life* [169]. Both interpret 'the
sexual problem' in Munch's characteristic way, with a pessimistic
fatalism akin to that of Strindberg. Each is also a round of life, in
which the three women stand for that succession of youth, maturity
and old age through which all must pass. (There is also implicit an

168. *Woman in Three Stages*, 1894. Munch

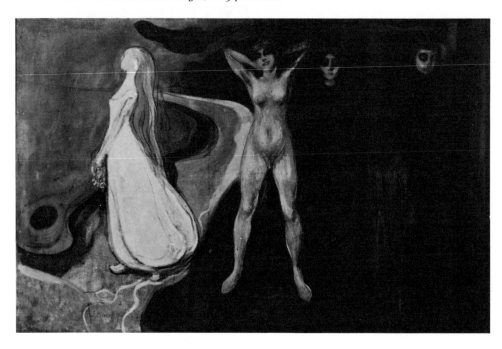

169. *The Dance of Life*, 1899–1900. Munch

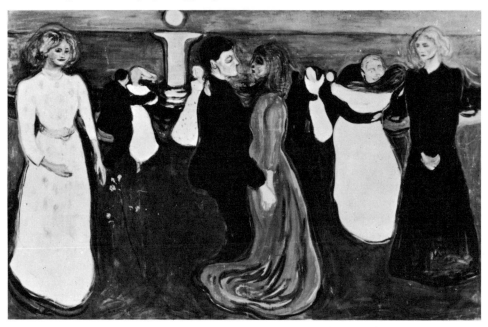

ironic equation with the traditional dance of death.) But each also, through pose and dress, and symbolic colour, can be read as setting forth the three aspects of woman's eternal nature, seen from the point of view of man. Described in Jungian terms, she makes her appearance first as the mother figure (which for Munch, because of his mother's death, meant abandonment and betrayal), second as the object of desire, and third as the anima or soul figure, mistress of the psyche. So in this way too the changing and the changeless have been brought together; these figures, if they move at all, do so not of their own volition, but as automatons caught up by out-side forces, of which, in turn, they are the symbols.

After 1900, and especially after his permanent return to resi-dence in Norway in 1908, Munch's art relaxes. With the expres-sionist intensity subdued in favour of more cheerful moods, the unity of theme and style that characterizes the previous decade also diminishes. Now Munch works more directly from nature, in both landscapes and portraits; his palette lightens and his surfaces and contours become more painterly. His interest in symbolist subjects nevertheless continues, he adds to the series of paintings, begun in the early nineties that together make up 'The Frieze of Life', and he executes the allegories for the Aula of Oslo University. But the in-creasing naturalism of these works, their deep space (often in itself

170. *The Sun*, c.1911–12. Munch

intended to carry mystic meaning), the weight and three-dimen-
sionality of the figures, lessens both the flat, decorative unity, and
the immediate abstract expressiveness typical of Munch's earlier
style. *Life* (1910) is a renewal of an old symbolist theme in which
details of costume, expression and the foliage of the central tree of
life seem to intrude so that the rendering of appearance disturbs the
synthetist rendering of the underlying idea, and imitation has inter-
fered with symbolist correspondence. The same is true of most of the
Oslo wall-paintings. Only in *The Sun* [170] has perhaps a new ex-
pressive unity been attained, but now on the basis of a fragmenta-
tion of line and a breaking up of colour areas in such a way that the
two are hardly to be distinguished. In the brilliantly coloured, radi-
ating energy of this composition Munch comes close to abstraction.
If this is also symbolism, it is of a new kind, much closer to that of
the contemporary works of Delaunay and Kandinsky, than to the
style and the meaning of an earlier symbolism.

HODLER AND KLIMT

Among those artists invited by the Sâr Péladan to exhibit at the
first *Salon de la Rose + Croix* was the Swiss painter Ferdinand Hodler.
The year before, at the newly founded *Salon de la Nationale* (Champ
de Mars), whose president was Puvis de Chavannes, and among
whose organizers were Rodin and Carrière, Hodler had exhibited
Night [171], the first of his large programme pictures. (Earlier in

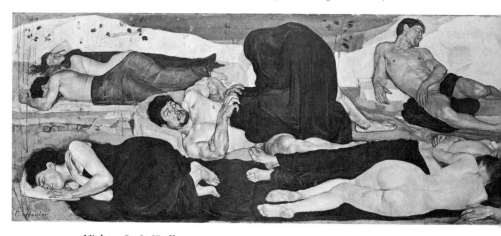

171. *Night*, 1896. Hodler

the year the mayor of Geneva had ordered it removed from the
municipal Salon on the grounds of its immorality.) Following
Puvis' recommendation, the Sâr sent Count Antoine de La Roche-
foucauld (who was helping to finance the exhibition) personally to

request Hodler's participation; as a result Hodler showed *The Disillusioned* (1891–2) at the Salon, and also suggested the inclusion of his Génévois friend, the painter-architect Albert Trachsel. These two pictures, and the contemporary *The Tired of Life* (1891–2),

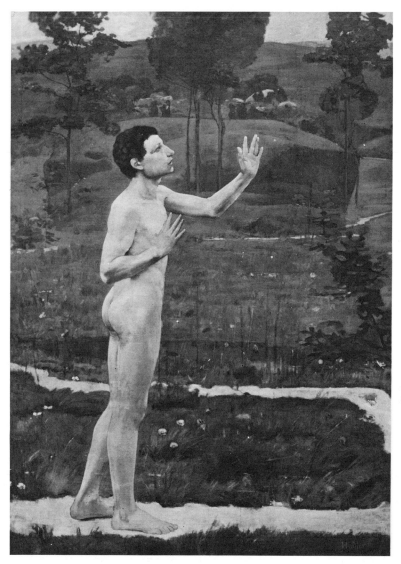

172. *Dialogue with Nature*, c.1884. Hodler

marked a change to an overt idealism, since until then Hodler's style had been realistic and factual in its rendering of both genre and landscape subjects. But the intention which lay beneath the new approach had been present for some time. Almost a decade

234 earlier he had composed a group of sketches of the various times of day and their analogous states of mind, indicated in their titles — *Dawn, Evening, Tired of Life, Awakening, Sleep*, etc. There is a painting of the mid-eighties whose subject is idealist — *Dialogue with Nature* [172] — but its style is still essentially naturalist, a carefully modelled

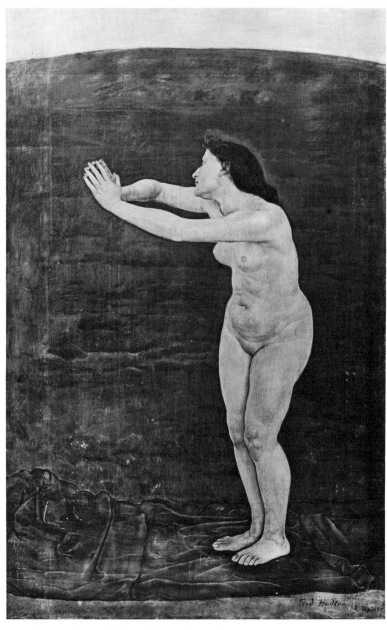

173. *Communion with the Infinite*, 1892. Hodler

nude in relief against a detailed landscape; only the aspiring pose
conveys the sense of the title.

Now, however, Hodler began to carry out the programme in a series of large oils which employ rhythmical groups of human figures as metaphors of his own profound disillusionment. In *Night*

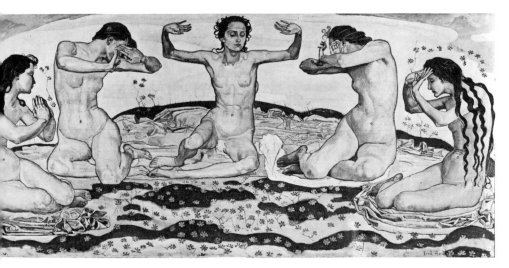

174. *The Day*, 1899. Hodler

the spectre of Death crouches over the suddenly awakened central figure who is Hodler's agonizing self-portrait (while the others, less powerfully modelled, sleep on unaware), and Hodler wrote out the message on the frame: 'More than one who has gone peacefully to bed in the evening, will not wake up the next morning.' It has been suggested that the pessimism expressed here and in the other pictures of the early nineties (e.g. *The Disillusioned*) had its origin in the extreme poverty and hardships of his youth and the deaths from consumption by the time he was thirty-two, of his father, mother, brothers and sister. It was the same kind of fated, tragic loss which haunted Munch (and indeed many artists of the period) and it produced a similar sense of what Hodler called 'life's ever present despair'.

Whether because of a different nature, or a different milieu, Hodler's obsession was less tenacious than Munch's, or at least he was shortly able to find release in such mystic themes as *Communion with the Infinite* [173], *The Consecrated One* (or *Infancy*) [47] and *Reverence* (1894). Then, after the European-wide success of these pictures, and the several years during which he was occupied with the Marignano murals for the Swiss Landesmuseum, he went on to the elegiac celebrations of *The Day* [174], *Spring* [175], *Emotion*

175. *Spring*, 1901. Hodler

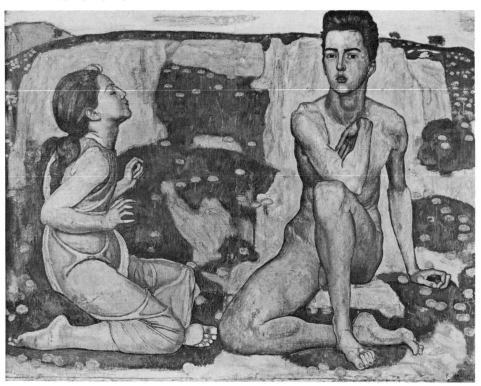

(1903), *Gaze into the Distance* (1905, which depicts young man-
hood), *Love* (1908) and *The Look into Eternity* (1915). Whatever
their immediate personal roots, it is evident enough from their titles
alone that these pictures belong to the stream of idealism: their pre-
occupation with the stages of life (conceived as a sequence of related
pictures rather than in a single composition, as with Gauguin and
Munch), their matching of human feeling with the moods of nature,
their suggestion of an unseen reality all attest to this. Like other
artists of his time Hodler interprets the stages of life through the
relations between the sexes, and throughout most of these pictures
the role of woman is emphasized. But characteristically for Hodler –
and uncharacteristically for the period – she is never the fleshy
temptress or the embodiment of evil; as in the less pantheistic idylls
of Maurice Denis, she is always 'the spiritual guide of man'.

Hodler's intention, then, is non-naturalistic. As Benesch has
said, 'His endeavour (like that of Munch and Klimt) is to represent
pictorially the realm of ideas that governs physical reality.' But this
idealistic purpose does not in itself constitute a symbolist art. When,
as in Hodler's painting, human figures are made to stand for a
picture's subject the more usual result is personification or allegory,

and in this period often that kind of academic 'idealism' which the
French *idéistes* expressly renounced, and to which Hodler himself
objected in Böcklin whom he found to be too 'literary'. Pictorially
Hodler's symbolist tendencies are to be found in several stylistic
traits. The simplest is his renunciation of any specific renderings of
nature: though *Night* is darker than *The Day*, the light in both is
arbitrary and depicts no given moment; neither *Adolescence* (which
is also *Spring*), nor *Autumn* (which is also an *Old Age*), really show
seasons of the year, though one is bright and the other black. In all
these pictures colour and tone are adapted to the theme, made to
accord with it as expressive equivalents. In his 1897 lecture de-
livered in Fribourg Hodler was quite clear about how 'colour in-
fluences emotions, causing joy, especially in the case of bright
colours which we associate with light, while dark colours engender
melancholy, sadness and even terror'; and giving specific symbolic
readings to 'white which usually means purity, while black repre-
sents evil or suffering. A vibrant red expresses violence, a pale blue
softness, purple sadness.' Here Hodler is employing the explicit
expressive conventions of the period.

Similarly line, instead of rendering the perspective depth of Hod-
ler's earlier pictures, is now used to establish a flat patterned design
with a high horizon and framing sky against which is set the rhythm
of the separated, repeated figure silhouettes. Hodler's desire for the
non-imitative 'ornamental' flatness of 'primitive' wall decoration,
which he like others of the time admired, is clearly evident in the
sketches for his idealizing compositions. A drawing for *The Day*, for
example, is arranged like a medieval manuscript with heavenly
figures floating above the seated nudes. In the sketch for *Spring* the
smooth line of the figures ties in with the curves of the landscape.
At this stage linear freedom and decorative unity are in evidence.
But as the work progresses a conscious alteration ensues, the
result, as Hodler said, of a struggle between the role of contour
'through whose affirmation art becomes ornamental' and the 'need
to stress the movement and the parts of the human body'. There is
almost always a conflict in this double search of the artist: 'first to
express the logic of movements, and second to enhance the beauty,
the character of the contour'.

The fundamental character of this conflict is illustrated in an
1892 photograph which shows Hodler painting *The Disillusioned*.
To carry out this idealist composition he had set up his monumental
canvas out of doors, and is painting from an appropriately costumed
model posed in the *plein-air*: evidently what Hodler elsewhere calls
'truthfulness' is not to be sacrificed to symbolic or decorative inten-
tion. Since the 'logic of movement' and the 'inside rounded model-
ling' is grounded in naturalistic representation the initial impulse

towards a fluid unifying line must be restrained; contour is interrupted and broken by the 'opposition of long and short lines' to indicate muscular tension, and the sculpturesque figures are set in frieze-like relief against the loose, open shapes of a rising landscape pattern. In *The Painter's Decalogue* (1875), Hodler had proclaimed that 'the painter must practise seeing nature as a flat surface', more than balancing this, however, with a repeated insistence upon 'mathematical accuracy', 'mastery of observation', and 'accurate measurements'. Now, in the early nineties, the implicit naturalism still holds, despite the attraction of the decorative contour, and it rules out the deformations (both objective and subjective) which for Gauguin and the Nabis (and for Munch) were inherent in Maurice Denis' famous definition of a picture as a flat surface covered with colours.

Hodler's stress on the importance of 'bodies clearly separate from each other, with the figure seen as light against dark, or dark against light' (cf. the tonal alternation in *Night*), a method of composition he valued in the old masters, may well have been influenced by Hildebrand's theory of planar vision and the primacy of outline in the ordering of a subject. He did not in any case allow it to diminish the volume of the separate figures, only their arrangement, as was recognized by Felix Vallotton when (in 1892) he compared Hodler's 'power of drawing . . . dignity of form' to Orcagna and Signorelli.

In any case it is the frieze-like composition of figures, set in relief against a landscape backdrop, that comprises the synthetist unity of these 'paintings of ideas'. Sometimes the break between figure and background is complete, as in the 'naive materialism' of the realistic nude of *Communion with the Infinite* [173], or the Della Robbia-coloured columnar angels, their feet resting solidly on air, who in *The Consecrated One* [47] adore the allegorical child so reminiscent of P. O. Runge. More often the gap between figure and landscape is only partial, as in *The Day* [174] and *Spring* [175]. (A more unified rhythmic continuity seems allowed to remain in occasional less important themes — *The Three Maidens* [1894], or *Evening Repose* [1908].) Though the landscape is flattened and made decorative its rhythms never fuse with those of the figures, who, in their always tangible modelling, occupy a shallow but separate space.

So it is above all through his figures that Hodler wishes to convey his idealist intentions. These rarely display those external attributes of conventional allegory which inform us what they 'stand for'. Instead, pose and gesture exteriorize states of mind and feeling which, in any one composition, all seem to share. The connection of the figures is not with each other — each is self-absorbed — but with some more general idea. Their movements appear both wilful

(i.e. controlled) and dominated, mastered from within yet in accord with unseen forces. Thus the confused emotion of the girl in *Adolescence* makes her lean towards the youth but throw back her head, just as her arms withdraw while her fingers reach out. She is less fearful than the frightened girl of Munch's *Puberty*; partially, at least, she accepts her desire though she masters it. But the signs of her emotion remain within herself (does she see, or only imagine, the youth?), do not expand to encompass her surroundings, and are not made visually manifest in the entire composition. Similarly, the figures in *The Day* take their positions in accordance with a power their actions seem to demonstrate, rather than, like Munch's figures, being overwhelmed by it. The result is less a sense of inevitable emotion than of willed feeling. As Beenken has said:

> What is bodied forth here is basically only an analogy: as the light of day on the hills rises from below on high, so the figures lift themselves from the ground. The intentional representation of the natural . . . and of feeling itself, by a bodily analogy . . . supposes a separation of form and nature as well as a division between the realm of art and the I of the beholder.

The artist, however, saw things differently. He ordered his pictures according to what he called the laws of 'parallelism', thus giving them 'a feeling of unity'. Parallelism he described as 'the principle of repetition' which underlies the order of nature, the symmetry of the body, and all of human experience, and which dominates all diversity.

> If I go for a walk in a forest of very high fir trees, I can see ahead of me . . . the innumerable columns formed by the tree trunks. I am surrounded by the same vertical line repeated an infinite number of times . . . The main note, causing that impression of unity, is the parallelism of the trunks . . . [In] our daily life, we again find the principle of parallelism. We know, and we feel at all times that what unites us is stronger than what divides us . . . [It] is easy to see a common principle and to understand that the parallelism of events is at the same time a decorative parallelism.

As Hodler says elsewhere, his figure groups, which are really the varied 'repetition' of a single figure (e.g. *The Day* or *Eurythmic* [1894–1895]), are based upon this principle. But 'parallelism' is more than the formal ordering of a perceived world, or even of experience. In Benesch's phrase, it expresses the pervasive unity of 'a spiritually transcendent world that reigns over the world of material accident', in which, behind appearances, nature and man are one. His compatriot, Heinrich Wölfflin, who knew Hodler and admired his art, summed up the effect of his compositions in this way:

> [In all his works] it appears as if the accidental, individual instance has, so to speak, been brought into coherent connection with a general world order . . . the occurrence has been lifted from the world of the single instance

and given its place in the sphere of the general and ever recurrent . . . the ethereal character of an ordered universe has been revealed.

This desire to express the 'eternal element of nature' (as Hodler put it), the 'Truth behind Appearance', is altogether symbolist; what distinguishes Hodler is precisely his faith in the 'ethereal character' of the universe. Unlike most of the artists of the time, there is for him neither doubt nor struggle. Redon's sense of irony, Gauguin's subjective feeling of the waking dream, Munch's personal fear are all foreign to him. Just as there is no place in Hodler's world for the truly sensuous – his nudes are chaste and his sleeping couples passive – so he refuses the equivocal in favour of clarity and order. Mystery is absent from Hodler's undoubting, confident faith, and suggestion plays no part in the positive revelation of truth. Only in a few of his late landscapes has Hodler restrained the desire for that separating sharpness of form which isolates his symbolic figures and gives his earlier landscapes a sense of airlessness. The parallelist-induced symmetry of *Eiger, Münch and Jungfrau in Moonlight* [176] or *Landscape Near Caux with Rising Clouds* (1917), is no less than in the earlier more brittle canvases, but now fluidity and soft outline have been allowed their role of suggestive unity. Planar design and perspective depth have an equivocal relation, and now that mystery (rather than clarity) inhabits these views of mountaintops and sky they induce that sense of unseen (religious?) powers for which Hodler strove in his figure paintings.

For it is this sense of pantheistic continuity that Hodler intends to embody in the rhythmic repetition of his figures and in the more fragmented, decorative designs of settings often composed in the undulating line and rounded colour areas of *art nouveau*. Figures and landscape are to be understood as echoing each other in a 'parallel' relation. In the stylized movements of their bodies, in their awareness of both the inward source and the outward display of those movements (as towards an audience), Hodler's figures are very much like dancers performing on a narrow stage with a flat backdrop that suggests infinity. (Late in his life he was friendly with Jacques Delcroze, professor at the Geneva conservatory of music, whose own teachings of eurythmics grow out of ideas widespread before 1900.) For Mallarmé and Yeats the dancer was the ideal symbol, direct and non-discursive, but only when she was seen not as a dancer with an expressive message, but as the complete fusion of form and meaning: 'the visual incorporation of the idea'. In this Hodler belonged to his time. But his insistence upon figural clarity, upon a sculptural, even if flattened, modelling, breaks more than the synthetist unity of his compositions. (Puvis' tendency to sink his figures into their setting, to soften and give distance to the whole was the surer impulse, though his style was more traditional.)

176. *Eiger, Münch and Jungfrau in Moonlight*, 1908. Hodler

Hodler employs the visible world as intermediary, instead of allowing the work to speak directly of the invisible. Because he never relinquishes illusionistic reference, he also forgoes any truly symbolist (Swedenborgian) correspondence. Finally, Hodler's self-conscious groups belong to the intellectual realm of allegory.

Hodler's still pessimistic themes of the early nineties soon received exhibition honours in Germany and Italy. In Vienna, just after 1900, the Swiss artist found a 'modern' public which bought his paintings and this success helped to reinforce his newly optimistic frame of mind. The first invitation to Vienna came from Gustav Klimt, founding president of the Sezession (1897), and like Hodler a composer of idealizing subjects as well as a landscape and portrait painter. Klimt's early decorations – at the Burgtheater (1886–8) and the Kunsthistorisches Museum (1890–92) – are in the eclectic–academic tradition of the much admired Hans Makart. Whether historical or allegorical they tell their stories in a style of precise illusion, the deep space of their compositions inserted into an

unrelated architectural framing, their manner varying to suit their subject. Klimt's symbolist orientation comes only at the end of the decade, under modernizing influences from beyond Austria mirrored in the work of those artists who were invited to show in the exhibitions of the Sezession.

Like the Belgian group of *Les XX* a decade earlier, the Sezession's somewhat belated opposition to an academy under the direct patronage of the Emperor was far from dogmatic. It was in principle open to anything 'progressive', 'actual' and 'new'. Its stance was more moral than stylistic, as an article in the first number of its characteristically named publication *Ver Sacrum* clearly stated: 'You [the academy] are manufacturers: we want to be artists'; the quarrel is between 'the commercial and the artistic spirit'; 'There is no Sezessionist style . . . only each one's individual feeling and the form that grows naturally from that feeling.' In practice this meant that it welcomed Franz Stuck, Max Klinger and Anders Zorn along with Khnopff, Toorop and Meunier, Whistler, Sargent, Frank Brangwyn and Segantini, as well as Puvis de Chavannes, Carrière, Aman-Jean and Rodin. (Significantly, Van Gogh, Cézanne, Seurat and Munch were recognized only somewhat later, and without much understanding.) All these artists could be included under the theoretical banner of the new and the sincere.

In the third number of *Ver Sacrum* (March 1898), all of whose illustrations were given over to works by Klimt, the main article (unsigned, but probably by its chief spokesman, Herman Bahr), entitled 'Symbolists of a Hundred Years Ago', calls upon the early German Romantics – Tieck, Friedrich and Runge – for ancestral justification of the new art. Böcklin,–in whose work there is that fusion of painting, music and poetry which the romantics called for and prophesied, is a connecting link to the present. The article begins with a sentence from Friedrich Schlegel: 'All the sacred games of art are only distant copies of the unending games of the world, the eternally self-portraying work of art. In other words, all beauty is allegory.' The author cites Tieck's conclusion in *Franz Sternbald* that the point where philosophy, religion and poetry meet is mysticism, i.e. a direct feeling of oneness with the world and with God: art is applied mysticism which when conscious is allegory and when unconscious is symbolism. Agreeing with Friedrich that art should not be 'invented' but must be 'felt' into being, he commends Runge's ideas of landscape and colour symbolism and quotes with approval his statement: 'I wish I did not have to practise art, for we should go beyond art, and we will know no art in Eternity.'

Klimt's new symbolist orientation reflects something of this mystical attitude but gives it a peculiarly Viennese inflection of sparkling erotic refinement. The earlier illusionistic space is not

177. *The Kiss*, 1895. Klimt

abandoned all at once, but it now begins to be filled with a dream-
like but none the less naturalistic space like that from which heads
representing infancy, youth and old age emerge as a warning back-
ground to the elegant profiles of the two levels in *The Kiss* [177]. He
is also indebted to the decorative tendencies of the 1900 style:
languid gestures of gracefully attenuated figures, slim hair-strewn
nudes and checkered costumes; the sensuous use of mosaic-like
colour and shining opaque gold. Many of Klimt's arabesque back-
grounds were based upon the mural patterns of early Greece and

the early Middle Ages; they offered the same kind of 'primitive' inspiration that Gauguin and the Nabis sought in folk art and the art of the South Seas.

A hazy illusionism still characterizes the three panels of the Vienna University murals (1897–1903, now destroyed). In the suffused, baroque-perspective atmosphere float crowded groups of realistically foreshortened nudes joined by their curving contours and long strands of flowing hair. The mass of figures in *Philosophy*, the embracing couples and the suffering aged with bent heads suggest that Klimt has studied Rodin's *Gates of Hell*. The space of *Medicine* too is deep and hazy. Only in the *Jurisprudence* does Klimt first attempt to reconcile (by means of keyhole cut-outs) realistically rendered heads and bodies with flat, brilliantly coloured abstract ornament. These sudden alternations – or interruptions – are to become a characteristic mark of his style.

The *Beethoven Frieze* (1902), on the four walls of a room specially designed by Josef Hofmann, off which was displayed Max Klinger's multicoloured statue of the composer, employs the decorative style more fully. There is a greater emphasis on lateral rhythm and linearity, though the influences of Beardsley, Khnopff and especially Jan Toorop are all evident in the figure groups of 'The Dark Powers' and 'The Longing for Happiness' – emaciated, hair swept, with angular gestures, pinched features and ecstatic eyes – they emerge from a richly filled mosaic-like patterned background (employing adaptations from Mycenae and Byzantium) that is peculiarly Klimt's own. The stylized figures are clearly not of this world, the more so as they tend alternately to emerge and lose themselves in the spaceless expanse of the coloured wall; they enact a static ballet which culminates in the nude couple who embrace in a symmetric bower beneath the masks of tragedy and comedy.

An embrace is again the culmination of Klimt's four-wall frieze in the dining room of the Palais Stoclet in Brussels (1904–9) designed by Hofmann. Here Klimt has allowed his characteristic decorative style, with its lines of gold and irregular patches of closely fitted green and blue and pink and rose, to obscure the subject, which is again an allegory of love. The few, flattened stylized figures – the woman who awaits her lover, and the couple who clasp each other – are barely distinguishable within the continuous design inspired by the mosaics of Ravenna. That design is meant to be more than a pleasing visual continuum, more than a visual play. Like Runge's arabesque, which his contemporary Görre called 'a hieroglyph of art, a visual symbolism', it is an abstract expansion of the work's theme, the pantheistic presence of Love, conveyed equally by design and figures. But here the two are hardly in balance and a rich and tasteful reticence is dominant. Given this 'retreat into

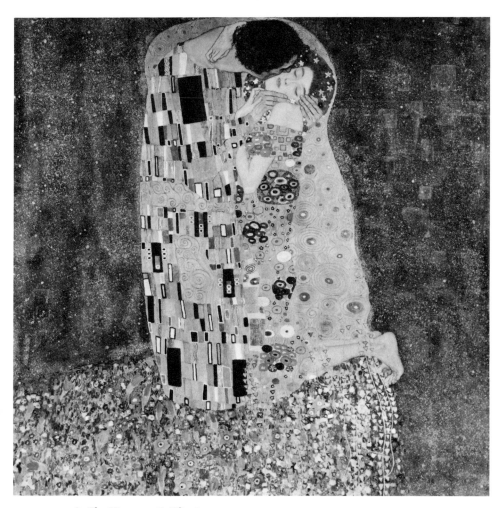

178. *The Kiss*, 1908. Klimt

decorative craftsmanship dominated by its own materials' (Max Eisler), the initial subject matter, far from being expressed by the formal elements of the composition, has become merely incidental. (Munch's small *Meeting in Infinity* [1898] has essentially the same subject; its naked figures, adrift in a cosmological and emotional void, are in striking contrast with the sensuous elegance of Klimt's lovers.)

The Stoclet frieze, which was the last of Klimt's monumental works, was also the high point of his purely decorative tendency. (Though it also marks *The Kiss* [178] and *Hope II*, painted during the years Klimt was working on the execution of the frieze.) In *The*

179. *The Three Ages of Life*, 1908. Klimt

Three Ages of Life [179] figures and background are more in balance, although they are distinct in their contrast of modelling and flatness, despite certain overlapping of outline. In the later works – e.g., *The Family* (1910), *The Maiden* [180], *Death and Life* (1911–16) – figures and design are more nearly integrated into a single rhythm, bodies less obliterated by an overlay of abstracted costume pattern, and the transitions from filled, flat surface to stylized modelling are both less abrupt and more generally distributed. Yet, despite the more consistent scale and the resulting increased unity, the inconclusive relation between subject and design, between the idea and its visual formation still persists.

The subjects of Klimt's University murals are those of more traditional allegory. They represent in human form religious or social ideas or institutions. Conventional attributes, whether classical or Christian, are lacking, and the poses express a contemporary anxiety; but these are still public subjects which individuals exemplify. In contrast Klimt's later idealist paintings embody the more emotionally personal, interiorized themes already common to the symbolist art of the previous decade. Like Gauguin, Munch and Carrière he portrays man's fate not in terms of personified abstractions, but through the individual round of life, the emotions of birth and maternal love, solitude and death, and he gives a central role to the erotic. But for Klimt the sexual is never the sinful; youth may

180. *The Maiden*, 1912–13. Klimt

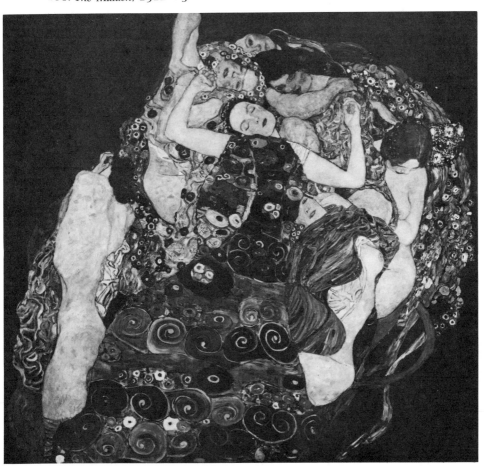

suggest the sadness of old age, and birth an inevitable death, but the sensuous is not evil and woman is neither the incarnation of temptation, nor the image of all that is ideal. Here Klimt is as different from Gauguin and Munch as he is from Khnopff and Hodler. Nevertheless, like them he is now concerned, not with abstract ideas depicted through signs approved by tradition, but with the generalization of individual feeling. Once again, we are presented not with action and interaction, but with mood and isolation; the groups that cling most closely together (in *Death and Life*, for example) seek a despairing escape from a dream-like solitude. The closed eyes, the bent heads, the limp gestures, the fluid silhouettes all point to a trance-like condition; while the invasion of the figures by the formal pattern and the marrying of the pattern to an airless, spaceless surface indicate that these figures have no real physical existence, but are symbolic of feelings of the states of being that qualify man's destiny.

As Novotny has written, Klimt's aim was to evolve 'a more or less conscious programme for achieving a stronger direct bond between thematic content and pure form . . . To create a new and immediate method of expressing conceptual and emotive content . . .' This aim was that of the symbolists of the previous decade, who also sought ways in which form could be directly 'required to express sorrow or comfort, oppression or relief' and so be able to dispense with those extraneous associations not inherent in the forms themselves that destroyed the work's unity and made it literary. Klimt's method was to give full freedom to the decorative constituents of his art. Unlike Hodler, whose ethical reticence makes him insist upon maintaining the willed integrity of his figures (and so also their existential mass and space), Klimt is ready, even eager, to give up all pretence of naturalism in order to give paramount importance to the decorated surface. So in one sense their styles are at opposite extremes: where Hodler's puritanism, the ultimate source of his 'naive materialism', compels him to renounce his impulse towards decorative vanity (i.e., the delight of 'objective deformation'), Klimt's sensibility to decorative nuance makes him attenuate his desire for expressive meaning (i.e., the impact of 'objective deformation'). The results, however, are very much the same. In both Klimt and Hodler style and theme remain divided (for very different reasons); neither achieves the inevitable unity which was the aim of symbolism – for only in this way could it 'go beyond art'. Novotny suggests that Klimt first conceived his thought, and then translated it into 'imagistic speech . . . his forms thwarted his symbolic programme [because] where metaphysical themes were to be illustrated . . . the distinctness and intensity of the thematic

content' have been lost. But perhaps it is precisely that the 'thematic content' does remain distinct from its 'illustration', and the 'imagistic speech', separate from the thought, becomes a manner. For Klimt (as much as for Hodler) this synthetic 'vision' of which Gauguin spoke, the 'equivocal' which Redon stressed, the power of suggestion arising from the fusion of theme and style is, finally, lacking, so that despite (or because of) the sensuous brilliance of his idealistic art, it remains literary and intellectual.

Only in some few of Klimt's landscapes is this dichotomy overcome. Most of his carefully observed studies of wooded clearings, of single trees, of massed flowers, all seen from close to and painted in great detail, remain within the realm of naturalism. By the use of an exceptionally low or high horizon, the frequent elimination of a horizon, and the repetition of tree trunks, stalks or flower blossoms, Klimt maintains the desired patterned surface of brilliant colour, reconciling depth and plane in an almost neo-impressionist vibrance. But in several of the wooded scenes – *Pine Forest I* (1901), for example – a breathless presence seems to inhabit the intervals between the forms, an evocative silence that gives a 'secret emotive meaning to appearances'. It is true, as Novotny says, that these pictures lack precise conceptual content. Perhaps for this very reason they achieve that 'correspondence' between outward appearance and hidden meaning which was the goal of symbolism.

DUTCH AND SCOTTISH

The oldest, and the most prominent, of the Dutch symbolists, Jan Toorop, had many links with the Belgian movement. He had been at the Brussels Academy for three years when he was elected to membership in *Les XX* in 1888, one year after it was founded. Later that same year he went to England with his friends the writers Jules Destrée and Emile Verhaeren, the latter especially attuned to the new influences coming from Paris. Toorop's first paintings of this time were in the manner of Ensor: sombre interiors whose heavily painted detail seems to overwhelm their contemplative inhabitants. But by 1888 he was working in the neo-impressionist style that had been adopted by Van Rysselbergh and other members of *Les XX*. It is not until about 1890, when Toorop returns to Holland, that the symbolist orientation begins to take hold, at first somewhat mildly

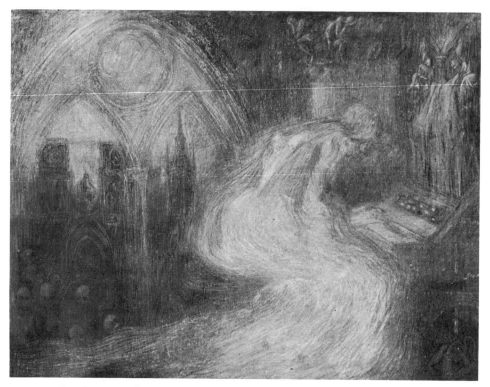

181. *Organsounds*, c.1889. Toorop

and more in subject than in style. In *Organsounds* [181], with its English Gothic setting (based on an earlier drawing) and its Redon-esque floating skulls, the organ-tones are translated into tremulous outlines which suffuse the atmosphere; the *Venus of the Sea* (c.1890) (recalling Ibsen's *Lady of the Sea*) mingles naturalism and illusion, with woman cast in the typical role of destructive *femme fatale*, as the accompanying serpent clearly informs us; in contrast *Mother-hood* (1851), drawn in the naive manner of Walter Crane and Kate Greenaway, portrays her as the embodiment of purity and innocence.

During the next few years these rather pleasant treatments are replaced by pictures of an emotional intensity rare in the repertory of symbolism. Their tone is at once mystical and lugubrious. Nature becomes alive and menacing, forests close in upon lost, innocent souls, and graveyards open. The atmosphere is that of Minne's illustrations of 1888–90 for Maeterlinck and Grégoire Le Roy, but with more explicit allegorical detail. It suggests that Toorop had read Maeterlinck's translation (1889) of the mystical writings of Ruvsbroec. In any case, as Spaanstra-Polak notes:

Under the influence of Maeterlinck's dramas, in which trees are animated beings, a change takes place in . . . Toorop's paintings. With chalk and pencil he draws gloomy scenes of ghostly gardens with dark ponds, over-shadowed by weeping willows like living beings whose arms writhe like tentacles. From the branches women's hair streams down. In such a *Garden of Woes* (1891) death's-heads grow on thorns – symbol of the destruction caused by lust. The church-yard – background to the sordid seducers of innocence, *Les Rôdeurs* – makes its appearance again as the stage-setting for Death.

Toorop also draws upon other sources for his iconography. He turns the *anyang* puppet figures of Java (where he had been born) into slim, curved floating spirits with billowing hair who rescue the dead soul from the thorns of passion (*O Grave Where is Thy Victory* [182]); he adapts the evil sphinx of Khnopff and the Sâr Péladan (who was in Holland in 1892), and employs such common symbols of purity as the swan and the lily along with the medievalizing dress

182. *O Grave Where is Thy Victory*, 1892. Toorop

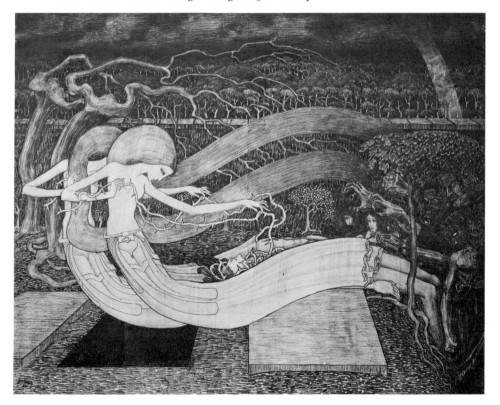

and flowing tresses of the Pre-Raphaelites (*Girl with Swans*, 1895–6). And some of his backgrounds are based upon the Celtic inter-lace. In all these pictures line is paramount; it holds the surface as a decorative design which permits only the suggestion of space; it is also the theme's visually expressive equivalent. For in almost all of these compositions Toorop denotes the dangers of evil, or temptation, by a nervous, broken, angular line, which often takes the representational form of thorns, but which can also be ab-stractly staccato, irregular and pointed, in opposition to a smoothly flowing line, which unmarred by sharp edges and sudden reversals of direction conveys, through hair, or drapery, or, again, in its own right, the peace and harmony that stems from the recognition of the good. So in *O Grave Where is Thy Victory* the good angels in the foreground disentangle the soul from the gnarled and twisted branches in which the demons of evil have enmeshed it, while in *The Song of the Times* [61] both the evil agitation of the left side, with its disorder and tangle, and the rhythmic order of salvation of the right retain their expressive character as they overflow into the abstract decoration of the frame.

All these elements are present in Toorop's best picture, *The Three Brides* [52], which like so much of his work is a black chalk drawing heightened by colour. A theme that might also be called 'on the nature of woman' it is the mystical equivalent of Munch's more sensuous (and personally expressive) treatments of a similar sub-ject. The pure but earthy bride stands in the middle, her breasts only partially hidden beneath the marriage veil. As Toorop explained, she is 'a perfumed, hardly blossomed flower which hides under its veil both things: the pure aroma of tenderness and the burning gift of sensual pleasure'. On either side stand the nun and the whore; the saintly bride of Christ who is 'nothing but ardour filled with gruesome asceticism', and the infernal bride, 'a hungry unsatisfiable sphinx, a dark passion flower dripping with pleasure', her hair bound by snakes, her necklace made of skulls, holding a dish into which flows the blood of the victims of sensuality. In the two upper corners are the images of Christ's hands nailed to the cross; they hold bells from which stream sounds which, descending, become the billowing hair of floating angels – half Javanese puppet, and half Pre-Raphaelite madonna. The lines of the background have their own expressive meaning: those on the good side are relaxed and curved, those on the side of evil are taut and sharp – Toorop himself called them 'yell and bang lines'. In these ways Toorop proposes a meaningful congruence between the complicated iconography of his subject and the intricate flat pattern of his design: the inherent form of the image is to match and 'clothe' the idea. His concern for visual synthesis is clearly evident in the simplified design of the

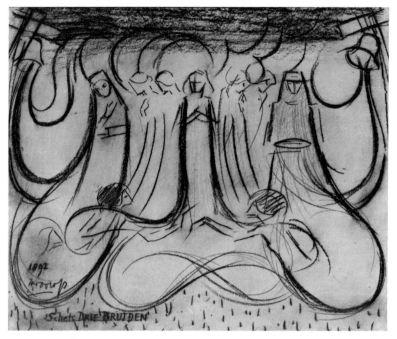

183. Sketch for *The Three Brides*, 1892. Toorop

preparatory study [183]. But in the finished picture the programme is so weighted by representational detail — facial expression (which however 'mystical' is inevitably imitative) and gesture so contradict the stylization of space and proportion — that decorative synthesis is fragmented and symbolic intensity is drained away.

The year 1893 marks the high point of Toorop's mystically motivated style. *Faiths in Decline* [184], showing mankind being rescued from the sea of illusion and the oppression of the state by an angelic maiden drawn by swans (shades of *Lohengrin*!), is still closely packed with figurative symbols. But as Toorop's own crisis of faith (perhaps first set in motion by an earlier illness) is gradually resolved he relinquishes his richly tortured iconographic programmes. The symbolist preoccupations — ecstatic vision, the round of life, with its pessimistic and moralizing implications — a sense of the beyond still remain (*The Sower*, c.1875; *Procession of Souls Beside the Ocean*, c.1900); but the allegories are less hermetic, the compositions less crowded, the proportions and the space less stylized. Although even at its most intense Toorop's art is never truly synthetic in its impact, his development here parallels that of the Nabis. As his religious faith grows more assured and more public (he was finally converted in 1905) his art, no longer required to convey the

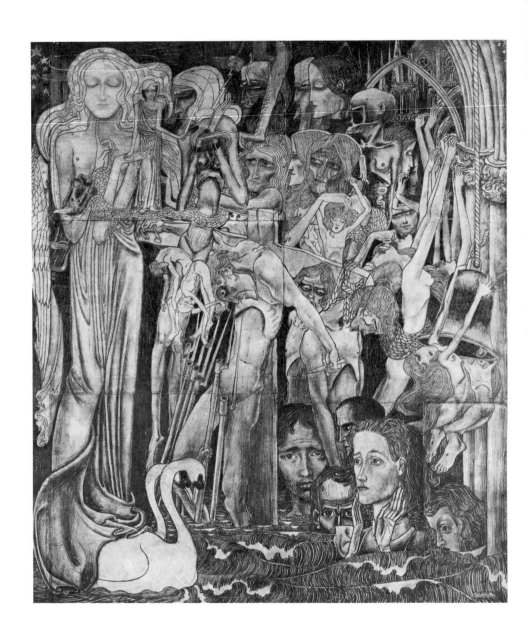

184. *Faiths in Decline*, 1894. Toorop

whole burden of unresolved emotion, can employ the easier, more
common (but less symbolist) vocabulary of illustration.

Johan Thorn-Prikker, who studied at The Hague Academy, was
converted to symbolism as a young man of twenty-four. A number
of his drawings and paintings of the life of Christ are composed as
flat designs in which a strongly linear, gracefully curved pattern
marks off areas filled with a stippled, or neo-impressionist, textured
surface. Thorn-Prikker is here following the lead of Henry van de
Velde (whose good friend he became at the time), whose own
painting was strongly influenced by the synthetist practice of the
Nabis, and the more theoretical symbolism of Seurat and his circle.
In his letters to the writer Henri Borel (between 1892 and 1897)
Thorn-Prikker explains that 'his basic intention [is] to fix . . . the
essence of things contained in general abstract concepts such as
life, purity, mysticism, but also in the emotions of love, hate, de-
pression'. Like van de Velde, who believed that line is not something
that describes an object but 'a force that works on human beings'
(at the same time that it is decoration), Thorn-Prikker, by varying
the 'speed' of his line, its thickness, tangibility and colour, seeks to
express the relations and the meaning of his forms. His subjects are
Christian (*Madonna*, 1892), but like Maurice Denis, the best of
whose early work has the same serene and lyric mood, Thorn-
Prikker is also voicing his own private emotion. *The Bride* [185],
herself only an insubstantial nearly transparent veil, is drawn with
an appropriately thin white line; but she is bound to suffering
(Christ) by heavy black lines and 'by the myrtle branch that gradu-
ally turns into Christ's crown of thorns. Misery is already lying in
wait for young love, it will be ensnared by treacherous sensuality
in the shape of the phallic tulips and the skull-like snapdragons.'
Thus line and colour (dull purples and greens) take on an indepen-
dent symbolic meaning expressive of the picture's tender subjects.
Thorn-Prikker exhibited with *Les XX* in 1893 and also executed
ornaments for *Van Nuen Strake*. Under van de Velde's influence (and
further prompted by opposition to his paintings in his own Dutch
milieu) he gradually shifted his energies to applied design.

The mysticism of Toorop and Thorn-Prikker was only one aspect
of the brief flowering of Dutch symbolism. There was also a social
side, strongly influenced by both the ideas and the medievalizing
style of Rossetti and William Morris, and sharing their goals of the
revival of a true and honest craftsmanship. In the words of
Spannstra-Polak, 'According to [Antoon] Derkinderen and [Richard]
Roland Holst the function of the artist, who at the same time was a
craftsman, was that of the priest – to disseminate his ideas among
the people, the community . . . Not beauty but ethics played the
important part in this aspiration.' Derkinderen based his ideal of a

185. *The Bride*, 1892–3. Thorn-Prikker

'communal art' on the writings of Morris and Walter Crane in England and Henry van de Velde and August Vermeleylen in Belgium and related it to his belief in a coming socialism. In practice, Derkinderen's many book illustrations of the nineties (and his two murals for the town hall of 's-Hertogenbosch) have little to do with symbolism, except in their nostalgic anti-naturalism. The interlaced borders, the slim and flattened figures in graceful, fluted robes that accompany the gothicizing type-faces are belatedly Pre-Raphaelite in both spirit and design. For both Derkinderen and Roland Holst (whose work is largely influenced by Rossetti) the expressive relation of style and subject depends almost entirely upon the generally 'spiritual' (if not specifically religious) associations of an old tradition that had fallen into disuse. Theirs is a revival style which makes no attempt to create in its own right a contemporary marriage of style and meaning.

During its comparatively short existence the Dutch symbolist movement was thus heavily indebted to the idealizing medievalism of its English forerunners, even if its more intense religious zeal and mysticism was distinctly its own. In return, Toorop's most important picture seems to have been one of the specific sources of inspiration in the creation of the style of the 'Glasgow Four'. *The Three Brides* was illustrated in the March 1893 number of the newly founded *Studio*; there it was seen by Charles Rennie Mackintosh, Herbert MacNair and Margaret and Frances MacDonald, a close group who adapted its emaciated figures and ecstatic profiles for the purposes of their own art of 'ethereal melancholy'. Their idiosyncratic style was subject to other influences: Beardsley's sharp, drawn-out line and flat surface; the medievalizing reverie of the late Pre-Raphaelites; the Celtic revival in Scotland, heralded by Yeats' *The Wanderings of Osin* (1889) and Grant Allen (1891) and perhaps works of Carlos Schwabe and Khnopff also seen in the *Studio*; but as Thomas Howarth has pointed out, their work 'approximates far more closely to that of the Dutchman's painting than to any work by contemporary British artists'.

Although it began to evolve as early as 1890, the style of *The Four* is seen at its most characteristic in their designs of the middle of the decade. Margaret (or Frances?) MacDonald's *Fountain* [48] and Frances MacDonald's *A Pond* combine in an elongated format a symmetrical arrangement of reed-like, bulbous-topped plants with stretched-out emaciated nudes whose hair flows into the natural forms. Mackintosh uses similar juxtapositions in his Diploma Award design of 1893, where the extremely stylized vines, bearing flowers or fruit form a grille-work that frames the three figures. In an 1896 bookplate by Herbert MacNair (who told Howarth that in his decorative work 'not a line was drawn without purpose, and rarely

was a single motive employed that had not some allegorical meaning') the tree of knowledge enfolds two sad female figures representing the spirits of art and poetry, holding in their hands rosebuds and lilies, emblems of painting and sculpture, and is itself nourished by the dew of inspiration. This kind of symbolic formalism is typical of the Glasgow style, though its significance may be obscure (Mackintosh's *The Tree of Influence*, 1895) or vague (Margaret MacDonald's *November 5th*, c.1894), while in the later work its attenuated and stylized animal–vegetable forms tend to become more decorative formula than meaningful content. But whatever the details, and whether the mood is more or less melancholy, the *Four* intended their work to be informed by a general sense of growth and renewal. The closest parallel is in the short-lived Scottish review of Patrick Geddes and William Sharp-Fiona Macleod, the *Evergreen*, whose title echoes its continental parallels: *Pan Jugend, Ver Sacrum*. 'The whole character of *Evergreen*, with its emphasis on nature and the seasons, on birth, flowering, harvest and death is the precise literary equivalent to the MacDonald sisters' craft work and painting.'

Abbreviations Used
in Catalogue of Illustrations

M. Bodelson, 1964 M. Bodelson, *Gauguin's Ceramics. A Study in the Development of his Art*, London, 1964.

C. Chassé, 1947 C. Chassé, *Le mouvement symboliste dans l'art du XIXe siècle*, Paris, 1947.

H. B. Chipp, 1968 H. B. Chipp, *Theories of Modern Art. A Source Book by Artists and Critics*, Berkeley & Los Angeles, 1968.

R. Goldwater, 1938 R. Goldwater, *Primitivism in Modern Art*, New York (1938), 1967.

R. Goldwater, 1957 R. Goldwater, *Paul Gauguin*, New York, 1957.

R. Heller, 1969 R. Heller, *Edvard Munch's 'Life Frieze'. Its Beginnings and Origins*, unpublished dissertation, Ann Arbor, Michigan, 1969.

R. Heller, 1973 R. Heller, *Edvard Munch: The Scream*, London & New York, 1973.

H. H. Hofstätter, 1965 H. H. Hofstätter, *Symbolismus und die Kunst der Jahrhundertwende*, Cologne, 1965.

La Faille, 1970 J. B. de La Faille, *L'Oeuvre de Vincent van Gogh* (1928), rev. ed., London, 1970.

G. Lacambre, 1972 G. Lacambre, *French Symbolist Painters*, exhibition catalogue, London–Liverpool, 1972.

F.-C. Legrand, 1972 F.-C. Legrand, *Symbolism in Belgium*, London, 1972.

S. Lövgren, 1959 S. Lövgren, *The Genesis of Modernism: Seurat, Gauguin, Van Gogh and French Symbolism in the 1880s*, Stockholm, 1959.

B. S. Polak, 1955 B. S. Polak, *Het 'Fin-de-siècle' in de Nederlandse Schilderkunst. De symbolistische Beweging 1890–1900*, The Hague, 1955.

J. Rewald, 1958 J. Rewald, *Gauguin Drawings*, New York, 1958.

J. Rewald, 1962 J. Rewald, *Post-Impressionism from Van Gogh to Gauguin*, New York, 1962.

260 H. R. Rookmaker, 1959 H. R. Rookmaker, *Synthetist Art Theories, Genesis and Nature of the Ideas on Art of Gauguin and his Circle*, Amsterdam, 1959.

H. R. Rookmaker, 1972 H. R. Rookmaker, *Gauguin and 19th Century Art Theory*, Amsterdam, 1972.

M. Roskill, 1970 M. Roskill, *Van Gogh, Gauguin and the Impressionist Circle*, Greenwich, Conn., 1970.

R. Schmutzler, 1964 R. Schmutzler, *Art Nouveau*, New York, 1964.

G. Wildenstein, 1964 G. Wildenstein, *Gauguin. Catalogue*, Paris, 1964.

Catalogue of
Illustrations compiled by
Kristin Murphy

1. POPLARS ON THE EPTE. By Claude Monet, 1890. Oil on canvas, 89 x 72 cm. The Tate Gallery, London. (Photo: Museum.)

2. NOCTURNE IN BLACK AND GOLD: THE FALLING ROCKET. By James A. McNeill Whistler, c.1876. Oil on panel, 76 x 53.3 cm. Detroit Institute of Arts, Detroit. (Photo: Museum.)

 One of the *Nocturnes* exhibited at the Grosvenor Gallery, London, in 1877 about which Ruskin's comments – 'I . . . never expected to hear a coxcomb ask 200 guineas for flinging a pot of paint in the public's face' – led to Whistler's famous libel action.

 Lit.: A. Staley, *From Realism to Symbolism, Whistler and His World*, exhibition catalogue, 1969, pp. 45–6.

3. HOPE. By G. F. Watts, c.1876. Oil on board, 66 x 53.3 cm. Walker Art Gallery, Liverpool. (Photo: Museum.)

 This is the earliest version of the once-famous *Hope* painted in 1885–6 and now in the Tate Gallery, London.

4. VITA SOMNIUM BREVE. By Arnold Böcklin, 1888. Oil on canvas, 180 x 114.5 cm. Öffentliche Kunstsammlung, Basle. (Photo: Museum.)

5. THE YELLOW CHRIST. By Paul Gauguin, 1889. Oil on canvas, 92.5 x 73 cm. Albright-Knox Art Gallery, Buffalo, New York. (Photo: Greenberg-May.)

 Painted at Pont-Aven in the late summer of 1889. As regards the inner impulses which drove Gauguin to identify with the 'primitivism' and 'sincerity' of the Breton people and inspired him to paint *The Yellow Christ* and other religious works of this period in Brittany, see Robert Goldwater, 'Gauguin's Yellow Christ' in *Gallery Notes*, Albright Art Gallery, Buffalo, June 1947, vol. XI, no. 3, pp. 3–13. There are two studies for this painting, see J. Rewald, 1958, nos 19 and 20.

 Lit.: G. Wildenstein, 1964, no. 327; W. Andersen, 'Gauguin's Calvary of the Maiden', *Art Quarterly*, spring 1971, pp. 84–104.

6. SPRING. By Edvard Munch, 1889. Oil on canvas, 169 x 263.5 cm. National Gallery, Oslo. (Photo: O. Vaering.)

 Exhibited in Munch's first one-man show at the Kristiania Studentersamfundet in 1889. Although painted four years after *The*

Sick Child (see no. 158), *Spring* is a more traditional treatment of the subject, compare for example Christian Krogh's *A Sick Girl* (1880, National Gallery, Oslo) and Hans Heyerdahl's *The Death of a Worker* (1888, Trondhjems faste galleri, Trondheim).

Lit.: C. von Glaser, *Edvard Munch*, Berlin, 1922, pp. 30–35; J. Thiis, *Edvard Munch*, Berlin, 1934, pp. 6–7, 30–33; A. Moen, *Edvard Munch: Woman and Eros*, London, 1958, pp. 10 ff; R. Heller, 1969, pp. 101–5.

7. SUNFLOWERS. By Vincent Van Gogh, 1889. Oil on canvas, 67.30 x 57.15 cm. Rijksmuseum Vincent Van Gogh, Amsterdam.

Painted in January 1889, this is a replica of the painting now in the National Gallery, London, which was painted in August 1888.

8. CATALOGUE COVER FOR VAN GOGH EXHIBITION. By Richard Nicolaus Roland Holst, 1892. Lithograph, 16 x 18 cm. Rijksmuseum Kröller-Müller, Otterlo. (Photo: Museum.)

Executed for the cover of the catalogue to the exhibition organized by Roland Holst at the Panorama in Amsterdam in December 1892.

9. SIN. By Franz von Stuck, 1895. Oil on canvas, 95 x 60 cm. Bayerische Staatsgemäldesammlungen, Munich. (Photo: Museum.)

One of several versions of this subject. Stuck built a special private altar as a setting for another version in his villa in Munich. See H. D. Hofman, 'The Villa Stuck, a Masterpiece of the Bavarian Attic Style', *Apollo*, November 1971, pp. 388–94.

10. ACCORDE: BRAHMS-PHANTASIE OPUS XII. By Max Klinger, 1894. Aquatint and mezzotint, 27.7 x 39.1 cm. Kunsthalle, Bremen. (Photo: Museum.)

11. THE PLAGUE. By Arnold Böcklin, 1898. Tempera on panel, 149.5 x 104.5 cm. Öffentliche Kunstsammlung, Basle. (Photo: Museum.)

12. SPIRIT OF THE DEAD WATCHING (MAMAO TUPAPAU). By Paul Gauguin, 1892. Oil on canvas, 73 x 92 cm. Albright-Knox Art Gallery, Buffalo, New York, A. Conger Goodyear Collection. (Photo: Museum.)

Gauguin wrote repeatedly about this painting's symbolic nature, e.g. 'I see here only fear . . . The tupapau (Spirit of the Dead) is clearly indicated. For the natives it is a constant dread . . . The title . . . has two meanings, either the girl thinks of the spirit, or the spirit thinks of her . . . The literary part: the spirit of a living person linked to the spirit of the dead. Night and Day.' (From Gauguin's manuscript 'Cahier pour Aline', 1893, quoted by H. Chipp, 1968, pp. 67–9.) A summary watercolour sketch of this painting accompanied the letter to Aline (J. Rewald, 1958, no. 67). This painting appears reversed in the background of *Self-Portrait with Hat* (1893, Jeu de Paume, Paris). *Nevermore O Tahiti* (1897, Courtauld Institute Galleries, London) is a variation of the same subject and composition. The hooded 'ancestral presence' or spirit appears in later works such as the monotypes *The Nightmare* (1895–1901) and *Escape* (1901), see J. Rewald, 1958, nos 101 and 107.

Lit.: R. Goldwater, 1957, p. 114; J. Rewald, 1962, pp. 526–8; H. R. Rookmaker, 1972, pp. 227–30.

13. MY PORTRAIT SKELETONIZED. By James Ensor, 1889. Etching, 11.6 x 7.5 cm. Musées Royaux des Beaux-Arts de Belgique, Brussels. (Photo: A.C.L.)

This is the rare second state of this etching. The conception derives in part from an etching executed the previous year, *My Portrait in 1960*. For a discussion of the skeleton motif in Ensor's work see M. de Maeyer, 'De genese van masken travestée en Skeletmotieven in het œuvre van James Ensor', *Bulletin des Musées Royaux des Beaux-Arts de Belgique*, 1963, pp. 69–88.

14. SELF-PORTRAIT WITH DEATH PLAYING THE FIDDLE. By Arnold Böcklin, 1872. Oil on canvas, 75 x 61 cm. Nationalgalerie, Staatliche Museen Preussischer Kulturbesitz, Berlin. (Photo: Walter Steinkopf.)

15. PRINCESS AND THE UNICORN. By Armand Point, 1896. Oil on canvas, 89 x 69 cm. Private collection.

Lit.: G. Lacambre, 1972.

16. THE BLESSED DAMOSEL. By Maurice Denis, 1893. Lithograph, 42 x 30 cm. Bibliothèque Nationale, Cabinet des Estampes, Paris. (Photo: B.N.)

Executed for the first edition of Claude Debussy's setting of 'La damoiselle élue, poème lyrique, d'après D. G. Rossetti', published by Edmond Bailly (*La Librairie de l'Art Indépendant*, 1893) in a limited edition of 160 copies. The poems of Rossetti were known in France as early as 1871, but it was the translation published by Gabriel Sarrazin in 1885 as part of a series – *Les poètes modernes de l'Angleterre* – that provided Debussy with the text for his composition of 1887 for orchestra and voices. Denis met Debussy around 1891.

17. LOVE OF SOULS. By Jean Delville, 1900. Oil on canvas, 238 x 150 cm. Musée Communal, Ixelles. (Photo: Studio Dulière, Brussels.)

Lit.: F.-C. Legrand, 1972, pp. 76–85, 89–94, 260.

18. ENCOUNTER IN SPACE. By Edvard Munch, 1899. Coloured woodcut, 18.1 x 26.1 cm. Museum of Modern Art, New York (Abby Aldrich Rockefeller Fund). (Photo: Museum.)

Related by the spermatozoa motif to the lithograph *Madonna* (see no. 65).

Lit.: G. Svenaeus, *Edvard Munch. Das Universum der Melancholie*, Lund, 1968, pp. 125–8; W. Hofmann, *Turning Points in Twentieth Century Art 1890–1917*, London–New York, 1973, pp. 37–8; G. Schiefler, *Edvard Munch, Das graphische Werk 1906–1926*, Berlin, 1974, no. 135.

19. TASSEL HOUSE STAIRCASE, BRUSSELS. By Victor Horta, 1892–3.

20. CANDELABRUM. By Égide Rombaux and Franz Hoosemans, 1900. Ivory, silver and onyx, height 36 cm. Kunstgewerbemuseum, Berlin. (Photo: Museum.)

21. DOMINICAL. By Henry van de Velde, 1892. Wood engraving, 32.5 x 26 cm. Musée des Arts Décoratifs, Paris. (Photo: Museum.)

Designed for the cover of Max Elskamp's first volume of poetry, *Dominical* (Antwerp, 1892). Julius Meier-Graefe wrote: 'Ces lignes montantes, comme oppressées par le noir qui les interrompent intro-

duisant le lecteur dans l'esprit du livre. Dans cette composition schématique, mer, rivages, nuages, se devinent encore.' (*L'art décoratif*, 1898, no. 1, p. 7.)

22. TROPON. By Henry van de Velde. 1898. Coloured lithograph poster. 29 x 21.5 cm. Musée des Arts Décoratifs, Paris. (Photo: Museum.)

Executed for the 'Tropon' brand of prepared food at Mülheim.

23. THE KISS. By Edvard Munch, 1892. Oil on cardboard (transferred to canvas). 100 x 80.5 cm. Oslo Community Art Collection, Munch Museum, Oslo. (Photo: Museum.)

Lit.: R. Heller, 1973, *passim*.

24. THE KISS. By Peter Behrens, 1896–7. Coloured woodcut, 27 x 21.6 cm. Museum of Modern Art, New York. (Photo: Museum.)

25. THE DAY OF THE GOD. By Paul Gauguin, 1894. Oil on canvas, 70 x 90 cm. The Art Institute of Chicago (Helen Birch Bartlett Memorial Collection), Chicago. (Photo: Museum.)

Lit.: G. Wildenstein, 1964.

26. THE SCREAM. By Edvard Munch, 1896. Lithograph, 32 x 25 cm. Museum of Modern Art, New York. Mathew T. Mellon Fund. (Photo: Museum.)

Lit.: R. Heller, 1973, *passim*.

27. SILENCE. By Odilon Redon, 1911. Oil on gesso on paper, 54 x 55 cm. Museum of Modern Art, New York. Lillie P. Bliss Collection. (Photo: Museum.)

Another version, possibly a preparatory drawing, is in the Minneapolis Institute of Fine Arts. For a discussion of Redon's literary and iconographic sources – notably Rodenbach's poem *Du Silence* (1888) and Préault's relief (1849) – as well as his own earlier and later treatments of the same theme, see T. Reff, 'Redon's Le Silence: An Iconographic Interpretation', *Gazette des Beaux-Arts*, 1967, pp. 359–68.

28. CLOSED EYES. By Odilon Redon, 1890. Oil on canvas, 44 x 36 cm. Jeu de Paume, Musée du Louvre, Paris. (Photo: Réunion.)

Lit.: G. Lacambre, 1972, no. 236.

29. SILENCE. By Lucien Lévy-Dhurmer, 1895. Pastel on paper, 54 x 29 cm. Private collection. (Photo: Agraci.)

Lit.: G. Lacambre, 1972, no. 113.

30. THE SOUL OF THINGS. By Xavier Mellery, *c*.1890. Crayon on paper, 93 x 67 cm. Musée Royaux des Beaux-Arts, Antwerp. (Photo: Museum.)

31. LA VIE MUETTE (THE WORDLESS LIFE). By Édouard Vuillard, 1894. Lithograph, 31 x 23 cm. Museum of Modern Art, New York. Gift of Abby Aldrich Rockefeller. (Photo: Museum.)

Designed for the programme for Maurice Beaubourg's play, *La Vie Muette*, presented at Lugné-Poë's Théatre de l'Oeuvre in Paris in November 1894.

Lit.: Claude Roger-Marx, *L'Oeuvre gravé de Vuillard*, n.d., Monte Carlo, no. 20.

32. MATERNITY. By Eugène Carrière, *c*.1892. Oil on canvas, 96 x 116 cm. Museum of Modern Art, New York. (Photo: Museum.)

33. LA DAME SOMBRE. By James Ensor, 1881. Oil on canvas, 100 x
80 cm. Musées Royaux des Beaux-Arts, Brussels. (Photo: A.C.L.)
 Lit.: F.-C. Legrand, 1972, p. 135.

34. LISTENING TO SCHUMANN. By Fernand Khnopff, 1883. Oil on
canvas, 101.5 x 116.5 cm. Musées Royaux des Beaux-Arts de
Belgique, Brussels. (Photo: A.C.L.)
 This painting caused a sensation when exhibited at the Cercle
Artistique in Brussels in 1883 (see *L'Art Moderne*, 27 April 1883, p.
127). Khnopff's was probably inspired by Ensor's·*La Musique russe*
(see no. 35) but, as F.-C. Legrand points out, whereas the music in
Ensor's painting forms a link between the figures; in Khnopff's it
actually divides them . . . Thus the theme of solitude reappears and
in a setting that might well have seemed to rule it out. With Khnopff
it was almost an obsession. (F.-C. Legrand, 'Fernand Khnopff – Per-
fect Symbolist', *Apollo*, April 1967, p. 279.)

35. LA MUSIQUE RUSSE. By James Ensor, 1881. Oil on canvas, 133 x
110 cm. Musées Royaux des Beaux-Arts de Belgique, Brussels.
(Photo: A. C. L.)
 Ensor claimed that Khnopff had plagiarized this work in his *Listen-
ing to Schumann* (see no. 34). Both paintings were exhibited at the
Cercle Artistique in Brussels in 1883. See 'Les Lettres de James Ensor
à Octave Maus'. *Bulletin des Musées Royaux des Beaux-Arts de Belgique*,
1966, nos 1–2, p. 24.

36. EVOCATION: BRAHMS PHANTASIE OPUS XII. By Max Klinger,
1894. Etching, engraving, aquatint and mezzotint, 29.2 x 35.7 cm.
Private collection.

37. PRELUDE TO LOHENGRIN. By Henri Fantin-Latour, 1882. Litho-
graph, 49.4 x 34.4 cm. New York Public Library, New York. (Photo:
Library.)
 Exhibited at the 1882 Salon, a painted version was exhibited at the
1892 Salon and a later reworking in oils was executed in 1902 (see
G. Lacambre, 1972, p. 48). Fantin-Latour made some 200 litho-
graphs inspired by German Romantic music and from 1885 onwards
Desjardin's *Revue wagnérienne* reproduced several of his Wagnerian
lithographs.
 Lit.: G. Hédiard, *Les maîtres de la lithographie, Fantin-Latour, étude
suivi du catalogue de son œuvre*, Paris, 1892, no. 39.

38. MELANCHOLY or JEALOUSY. By Edvard Munch, 1893. Oil on can-
vas, 65 x 93 cm. National Gallery, Christian Mustad Bequest, Oslo.
(Photo: O. Vaering.)
 The first version, now lost and entitled *Melancholy* or *The Yellow
Boat*, was painted in 1891 and exhibited in Berlin in 1892 as part of
The Frieze of Life. Christian Krohg wrote in its defence against hostile
critics: 'Thank you for the Yellow Boat – A long shore curves into the
painting and ends in a beautiful line, wonderfully harmonious. It is
music . . . Munch deserves thanks because the boat is yellow; if it
had not been yellow, he would never have painted the picture . . .
The latest slogan is "sound in colour". Has anyone ever heard such
sound in colours as in this painting?'
 Lit.: N. Stang, *Edvard Munch*, 1972, pp. 114–15; J. P. Hodin,

Edvard Munch, London, 1972, p. 55; R. Heller, 1973, pp. 55–6.

39. KNEELING YOUTH. By Georges Minne, c.1898. Bronze, height 79 cm. Musée des Beaux-Arts, Ghent. (Photo: A.C.L.)

40. I LOCK MY DOOR UPON MYSELF. By Fernand Khnopff, 1891. Oil on canvas, 72 x 140 cm. Bayerische Staatgemäldesammlungen, Munich. (Photo: Museum.)

First exhibited with *Les XX* in Brussels in 1892 and then in 1893 with the *Salon de la Rose + Croix*. The title is taken from Christina Rossetti's poem, 'Who shall deliver me?'. About isolation Khnopff wrote: 'My soul is alone and nothing influences it. It is like glass enclosed in silence, completely devoted to its interior spectacle.' (P. Jullian, *Dreamers of Decadence*, London, 1971, p. 261). Behind the figure is a nineteenth-century copy of a fourth-century Greek head of Hypnos, the Greek god of sleep, which Khnopff owned and placed on the top of an elaborate altar inscribed 'On n'a que soi' (One has only oneself).

Lit.: B. S. Polak, 1955, p. 79; F.-C. Legrand, 'Fernand Khnopff – Perfect Symbolist', *Apollo*, April 1967, pp. 284–5; F.-C. Legrand, 1972, pp. 69, 72–3.

41. UNE AILE BLEUE. By Fernand Khnopff, 1894. Oil on canvas. Present whereabouts unknown. (Photo: Bibliothèque Royale, Brussels.)

A later but almost identical version entitled *Blanc, noir et or* of 1901 is in the Musées Royaux des Beaux-Arts de Belgique in Brussels.

Lit.: *Le Symbolisme en Europe*, exhibition catalogue, 1976, no. 73.

42. THE BLESSED DAMOSEL. By Dante Gabriel Rossetti, 1875–9. Oil on canvas, 152 x 80 cm. Lady Lever Art Gallery, Port Sunlight. (Photo: Gallery.)

Lit.: V. Surtees, *The Paintings and Drawings of Dante Gabriel Rossetti 1828–82, A Catalogue Raisonné*, Oxford, 1971, no. 244; *Le Symbolisme en Europe*, exhibition catalogue, 1976, no. 206.

43. VIRGIN OF THE LILIES. By Carlos Schwabe, 1899. Watercolour, 97 x 47 cm. Private collection. (Photo: Agraci.)

Although exhibited at the 1898 Société Nationale des Beaux Arts in Paris, it was not until the following year that Schwabe touched up certain details and signed and dated this work.

Lit.: R. Pincus Witten, 'Ideal Interlude: The First Retrospective of the Salons de la Rose-Croix', *Art Forum*, September 1968, pp. 51, 54; G. Lacambre, 1972, no. 316.

44. SOLITUDE. By Paul Sérusier, c.1890–92. Oil on canvas, 75 x 70 cm. Musée des Beaux-Arts, Rennes. (Photo: Réunion.)

Lit.: *Le Symbolisme en Europe*, exhibition catalogue, 1976, no. 221.

45. THE POOR FISHERMAN. By Puvis de Chavannes, 1881. Oil on canvas, 155 x 192 cm. Musée du Louvre, Paris. (Photo: Réunion.)

Though it was appreciated by Seurat when first exhibited at the 1881 Salon it was not well received by the critics, apart from Péladan (*L'Art orchlocratique*, Paris, 1888, pp. 23–4). In 1883 Huysmans described it as 'a curious panel . . . a crepuscular painting, an old fresco which has been eaten up by the moonbeams and washed away by rain . . . I shrug my shoulders in front of this canvas, annoyed by

this travesty of biblical grandeur achieved by sacrificing colour to line . . .' (*L'Art moderne*, Paris, 1883, pp. 178–9). It was bought for the Musée du Luxembourg in 1887. A gouache and pencil study, with composition reversed, of c.1880 is in the Cabinet des Dessins, Musée du Louvre.

Lit.: *Le Symbolisme en Europe*, exhibition catalogue, 1976, no. 173.

46. APRIL. By Maurice Denis, 1892. Oil on canvas, 38 x 61 cm. Rijks-museum Kröller-Müller, Otterlo. (Photo: Museum.)

One of a set of four paintings which loosely represent the Seasons and were exhibited at the Salon des Indépendants in 1892.

Lit.: G. Lacambre, 1972, no. 37.

47. THE CONSECRATED ONE. By Ferdinand Hodler, 1893–4. Tempera and oil on canvas, 219 x 296 cm. Kunstmuseum, Berne. (Photo: Museum.)

Exhibited at the Salon du Champ-de-Mars, Paris, in 1894 and again at the Vienna Secession in 1901 when it was bought for the Kunstmuseum, Winterthur. In 1903 Hodler made a replica which was placed in the Hohenhoff designed by Henry van de Velde for Karl Ernst Osthaus in Hagen (now the Karl-Ernst-Osthaus Museum). Hodler commented on the painting: 'A child surrounded by female figures. The picture is like a rose. What is a rose? Similar forms grouped round a centre.' (F. Hodler, MSS. Notebook, Musée d'Art et d'Histoire, Geneva, Inv. no. 1958, pp. 176–234.)

Lit.: S. Latchaw, 'The Consecrated One: Approaches to Hodler's Iconography', *Abstracts of Papers Delivered in Art History* (63rd Annual College Art Assoc. of America), January 1975.

48. THE FOUNTAIN. By Margaret (or Frances?) MacDonald, c.1894. Watercolour, 40 x 15.5 cm. Hunterian Art Gallery, University of Glasgow, Mackintosh Collection, Glasgow. (Photo: University.)

49. FRONTISPIECE TO MAURICE MAETERLINCK'S SERRES CHAUDES. By George Minne, 1889. Woodcut. Bibliothèque Royal de Belgique, Brussels. (Photo: Royal Library.)

In 1888 Minne executed several woodcut illustrations to Maeter-linck's *Serres chaudes*, published in Paris in a limited edition in 1889. A preparatory study, in pen and ink and wash, was published by L. Van Puyvelde, *George Minne* (Brussels, 1930, no. 150).

Lit.: A. Alhadeff, 'George Minne, Maeterlinck's fin de siècle illustra-tor', *Annales de la Fondation Maurice Maeterlinck*, no. 12, 1966, p. 10 ff.

50. LES ADOLESCENTS DANS LES ÉPINES. By George Minne, 1892. Pencil. Present whereabouts unknown.

Exhibited with *Les XX* in Brussels, at the *Rose + Croix* and again with Henry van de Velde's L'Association pour l'art, all in 1892. It was commissioned by Edmond Picart, an editor of *L'Art Moderne*, as a coming-of-age present for his son, Robert.

Lit.: L. van Puyvelde, *George Minne*, Brussels, 1930, no. 11; A. Alhadeff, *George Minne: Fin de Siècle Drawings and Sculpture* (un-published Ph.D. dissertation, Institute of Fine Arts, New York University, 1971), pp. 97–108.

51. THE BRIAR WOOD. By Edward Burne-Jones, 1884–90. Oil on panel, 48 x 98 cm. Faringdon Collection Trust, Buscot Park. (Photo: Courtauld Institute of Art.)

One of the four figural panels from the finest complete Briar-Rose cycle, still in its original setting. Each of the large panels bears on the frame a stanza from William Morris: *Poems By the Way* (1871): the stanza under this panel reads –

The fateful slumber floats and flows
About the tangle of the rose
But lo! The fated hand and heart
Do rend the slumbrous curse apart!

Lit.: B. Waters and M. Henderson, *Burne-Jones*, London, 1973, pp. 149–53; M. Thau, 'The Briar-Rose Theme in the Works of Edward Burne-Jones' (unpublished dissertation, New York University, 1975).

52. THE THREE BRIDES. By Jan Toorop, 1893. Charcoal and coloured pencils, 78 x 98 cm. Rijksmuseum Kröller-Müller, Otterlo. (Photo: Museum.)

The first of three studies, dated 1891, it was described by Charles Ricketts as being in 'a typical Art Nouveau spirit, designed [as] an almost abstract ornament, a kind of formal "vessel" which only later was filled with figurative elements that explained its meaning and translated it into terms of concrete illustration.' (T. S. Moore, *Charles Ricketts*, foreword (unpaged), London, 1932.) *The Three Brides* was reproduced in the first issue of *The Studio*, London, 1893. Toorop gave a detailed explanation of the work's meaning in 1894 (see B. S. Polak, 1955, pp. 119 ff.).

Lit.: *Le Symbolisme en Europe*, exhibition catalogue, 1965, no. 242.

53. THE EVIL MOTHERS. By Giovanni Segantini, 1897. Pastel on paper, 40 x 73 cm. Kunsthaus, Zurich. (Photo: Museum.)

Also called *Le châtiment des mauvaises mères* and *Les infanticides*, this is a variant of the oil painting of 1894 in Vienna, Kunsthistorisches Museum. Together with *Luxurieuses* (1891, Kunsthaus, Zurich and Walker Art Gallery, Liverpool) it was inspired by a passage from the Indian poem *Pangiavahi* much admired by Schopenhauer.

Lit.: *Le Symbolisme en Europe*, exhibition catalogue, 1976, no. 215.

54. OEDIPUS AND THE SPHINX. By Gustave Moreau, *c*.1864. Oil on canvas, 206 x 105 cm. Metropolitan Museum of Art, New York. Bequest of William H. Herriman, 1921. (Photo: Museum.)

Lit.: G. Lacambre, 1972, no. 151; H. Dorra, 'Guesser Guessed: Gustave Moreau's Oedipus', *Gazette des Beaux-Arts*, March 1973, pp. 129–41; M. Amaya, 'The Enigmatic, Eclectic Gustave Moreau', *Art in America*, 1974, pp. 94–7.

55. THE SPHINX. By Fernand Khnopff, 1884. Medium and location unknown. (Photo: Bibliothèque Royale, Brussels.)

56. PORNOCRATES. By Félicien Rops, 1883. (Photo: Giraudon.)

The frontispiece to Barbey d'Aurévilly's *Les diaboliques*.

57. THE ISLAND OF THE DEAD. By Arnold Böcklin, 1886. Oil on panel,

80 x 150 cm. Museum der bildenden Künste, Leipzig. (Photo:
Museum.)

Between 1880 and 1900, Böcklin painted six versions of this subject which he characterized simply as 'Ein Bild zum Traumen'. The popular title *Toteninsel* was given it by the art dealer, Fritz Gurlitt.

Lit.: R. Andrée, *Arnold Böcklin 1827–1901*, exhibition catalogue, Düsseldorf, 1974, no. 46.

58. MADELEINE AU BOIS D'AMOUR. By Émile Bernard, 1888. Oil on canvas, 138 x 163 cm. Private collection. (Photo: Cauvin.)

Lit.: *Le Symbolisme en Europe*, exhibition catalogue, 1976, no. 7.

59. THE SCREAM. By Edvard Munch, 1893. Oil, pastel and casein on cardboard, 91 x 73.5 cm. National Gallery, Oslo. (Photo: Vaering.)

Lit.: R. Heller, 1973, *passim*.

60. THE BRIDESMAID. By John Everett Millais, 1851. Oil on canvas, 25.5 x 35 cm. The Fitzwilliam Museum, Cambridge. (Photo: Museum.)

61. THE SONG OF THE TIMES. By Jan Toorop, 1893. Black chalk, pastel and crayons heightened with white on brown paper, 32 x 58.5 cm. Rijksmuseum Kröller-Müller, Otterlo. (Photo: Museum.)

The painting depicts the forces of Good and Evil, with Cain on the left and Abel on the right. On either side of the enigmatic central figure stand 'L'anarchie matérielle' and 'l'anarchie idéaliste et spirituelle'.

Lit.: B. S. Polak, 1955, pp. 142 ff.

62. DELFTSCHE SLAOLIE. By Jan Toorop, 1895. Coloured lithograph, 92 x 61 cm. Stedelijk Museum, Amsterdam. (Photo: Museum.)

63. THE GODDESS OF LOVE. By Giovanni Segantini, 1894–7. Oil on canvas, Galleria Civica d'Arte Moderna, Milan. (Photo: Museum.)

64. THE DANCER'S REWARD. By Aubrey Beardsley, 1894. Illustration to Oscar Wilde's *Salomé* (1894).

65. MADONNA. By Edvard Munch, 1895. Lithograph, 61 x 44.5 cm. Museum of Modern Art (The William B. and Evelyn Jaffé Fund), New York. (Photo: Museum.)

66. FISHBLOOD. By Gustav Klimt, 1898. From *Ver Sacrum*. (Photo: Stanley J. Coleman.)

67. JEALOUSY. Edvard Munch, 1896. Lithograph, 47.5 x 57.2 cm. Museum of Modern Art (The William B. and Evelyn Jaffé Fund), New York. (Photo: Museum.)

68. THE VISION AFTER THE SERMON (JACOB WRESTLING WITH THE ANGEL). By Paul Gauguin, 1888. Oil on canvas, 73 x 92 cm. National Gallery of Scotland, Edinburgh. (Photo: Annan.)

On the much discussed question of Gauguin's debt to Bernard in connection with this painting see H. Dorra, 'Émile Bernard and Paul Gauguin', *Gazette des Beaux-Arts*, 1955, pp. 227–46.

Lit.: G. Wildenstein, 1964, no. 245; M. Bodelson, 1964, pp. 178–82; M. Roskill, 1970, pp. 103–6.

69. THE LOSS OF VIRGINITY (LA PERTE DU PUCELAGE). By Paul Gauguin, 1890–91. Oil on canvas, 90 x 130 cm. The Chrysler Museum, Norfolk. (Photo: Museum.)

Lit.: D. Sutton, 'La perte du pucelage by Paul Gauguin', *Burlington Magazine*, April 1949, pp. 103–5; G. Wildenstein, 1964, no. 412; W. Andersen, 'Gauguin's Calvary of the Maiden', *Art Quarterly*, spring 1971, pp. 84–104.

70. BRETON CALVARY. By Paul Gauguin, 1889. Oil on canvas, 92 x 73 cm. Musées Royaux des Beaux-Arts de Belgique, Brussels. (Photo: A.C.L.)

Lit.: G. Wildenstein, 1964, no. 328.

71. VINEYARD IN ARLES. By Paul Gauguin, 1888. Oil on canvas, 73 x 92 cm. Ordrupgaardsamlingen, Copenhagen. (Photo: Museum.)

Lit.: G. Wildenstein, 1964, no. 304.

72. HUMAN MISERIES. By Paul Gauguin, 1888–9. Zincograph, 19 x 23.3 cm. National Gallery of Art (Rosenwald Collection), Washington D.C. (Photo: Museum.)

Lit.: M. Guerin, *L'Oeuvre gravé de Gauguin*, Paris, 1927, vol. 5, no. ii.

73. SORROW. By Vincent Van Gogh, 1882. Lithograph, 38.5 x 29 cm. Stedelijk Museum, Amsterdam. (Photo: Museum.)

Executed during Van Gogh's liaison with the thirty-two-year-old Christine Hoornik, a prostitute with whom he lived openly for two years. She was pregnant and ill when he met her in 1881.

Lit.: P. Cabanne, *Van Gogh*, Englewood Cliffs, N.J., 1963, pp. 29, 68–71; H. R. Graetz, *The Symbolic Language of Vincent Van Gogh*, New York–Toronto–London, 1963, pp. 27–9.

74. AUX ROCHES NOIRES. By Paul Gauguin, 1889. Lithograph.

Lit.: C. Gray, *Sculpture and Ceramics of Paul Gauguin*, Baltimore, 1963, p. 44.

75. WOMAN IN THE WAVES. By Paul Gauguin, 1889. Oil on canvas, 92 x 72 cm. Private collection.

Lit.: G. Wildenstein, 1964, no. 336.

76. LES ONDINES. By Paul Gauguin, 1889–90. Oak, blackened and tinted green, 18 x 57 cm. Private collection.

Lit.: C. Gray, *Sculpture and Ceramics of Paul Gauguin*, Baltimore, 1963, pp. 43–51, 194.

77. BRETON EVE. By Paul Gauguin, 1889. Pastel and watercolour, 33 x 31 cm. Marion Koogler McNay Art Institute, San Antonio, Texas. (Photo: W. Fair.)

Lit.: H. Dorra, 'The First Eves in Gauguin's Eden', *Gazette des Beaux Arts*, 1953, pp. 189–202; J. Rewald, 1958, pp. 25–6.

78a, b and c. LEDA AND THE SWAN. By Paul Gauguin, c.1889. Stoneware, height 22.5 cm. Private collection.

Lit.: C. Gray, *Sculpture and Ceramics of Paul Gauguin*, Baltimore, 1963, no. 63, pp. 65–7; M. Bodelson, 1964, pp. 232–4.

79. SELF-PORTRAIT ('LES MISÉRABLES'). By Paul Gauguin, 1888. Oil on canvas, 45 x 56 cm. Rijksmuseum Vincent Van Gogh, Amsterdam. (Photo: Museum.)

Inscribed 'Les Misérables – à l'Ami Vincent – P. Gauguin 1888'. In a letter to Van Gogh he wrote: 'By painting him [Jean Valjean in Hugo's *Les Misérables*] in my own likeness, you have an image of myself as well as a portrait of all of us, poor victims of society, who retaliate only by doing good.' (See H. B. Chipp, 1968, p. 67.) Van

Gogh gave Gauguin his self-portrait (see no. 83) in exchange.
Lit.: J. Rewald, 1962, pp. 210–11; M. Bodelson, 1964, pp. 111–12, 182–6; G. Wildenstein, 1964, no. 239.

80. SELF-PORTRAIT WITH HALO. By Paul Gauguin, 1889. Oil on panel, 80 x 52 cm. National Gallery of Art (Chester Dale Collection), Washington D.C. (Photo: Gallery.)

Painted on the right-hand door of a cupboard at Marie Henry's inn at Le Pouldu. On the left-hand door he painted *Portrait of Meyer de Haan: Nirvana* (Museum of Modern Art, New York.)

Lit.: K. Van Hook, 'A Self-Portrait by Gauguin . . .', *Gazette des Beaux Arts*, 1941, pp. 183–6; G. Wildenstein, 1964, no. 199.

81. CHRIST IN GETHSEMANE. By Paul Gauguin, 1889. Oil on canvas, 73 x 92 cm. Norton Gallery, West Palm Beach, Florida. (Photo: Gallery.)

Lit.: G. Wildenstein, 1964, no. 326.

82. SELF-PORTRAIT WITH YELLOW CHRIST. By Paul Gauguin, c.1890. Oil on canvas, 38 x 46 cm. Private collection. (Photo: Giraudon.)

The jug to the right of Gauguin's head is after the mask-like, self-portrait jug of 1889 now in the Jeu de Paume, Paris (see M. Bodelson, 1964, pp. 135–7).

Lit.: G. Wildenstein, 1964, no. 324.

83. SELF-PORTRAIT. By Vincent Van Gogh, 1888. Oil on canvas, 62 x 52 cm. Fogg Art Museum, Cambridge, Massachusetts. Collection of Maurice Wertheim. (Photo: Museum.)

Inscribed 'À mon ami Paul G. Arles, Sept. 1888' and exchanged for Gauguin's *Self-Portrait* (see no. 79).

Lit.: H. R. Graetz, *The Symbolic Language of Vincent Van Gogh*, New York–Toronto–London, 1963, pp. 283–9; M. Roskill, 1970, pp. 129, 259; J. B. de la Faille, *The Works of Vincent Van Gogh*, London, 1970, no. F.476.

84. SOYEZ AMOUREUSES ET VOUS SEREZ HEUREUSES. By Paul Gauguin, 1889. Linden wood, carved and painted, 97 x 77 cm. Museum of Fine Arts, Boston. Arthur Tracy Cabot Fund. (Photo: Museum.)

In about 1893–5 Gauguin did a woodcut of the same subject.

Lit.: C. Gray, *Sculpture and Ceramics of Paul Gauguin*, Baltimore, 1963, pp. 42–51.

85. SOYEZ MYSTÉRIEUSES. By Paul Gauguin, 1890. Wood panel, 73 x 95 cm. Private collection. (Photo: Réunion.)

Lit.: C. Gray, *Sculpture and Ceramics of Paul Gauguin*, Baltimore, 1963.

86. MARKET IN BRITTANY—BRETON WOMEN IN THE MEADOW. By Émile Bernard, 1888. Oil on canvas. Private collection. (Photo: Giraudon.)

Lit.: H. Dorra, 'Émile Bernard and Paul Gauguin', *Gazette des Beaux Arts*, 1955, pp. 227–46; H. R. Rookmaker, 1972, pp. 123–31.

87. BRETONNES AU GOÉMEN. Émile Bernard, 1892. Oil on canvas, 81 x 63 cm. Private collection.

Lit.: H. R. Rookmaker, 1972, pp. 172–5.

88. THE PIETÀ. By Émile Bernard, 1890. Oil on canvas. Private collection.

Other examples of his religious works at this date include a woodcut of *Christ on the Cross*.

Lit.: H. Dorra, 'Émile Bernard and Paul Gauguin', *Gazette des Beaux Arts*, 1955, p. 242; J. Rewald, 1962, pp. 363, 384; H. R. Rookmaker, 1972, pp. 172–5.

89. THE MUSES or THE SACRED WOOD. By Maurice Denis, 1893. Oil on canvas, 168 x 135 cm. Musée National d'Art Moderne, Paris. (Photo: Giraudon.)

Lit.: C. Chassé, 1947, *passim*; H. R. Rookmaker, 1972, pp. 160–65.

90. THE ANNUNCIATION. By Maurice Denis, 1890. Oil on canvas, 57 x 77 cm. Private collection.

Inscribed ΑΣΠΑΣΜΟΣ ('Hail'). It is also known as *Le Mystère catholique* and was repeated by Denis in several replicas for collectors such as Lugné-Poë.

Lit.: G. Lacambre, 1972, no. 36.

91. JACOB AND THE ANGEL. By Maurice Denis, 1892–3. Oil on canvas, 48 x 36 cm. Private collection.

Lit.: *Le Symbolisme en Europe*, exhibition catalogue, 1976, no. 34.

92. THE TALISMAN. By Paul Sérusier, 1888. Oil on wood, 27 x 22 cm. Private collection. (Photo: Giraudon.)

Painted on the lid of a cigar box while Sérusier was staying with Gauguin at Pont-Aven and inscribed on the back, 'Fait en Octobre 1888 sous la direction de Gauguin par P. Sérusier Pont-Aven'. It so impressed Denis and other Nabis that they called it 'le talisman'.

Lit.: *Le Symbolisme en Europe*, exhibition catalogue, 1976, no. 219.

93. CHRIST AND BUDDHA. By Paul Ranson, c.1890. Oil on canvas, 67 x 51 cm. Private collection.

94. PAUL RANSON IN NABI COSTUME. By Paul Sérusier, 1890. Oil on panel, 60 x 40 cm. Private collection.

95. THE DREAM. By Georges Lacombe, 1892. Musée Nationale d'Art Moderne, Paris. (Photo: Réunion.)

96. WOMEN IN WHITE. By Paul Ranson, 1895. Tapestry, wool on canvas, 150 x 98 cm. Musée Nationale d'Art Moderne, Paris. (Photo: Réunion.)

97. TWO WOMEN BY LAMPLIGHT. By Edouard Vuillard, 1892. Oil on canvas, 32 x 40 cm. Musée de l'Annonciade, St Tropez. (Photo: Giraudon.)

98. MARRIED LIFE. Edouard Vuillard, c.1894. Oil on cardboard, 51 x 56 cm. Private collection.

99. LA DAME EN DÉTRESSE. By James Ensor, 1882. Oil on canvas. Musée National d'Art Moderne, Paris. (Photo: Giraudon.)

100. À L'HORIZON, L'ANGE DES CERTITUDES, ET, DANS LE CIEL SOMBRE, UN REGARD INTERROGATEUR, from *À Edgar Poe*. By Odilon Redon, 1882. Lithograph, 27.3 x 20.5 cm. Art Institute of Chicago (The Stickney Collection), Chicago. (Photo: Museum.)

101. THRACIAN MAIDEN WITH THE HEAD OF ORPHEUS. By Gustave Moreau, 1865. Oil on panel, 154 x 99.5 cm. Musée du Louvre, Paris. (Photo: Réunion.)

Lit.: G. Lacambre, 1972, nos 140, 183b.

102. HEAD OF A MARTYR. By Odilon Redon. 1877. Charcoal on tinted paper, 37 x 36 cm. Rijksmuseum Kröller-Müller, Otterlo. (Photo: Museum.)

Lit.: *Le Symbolisme en Europe*, exhibition catalogue, Paris, 1976, no. 179.

103. GERMINATION, from *Dans le rêve*. By Odilon Redon, 1879. Lithograph, 27 x 19 cm. Bibliothèque Nationale, Paris. (Photo: B.N.)

104. LA FLEUR DU MARÉCAGE, UNE TÊTE HUMAINE ET TRISTE, from *Hommage à Goya*. By Odilon Redon, 1885. Lithograph, 28 x 21 cm. Kunstmuseum, Winterthur. (Photo: Museum.)

105. L'ART IDÉALISTE. By Odilon Redon, 1896. Lithograph, 9 x 8 cm. Bibliothèque Nationale, Paris. (Photo: B.N.)

106. L'OEIL, COMME UN BALLON BIZARRE, SE DIRIGE VERS L'INFINI, from *À Edgar Poe*. By Odilon Redon, 1882. Lithograph, 26 x 20 cm. Museum of Modern Art, New York. (Photo: Museum.)

Lit.: G. Lacambre, 1972, pp. 127–8.

107. GLOIRE ET LOUANGE À TOI, SATAN, from *Les fleurs du mal*. By Odilon Redon, 1890. Lithograph, 17.8 x 18 cm. National Gallery of Art, Washington. Rosenwald Collection. (Photo: Museum.)

Lit.: G. Lacambre, 1972, no. 292.

108. Detail of no. 134.

109. LA MORT: MON IRONIE DÉPASSE, from *À Gustave Flaubert*. By Odilon Redon, 1889. Lithograph, 26 x 20 cm. The Art Institute of Chicago, Chicago. (Photo: Museum.)

One of Redon's illustrations to Flaubert's *La tentation de Saint Antoine*. A slightly different version appeared in the original 1888 edition of the novel. The motif appears again later in several paintings, e.g. *The Green Death*, c.1905–16 (Museum of Modern Art, New York).

110. PORTRAIT OF EUGENE BOCH. By Vincent Van Gogh, September 1888. Oil on canvas, 60 x 44 cm. Musée du Louvre, Paris. (Photo: Réunion.)

Van Gogh met this Belgian artist and poet at Arles during the summer of 1888. A member of *Les XX*, Boch was later responsible for the inclusion of Van Gogh's work in the society's March 1890 exhibition in Brussels.

Lit.: La Faille, 1970, F.462; C. S. Moffett, 'Van Gogh as Critic and Self-Critic', *Art News*, December 1973, pp. 38–9.

111. NIGHT CAFÉ. Vincent Van Gogh, September 1888. Oil on canvas, 70 x 80 cm. Yale University Art Gallery, New Haven. (Photo: Museum.)

Probably an interior view of the Café de l'Alcazar, Place Lamartine, Arles, where Van Gogh rented a room from May to mid-September 1888. It was given to the landlord, M. Gineux, in payment of rent. A preparatory watercolour study was enclosed in a letter of September 1888 (Hans R. Hahnloser Collection, Berne).

Lit.: M. Schapiro, *Vincent Van Gogh*, New York, 1950, p. 70; J. Rewald, 1962, pp. 233–4; La Faille, 1970. F.463.

112. THE ARTIST'S BEDROOM AT ARLES. By Vincent Van Gogh, October

1888. Oil on canvas, 73 x 91.4 cm. The Art Institute of Chicago, Chicago. (Photo: Réunion.)

Lit.: M. Schapiro, *Vincent Van Gogh*, New York, 1950, p. 78. J. Rewald, 1962, pp. 234–5, 256; La Faille, 1970. F.48.

113. A MEMORY OF THE GARDEN AT ETTEN. By Vincent Van Gogh, November 1888. Oil on canvas, 73.5 x 92.5 cm. Pushkin Museum, Moscow. (Photo: Museum.)

Painted in Arles during Gauguin's visit there, it was partly inspired by Gauguin's *Women in a Garden*, 1888 (Art Institute of Chicago).

Lit.: H. R. Graetz, *The Symbolic Language of Vincent Van Gogh*, New York–Toronto–London, p. 134; La Faille, 1970, F.496.

114. REAPER IN A CORNFIELD. By Vincent Van Gogh, 1889. Oil on canvas, 74 x 92 cm. Rijksmuseum Van Gogh, Amsterdam. (Photo: Museum.)

Lit.: La Faille, 1970. FM.617.

115. THE STARRY NIGHT. By Vincent Van Gogh, June 1889. Oil on canvas, 78 x 92 cm. Museum of Modern Art (Lillie P. Bliss Bequest), New York. (Photo: Museum.)

Painted in Van Gogh's room in the St Rémy lunatic asylum and showing, in part, his view through the bars of the window. A great deal has been written about the symbolism and psychological significance of this painting.

Lit.: M. Schapiro, *Vincent Van Gogh*, New York, 1950, p. 100; J. Bialostocki, *Stil und Iconographie*, Dresden, 1965, pp. 185–6; H. R. Graetz, *The Symbolic Language of Vincent Van Gogh*, New York–Toronto–London, 1963, pp. 196–213; La Faille, 1970, F.612.

116. LANDSCAPE WITH OLIVE TREES. By Vincent Van Gogh, October 1889. Oil on canvas, 72 x 90 cm. Collection of Mr and Mrs John Hay Whitney, New York. (Photo: John D. Schiff.)

Lit.: M. Schapiro, *Vincent Van Gogh*, New York, 1950, p. 108; H. R. Graetz, *The Symbolic Language of Vincent Van Gogh*, New York–Toronto–London, 1963, pp. 185, 221–3; La Faille, 1970, F.712.

117. LA PARADE. By Georges Seurat, 1888–9. Oil on canvas, 101 x 150.2 cm. Metropolitan Museum of Art, New York. Bequest of Stephen C. Clark, 1960. (Photo: Museum.)

118. LE CHAHUT. By Georges Seurat, 1890. Oil on canvas, 170 x 140.3 cm. Rijksmuseum Kröller-Müller, Otterlo. (Photo: Museum.)

119. LE CIRQUE. Georges Seurat, 1890–91. Oil on canvas, 185.4 x 150.2 cm. Musée du Louvre, Paris. (Photo: Réunion.)

120. THE APPARITION. By Gustave Moreau, 1876. Watercolour, 106 x 72 cm. Musée du Louvre, Paris. (Photo: Réunion.)

Exhibited together with one of the several other versions of the same theme (*Salomé dansant*, formerly in the Huntington Hartford Collection, New York) and later diffused by Bracquemond's engraving of it, this work fascinated both artists and writers, notably Redon, Beardsley, Mallarmé, Proust and Huysmans. Huysmans describes it at length in *À Rebours*, chapter V.

Lit.: G. Lacambre, 1972, nos 141, 142.

121. DEAD POET CARRIED BY A CENTAUR. By Gustave Moreau, c.1870.

Watercolour, 33.5 x 24.5 cm. Musée Gustave Moreau, Paris. (Photo:
Bulloz.)

Lit.: G. Lacambre, 1970, no. 157.

122. JUPITER AND SÉMÉLÉ. By Gustave Moreau, 1896. Oil on canvas,
213 x 118 cm. Musée Gustave Moreau, Paris. (Photo: Bulloz.)

Lit.: J. Kaplan, 'Gustave Moreau's Jupiter & Sémélé', *Art Quarterly*,
vol. 33, 1970.

123. SALOMÉ. By Gustave Moreau, 1876. Oil on canvas, 92 x 60 cm.
Musée Gustave Moreau, Paris. (Photo: Bulloz.)

124. THE SACRED WOOD. By Puvis de Chavannes, 1884. Fresco secco,
45.8 x 106.15 metres. Musée des Beaux-Arts, Lyons (Photo:
Museum.)

Commissioned in 1883 for the staircase of the Palais des Arts at
Lyons, it was exhibited at the 1884 Salon as 'Le Bois Sacré cher aux
Arts et aux Muses'.

Lit.: R. Goldwater, 'Puvis de Chavannes: some reasons for a reputa-
tion', *Art Bulletin*, 1946, pp. 33–43.

125. GIRLS BY THE SEA-SHORE. By Puvis de Chavannes, 1879. Oil on
canvas, 205 x 154 cm. Musée du Louvre, Paris. (Photo: Arch.
Phot., Paris.)

Lit.: M. Th. de Forges, 'Un nouveau tableau de Puvis de Chavannes
au Musée du Louvre', *La Revue du Louvre et des Musées de France*, 1970,
pp. 248–52.

126. PORTRAIT OF PAUL VERLAINE. By Eugène Carrière, 1890. Oil on
canvas, 61 x 51 cm. Musée du Louvre, Paris. (Photo: Réunion.)

Lit.: G. Lacambre, 1970, no. 16.

127. THE SICK CHILD. By Eugène Carrière, c.1890. Oil on canvas, 65.2 x
54.5 cm. Musée du Louvre, Paris. (Photo: Bulloz.)

128. SOURCE DE VIE or LE BAISER DU SOIR. By Eugène Carrière, 1901.
Oil on canvas, 97 x 129 cm. Private collection.

Lit.: C. Chassé, *Eugène Carrière et le Symbolisme*, exhibition cata-
logue, Paris, 1949–50, no. 48.

129. THOUGHT. By Auguste Rodin, 1886. Marble, 74 x 55 x 52 cm.
Musée Rodin, Paris. (Photo: Bulloz.)

130. HEAD OF SORROW. Auguste Rodin, c.1882. Bronze, height 23.5 cm.
Yale University Art Gallery (Gift of Mrs Patrick Dinehart), New Haven,
Conn. (Photo: Museum.)

Rodin used this work for several male figures in *The Gates of Hell* —
notably the Prodigal Son and Paolo in the Paolo and Francesca group
(see no. 136). In 1905 he seems to have remodelled it as a portrait of
Eleonora Duse.

131. THE AGE OF BRONZE. By Auguste Rodin, 1875–6. Bronze, height
180.3 cm. Musée Rodin, Paris. (Photo: Bulloz.)

132. THE BURGHERS OF CALAIS. By Auguste Rodin, 1886–9. Bronze,
height, 215.9 cm. Calais. (Photo: Bulloz.)

133. Detail of 132.

134. THE GATES OF HELL. By Auguste Rodin, 1880–1917. Bronze, height
549 cm. Musée Rodin, Paris. (Photo: Schneider-Lengyel.)

Lit.: A. Elsen, *Rodin's Gates of Hell*, New York, 1960.

135. Detail of 134.

136. THE PRODIGAL SON. By Auguste Rodin, 1889. Bronze, height 137.8 cm. Allen Memorial Art Museum, Oberlin College. (Photo: Museum.)
Lit.: A. Elsen, *Rodin*, New York, 1967, pp. 57–60.

137. Detail of 134.

138. Detail of 134.

139. BALZAC. By Auguste Rodin, 1891–8. Bronze (cast 1954), height 282 cm. Museum of Modern Art, New York. (Photo: Museum.)
Lit.: A. Elsen, *Rodin*, New York, 1967, pp. 88–105; L. Steinberg, *Other Criteria*, New York, 1972, pp. 395–9.

140. Poster for the first Salon de la Rose + Croix. By Carlos Schwabe, 1892. Lithograph, 185.5 x 81.5 cm. Piccadilly Gallery, London.

141. PORTRAIT OF SÂR MERODACK JOSÉPHIN PÉLADAN. By Alexandre Séon, 1891. Oil on canvas, Musée de Lyon, Lyons. (Photo: Museum.)
Séon exhibited nineteen works with *Les Rose + Croix* of which this portrait is the most important. It is mentioned by Péladan in the dedication to his *Le Panthée. La Décadence latine*, Paris, 1892. See P. Jullian, 'Les Rose Croix', *Connaissance des arts*, August 1969, pp. 28–35.

142. THE SIREN. By Armand Point, 1897. Oil on canvas, 90 x 71 cm. Piccadilly Gallery, London.
Lit.: G. Lacambre, 1972, no. 198.

143. THE FOREST POOL. By Alphonse Osbert, 1895. Oil on wood, 35 x 56 cm. Private collection.

144. THE VISION. By Alphonse Osbert, 1892. Oil on canvas, 235 x 138 cm. Private collection.
Exhibited at the second *Salon de la Rose + Croix* in 1893, *The Vision* depicts St Geneviève, the patron saint of Paris, frequently painted by Puvis de Chavannes. Degron described it as a 'rustic virgin more as an incarnation of faith than as a Joan of Arc . . . Moved to ecstasy at hearing the Word of God, she clasps her hands in an act of adoration . . . she raises herself upwards towards "the actual vision of God".' (H. Degron, 'Osbert', *La Plume*, 1896, p. 142.)
Lit.: *Le Symbolisme en Europe*, exhibition catalogue, Paris, 1976, no. 159.

145. ORPHEUS. By Jean Delville, 1893. Oil on canvas, 79 x 99 cm. Private collection.
Lit.: R. Pincus-Witten, 'The Iconography of Symbolist Painting', *Art Forum*, January 1970, p. 62.

146. PORTRAIT OF MRS STUART MERRILL (MYSTERIOSA). By Jean Delville, 1892. Coloured chalks, 36 x 28 cm. Private collection.

147. WHAT, ARE YOU JEALOUS? (AHA OE FEII?). By Paul Gauguin, 1892. Oil on canvas, 68 x 92 cm. Pushkin Museum, Moscow. (Photo: Museum.)
Lit.: G. Wildenstein, 1964, no. 461.

148. NATIVITY. By Paul Gauguin, 1896. Oil on canvas, 96 x 129 cm. Bayerische Staatsgemäldesammlungen, Munich. (Photo: Museum.)
Lit.: R. Goldwater, *Paul Gauguin*, New York, 1957, p. 136; G. Wildenstein, 1964, no. 541.

149. WHERE DO WE COME FROM? WHAT ARE WE? WHERE ARE WE
GOING? By Paul Gauguin, 1897. Oil on canvas, 141 x 376 cm.
Courtesy Museum of Fine Arts, Boston. (Photo: Museum.)
 Lit.: R. Goldwater, 'The Genesis of a Picture: Theme and Form in
Modern Painting', *Critique*, New York, October 1946; G. Wildenstein,
'L'idéologie et l'esthétique dans deux tableaux-clés de Gauguin',
Gazette des Beaux-Arts, 1956, pp. 127–59; R. Goldwater, 1957, pp.
140–44; H. R. Rookmaker, 1959, pp. 230–37; H. B. Chipp, 1968,
pp. 69–77.
150. L'ART (LES CARESSES, LE SPHINX). By Fernand Khnopff, 1896. Oil
on canvas, 50.5 x 150 cm. Musées Royaux des Beaux-Arts de
Belgique, Brussels. (Photo: A.C.L.)
 A preparatory study (Private Collection) depicts the two heads in a
tondo, the features being more pronounced than in the final version
and bearing a striking resemblance to Khnopff's sister, Marguerite.
 Lit.: *Le Symbolisme en Europe*, exhibition catalogue, 1976, no. 71.
151. THE BLOOD OF THE MEDUSA. By Fernand Khnopff, c.1895. Charcoal
on paper, 21.9 x 14.7 cm. Bibliothèque Royale de Belgique, Cabinet
des Estampes, Brussels. (Photo: Bibliothèque.)
152. PORTRAIT OF THE ARTIST'S SISTER. By Fernand Khnopff, 1887.
Oil on panel, 96 x 74.5 cm. Private collection. (Photo: A.C.L.)
 Lit.: F.-C. Legrand, 'Fernand Khnopff. Perfect Symbolist', *Apollo*,
April 1967, p. 238; F.-C. Legrand, 1972, pp. 70–71.
153. MEMORIES. By Fernand Khnopff, 1889. Pastel, 127 x 200 cm.
Musées Royaux des Beaux-Arts de Belgique, Brussels. (Photo: A.C.L.)
 Khnopff photographed his sister Marguerite in country settings and
from these developed the figural poses. It was exhibited in 1890 in
London (Hanover Gallery) as *The Tennis Party*.
 Lit.: C. de Maeyer, 'Fernand Khnopff et ses modèles', *Bulletin des
Musées Royaux des Beaux-Arts de Belgique*, 1964, nos 1/2, pp. 43–56;
F.-C. Legrand, 1972, pp. 71–3.
154. EVENING DREAM. Xavier Mellery, c.1890. Black crayon on paper,
25.7 x 20.2 cm. Musées Royaux des Beaux-Arts de Belgique,
Brussels. (Photo: A.C.L.)
 Lit.: F.-C. Legrand, 1972, pp. 44–7.
155. MOTHER MOURNING HER DEAD CHILD. By Georges Minne, c.1886.
Bronze, height 45.5 cm. Musées Royaux des Beaux-Arts de Belgique,
Brussels. (Photo: A.C.L.)
 This work is closely related to Minne's title-page woodcut for
Grégoire Le Roy's *Mon Cœur pleure d'autrefois*, Paris, 1889.
 Lit.: F.-C. Legrand, 1972, p. 156; A. Alhadeff, 'Georges Minne:
Fin de Siècle Drawings and Sculpture' (Ph.D. dissertation, New York
University, 1971), pp. 45–50.
156. RELIC BEARER. By Georges Minne, 1897. Marble, height 66.7 cm.
Musées Royaux des Beaux-Arts de Belgique, Brussels. (Photo: A.C.L.)
 Lit.: B. S. Polak, 1955, p. 77; F.-C. Legrand, 1972, p. 159; A.
Alhadeff, 'Georges Minne: Fin de Siècle Drawings and Sculpture'
(Ph.D. dissertation, New York University, 1971), pp. 180–81.
157. THE FOUNTAIN OF THE KNEELING YOUTHS. By Georges Minne,

1898-1906. Marble. Folkwang Museum, Essen. (Photo: Liselotte Witzel.)

This is one of three later replicas of the original plaster sculpture of 1898, now lost. It was originally intended for the sculpture court of the Conservatoire Royale de Musique in Brussels.

Lit.: A. Alhadeff, 'Georges Minne: Fin de Siècle Drawings and Sculpture' (Ph.D. dissertation, New York University, 1971), pp. 180 ff.; F.-C. Legrand, 1972, pp. 156–60.

158. THE SICK CHILD. By Edvard Munch, 1885-6. Oil on canvas, 119.5 x 118.5 cm. National Gallery, Oslo. (Photo: Vaering.)

In a letter of c.1933 to Jens Thiis, Munch discussed the origins of this painting in the death of his sister Sophie when he was fifteen. 'Numerous artists were painting sick children with the pillows of the sick bed in the background . . . I was concerned with that which tied my home to . . . sickness and death. Certainly I have never been able to overcome totally this tragedy. It has always been the determining factor of my art.' Munch also mentioned the painting in *Livsfrisens tilblivelse* (Oslo, n.d., pp. 9, 10, transl. R. Heller, 1969, pp. 88–9): 'When I first saw the sick child – it gave me an impression which disappeared while I worked on it. During the year, I repainted the picture many times . . . and tried over and over again to catch that first impression on the canvas – the transparent, pale skin – the quivering mouth – the trembling hands. In the sick girl I broke new trails for myself – it was a breakthrough in my art. Most of what I later did was born in this painting.'

Lit.: J. Thiis, *Edvard Munch*, Berlin, 1934, pp. 5, 28, 135-8; G. Svenaeus, *Edvard Munch, Das Universum der Melancholie*, Lund, 1968, pp. 67 ff.; R. Heller, 1969, pp. 86–96.

159. NIGHT IN ST CLOUD. By Edvard Munch, 1890. Oil on canvas, 64.5 x 54 cm. National Gallery, Oslo. (Photo: Museum.)

Also called *Moonlight*, the shadow of the window frame on the floor forms a cross and may be a reference to the death of Munch's father (I. Langaard, *Edvard Munch Modingsar*, Oslo, 1960, pp. 106–7). For Munch's interest in Whistler, especially the *Nocturnes*, see L. J. Ostby, *Fra naturalisme til nyromantikk . . .*, Oslo, 1934, pp. 52 ff. In 1895 Munch did a drypoint and aquatint after this painting.

Lit.: J. Thiis, *Edvard Munch*, Berlin, 1934, pp. 20–21, 39, 111–12; G. Svenaeus, *Edvard Munch, Das Universum der Melancholie*, Lund, 1968, pp. 28–32; R. Heller, 1969, pp. 113–16; N. Stang, *Edvard Munch*, 1972, pp. 64, 71-3.

160. EVENING HOUR. By Edvard Munch, 1888. Oil on canvas, 37 x 44 cm. Private collection.

Lit.: R. Heller, 1973, pp. 26–7.

161. Study for DESPAIR. By Edvard Munch, c.1891–2. Pencil on paper, 23 x 30.7 cm. Oslo Community Art Collection, Munch Museum, Oslo. (Photo: Museum.)

162. DESPAIR (DERANGED MOOD AT SUNSET). By Edvard Munch, 1892. Oil on canvas, 92 x 67 cm. Thiel Gallery, Stockholm. (Photo: Museum.)

Lit.: R. Heller, 1973, pp. 67 ff.

163. SPRING EVENING ON KARL JOHAN STREET. By Edvard Munch, 1892. Oil on canvas, 84.5 x 121 cm. Rasmus Meyers Collection, Bergen.

Lit.: J. P. Hodin, *Edvard Munch*, London, 1972, pp. 40–41.

164. THE VOICE (SUMMER NIGHT'S DREAM). By Edvard Munch, 1893. Oil on canvas, 88 x 110 cm. Museum of Fine Arts (Ernest Wadsworth Longfellow Fund), Boston. (Photo: Museum.)

Now known as *The Voice*, it was originally entitled *Summer Night's Dream*. It was the first painting in Munch's series 'Love' in which six of the 'Frieze of Life' series were grouped in the Munch Exhibition in Berlin in 1893.

Lit.: R. Heller, 1969, pp. 155–66; R. Heller, 1973, pp. 45–6.

165. LOVE AND PAIN (THE VAMPIRE). By Edvard Munch, c.1893–4. Oil on canvas, 77 x 98 cm. Oslo Community Art Collection, Munch Museum, Oslo. (Photo: Museum.)

166. THE MADONNA. By Edvard Munch, 1893. Oil on canvas, 91 x 70.5 cm. National Gallery, Oslo. (Photo: Museum.)

Painted in Berlin and exhibited there in 1893 as part of the 'Love' series. In 1896 it was exhibited at Bing's Gallery, *L'Art Nouveau*, in Paris. The frame (now lost) was designed by Munch with spermatozoa running round three sides and a fœtus in the lower left corner as in his 1895 lithograph (see no. 65).

Lit.: G. Svenaeus, *Edvard Munch, Das Universum der Melancholie*, Lund, 1968, pp. 129–44; R. Heller, 1969, pp. 152, 188–96; R. Heller, 1973, *passim*.

167. JEALOUSY. Edvard Munch, 1893. Oil on canvas, 65 x 93 cm. Rasmus Meyer Collection, Bergen.

168. WOMAN IN THREE STAGES. By Edvard Munch, 1894. Oil on canvas, 164 x 250 cm. Rasmus Meyer Collection, Bergen.

Exhibited in Oslo in 1895 together with several other works from the 'Frieze of Life' series. In 1898 Munch wrote in his Journal:

'It was in 1895 that I had an autumn exhibition at Blomqvit's . . . I met Ibsen there . . . He was particularly interested in *Woman in Three Stages*. I had to explain it to him. Here is the dreaming woman, there the woman hungry for life, and there woman as nun . . . A few years later Ibsen wrote *When We Dead Awaken* . . . I came across many motifs similar to my pictures in the "Frieze of Life": the man bent in melancholy, sitting among rocks . . . The three women – Irene the white-clad dreaming of life . . . – Maja, naked, lusting for life. The woman of sorrows – with the staring pale face between the trees – Irene's fate, a nurse. These three women appear in Ibsen's work, just as in my paintings.'

Munch did several other versions of the subject in various media.

Lit.: J. Moen, *Edvard Munch: Woman and Eros*, Oslo, 1957, pp. 10–15, 20–38; J. P. Hodin, *Edvard Munch*, London, 1972, pp. 55–61; R. Heller, 'Iconography of Edvard Munch's Sphinx', *Art Forum*, 1970, pp. 72–82.

169. THE DANCE OF LIFE. By Edvard Munch, 1899–1900. Oil on canvas, 125.5 x 190.5 cm. National Gallery, Oslo. (Photo: Museum.)

Lit.: G. Svenaeus, *Edvard Munch, Das Universum der Melancholie*, Lund, 1968, pp. 188–225; R. Heller, 1969, pp. 52–61.

170. THE SUN. By Edvard Munch, *c*.1911–12. Oil on canvas, 122 x 176 cm. Oslo Community Art Collection, Munch Museum, Oslo. (Photo: Museum.)

A study for the central painting in the series commissioned in 1909 for the Aula of Oslo University. They were installed in 1916.

Lit.: J. H. Langaard & R. Revold, *Edvard Munch, The University Murals*, 1960, *passim*; N. Stang, *Edvard Munch*, 1972, pp. 235–55.

171. NIGHT. By Ferdinand Hodler, 1890. Oil on canvas, 116 x 299 cm. Kunstmuseum, Berne. (Photo: Museum.)

Night was, Hodler wrote, 'up to now my most important painting, in which I reveal myself in a new light . . . The ghost of death is there not to suggest that many men are surprised by death in the middle of the night, . . . but it is there as a most intense phenomenon of the night . . . *Night* is what I claim to be my first work . . . At the Champ-de-Mars it was the most original picture . . . I considered *Night* as the great symbol of death and tried to render it by draped figures in attitudes which fit the subject' (from Hodler's *My Present Tendencies*, *c*.1891). The Berne Kunstmuseum bought it in 1901.

Lit.: E. Bender, *Die Kunst Ferdinand Hodlers*, Zurich, 1923, p. 213; H. Mühlestein and G. Schmidt, *Ferdinand Hodler 1853–1918. Sein Leben und sein Werk*, Erlenbach–Zurich, 1942, pp. 305–19; W. Hugelshofer, *Ferdinand Hodler*, Zurich, 1952, pp. 45 ff.; J. Bruschweiler, 'Ferdinand Hodler – und sein Sohn Hector', *Neujahrsblatt der Zürcher Kunstgesellschaft*, 1966–7; P. Selz, *Ferdinand Hodler*, exhibition catalogue, New York, 1973, pp. 30, 68, 115–17.

172. DIALOGUE WITH NATURE. By Ferdinand Hodler, *c*.1884. Oil on canvas, 237 x 162 cm. Gottfried Keller-Stiftung, Kunstmuseum, Berne. (Photo: Museum.)

173. COMMUNION WITH THE INFINITE. By Ferdinand Hodler, 1892. Oil and distemper on canvas, 159 x 97 cm. Kunstmuseum, Basle. (Photo: Museum.)

Lit.: *Le Symbolisme en Europe*, exhibition catalogue, Paris, 1976, no. 62.

174. THE DAY. By Ferdinand Hodler, 1899. Oil on canvas, 160 x 340 cm. Kunstmuseum, Berne. (Photo: Museum.)

Lit.: S. Guerzoni, *Ferdinand Hodler*, Geneva, 1957, *passim*; P. Dietschi, *Der Parallelismus Ferdinand Hodler*, 1957, pp. 7, 94–5.

175. SPRING. By Ferdinand Hodler, 1901. Oil on canvas, 105 x 128 cm. Museum Folkwang, Essen. (Photo: Liselotte Witzel.)

This is the first of three versions, see *Le Symbolisme en Europe*, exhibition catalogue, Paris, 1976, no. 64.

176. EIGER, MÜNCH AND JUNGFRAU IN MOONLIGHT. By Ferdinand Hodler, 1908. Oil on canvas, 72 x 67 cm. Private collection.

177. THE KISS. By Gustav Klimt, 1895. Oil on canvas, 60 x 44 cm. Stadt Museum, Vienna. (Photo: Museum.)

178. THE KISS. By Gustav Klimt, 1908. Oil on canvas, 180 x 180 cm.
Österreichische Galerie des XIX und XX Jahrhunderts, Upper Belvedere, Vienna. (Photo: Museum.)

179. THE THREE AGES OF LIFE. By Gustav Klimt, 1908. Oil on canvas, 173 x 171 cm. Galleria Nazionale d'Arte Moderna, Rome. (Photo: Museum.)

180. THE MAIDEN. By Gustav Klimt, 1912–13. Oil on canvas, 190 x 200 cm. Narodni Galerie, Prague. (Photo: Museum.)

Lit.: F. Novotny and J. Dobai, *Gustav Klimt: with a Catalogue Raisonnée of his Paintings*, Salzburg, 1967, pp. 83, 92, 359–75.

181. ORGANSOUNDS. By Jan Toorop, *c.*1889. Pencil and pastel on linen, 54 x 69 cm. Rijksmuseum Kröller-Müller, Otterlo. (Photo: Museum.)

182. O GRAVE WHERE IS THY VICTORY. By Jan Toorop, 1892. 60 x 75 cm. Rijksmuseum, Amsterdam. (Photo: Museum.)

183. THE THREE BRIDES. By Jan Toorop, 1892. Sketch. 63 x 74 cm.

184. FAITHS IN DECLINE. By Jan Toorop, 1894. 93 x 76.5 cm. Rijksmuseum, Amsterdam. (Photo: Museum.)

185. THE BRIDE. By Johan Thorn-Prikker, 1892–3. 146 x 88 cm. Rijksmuseum Kröller-Müller, Otterlo. (Photo: Museum.)

Index